European Art of the
Fourteenth Century

D0110795

Sandra Baragli

European Art of the Fourteenth Century

Translated by Brian D. Phillips

The J. Paul Getty Museum
Los Angeles

Art through the Centuries

Italian edition © 2005 by Mondadori Electa S.p.A., Milan
All rights reserved. www.electa.it

Series Editor: Stefano Zuffi
Original Design Coordinator: Dario Tagliabue
Original Graphic Design: Anna Piccarreta
Original Layout: Sara De Michele
Original Editorial Coordinator: Caterina Giavotto
Original Editing: Virginia Ponciroli
Original Image Research: Marta Alvarez
Original Technical Coordinator: Andrea Panozzo
Original Quality Control: Giancarlo Berti

English translation © 2007 J. Paul Getty Trust

First published in the United States of America in 2007 by
Getty Publications
1200 Getty Center Drive, Suite 500
Los Angeles, California 90049-1682
www.getty.edu

Mark Greenberg, *Editor in Chief*

Ann Lucke, *Managing Editor*
Mollie Holtman, *Editor*
Robin H. Ray, *Copy Editor*
Pamela Heath, *Production Coordinator*
Hespenheide Design, *Designer and Typesetter*

Printed in Hong Kong

Library of Congress Cataloging-in-Publication Data
 [Trecento. English]
 European art of the fourteenth century / Sandra Baragli ;
 translated by Brian D. Phillips.
 p. cm. — (Art through the centuries)
 Includes index.
 ISBN-13: 978-0-89236-859-4 (pbk.)
 1. Art, Gothic. 2. Art, European—14th century. I. Title.
 N6310.B3713 2006
 709'.023—dc22
 2006024548

Page 2:
Niccolò di Pietro Gerini, *Orphans Delivered
to Their Adoptive Parents* (detail), 1386.
Florence, Museo del Bigallo.

Contents

KEY WORDS

Gothic

City

Palace

Castle

Seigniories

Chivalry

Woman

Mendicant Orders

Plague

Funerary Monument

Portrait

Chapel

Building Site

Architect

Artist

Commission

Clothing

Fabrics

Embroidery

Tapestry

Goldwork

Ivory

Miniature

Ceramics

Stained Glass

Furnishings

Wood Sculpture

Vesperbild or Pietà

"New architects appeared on the scene, and established in their barbarous countries that style of building we now call German" (Vasari, Lives).

Gothic

Notes of interest
The term "Gothic" was
first used by Italian
Renaissance theorists to
describe, in negative terms,
the "German" or "Goth"
style of classical tradition

The term "Gothic," as applied to an art style that followed the Romanesque, is used to describe an artistic phenomenon that began in France around 1140. It took hold in England and Spain around the third quarter of the 12th century, but it reached Germany no earlier than the 13th century, and Italy even later. Such conventional definitions attempt to differentiate among monuments and analyze them in terms of their form, but they do not reveal the works' historical and spiritual significance. The division of medieval art into periods on the basis of characteristic forms began with architecture, but art historians later extended the practice to painting, sculpture, and decorative arts, for they were convinced that a genuine cultural unity existed across the various ages. Scholars were led by the particular forms they identified—compound piers, pinnacles, rose windows, and so on—to define characteristic national and regional forms of Gothic architecture and to trace the stages of their evolution, hence references to the Rayonnant period, the Flamboyant period, and, in England, the Perpendicular style. For the period from 1370/80 to 1430, the term "International Gothic" describes a cosmopolitan style that began in aristocratic circles and spread throughout Europe, with a predilection for darting lines accompanied, in painting, by a taste for luxury.

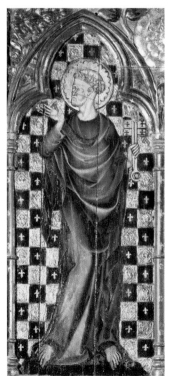

▶ *Saint John the Baptist*
(detail of *The Thornham Parva Retable*), 1325–30.
Thornham Parva (England),
church of Saint Mary.

Between the 12th and the 14th centuries, cathedrals increased in overall size and height, and their large windows allowed a great deal of light to enter through stained glass, thereby adding a mystical element to the religious architecture of the time. We are reminded, for example, of light as a symbol of the grace of God.

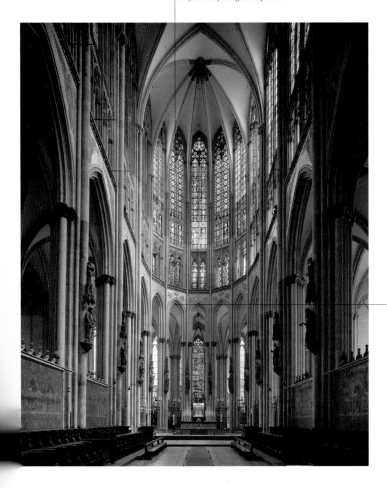

One characteristic of the Gothic style is the use of pointed arches. Other typical elements are the vaulting between the arches and the use of flying buttresses on the outside of large churches.

▲ The choir (consecrated in 1322) of the cathedral, begun in 1248. Cologne (Germany).

The figure of the angel smiling at the Virgin is accentuated vertically, simultaneously lightening and enlivening it.

Elizabeth greets Mary. The sweeping and abundant draperies in which their bodies are wrapped remind one of antique sculpture. The two women are leaning against the columns in the recess, which are almost entirely decorative in function.

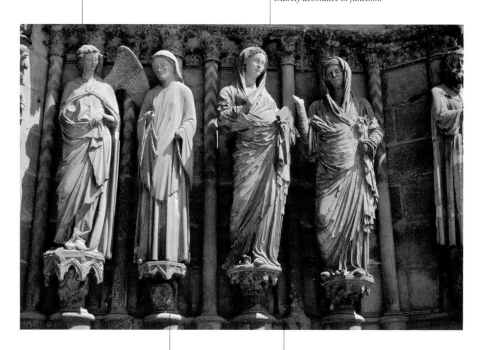

Elegance of form, soft draperies, and expressive faces are central features of Gothic sculpture.

These two groups exemplify two aspects of the sculpture of the time: the figures of Mary and Elizabeth have classical echoes, while the Virgin and the archangel are definitely more "modern."

▲ *The Annunciation* and *The Visitation*, main west entrance portal, right-hand uprights, 1252–75. Reims, cathedral.

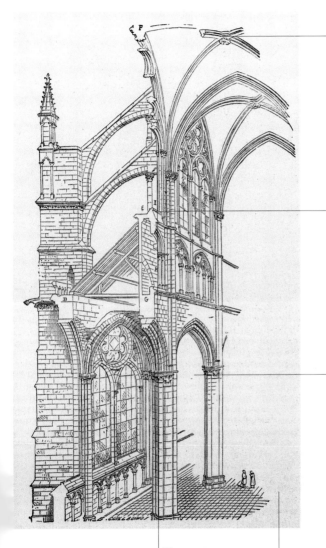

The vaulting stretches between pointed arches. Its weight and thrust are gathered at the four corners of the arching and supported by flying buttresses.

The use of flying buttresses allowed the builders to eliminate the upper galleries and enlarge the tall aisle windows. Hence more light enters the building.

This section through the nave reveals the characteristics of Gothic architecture: flying buttresses, compound piers, pointed arches, cross-vaulting, and large two- or three-light pointed-arch windows.

The support provided to the ribs by the flying buttresses made it possible to build increasingly high and light vaulting.

Section of the nave of Amiens athedral, from E. Viollet-le-Duc, *ictionnaire raisonné de l'architecture ançaise* (Paris, 1854).

This drawing was made by the French architect Viollet-le-Duc (1814–1878), who was largely responsible for the revival of interest in the study of medieval architecture. His Dictionnaire raisonné de l'architecture française *was widely read and used by neo-Gothic architects.*

"Man is called a social and gregarious animal . . . because each man helps the other . . . and that is why they make villages and towns" (Giordano da Pisa, Prediche, 1304).

City

Related entries
Palace, Seigniories,
Mendicant Orders,
Architect

The typical 14th-century city was notable for its open spaces, intended for trade, religious festivities, and political and military gatherings. Life centered both on the main square as a place to meet and trade and on the streets lined with shops, often arranged according to the goods they sold and the guild to which the owners belonged. Trade associations, called *arti* in Italy and "guilds" in northern Europe, began to gain political influence; and the buildings that housed their headquarters are evidence of their increasing power. The cathedral and the city hall adjoining a central square became the hallmarks of the late medieval European city. The city's self-image, symbolizing its importance and distinctive identity, was expressed through the care of its streets and thoroughfares. In Italy, communes called on famous architects to revitalize their urban spaces: new city walls and palaces were built, cathedrals were restored, and space was found for monumental public fountains, merchants' loggias, and tabernacles. New settlements were established to repopulate and organize dependent territories and help defend them from the expansionist policies of rival cities. Towns and cities depended on rural areas for food, and, in addition, the new dominant oligarchies of nobles, merchants, and bankers owned vast properties in the areas around their cities.

▼ *Map of the World* (detail of *Prudence*), 1360–70. Ferrara, Casa Minerbi.

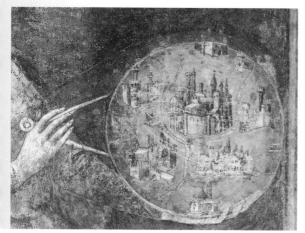

The church and the bell tower that often accompanied it came to symbolize the city as a place where the faithful gathered under the protection of their pastor. With the advent of communes in Italy, the protective role of the religious authorities diminished in the face of a lay ideology.

The city is represented here as a circle of turreted walls, designed to protect medieval man from the innumerable things he feared. The space outside the city has a negative connotation, being inhabited by demons and the forces of evil.

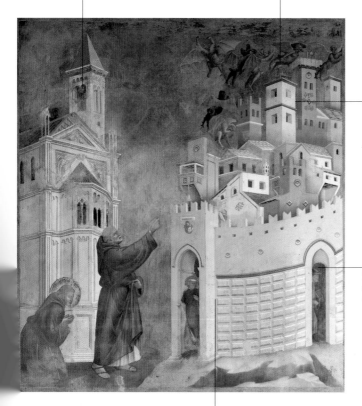

Here, Giotto has painted only secular buildings in the city. Opposite them he has painted an enormous church, which serves to indicate the sanctity of the two friars. Their intervention is needed for the city to regain its peace and tranquillity.

The gate functioned to separate the city from and join it to the surrounding country. Its appearance is therefore very important, and sculptors, painters, and stained-glass masters were hired to decorate it, often with images of celebration and good fortune.

Giotto and workshop, *The Exorcism the Demons at Arezzo*, late 14th ntury, from *Scenes from the Life of 'nt Francis*. Assisi, upper church of ı Francesco.

The 14th century saw widespread rebuilding of city walls, symbols of the city's power. Construction was expensive, however: the city of Bruges had to take out loans from Italian bankers to pay for the work.

These lovely palaces and other buildings are recognizably Sienese. The presence of masons working on a roof is indicative of a continuing concern to maintain and improve the city's appearance.

In this fresco we see the emerging concept of the secular city: the craftsmen and shopkeepers, busy at their work, point to a new social reality in which all the trades have a part to play.

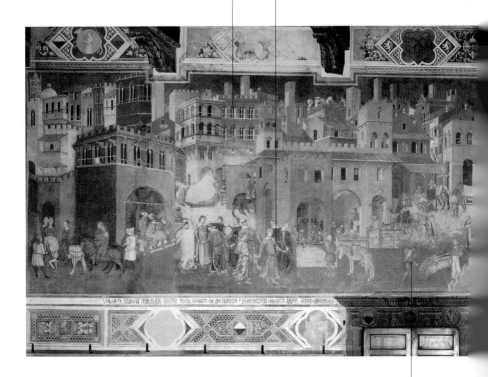

▲ Ambrogio Lorenzetti, *The Effects of Good Government on City Life and Country Life*, 1337–39. Siena, Palazzo Pubblico, Sala dei Nove.

The broad, well-kept streets bustle with trade caravans and merchants who no longer fear for their own safety. Urban links are facilitated by means of masonry bridges. The continuous flow of traffic and public control of the streets were vital for the survival of the city-commune.

In the early 14th century, Siena was responsible for opening a new chapter in the history of landscape painting. Ambrogio Lorenzetti's fresco is the first image of an environment busy with human activity and based essentially on visual experience—though obviously serving purposes of political propaganda.

The landscape conveys the message that Siena's government of the Nine wished to broadcast: it shows fruitful fields along with a peaceful, busy city whose serene inhabitants are cheerfully occupied with their work.

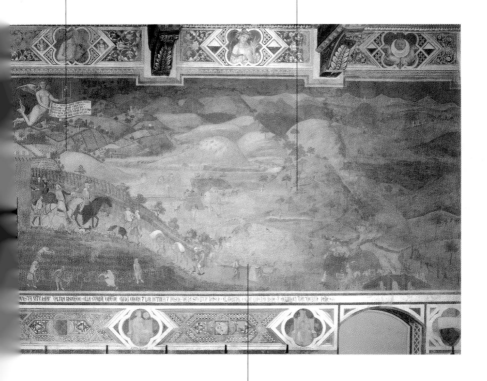

The city walls help to emphasize the continuous movement of people and goods between city and country. The gates are open because the city fears no enemies. The countryside supplies the city with food, in a stable, reciprocal relationship.

In the countryside, peasants are sowing, plowing, and reaping. There are olive trees and grapevines, and stacks of wood and pork for the winter. These images and activities, traditionally represented separately in series of the Months in medieval art, are here brought together in a single work.

15

Rome was one of the most frequently depicted cities in the Middle Ages. It had a mythical dimension for Christians because of its antiquity, its monuments, and the presence of the pope, and because of the link between temporal government and spiritual leadership.

Within the turreted walls one can identify the river Tiber, the Isola Tiberina, the seven hills toward the right, and the Janiculum on the left. The most important monuments (the Pantheon and the Colosseum) are also depicted.

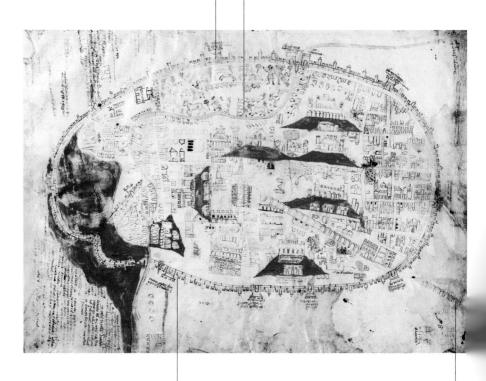

The city is embellished with new churches and bell towers, new districts and new palaces, but the old Roman walls continue to surround it.

The illustrations to Fra Paolino da Venezia's works are an important stage in the development of map-making, an activity much cultivated by artists.

▲ Fra Paolino da Venezia, *Plan of Rome at the Time of Innocent III*, first half of the 14th century. Venice, Biblioteca Nazionale Marciana.

In the first half of the 14th century, the monasteries of the new mendicant orders began to appear within the urban fabric of cities, bringing about a substantial change in the history of European urban development.

The introduction of mendicant order churches affected the structure of the city of Siena. They were situated away from the city center but were linked to it and visible from all vantage points.

At the time of the communes, Italy developed a triangular urban plan. At its corners were the Franciscan, Dominican, and Augustinian churches, and in the center were the square with the city hall and the merchants' loggia or the guild headquarters. Where bishops still held power, however, the cathedral retained its central position.

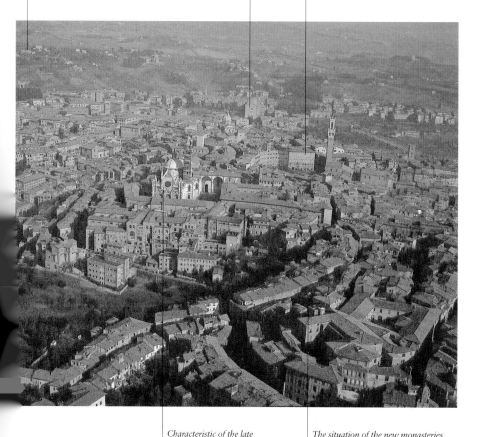

Aerial view of Siena.

Characteristic of the late medieval city were the cathedral, the city hall, the central square, and the city walls, but its layout was affected by the presence of mendicant order monasteries, which were usually situated in the outskirts.

The situation of the new monasteries was regulated by papal bulls, which took into account such practical matters as the need to collect alms. This meant that the number of monasteries was proportional to the economic importance and population of the city.

Imposing palaces belonged not just to noble or princely families, but also to wealthy members of the bourgeoisie, or they might house ecclesiastical or political authorities.

Palace

Notes of interest
To make their rooms more
comfortable in cold
weather, the floors in 14th-
century noble and princely
homes were covered with a
layer of dried grass or
branches (if the floors were
made of colored terracotta
tiles), or of cloth (if the
floors were made of wood).

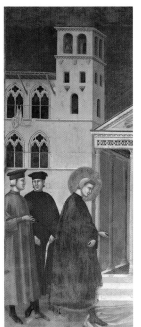

► Giotto, *The Homage of
a Simple Man of Assisi*
(detail), late 14th century,
from *Scenes from the Life
of Saint Francis*. Assisi,
upper church of San
Francesco.

In the early Middle Ages, the word *palatium* was used to refer to a royal or imperial residence, but in the 14th century it was used more generally to refer to the homes of secular princes and princes of the church, local authorities, confraternities, or even rich members of the bourgeoisie. Cities were undertaking ambitious rebuilding programs at a time when a new social class, the bourgeoisie, was gaining power. Their houses became increasingly important status symbols, growing in height and monumentality, with imposing facades. The palaces of the new merchant aristocracy were arranged vertically: the ground floor was for commerce or entrepreneurial activities, while the upper floors were for living and formal occasions. The city hall might house the committees of the commune or the guilds, and it could take various forms. The ground floor was usually open; on the next level were committee rooms and offices; and finally, at the top, were the living quarters of the city authorities. The city halls of central Italy are particularly interesting for their compact ground plan, whereas north of the Alps, the plans are more varied. In spite of its castle- or fortresslike appearance, the 14th century princely palace became increasingly residential in form, in accordance with courtly principles. Adjoining the hall where the prince administered justice were smaller, more attractive rooms, with fireplaces and tapestries to decorate the walls.

The inner rooms are arranged around a small courtyard overlooked by wooden galleries. In accordance with the standards of courtly life, some rooms, including the bridal chamber, were frescoed.

Five large windows bring light into the rooms on the various floors (the covered loggia on the top floor is a later addition). The building probably had Guelph-type battlements at the top when it was first built.

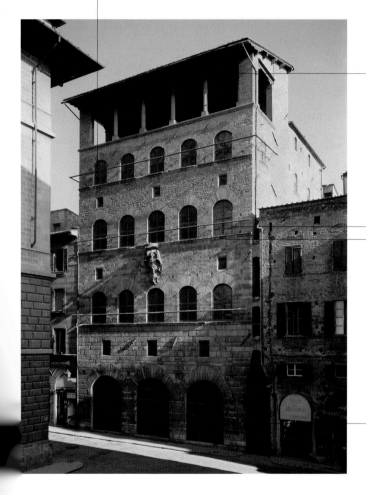

The upper windows are flanked by iron brackets, some for torches and others for wooden poles on which residents could hang their washing or attach external hangings.

On the gallery of each floor, a small opening gave access to the palace well. This was a luxury only a few could afford.

This five-story palace, built for the Davizzi family, gives us a good idea of Florentine residential building. The three portals in the rusticated masonry of the ground floor are flanked by bolts and rings for tethering horses.

Palazzo Davanzati, mid-14th century.
ɔrence.

Towers have always been a symbol of power. This one rises above the palace that housed the city authorities, who had military as well as civil duties.

In Italy at the time of the communes, city halls were often castellated, and their fortresslike structure was intended to withstand the assaults of the various local factions, which were often fighting among themselves.

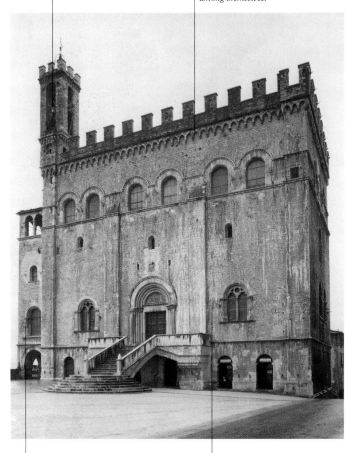

In Italy, unlike France and England, the cathedral was not the center of activity: life was organized around the square and along the streets where the merchants did business.

In the cities of Tuscany and Umbria, which were governed by merchant oligarchies, the city hall became the most important feature in the local topography.

▲ Matteo Gattapone, Palazzo del Consoli, 14th century. Gubbio.

The top part of the room wall is arranged in a variety of planes.

The great reception hall, with its bare roof trusses, was heated by means of a monumental fireplace decorated with statues of Charles V, Queen Isabella, Jean de Berry, Jean de Valois, and his wife, Jeanne de Boulogne.

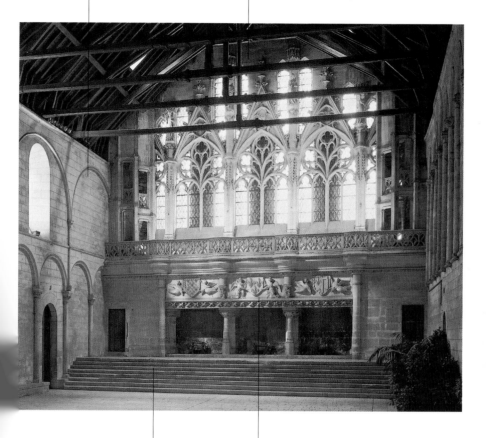

The palace at Poitiers was restored in the 1380s by the architect Guy de Dammartin at the behest of Jean de Valois.

The fireplace was used as a stage, and the gallery above it was for musicians.

The fireplace wall in the Salle des ⸝s Perdus in the ducal palace, late ⸝8os. Poitiers.

Chipping Campden was the center for English wool production. This town house was built as a symbol of his wealth by William Grevel, the most important wool merchant of his day.

It was in the 14th century that masonry fireplaces and chimneys became more common in the houses of the affluent.

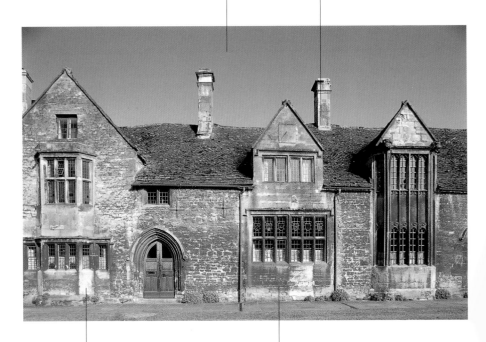

The ground floor windows look out on the main street of Chipping Campden.

This building is unusual in a number of respects: it is built of stone, which was seldom used for the houses of the bourgeoisie in the 14th century, and it is particularly large and richly decorated.

▲ The house of William Grevel, late 14th century. Chipping Campden (England).

While the 14th-century castle continued to function as a fortified building with defensive structures, it was increasingly a noble residence as well.

Castle

Although we tend to have a fixed and idealized notion of what a medieval castle is, in fact the birth, function, and development of this architectural genre varied in form and time from one part of Europe to another. Across the centuries, the castle has had three basic elements: the surrounding walls (single, double, or triple); the keep, which always occupied a dominant position as the last line of defense; and the noble palace, which might be incorporated in the keep. As the seigniories spread in northern Italy from the middle decades of the 14th century onward, a system of castles began to be built at strategic points, to defend and control the surrounding territory. In France, the kings built castles in order to consolidate their power. During the reign of Philip Augustus in the late 12th and early 13th centuries, increasing use was made of geometric surrounding walls with round towers called donjons. Royal castles became a model for feudal lords and, as the years went by, improvements led to the creation of a particular style, with a profusion of overhanging turrets and large towers with characteristic conical roofs. Throughout Europe, the 14th-century castle provided not only security but also comfort. These were elegant, sumptuous, richly decorated residences, whose defensive military purpose was often concealed behind their civil function.

Notes of interest
The terms *castrum* and *castellum* were generally used in medieval Latin sources to indicate a fortified structure intended for defense but sometimes for habitation as well.

▼ Fénis Castle, originally built in the 13th century, redesigned and enlarged in the 14th and 15th centuries. Val d'Aosta (Italy).

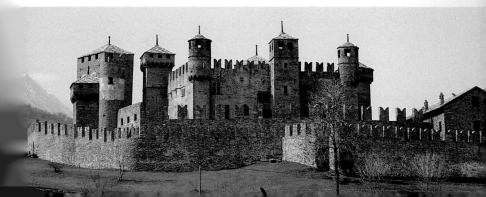

Castle

The castle is called gran buque (big ship) because of its unusual appearance, resulting from the blend of French Gothic and Arab-Islamic styles that is typical of Spanish castles after the Reconquista.

The castle complex was substantially modified in the first half of the 14th century. This was the period when the Torre del Homenaje was linked to the central part of the palace.

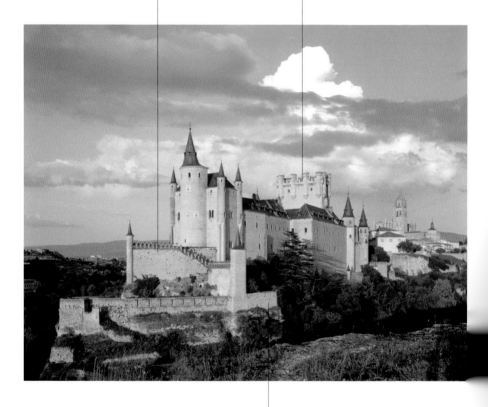

▲ Alcázar (Arabic for "castle" or "fortress"), 1364. Segovia (Spain).

Under Alfonso VIII (1158–1214), the castle began to be used as a royal residence, beginning the process of transformation that over the following centuries created the Alcázar.

The fortress was completely surrounded by walls. It had covered, crenellated bastions, lookout towers, embrasures, and small bulwarks.

The upper part of the castle contains the palace, a medium-sized tower, and the massive rectangular keep.

The well-preserved castle complex stands on a rocky outcrop and consists of a fortified surrounding wall and the castle-palace, both of which have their different constituent parts.

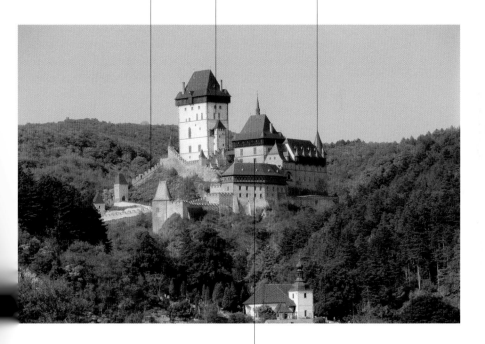

The imperial palace contained the royal bedchamber, a reception hall, workrooms, sitting rooms, the chapel of Saint Nicholas, and one floor reserved for the empress.

Karlštejn Castle, attributed to Mathieu d'Arras, founded as an imperial property on June 10, 1348, and completed in 1357. Prague.

"Certain envious men . . . apply all their cunning and strength against their fellow citizens" (Bonvesin de la Riva, Le meraviglie di Milano, *early 14th century).*

Seigniories

Notes of interest
Anyone who took control
of a city immediately built
a castle there. This fortified
building was sometimes the
lord's residence as well, but
it always housed his
representative and a
garrison. It stood in a
prominent position from
which the city walls could
be monitored, and at the
same time it guaranteed the
lord a refuge.

In the core centuries of the Middle Ages, France, England, and Spain were in the process of a monarchical consolidation that would lead to the creation of nation-states, but in Italy a variety of political forms developed. In the 13th and 14th centuries in particular, we find the seigniory (*signoria*) becoming established in many Italian cities. Characteristically, a strong man seized power, with the backing of several social classes, and put an end to democratic forms of political organization (the commune); in some cases, such as that of the Bonacolsi family at Mantua, the break with the institutions of the commune was almost total. The lord's rule, a sort of dictatorship, was generally handed down from father to son and was almost always plagued by factional struggles. The seigniory also encouraged a development from city-state to regional state, as substantial areas of land as well as urban and rural seigniories were taken over. Alongside whatever institutions of the commune survived, the new lords instituted forms of government and a lifestyle that imitated the model of courtly monarchy, promoting—as in the case of the Visconti in

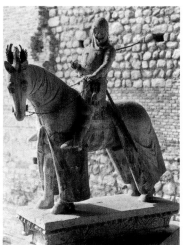

Lombard—a policy of feudal investitures that allowed local lords to consolidate their own power. Architecture also turned to the courtly models of feudalism for inspiration. In addition, lords and princes were demanding in their art commissions, and the feudal courts, together with the monasteries and large urban communes, were places where art of the highest quality was produced.

▶ Equestrian Statue
(part of the tomb of
Cangrande I della Scala),
ca. 1329. Verona, Museo
di Castelvecchio.

These frescoes were probably commissioned by Matteo Visconti at the beginning of the 14th century, as a record of his family's rise to power.

Napo della Torre, who was lord of Milan and an enemy of the Visconti, is seen kneeling before Bishop Otto. On his ceremonial entry into the city, Otto makes a gesture of clemency toward the defeated lord.

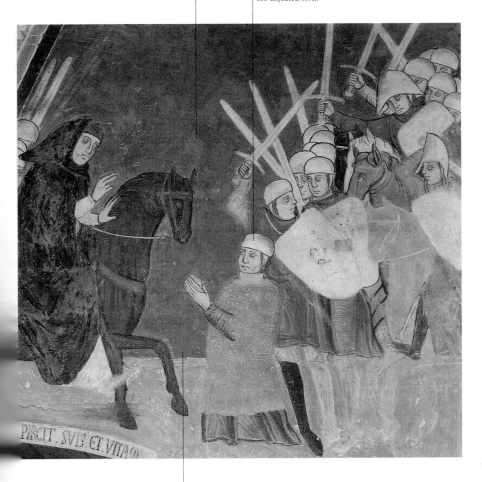

The Surrender of Napo della Torre, rly 14th century. Angera (Italy), rromeo Castle, Sala di Giustizia, uth wall.

The Angera frescoes illustrate the Visconti's designs on Milan and at the same time use imperial iconography to legitimize power seized by military force.

Seigniories

The western part of the castle was to be the lord's residence and was built outside the city walls.

When the use of firearms spread from the second half of the 14th century onward, the tops of towers tended to be fitted with platforms to support the heavy weight of artillery.

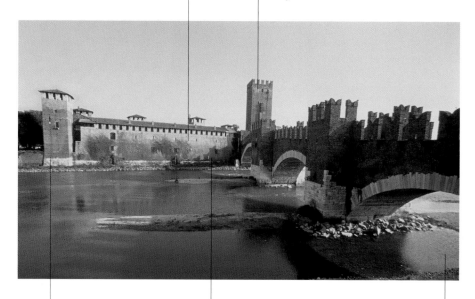

Since castles were used as lordly residences in the 14th century, they were provided with more comfortable rooms and larger windows, in order to be more attractive to the lord and his entourage.

Castelvecchio was built by Cangrande II della Scala. It straddles the city walls with the dual intention of dominating and controlling the city and protecting the lord against possible uprisings.

The defensive system, based on seven towers, is surrounded by a substantial moat of river water.

▲ Castelvecchio and the Ponte Scaligero, 1354–56. Verona.

► *Jousting Scene*, first half of the 14th century, decorated page of the *Entrée d'Espagne*. Venice, Biblioteca Nazionale Marciana.

"When the noblest man was provided with the noblest beast, [the noblest] arms . . . were granted to the knight" (Ramon Llull, Livre de l'Ordre de Chevalerie, *13th century*).

Chivalry

The courtly romance developed in France before the 13th century, but it was in the 14th century, when Europe was torn by war, famine, and plague, that it enjoyed its greatest success. Chivalry provided the aristocracy with models of behavior that became an increasingly rigid system of rituals. As the wealthy bourgeoisie emerged as a new social class, the old code of chivalry became a standard means by which the new men could gain acceptance in the most lofty circles. The duties of the perfect knight as laid down in the feudal system acquired some new overtones in 14th-century society, especially in the Italian communes. There, for example, certain texts speak of loyalty to the commune, and the concept of chivalry became linked to lavish spending. The "courtly" and the "chivalrous" ceased to be regarded as involving sublimation of the instincts and interior perfection but rather as the satisfaction of desire and the search for pleasure through abundant possessions. Kings and nobles organized feasts, parades, tournaments, and nocturnal balls in the name of "valor" and "chivalry." In 1344 in England, Edward III set up a "Round Table" at Windsor in imitation of the legendary court of King Arthur. Chivalric values were shared by the great art of the 14th century, which contributed to their codification and success. Secular and chivalrous themes became widespread, and art also began to convey that yearning for earthly happiness for which chivalrous and courtly culture provided the best means of expression.

Related entries
Woman, Plague, Goldwork, Miniature

Paris, Avignon, Prague, and Bohemia

Notes of interest
The ideal of the perfect knight—strong, valiant, and loyal—came into being in the feudal society of 11th-century France. In addition to these manly values, there were new rules about behavior toward women: war and love were the bases on which the standards of chivalry depended.

Rollat̃ ante . anoiz . pzis ñanz cuñ neuait
Lacauesque trepiß ne fleit plus enegnit.
Le pzt passe . pusgat foz le ha naros qe bnit.
Desiros de cõfondite le tuz qeloz messut.
Dut qe bie ueule mouz safon bnie nel ornut.

E mõs espeone lacauesa ualat.
Alozs fu feagu dune pems asirut.
Atens paies bath son guie uuid pesat.
Et apzis une lange aun senos balloiat.
pues fiert deseseos les temes auiat.
Ne senble qi coze pazla ũus auiat.
S elebueß arauesa ott paoz ne dunat.
Wais dutot lesen nolaiß pazisit.
Salance lo penue soz lesens ma ineuat.
Q enel puer enpiez uus dmezs ualesat.
Le mes Mot waiz . lui fert foz mauentar-

Chivalry

The episodes that have survived depict battle scenes involving closely packed groups of knights, armed with lances, shields, and swords, and wearing medieval cuirasses.

The legend of Troy enjoyed considerable success in the Middle Ages, being told and retold in versions such as Roman de Troie *by Benoît de Sainte-More (1160–70) and* Historia destructionis Troiae *by Guido delle Colonne (1270–87).*

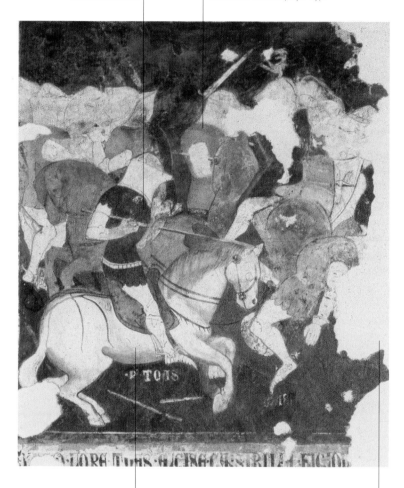

▲ *Scenes from the History of Troy,* before 1364. Udine, Civici Musei e Gallerie di Storia ed Arte.

These frescoes have now been detached and rearranged, but they originally decorated the walls of the city hall at Udine and depict scenes from the Trojan legend.

This iconographic theme was stipulated as part of a public commission. It sought to express the political and cultural role played by chivalrous ideals while at the same time ennobling the commissioners' own origins.

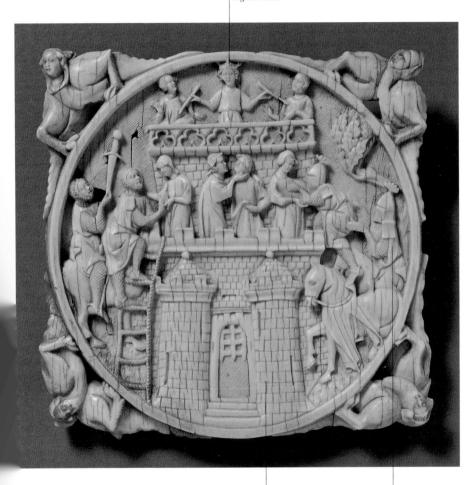

The lady is protected by the substantial walls of the castle, but the virtuous knight will nevertheless succeed in capturing her heart.

French workshop, Mirror Case ̣picting an Assault on the Castle of ̣ve, 14th century. Florence, Museo ̣zionale del Bargello.

A mirror was a precious accessory for a lady. The fact that objects of this kind for private use often depict themes from courtly romances is an indication of the enormous success of the genre.

The knight, accompanied by his squire, is about to conquer the lady in accordance with courtly ritual, a sort of game with rules that permitted honorable amusement. But the code had to be observed.

Chivalry

Young ladies as well as gentlemen had to know how to play chess. And winning had symbolic significance: if the lady won, the knight had to undertake fresh trials.

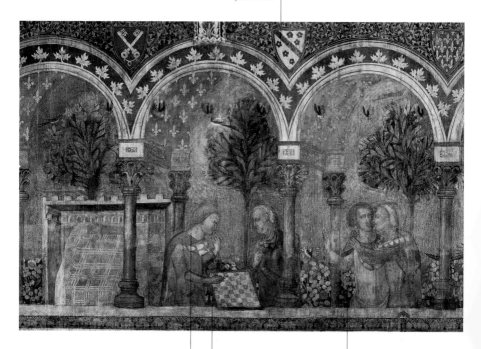

Duke Guernieri's wife is trying to seduce Guglielmo, the protagonist of the story. She takes him into the bedroom and has a chessboard brought so that they can play together. According to the rituals of courtly love, chess was a clear indication that seduction was being invited.

Chess is a game of Eastern origin that became a favorite pastime in medieval high society. The chessboard itself was a precious object, often used as a gift to express gratitude or regard.

This fresco shows an episode from a chivalrous story taken from a French poem and narrated in Florentine form as La donna del vergiù, perhaps by Antonio Pucci.

▲ *A Lady and a Knight Playing Chess*, ca. 1395. Florence, Palazzo Davanzati, bridal chamber.

"That a bold woman is by nature a devil in human form"
(Niccolò del Rosso, Sonnets, *14th century).*

Woman

Medieval society was undoubtedly male dominated. For a long
time, women deserved consideration only for their bodies,
their ability to procreate, and their relationships within the
family. Medieval art clearly reflects change in the image of
women in society and religious thought. The curse of suffering
in childbirth, inflicted on Eve in Genesis, was to have a
profound effect on woman as wife and mother. Eve becomes
the guilty party in sexual union, while the Virgin Mary is held
up as the model that every woman should seek to imitate. For
centuries, the female world was a source of both attraction
and fear, hence representations of the devil as a girl and of the
tempter-devil with a female face; and hence the representation
of the female body as a personification of Lust and as an
occasion for sin inexorably offered to man. Though woman
remains subject to male power and the image of woman that
has come down to us depends largely on male attitudes, it is
clear that reality was more complex. In particular, as towns
developed from the late 13th century onward, many changes
took place, not only in the work women did but also in the
spheres of marriage and religion. In the
14th century, there were many schools
for girls throughout Europe, and some
women worked outside the family or the
convent. But apprehension that women
might usurp male prerogatives and fear of
their seductive power came together in an
obsession with witches, which was fueled
at the end of the 14th century by
Bernardino of Siena (1380–1444).

Related entries
Chivalry, Artist, Clothing

Jean Le Noir

Notes of interest
From the 13th to the 15th
century, hatred and
vendettas between noble
families in the towns could
still be settled with a
strategic marriage. In all
areas of society, men ruled
over women: a woman's
actions were always
controlled by her father or
husband, as well as being
subject to social controls
and rules of conduct.

▼ Giotto, *Joachim and Anne at
the Aurea Gate*, 1303–4. Padua,
Scrovegni chapel.

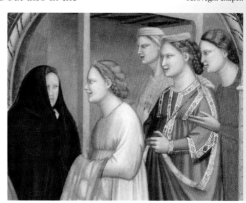

Woman

A woman's primary task was to produce heirs. The chamber where she worked, gave birth, and lived a large part of her life is at the heart of the medieval home.

As she gave birth, a woman was assisted by close relatives and a midwife, who was paid for her work.

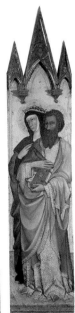

▲ Paolo di Giovanni Fei, *The Birth of the Virgin*, ca. 1380. Siena, Pinacoteca Nazionale.

Death in childbirth was common. But when a birth had been successfully accomplished, the mother was given restorative but light food. Meanwhile, the other women took charge of the baby.

In the 14th century, women in wealthy families married while still in adolescence. Their husbands would be at least ten years older, and about half of the woman's married life would be spent in a state of pregnancy.

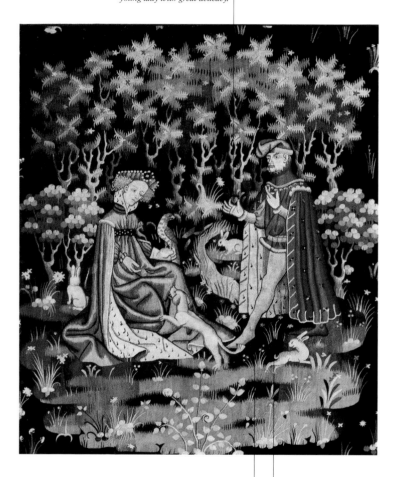

Arras manufactory, *Offering of the heart*, tapestry, early 15th century. Paris, Musée National du Moyen-Âge.

Men who wished to be civilized learned how to gain the goodwill of their lady or "maiden," and how to take into consideration women's sensibility and intelligence in order to win their hearts.

The rituals of courtly love helped modify men's rough behavior and the matrimonial politics of family descent. It gave rise to a new relationship with women.

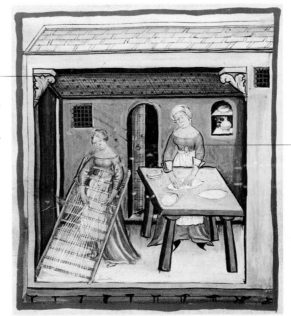

This miniature shows pasta being made. The woman at the table is kneading the dough, while her companion is arranging the strips on a drying frame shaped like a ladder, pulling them up to keep them separate and allow them to dry.

Many townswomen were employed in small commercial or craft businesses and some belonged to guilds. Companies employed women as apprentices, assistants, or craftswomen.

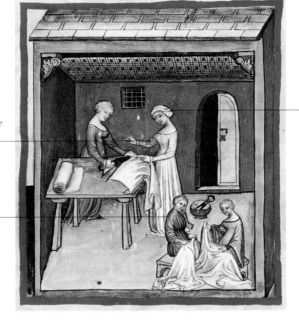

In many northern European cities women could enter the fur or textile guilds with the same rights as men.

Textile production, together with food preparation, accounted for the bulk of women's work in the late Middle Ages.

Four women are busy sewing clothes in the tailor's workshop.

Saint Catherine invoking protection for "her" town of Treviso is evidence of both the emergence of the female figure and the slow pace of change in the condition of women in the society of the communes.

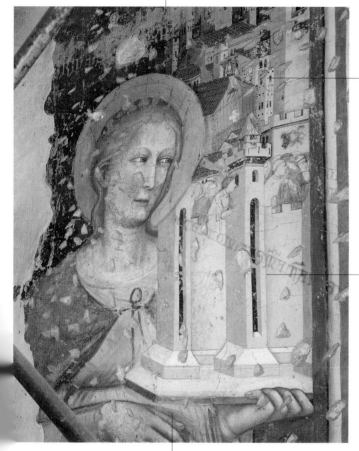

The vitality of cities is conveyed by the proliferation of shields, towers, and flags, and by the ongoing construction of a church, whose bell marks out the passage of time.

Saint Catherine is holding "her" city with one hand, and from her mouth come the words "Haec est civitas mea Tarvisina pro quam Deum meum rogo" (This is my city of Treviso on behalf of which I appeal to my God).

With the flowering of the communes, a deep civic-religious feeling came into being. New saints were canonized, some of whom were women.

Women Making Pasta and *Women ...wing Clothes*, late 14th century, ...m *Tacuinum sanitatis*. Vienna, ...terreichische Nationalbibliothek.

▲ Follower of Tomaso Barisini, *Saint Catherine with a Model of the City of Treviso*, mid-14th century. Treviso, Santa Caterina.

The mendicant orders contributed to the dialogue between society and the Church. Their spiritual influence also affected art, with new themes and more objects for private devotion.

Mendicant Orders

Related entries
City, Chapel

Notes of interest
The Dominican order was
founded in 1215 by
Domingo de Guzmán
(1170–1221), later Saint
Dominic. The friars
belonging to the new order
devoted their time to
missionary preaching and
were in direct contact with
the peasantry. The Order
of Friars Minor was
founded by Francesco di
Pietro di Bernardone, who
became Saint Francis of
Assisi. The rule of the
Franciscan order was
approved in 1222. The
secondary female orders of
Dominicans and Clares
were based on the
Dominican and Franciscan
models. Other mendicant
orders were the Carmelites,
Augustinians, and Servites.

► Giotto and workshop,
*The Sanctioning of the
Rule*, late 13th century,
from *Scenes from the Life
of Saint Francis*. Assisi,
upper church of San
Francesco.

In the 14th century the monasteries of the Franciscans and Dominicans, the mendicant orders, were situated inside towns so that they could have closer contact with the faithful, and almost all of them promoted art. In spite of their initial diffidence toward the luxury of decoration and the cult of images, particularly in sculpture, these orders—especially the Franciscans—took full advantage of the figurative arts as instruments of religious propaganda. Francis himself became a favorite subject because his life story was full of miraculous events, and his frequent appearance in altarpieces, stained glass, and frescoes helped broadcast his image. Furthermore, the monasteries of the mendicant orders benefited from princes and wealthy members of the bourgeoisie who wished to salve their consciences by giving generously to men who preached poverty and asceticism. The enrichment of the Franciscan order banished the tone of simplicity and poverty that had characterized their 13th-century architecture. In their sober early buildings, the nave, where they preached, had a simple wooden ceiling, as though it were a meeting hall. This gave way in the 14th century to increasingly substantial and monumental buildings with large stained-glass windows. Furthermore, the Franciscans and Dominicans played an important part in preaching and at funerals, at which custom required a certain amount of pomp and ceremony. The mendicant orders aided the spread of Gothic architecture and, in spite of their austerity, promoted art for the greater glory and honor of God.

The Franciscan order took its inspiration from the mysticism of Francis himself and devoted itself to poverty, charity, and social work. The friars lived by their own manual labor without depending on alms.

When Francis died in 1226, disagreements among the friars began to deepen. Some interpreted the way of life suggested by Francis in a less rigid manner, while others wished to respect his rule strictly.

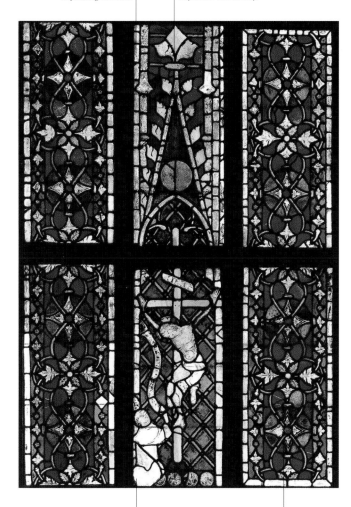

The tall church windows were filled with narrow stained-glass panels. Saint Francis wears the Franciscan habit, tied at the waist with a cord, and kneels before the Crucifix of Saint Damian.

The brightly colored glass and repeated floral motifs with inserted figured scenes are typical of the stained-glass windows in mendicant order churches in southern parts of the Holy Roman Empire.

*tained-Glass Window with Saint
rcis, first half of the 14th century.
is, Musée National du Moyen-Âge.*

This enormous and very simple brick building has no architectural decoration and conveys a total severity of form.

The interior is striking for its very long transept, and its frescoes bear witness to the many donations made to the mendicant orders.

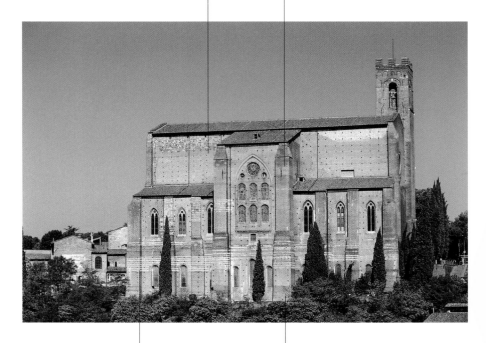

Thomas Aquinas, a member of the Dominican order, was a very important figure in the 14th century. As a learned intellectual, he was destined to become representative of Christian orthodoxy.

At the earliest stage, the friars depended on alms for their survival, but they were soon given permission to have possessions in common. The learned, scholarly Dominicans were closely allied to the Church, which was strenuously defending itself against heretics.

▲ View of the apse area of the church of San Domenico, begun in 1309. Siena.

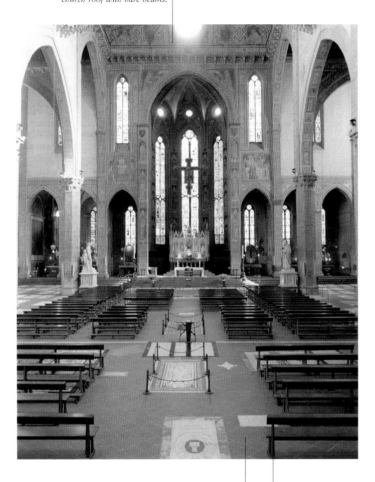

The initial project seems to have been the work of Arnolfo di Cambio, who wanted a very substantial church roof with bare beams.

Interior of Santa Croce, built to [a] design by Arnolfo di Cambio, [13]05–1443. Florence.

The Franciscans chose a district outside the city walls for their church. The area was full of ditches and often flooded by the Arno, and its chief inhabitants were dyers and tanners. It was to the lower classes that the Franciscans directed their preaching.

There were many contributions to the building of the church. The commune itself made a monthly grant toward the work, and the nobles built splendid chapels whose frescoes were to have a profound effect on 14th-century painting.

The Triumph of Saint Thomas Aquinas *is on the left wall of the room. Saint Thomas sits in the center on a throne, around which fly the seven Virtues. On either side are the evangelists and major prophets, while heretics collapse in defeat on the steps.*

Andrea da Firenze's frescoes are in the chapter house. They are to be viewed in sequence and aim to provide both a glorification of the Dominican order through its history and values and a statement of its relations with the commune and the Church.

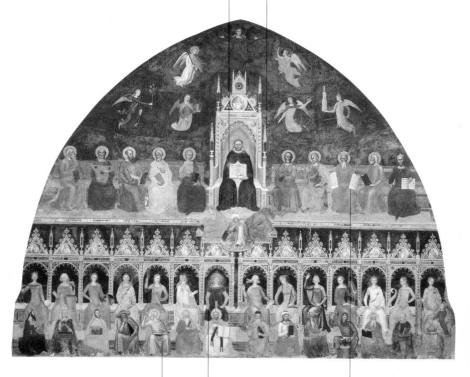

Painting is used here to set out the dogmatic program of the Dominican order. At the time the room was used for chapter meetings, at which the friars carried on doctrinal discussions.

Personifications of the trivium (Logic, Rhetoric, and Grammar) and quadrivium (Arithmetic, Geometry, Astronomy, and Music) are lined up in the lower tier. Each is accompanied by its most eminent exponent.

The Dominican order is glorified in the dual aspects of its activity: theological speculation and the application of the principles of Saint Thomas Aquinas to daily life.

▲ Andrea da Firenze (Andrea di Bonaiuto), *The Triumph of Saint Thomas Aquinas*, ca. 1366–68. Florence, Santa Maria Novella, Spanish chapel.

"Many were those, among ordinary people, who died. . . . It was the young and strong especially whom the plague attacked."
(Geoffrey le Baker, Chronicle, 14th century).

Plague

The plague epidemic that struck Europe in the second half of the 14th century (first in 1348, then in 1361, again in 1369–75, and finally in 1399) had very serious consequences in the field of art, because it decimated both the practitioners and their clients. Among the latter, the cultural level of the nouveaux riches was fairly low and their ideas were conditioned by the preaching of the mendicant orders. This meant that the prodigious flowering of art in the first half of the century came to an end, especially in the areas worst affected by the plague, such as central Italy. Certain iconographic themes take hold at this period, such as the Triumph of Death, in which Death stalks the earth armed with a great scythe, and, especially in northern Europe, the Dance of Death. The theme of death was already present in the 13th century, but increased living standards in the 14th century led to a new sensitivity toward the pleasures of life and contributed to a new attitude toward death, which was now perceived in a secular sense as a complete cessation of earthly pleasures. Given this new sensitivity, the spread of the plague helped add a strongly macabre aspect to the representation of death: it was shown as something cruel and sudden, which attacked the fragile human frame without distinction of social class, age, or moral conduct.

Notes of interest
Over the course of the 14th century, Europe suffered a severe demographic and economic crisis. Climate change—average temperatures dropped—and population increases led to frequent famine. On top of it all, around midcentury came the scourge of the plague, hitherto unknown in the medieval West. At the time, nothing was known about the dynamics of the plague. It was thought that there was some sort of putrefaction of the air, and so great fires with aromatic herbs were lit at city gates.

◄ *The Plague at Tournai in 1349*, 14th century, illuminated page from the *Annales* of Gilles le Muisit. Brussels, Bibliothèque Royale Albert Ier.

Plague

Three elegant, carefree knights are out hawking when they encounter three tombs, out of which come three corpses (right), one of which is naked and reduced to a skeleton.

The memento mori of Christian inspiration is no longer concerned solely with bodily transformation after the final resurrection: it now answers a desire to see what remains of the body, its material destiny.

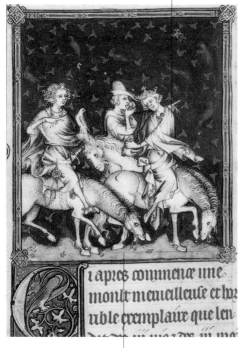

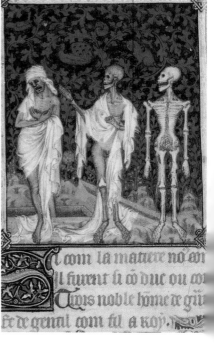

The subject of three live men meeting three corpses derives from an ancient Eastern legend, which was already well known in the West in the 13th century. Its principal theme was the macabre.

▲ Jean Le Noir, *The Three Living* and *The Three Dead*, before 1349, illuminated pages from *The Psalter and Hour of Bonne of Luxembourg.* New York, Metropolitan Museum, The Cloisters.

The woman holds out her open hand toward Death in a gesture of supplication that is typical of the poor.

The figure of Christ pronounces the words, "O you who read, take note of the blows of those who killed me, for I am their lord." This has a typically Franciscan tone in stressing the humanity of Christ.

The fear of death, amplified by the arrival of the plague, can engender a resigned contemplation of the mortality of man.

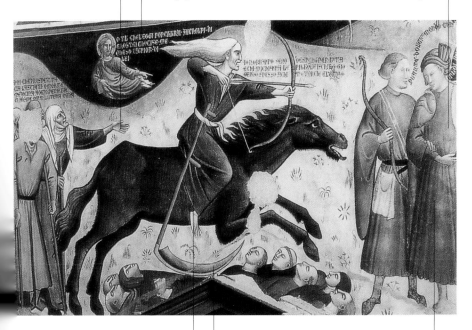

Death is a woman dressed in black riding a black horse, with an enormous scythe tucked into her belt. She takes no notice of those who appeal to her and releases her arrows in the direction of two young, richly attired huntsmen.

The scythe is an attribute of Time, and it expresses very well the decimation of the population, mown down like grass beneath its sharp blade.

The two young men, armed for the hunt, have earthly pleasures in mind and do not worry about their souls in the life beyond. But there are still grounds for hope regarding their eternal destiny.

Attributed to Bartolo di Fredi, Lippo Memmi, or another Sienese painter, *The Triumph of Death*, late 14th century. Lucignano (Arezzo), San Francesco.

Plague

In his book titled Lo specchio umano (The Human Mirror), Domenico Lenzi, a Florentine grain merchant who died of the plague in 1348 or a little earlier, described the famine that struck Tuscany in 1329 and 1330.

Since Lenzi was a Florentine and hence an opponent of Siena, he took pride in the fact that Florence opened its gates to the poor who had been expelled from the enemy city.

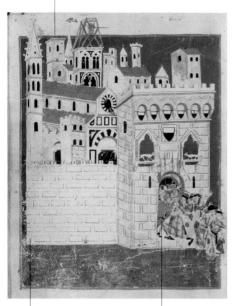

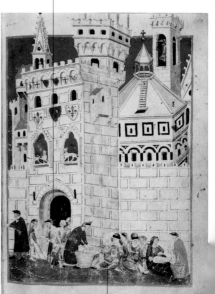

The 14th-century city is shown enclosed by its walls. The most important buildings of each city are represented in the two miniatures.

Because of the famine, Siena decided to stop the traditional distribution of bread to the poor, which took place three times a week at the hospital of Santa Maria della Scala. This led to violent uprisings and to a decision by the government of the Nine to expel the poor from the city.

Some Florentine citizens welcome the poor Sienese by coming out of the city gate with baskets of bread.

▲ *The Expulsion of the Poor from Siena and Florence Welcomes the Poor from Siena*, ca. 1340, illuminated page from *Lo specchio umano (Il libro del biadaiolo fiorentino)* of Domenico Lenzi. Florence, Biblioteca Medicea Laurenziana.

Those who commissioned funerary monuments preferred to be represented not lying in a coffin but in active attitudes, so that the living would remember them and think well of them.

Funerary Monument

It was probably in the 13th century that the habit of representing the real features of the dead on funerary monuments began, and in the 14th century it became increasingly common. If the subject was no longer alive when the artist began work, sculptors might even make use of death masks to help portray the person's features; such masks were sometimes used during funerals. In any case, the funerary monument was the best way of using a portrait to stimulate remembrance among the living. To have a beautiful tomb built during one's lifetime was a somewhat ostentatious sign of social prestige, but in addition it was a way of preserving one's image from the devastation of death. In the 14th century, the human figures represented on funerary monuments no longer have the unreal appearance of those in the 13th century; in fact, portraiture was increasingly used in both sculpture and painting. The dead could now be consigned to the world beyond with their true likeness and with the attributes of their rank—kneeling, enthroned, or on horseback. In Italy, the monument made by Arnolfo di Cambio for the tomb of Cardinal De Braye at Orvieto in 1282 (it blends architecture and sculpture, and the figure of the cardinal lies at the center of the composition) served as a model for a number of 14th century monuments: Tino di Camaino in Tuscany and Naples and Giovanni Balducci in Lombardy adopted the same arrangement.

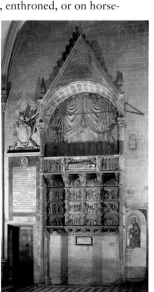

◄ Agostino di Giovanni and Agnolo di Ventura, *Funerary Monument of Bishop Tarlati*, 1330. Arezzo, cathedral.

Funerary Monument

The Scaligeri tombs are the most spectacular of 14th-century aristocratic monuments. They were designed to stand in the open air and are both funerary monuments and equestrian statues.

The equestrian statue of the dead man is placed at the top of a pyramidal structure that covers and protects the actual tomb.

A tall pyramid rises above the baldachin. At its summit is a hero mounted on horseback, brandishing his bloody sword to affirm his greatness even in death.

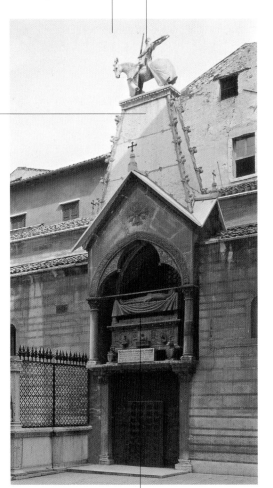

▲ Tomb of Cangrande I della Scala, ca. 1329. Verona, Santa Maria Antica.

Cangrande I della Scala (who died in 1329) is represented in the conventional way, lying on his funerary bed.

We see evidence of the increasing social prestige of the professions from the 14th century onward: the funerary monuments of jurists and doctors are found along with those of noblemen, senior clerics, lords, and kings.

The figure of the jurist is enlarged, in accordance with the convention— usually reserved for holy persons— that made the size of figures proportional to their importance.

The jurist is represented sitting on a throne atop his sarcophagus, stressing his point with a lively gesture. The figures on either side of him represent his colleagues.

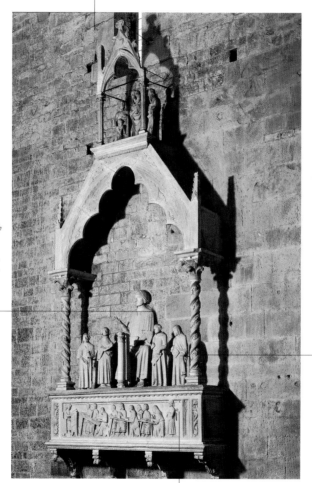

enese artist, Funerary Monument ino da Pistoia (detail), early 14th ury. Pistoia, cathedral.

In the low relief, the great jurist Cino da Pistoia (who died in 1337) is shown seated in his chair as he teaches pupils in a classroom.

Careful attention has been paid to the features on the king's face, as well as to his beard and hair.

Signs of the illness that afflicted the king in his closing years can be seen in the wooden model for this figure. The fact that they have been attenuated but not effaced in the copper effigy indicates that the artist intended to produce a faithful likeness.

▲ Recumbent Statue of Edward III (detail), 1377–80. London, Westminster Abbey.

This copper statue is an important example of how, after the arrival of the funerary monuments by Jean de Liège, a more three-dimensional conception of the human figure developed in England and elsewhere, together with a realism that had not theretofore been seen in London art circles.

English tombs are usually fairly simple in form, and the tomb effigy is normally recumbent. Italian and French tombs are more imposing.

The early medieval portrait that depicts certain categories of person or situations becomes a portrait of an individual in 13th-century sculpture and 14th-century painting.

Portrait

The tradition of portraying people with individualized features was of Roman origin, but apparently it came to a halt in the 6th century. However, the idea of representing a true likeness was taken up again in medieval sculpture and painting. Anecdotal evidence suggests that Giotto was probably the first artist to portray the true features of the person represented. The only surviving example is his portrait of Enrico Scrovegni, who is shown as a donor in *The Last Judgment* fresco in the Scrovegni chapel at Padua (1306–7). In the innovative, stimulating atmosphere of Avignon, Simone Martini seems to have conveyed the real features of Laura in a portrait that Petrarch speaks of with enthusiasm; Simone went on to paint the great portrait of Cardinal Stefaneschi in the cathedral lunette. These very important portraits are the earliest examples of 14th-century likenesses, and they were to be followed later in the century by others that can be picked out among the figures around the edges of frescoes or on panels depicting religious or secular subjects. The identity of these individuals is not always easy to determine, however. The portrait-likeness first appeared in sculptures of the dead on funerary monuments, but it became widespread in painting, thanks to the numerous requests from kings, lords, and wealthy members of the bourgeoisie. The result was that their features soon invaded spaces hitherto reserved for sacred images: they were painted or sculpted in chapels and portrayed in stained-glass windows and church portals, taking the place of angels and saints.

Related entries
Funerary Monument,
Commission

Avignon

Giotto, Jan Boudolf,
Simone Martini

Notes of interest
One special kind of portrait, typical of late medieval Italy, is the "shaming painting" (*pittura infamante*). It was the custom to paint, in certain districts of a town, the portraits of those found guilty of various crimes, ranging from treason to murder and fraudulent bankruptcy. These 14th-century portraits are mentioned in chronicles and statutes, but none has survived.

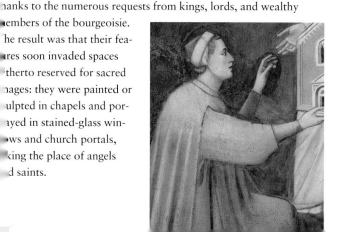

◀ Giotto, *Enrico Scrovegni* (detail of *The Last Judgment*), 1303–4. Padua, Scrovegni chapel.

Portrait

The fact that the king is not wearing a crown makes it possible to date the portrait to before his coronation.

The king is shown in profile, as he would be on a medal. An inscription identifies him as "Jehan Roy de France" and his features seem clearly individualized.

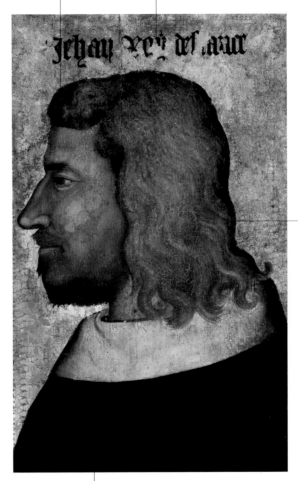

This panel painting is the first in which the features of an individual were represented as they actually appeared, rather than as a "type" of donor or client, or as part of a larger scene.

The original purpose of this portrait is unclear, but it is possible that there was a 14th-century tradition of portable royal portraits with individualized features.

▲ John II the Good, before 1350. Paris, Louvre.

In the 14th century, portraits of local individuals were included in religious images, sometimes among a crowd of figures.

Nello dei Tolomei, the magistrate (podestà) who commissioned the work, is shown kneeling in the foreground among the saints.

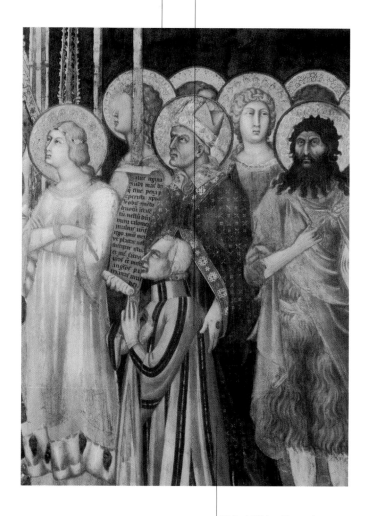

ippo Memmi, *Podestà Nello Tolomei* (detail of *Maestà*), 7. San Gimignano (Siena), seo Civico.

Nello dei Tolomei is wearing a rich fur-lined robe as he is presented to the Virgin by Saint Nicholas. The latter is carrying a scroll bearing a prayer that Nello be admitted to the court of heaven as a representative of his town.

"Somebody paints a painting in a church and . . . wishes to be praised for it . . . Who did this painting? So-and-so did it. That is the reward he gets" (F. Sacchetti, Sposizioni di vangeli, 1378–81).

Chapel

Notes of interest
Demand for relics was on the rise in this century. They were jealously preserved in chapel reliquaries and even came to be carried on the person in jeweled mountings. It is no coincidence that Sainte-Chapelle in Paris was inspired by the Byzantine emperors' Pharos chapel, where the most precious relics in Christendom were preserved.

Chapels were originally conceived as places where kings and their courts could pray and where holy relics could be housed. Their role in housing relics made chapels special places for their display and preservation, and the walls of such highly valued places were covered with precious materials intended to enhance the sacred nature of the rites involved. When King Louis of France had Sainte-Chapelle built (it was consecrated in 1248) to house Christ's crown of thorns, the building was considered unsurpassable and was imitated by European monarchs throughout the 14th century. But the building of princely chapels inspired great novelty, and those built by private individuals were even more original. In fact, they were chapels not so much for individuals as for rich families or dynasties who built private oratories in imitation of great lords; or for corporations, guilds, or religious associations that needed a place to meet periodically in prayer. The richest families built private chapels inside their own houses, but it was increasingly common to make generous donations to a church in order to qualify for a reserved space, near the choir or along the aisles, as tangible evidence of the donors' social status. In this way, the mendicant order churches were filled with chapels belonging to influential lay families. Apart from its liturgical uses, the chapel housed the family tombs and became a special place for meditation and private reflection.

▶ Scrovegni chapel, early 14th century. Padua.

This chapel was built on two levels with large tracery windows, in imitation of Sainte-Chapelle; it was almost completely destroyed by fire in 1834.

The interior had the appearance of being brightly colored because of the stained-glass windows and frescoed walls. There was also gesso decoration with Flamboyant-style details, which looked forward to the language of the Decorated style.

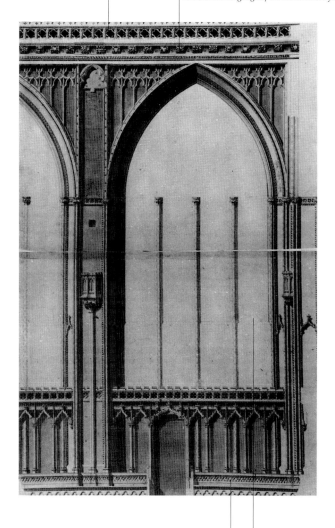

Detail of an elevation drawing of nt Stephen's chapel (1292), don, Westminster Palace. 19th-tury drawing by Richard Dixon.

The delicate reticulated tracery of the chapel exterior was the point of departure and inspiration for the Perpendicular, the final phase of English Gothic.

In shape, the chapel is a pinnacled parallelepiped, and it became the model for all English royal chapels in the late Middle Ages.

Chapel

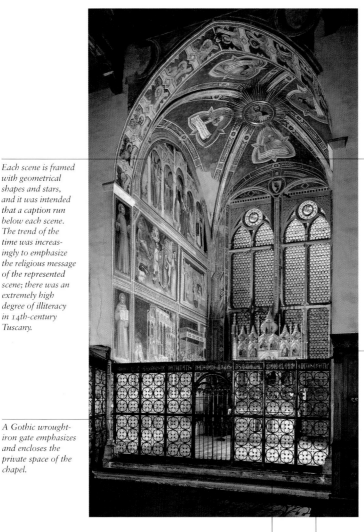

Chapels were embellished with holy images such as paintings and statues of the patron saints of families or confraternities, together with heraldic emblems or portraits that bore witness to the ownership of the chapel.

Each scene is framed with geometrical shapes and stars, and it was intended that a caption run below each scene. The trend of the time was increasingly to emphasize the religious message of the represented scene; there was an extremely high degree of illiteracy in 14th-century Tuscany.

Standing on the principal altar is a monumental polyptych by Giovanni del Biondo, dating to 1379.

A Gothic wrought-iron gate emphasizes and encloses the private space of the chapel.

▲ Rinuccini chapel, 1365. Florence, Santa Croce.

This chapel was founded and frescoed in accordance with the will of Lapo di Lizio Guidalotti. It was taken over by the Rinuccini family in 1371.

The chapel is dedicated to the Virgin and Mary Magdalen. Its frescoes were begun by Giovanni da Milano and completed by a lesser Florentine master, probably Matteo di Pacino.

"Founded on secrets, / and the powers of science . . . / the mason's art was born /. . . Then one saw rise from the ground / palaces that none could equal" (Manuscrit regius, 1390).

Building Site

The medieval building site is one of the most powerful expressions of the technical, artistic, and organizational skills of the society of the time. The great 14th-century building sites—particularly those of cathedrals, but also those of secular buildings—were important meeting places for skilled workers from a variety of places, providing them with an opportunity to exchange knowledge and techniques. Furthermore, once work had started, cathedral and palace sites became important not just because they offered employment but also because they created a vast network of production and trade interests: brick and lime production, stone quarrying, and the cutting of timber, to name a few. Vast numbers of people were directly or indirectly involved in a building site, including artists, craftsmen, and laborers of various kinds. Hence major building sites had considerable economic and social importance in a medieval city. Apart from the architects, masons, stonecutters, and laborers at work, the sources also mention carpenters, smiths, glaziers, plumbers, plasterers, painters, and workers in marble and mosaic. There were many stages in building construction, from planning with the architect's drawings and approval by the religious or secular authorities to the actual start of work and the realization of the project itself. The immense cost of constructing cathedrals and similar buildings meant that the work could go on for generations.

Related entries
Gothic, Woman, Architect, Commission, Clothing, Stained Glass

Notes of interest
The terms *opus* and *opus fabricae* (which became *Werk* in Germany, *oeuvre* or *fabrique* in France, *office of works* in England, *fabbrica* in northern Italy, and *opera* in Tuscany) describe the organizational and administrative structure surrounding a building under construction, as well as the site itself. An onsite loggia served both as store and workplace: that was where tools and models were kept and where stonemasons might be found at work; it also served as a shelter and meeting place during rest periods.

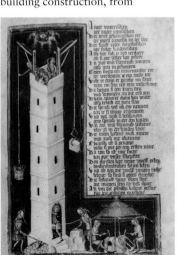

◄ *Building the Tower of Babel*, ca. 1370, illuminated page from the *Weltchronik* of Rudolf von Ems. Munich, Bayerische Staatsbibliothek.

Machinery for lifting heavy objects was vital on sites for large buildings. It was often designed by architects and engineers and built by skilled carpenters.

The biblical story of the Tower of Babel was often depicted, and illustrators used contemporary building sites as their models. From these depictions, we can gain useful information about hierarchies and customs on a building site, and also about the tools that were used.

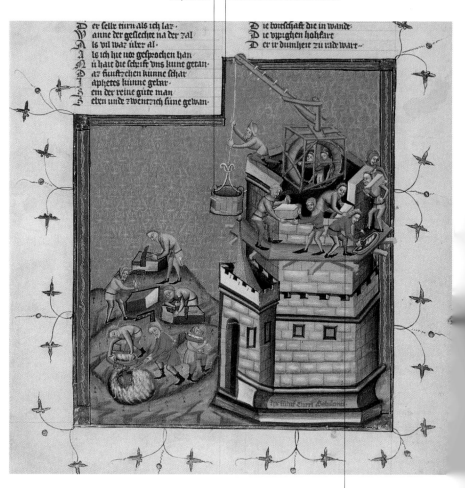

▲ *Building the Tower of Babel*, 1383, illuminated page from the *Weltchronik* of Rudolf von Ems. Stuttgart, Württembergische Landesbibliothek.

The different on-site roles are emphasized by the different clothes the workers are wearing: the architect is more elegantly dressed than the masons, and they in turn are differentiated from the simple laborers, who are poorly dressed and often barefoot.

Materials were moved around with the help of large baskets of various shapes, trays, and wooden pails. The wheelbarrow made its appearance in the 13th century and was used fairly widely at 14th-century building sites.

A woman is carrying a tray of lime. Women were often employed as laborers and were paid at day rates, but their wages were much lower than those of their male co-workers.

The typical mason's tool was the trowel. It consisted of a triangular or trapezoidal iron blade with a wooden handle and was used for spreading mortar.

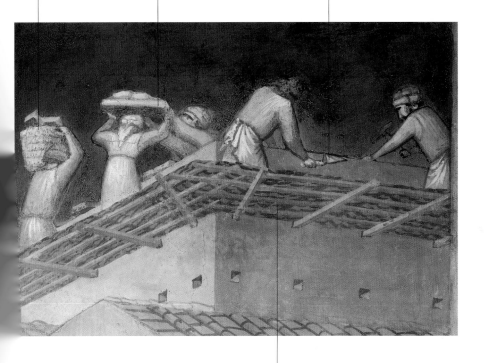

The masons are standing on wooden scaffolding consisting of a trellis supported by a rigid frame of small beams. They are thus able to work on two sides of the wall at once.

Ambrogio Lorenzetti, *A House under construction* (detail of *The Effects of Good Government on City Life*), 1337–39. Siena, Palazzo Pubblico, Sala dei Nove.

"In these great building operations there is an expert in charge who ... rarely carries out any physical tasks, yet he is paid more than the others" (Nicolas of Biard, Distinctiones, *1250–75).*

Architect

Related entries
Building Site, Artist,
Commission

Arnolfo di Cambio, Giotto,
Giovanni Pisano, Lorenzo
Maitani, Peter Parler, Claus
Sluter, Tino di Camaino

Notes of interest
Generally called an
architectus, *architector*,
or *architectarius*, he is
sometimes called *magister*
(*maistre* or *maître*,
maestro, *master*, *maior*,
Baumeister, etc.), but in the
14th century he was still
sometimes referred to
simply as *murator*.

The most important figure in the building site hierarchy was the architect. He dealt with planning as well as matters of practical and financial organization, and he supervised the work itself. For the most part, medieval architects were trained on-site, but for the purposes of building construction they adopted certain rules based on proportions derived from geometry. It seems to have been normal practice in the 14th century to draw up plans, but all such early architectural drawings have been lost. Drawings may have been made on parchment, but full-scale drawings may also have been made on walls, on the ground, or on wood or plaster supports. For certain architectural details, special sheet-metal or wood templates were used to make copying easier. Drawings at 14th-century building sites were made at a designated area (the so-called tracing-house, primarily documented in England), separate from the skilled workers' loggia. Here the profiles and templates were prepared for the workmen. The architect's technical knowledge and acquired experience lent him prestige, and he was distinguished from the other workers in that his duties were purely executive. As early as the second half of the 13th century, some architects enjoyed special privileges and high wages, especially in France but also in England. In 14th-century Italy, the communes competed for the services of the best architects and artists, exempting them from taxes and granting them privileges.

In France, during the 13th century, when the great Gothic construction sites were flourishing, the figure of the architect acquired great importance.

The architect was increasingly responsible for planning and supervision. A sermon of 1261 describes an architect arriving at his site with gloves and rod in hand and instructing the stonecutters what they are to do.

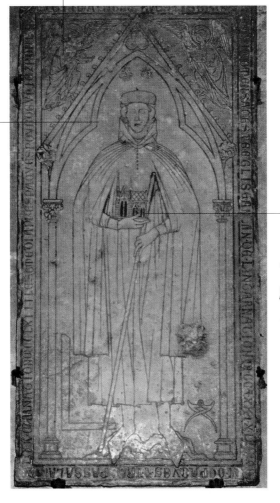

The architect Hugues Libergier wears a prestigious robe, is portrayed with the tools of his profession (rod, set square, and compasses), and in his hand holds a model of the church he has built—a privilege previously granted only to donors.

The Architect Shows the Stonecutters …v to Do Their Work, late 13th …tury. Paris, Bibliothèque Nationale.

▲ Tombstone of Hugues Libergier, late 13th century. Reims, cathedral (formerly in the church of Saint-Nicaise).

Architect

The drawing shows plans for an ambitious program of sculptures. This was unusual north of the Alps but was common in Italy, where the figure of the sculptor-architect emerged as early as the 13th century.

This is one of the most beautiful surviving medieval architectural drawings. It even makes use of color.

The rose window is shown in the center, and above it is a row of statues of saints, each in a niche surmounted by an angel playing a musical instrument. Christ the Savior is in a mandorla in the middle of the angels.

The drawing's considerable dimensions (the whole facade measures 410 × 82.5 cm, or 161⁷⁄₁₆ × 32½ in.) suggest that it had an "official" purpose, i.e., that it was to be shown to the donors.

▶ Project for the west facade of Strasbourg cathedral (detail showing the rose window), second half of the 14th century. Strasbourg, Musée de l'Œuvre Notre-Dame.

The king and the architect watch stonecutters and masons at work on the building site. A machine for lifting materials—probably designed by the architect himself—is operated by some workmen.

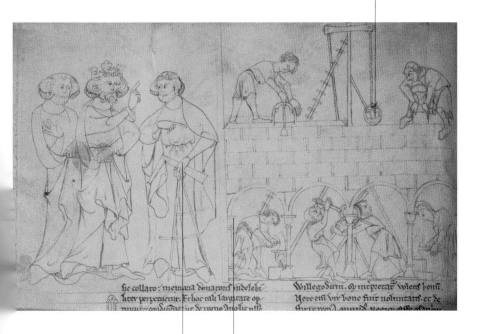

The donor-king is having a discussion with the architect. The latter is elegantly dressed, as befits a person of importance, and he holds a set square and compasses—the attributes of his calling.

There are many miniatures and paintings of building sites in which the figure of the architect appears.

*he King and the Architect Direct
rk at the Clifford Tower, ca. second
*of the 14th century, illuminated
*e from *Vitae duorum Offarum* (*The
es of the Two Offas) by Matthew
*s. London, British Museum.

"Certain painters were not inferior in talent to those who were masters in the liberal arts" (F. Villani, De origine civitatis Florentie . . ., *14th century*).

Artist

Notes of interest
During the Middle Ages, manual work was long regarded as inferior to intellectual activity. There was a famous distinction between those who practiced the "liberal arts" (intellectual activity) and those who practiced the far less noble "mechanical arts" (manual work). But this attitude began to change in the 13th and 14th centuries with the development of towns, where a great variety of work was required.

The term "artist" as we use it today lays emphasis on the creative act and the unique nature of the product, and adds a suggestion of genius, whereas the highly skilled medieval craftsmen who produced the splendid works of goldwork, painting, sculpture, and architecture were not thought of in that way. For a long time the person who commissioned the work—perhaps paying for it or simply putting forward the idea for it—was considered far more important than the artist. But a new attitude toward the artist gradually developed: plaques appeared with increasing frequency in cathedrals, praising those who had worked there, and in European courts around the early 14th century one can detect the increasing consideration given to the maker of a work of art, leading to the creation of the court artist. But it was in Italy at the time of the communes that the figure of the *artifex* gained increasing prestige, thanks to the art and building projects of the communes. The extraordinary works of art and buildings that embellished the cities became a source of pride for their citizens. When great writers like Dante, Boccaccio, and Petrarch recognized the skill of contemporary painters and wrote of them with admiration, this helped modify the subordinate position of artists and the figurative arts relative to the liberal arts. At the end of the century the Florentine historian Filippo Villani included Giotto and other Florentine painters in his eulogy of illustrious Florentines.

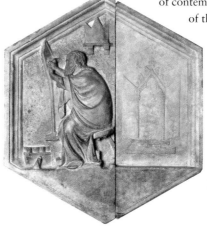

▶ Andrea Pisano, *Painting*, 1334–42, panel from the east side of Giotto's bell tower. Florence, Museo dell'Opera di Santa Maria del Fiore.

Stories from the Gospel are shown on the pulpit. As a piece of architecture, it is characterized by its hexagonal base and slender columns rising to pointed arches with sculpted figures at the corners.

From a stylistic point of view, the Pistoia pulpit is the peak of Giovanni Pisano's achievement. All tension is released, equilibrium is created, and the sculptural language is homogeneous.

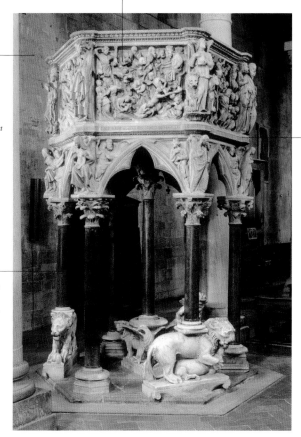

According to the inscription, the pulpit "was sculpted by Giovanni who never made inferior works, son of Nicola, but endowed with greater knowledge and more learned than any before him."

Giovanni Pisano was so conscious of his own worth that he often found himself at odds with those who commissioned his work. His pride as an artist" is clear from the inscriptions he left on his works.

Giovanni Pisano, Pulpit, completed in ı. Pistoia, Sant'Andrea.

The architect is represented on a larger scale to emphasize his importance. His right hand is raised to give instructions to the two masons, while in his left hand he holds the compasses that were a typical tool of his trade.

The sculptor is seen shaping a figure with mallet and chisel. He is surrounded by various tools on the ground, and behind him is a drill on a stand.

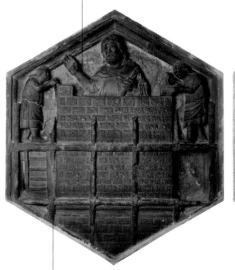

It was in his workshop that the artist carried out his commissions. Here, as with all the crafts, an apprentice started out very young and began with the lowliest jobs.

Fourteenth-century painters, sculptors, and architects were organized into corporations. Artists' activities were in any case controlled by the wishes of whoever commissioned their work, through a contract stating very precise requirements.

▲ Andrea Pisano, *Architecture* and *Sculpture*, 1334–42, panels from the east side of Giotto's bell tower. Florence, Museo dell'Opera di Santa Maria del Fiore.

The lady is painting a panel on an easel. Beside her, an assistant is preparing the paints. Brushes and containers can be seen on the small table in the foreground.

Panel painting was the principal source of income for artists working in towns. Only a few managed to free themselves from the restrictions imposed by the corporations or the courts and go on to achieve international fame.

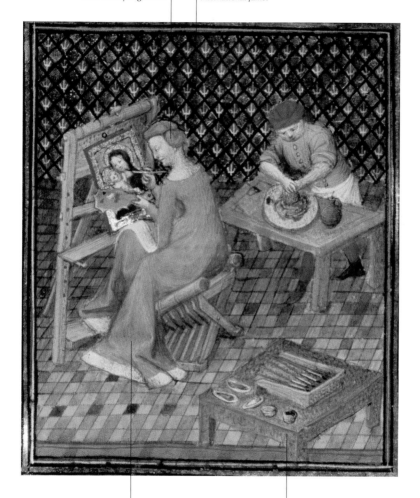

Female Painter with a Male istant, early 15th century, ninated page from Giovanni :accio's De claris mulieribus. s, Bibliothèque Nationale.

Women as well as men could devote themselves to painting, miniatures, and sculpture. Their occupation as artists, though rare, is documented. Many nuns, for example, painted miniatures.

In his De claris mulieribus *(On Famous Women), Boccaccio mentions women who became famous for their skill at painting or sculpture: an interesting case of an artist praising female achievement.*

The person who commissioned a work of art played an important part in its production. He chose the subject and often the style as well.

Commission

To the medieval mind, the most important contributor to a work of art—whether a building, a gold object, or a painting—was the person who commissioned it. His influence on the work was considerable, for his wealth and social position, his culture, and his religious and political ideas were reflected in the form, program, and sometimes style of the resultant work. Some forceful personalities also managed to introduce innovations and to use art as a means of expressing their own ideological tendencies. Throughout the Middle Ages, kings and clergy were chiefly responsible for commissioning works of art; but in the 14th century, local lords, the communes, and confraternities replaced the Church as arbiters of the most important artistic programs, which consequently underwent a sort of secularization. Religious values were partly replaced by political programs and secular values, which arose in the universities and at the courts. In France, Spain, England, and the Holy Roman Empire, art helped to glorify the sovereign and spread his fame. Hence royal "portraits" came into being. But all artistic fields, including urban embellishment, were subject to the artistic program envisioned by those who commissioned the work. The visual affirmation of power and a taste for the antique were imposed on artists, and hence became typical of art at the great European courts, from Peter IV the Ceremonious in Aragon to the pope in Avignon, Emperor Charles IV, and King Charles V of France.

▶ Deodato Orlandi, *Constantine Begins the Construction of St. Peter's* (detail), late 13th–early 14th century, from *Scenes from the Life of Saint Peter and Saint Paul*. Grado (Pisa), San Pietro.

Saint John, the Virgin, and Saint Catherine look kindly upon the donor and show that they accept the offering, which he hopes will gain him a place in paradise and permanently purge his father's sin of usury.

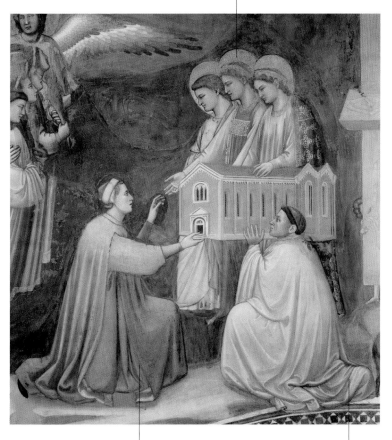

Enrico Scrovegni, who commissioned and donated the chapel, has had himself painted among the group of the blessed in The Last Judgment, *beside the model of the chapel that he has had built.*

A regular Augustinian canon (perhaps the head of the community responsible for services in the church) is in his white habit, at the top of which his black-and-blue hood can just be made out. He bears on one shoulder the building that Enrico is supporting with one hand.

Giotto, *Enrico Scrovegni Offers the Chapel to the Virgin* (detail of *The Last Judgment*), 1303–4. Padua, Scrovegni chapel.

Commission

The images of Justice and of the Commune, both representing the common good, are closely linked. There is even a cord joining them. They are flanked by the figures of Peace and Concordia as personifications of good government.

The regal figure wearing the colors of the city of Siena represents the commune, which also stands for the common good.

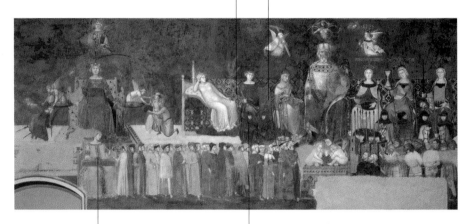

The regime of the Nine in Siena was an expression of the power of a merchant oligarchy. It commissioned this "propaganda" fresco from Ambrogio Lorenzetti at a time when the oligarchy had more than once been endangered by the plots of the nobility.

In the 14th century, artists were still subordinate to and clearly much influenced by those who commissioned work from them. An artist might well be pushed into celebrating or legitimizing some position of power or become responsible for conveying political messages. These "powers" were more or less numerous at various times and places in the Middle Ages: the emperor, monarchs, and local lords who needed to construct images for themselves; the communes; religious bodies, bishops—the list goes on.

▲ Ambrogio Lorenzetti, *Allegory of Good Government*, 1337–39. Siena, Palazzo Pubblico, Sala dei Nove.

The emperor Charles IV had the walls of the chapel of Saint Catherine at Karlštejn decorated with hard polished stones, which, together with reliquaries, were intended to evoke the heavenly Jerusalem.

The figure of the emperor, with a faithful representation of his features, invades the sacred space so much that he becomes its protagonist. He and his wife are represented on either side of the cross and become part of the iconographic scheme of the chapel.

Charles IV and His Wife Anne of Svidnica Supporting the Reliquary of Cross, 1355–60. Prague, Karlštejn tle, chapel of Saint Catherine.

Ever since antiquity, monarchs had erected public buildings, both sacred and secular, as symbols of their power and magnificence, but they also commissioned works of art in precious stones.

"And [Cisti the baker] wore a pure white doublet and a freshly laundered apron which always made him look more like a miller" (G. Boccaccio, Decameron, 14th century).

Clothing

Related entries
Chivalry, Woman, Fabrics

Notes of interest
Fabrics and clothing were bought and sold by merchants and dealers, but their value was such that they were also used in exchanges and as gifts, loans, or deposits. They formed part of a bride's trousseau and could be left in a will. Clothing and fabric production required the work of highly skilled craftsmen.

In addition to protecting the body and keeping out the cold, clothes have always been used to establish distance, convey messages, and provide an indication of social status and lifestyle. In the closing centuries of the Middle Ages, certain rules about personal appearance became codified. They were based not only on the use of colors (often with a different significance from one city to another), but also on types of fabric and clothing styles, all of which could convey hierarchies, functions, and social extraction. Courtiers put on expensive displays and created new fashions, and in cities the best way to stand out was by means of one's costume. At 14th-century princely courts, women increasingly favored dresses that emphasized the figure, not without certain seductive overtones. Men wore tight, colored stockings with ever-shorter shirts (doublets) that tended to emphasize the legs, but before 1340 men also wore long, loose-fitting robes. Local sumptuary laws, and the sermons of preachers, tried to rein in all this luxury. These laws list many different objects, indicating the wide variety of available clothes and ornaments: bags, engraved objects, embroidery, pearls, and so on were all to be found in the wardrobes of the wealthy. But ostentation of this kind was permitted only to the knightly class and to doctors—in other words, only to those who no longer had a higher social position to aspire to.

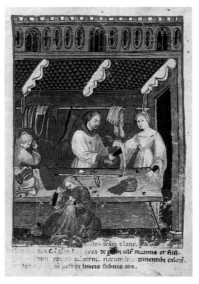

▶ The Lancelot Master, *A Tailor's Shop*, late 14th century, illuminated page from the *Tacuinum sanitatis*. Paris, Bibliothèque Nationale.

The young women are
wearing elegant dresses
gathered under the bust to
emphasize the figure. The
slight looseness of the fab-
ric at the belly is an allu-
sion to maternity as a way
of ensuring the continuity
of the family.

Balls were one of the
pastimes of courtly
life, and they provided
an excellent opportu-
nity for showing off
rich and fashionable
clothing.

Short tunics were
worn over tight
stockings, thereby
revealing muscular
legs. The two stock-
ings were often of
different colors.

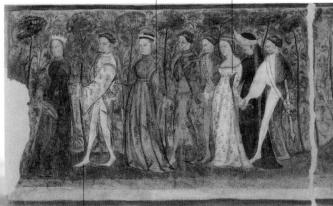

Men and women alike
enjoyed wearing light,
elegantly decorated shoes.
Like the stockings, they
were soled, and they had
enormously long toes,
which were padded so
they kept their shape.

The length and looseness
of sleeves were an indica-
tion of the privileged
position of noblemen:
they had no practical
tasks to which such
sleeves might be an
impediment.

Tyrolese artist, *Round Dance*,
90–1400. Bozen/Bolzano, Castel
ncolo, Sala del Torneo.

Clothing

The lord's foreman leans on a stout stick and raises his rod of command toward the peasants.

The peasants wore hoods, straw hats, or berets to keep out the cold or the heat of the sun, depending on the season.

The peasants' dress consisted of a long-sleeved tunic (made of wool or linen), an apron (which covered their hips) and a cloak (with or without a hood) made of heavy cloth, fur, or leather.

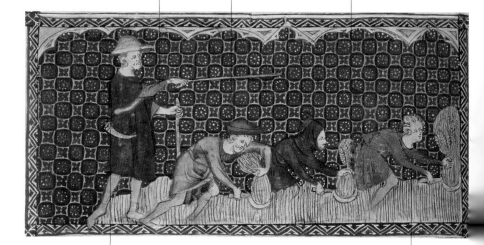

Men might also wear trousers held up at the waist by a belt. On their feet they might wear leather shoes or boots reaching halfway up their calves.

Their clothes were usually gray or dark in color, or else the natural color of wool, which was typically of mediocre quality.

▲ *The Peasants' Hard Labor*, 1310–20, from *Queen Mary's Psalter*. London, British Library.

This doublet is made from four pieces of fabric, which together form the back and front. The front has thirty-two buttons.

The fabric has hexagonal motifs that contain lion and eagle figures reminiscent of the Hispano-Moorish style.

This is a luxury garment, as one can tell from the button-edged sleeves. The padded shoulders form a sort of gilet (short vest) obtained by means of concentric stitching over the doublet.

Buttons were already used in the 13th century and their use became very widespread in the 14th. At first they were thought of simply as an important form of decoration, but then they made it possible to create new styles, such as narrow sleeves that followed the shape of the arm.

Doublets of this type are frequently represented in paintings, miniatures, and sculptures from the mid-14th century.

Doublet of Charles of Blois, 14th century, France (the ment) and 14th century, Sicily the fabric). Lyon, Musée des us.

Fabrics were made into fine clothes but also hangings, curtains, and bedcovers. They could be luxury items in and of themselves, with precious colors, embroidery, and other intricate work.

Fabrics

Notes of interest
In the 14th century there was a fashion among the wealthy for dyes based on blue: green, violet, and a deep, shiny, and very expensive black. The various shades of red were also highly regarded: merchants, doctors, and lords dressed in scarlet or purple.

▼ Overgarment for the Body of Cangrande I della Scala (detail), ca. 1329. Verona, Museo Civico.

The fibers used for weaving in the closing centuries of the Middle Ages were sheep's wool, silk, linen, and hemp. Fabrics could then be embellished with gold and silver thread, precious metals and stones, and pearls. Wool was the most common material used for clothes and for tapestries, which helped insulate the interiors of the great aristocratic houses from the cold. The best wool came from England, but the best woolen textiles were made in Flanders. In the 14th century, sheer fabrics became fashionable, and silk was increasingly prized. In Tuscany it was used to make very refined luxury fabrics: the quality and color of the fabric served to indicate differences of social class. Linen and hemp were used for ordinary fabrics. Hemp was cheaper than linen, and working-class people often wove it at home. The poor wore dull colors, whereas the wealthy and high ranking could afford fabrics tinted with costly dyes. The most precious fabrics were sewn with jewels, pearls, or gold thread and were used for wall and altar hangings and vestments; they might be offered as gifts to popes and bishops. In the closing centuries of the Middle Ages, developments in dyeing techniques broadened the range of colors and treatments. Along with the widespread use of twill (with diagonal weave), there were brocades, brocatelle, damask, lampas, and other fabrics, with an endless variety of styles and embroidery, thanks to the artistic imagination and improvements in technical skills.

This is a valuable lampas, or "half-silk," material, that is, a silk fabric strengthened with a base warp of linen or hemp.

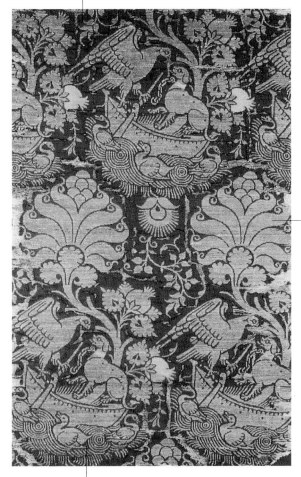

The decoration consists of animals and birds face-to-face. They are treated with a certain naturalism and have Eastern echoes.

abric Fragment, second half of 14th century. Krefeld, Deutsches ilmuseum.

This fabric was probably made in Venice. In the first twenty years of the 14th century, many skilled workers came to Venice from Lucca (for political reasons), bringing with them their centuries-long experience in silkmaking. They contributed enormously to the technological and aesthetic development of Venetian fabric manufacture.

Embroidery was much used to embellish and add value to fabrics. Skill in the art became so consummate that embroidery can sometimes bear comparison with panel painting.

Embroidery

▼ The Ascension,
ca. 1300–30, from *The Cope of the Passion*. Saint-Bertrand-de-Comminges, cathedral treasury.

As elegant and refined fabrics were increasingly sought after, demand grew for embroidered materials, but it is largely those made for liturgical use that have survived. The extremely rich iconographic repertory available for embroidery followed the general trends in art, to the extent that we can now make comparisons with contemporary painting and miniatures. The art of silk embroidery in particular spread throughout 14th-century Europe, and it reached an extremely high level of artistry. Embroidery technique, however, changed little over the centuries. In medieval inventories we find mention of *opus cyprense, anglicanum, romanum, florentinum*, and *theotonicum*. The differences among them lay in the source of the embroidered fabrics or their quality: *opus cyprense*, for example, used gold thread from Cyprus. From the mid-13th century onward, in particular, England was responsible for making most of the embroidery for ecclesiastical use (for miters, copes, and antependia, which became most popular in the 14th century), and it was highly regarded throughout Europe. English embroiderers were usually women, and their technical virtuosity was such that their stitches were almost invisible and they could produce a great variety of iconographic subjects, where the figurative element was increasingly important. In 14th-century Germany, large woolen items known as carpets, were also produced, with images taken from the world of legend. Most of this embroidered work came from women's convents.

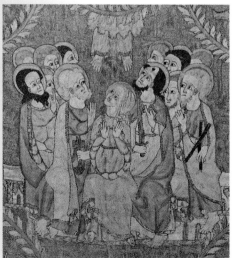

This precious fabric is made of velvet embroidered with gold thread and polychrome silk. The pattern shows the leopards of England, young ladies, and foliage.

The sumptuousness, high quality, and prolific use of precious metal thread suggest that this piece of embroidery came from one of the numerous 14th-century English workshops.

Embroidered fabrics were much used for church furnishings and priests' vestments.

glish manufactory, Embroidery
Leopards, ca. 1300–30. Paris,
e National du Moyen-Âge.

Embroidery

Embroidery was the most typically English art form in the early 14th century. In the other arts, in contrast, the strongest influences were Continental.

Embroidered fabrics in opus anglicanum were sold throughout continental Europe and were even used for the pope's pontificabilia.

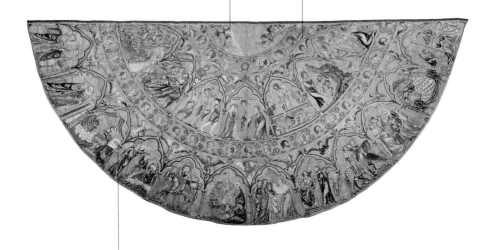

The design is reminiscent of contemporary frescoes in Westminster Abbey and shows scenes from the Gospel (from the Annunciation, the Visitation, and the Nativity to the Resurrection and the Appearance to Mary Magdalen).

▲ English manufactory, Cope, early 14th century. Bologna, Museo Civico Medievale.

► Arras manufactory, *The Meeting of Fromont and Gérard*, 1375–1400, from *Scenes from the Life of Jourdain de Blaye*. Padua, Musei Civici.

"The banqueting hall was large and the walls were covered in tapestries depicting scenes from the life of Hercules" (Olivier de la Marche, Mémoires, 15th century).

Tapestry

Tapestry weaving had been known in the West since the 11th century but became particularly widespread in the late 14th century, thanks to the increasing demand from nobles and kings. In 1364, for example, Louis of Anjou owned as many as seventy-six historiated tapestries, and Philip the Bold, who had inherited the counties of Flanders and Artois in 1384, also contributed to the fashion for *tapisseries historiées*. Tapestries were most used in northern Europe, because these brightly colored woolen hangings, with their sacred and profane scenes, not only decorated and brightened rooms but also provided protection from the cold. They could also be moved about, used as room dividers, or hung across doorways as curtains. Furthermore, they were not affected by damp in the way that frescoes were. Tapestry making was complicated, and numerous people contributed at different stages of their preparation and production. Once the subject was chosen, artists of greater or lesser talent prepared a sketch for transfer to a cartoon of the same dimensions as the tapestry itself. The cartoon was a reverse image of the sketch, because the tapestry was woven from the back. Working on a frame, skilled workers could reproduce the figured scenes with intricate interweaving of warp and weft. When tapestries were ordered by eminent clients, top-class artists were often commissioned to make the sketches.

Related entries
Seigniories, Chivalry,
Fabrics, Embroidery

Burgundy, Paris

Jan Boudolf

Notes of interest
Tapestries were made in Germany, Flanders, and France. In the late 14th century, the town of Arras, France, became renowned for its tapestry production (hence the English word *arras*), and the quality was so high that its fame even reached the East.

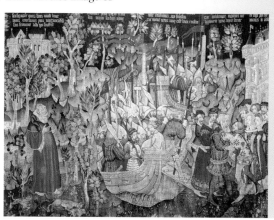

Tapestry

The sketches for this series of tapestries were made by Jan Boudolf, an artist in the service of Louis of Anjou. The series forms the largest and most important group of medieval tapestries.

An angel is giving Saint John a book to eat. This means that he must digest and meditate on the revelations he will find in it about Church history, whether they are bitter or sweet.

This series was completed in seven years and consisted of six tapestries. Each one included fourteen scenes arranged on two tiers. The scenes had alternating blue and red backgrounds, and each tapestry measured 6 by 2.4 meters (almost 20 by 8 ft.).

These tapestries were brought out on special occasions, such as weddings and other ceremonies and the visits of important personalities.

The tapestries show scenes from the Apocalypse. Some are partly imaginative or allegorical, but they also contain dramatic elements from history, which at the time was dominated by the Hundred Years' War.

▲ Jan Boudolf, *Saint John Eating a Book*, ca. 1380, Tapestry 2 in the Apocalypse series. Angers, castle, Galerie de l'Apocalypse.

"Now, if you want to make a female figure, take one part of gold and four of silver, and that is the mixture that will produce a glistening female body" (Mappae clavicula, 12th century).

Goldwork

Because its precious materials came from the depths of mines, were treated with fire, and transformed into works of art by means of sophisticated techniques, medieval goldwork held a position of primary importance among the figurative arts. A gold object was very costly, contributed to the splendor of liturgical or royal rituals, and had great symbolic value. It thus constituted the greatest homage that a donor could pay in a religious or secular context. The extraordinary importance of the art of the goldsmith called for the highest efforts on the part of these craftsmen. They had to be taught a number of techniques, from drawing the initial project (architects, sculptors, and artists were sometimes employed for that purpose) to modeling or carrying out decorative work, which might involve embossing, engraving, chasing, intaglio, perforation, filigree work, stone setting, and, in particular, the application of opaque or translucent enamels. One specialist in this field was the enameler. His job was to apply powders made of colored glass—enamel paste—which were then fired to bond them to a metal support. Enamel was much used in the 14th century. In this period, translucent enamels on silver or gold were favored over the formerly popular champlevé enamels, which designs incised into metal surface were filled with enamel paste and fired.

Related entries
Commission, Clothing, Miniature

Paris, Avignon, Prague and Bohemia, Catalonia, Siena

Andrea Pisano

Notes of interest
Unfortunately, many gold objects have not survived, partly because it was often tempting to melt down the precious metal in cases of dire necessity, and partly because goldwork was readily portable and saleable, thus easy prey for thieves. But 14th-century inventories reveal the existence of an enormous quantity and variety of precious objects, for secular as well as religious purposes. They were included in the rich treasuries of the French princes and princesses, the largest being those of Louis of Anjou, Philip the Bold, Jean de Berry, and Charles V.

◀ *The Egmont Pastoral* (detail), 1351. Haarlem, cathedral.

Goldwork

In the late 13th and early 14th centuries, Sienese goldsmiths stood out for their technical and inventive skills.

This chalice was made for Pope Nicholas IV. It seems to be the earliest example of the use of a new kind of enameling, known as "translucent enameling": finely powdered glass was bonded to very delicate low relief on silver.

The technique of translucent enameling made it possible to obtain results that looked like painting. This can be seen in the plaquettes on the chalice, which reflect the influence of northern Gothic miniatures.

Guccio is considered the inventor of translucent enameling, which enjoyed great success across Europe and contributed to a dramatic change in the appearance of gold objects.

▲ Guccio di Mannaia, Chalice of Pope Nicholas IV, 1288–92. Assisi, Museo del Tesoro, San Francesco.

In the early decades of the 14th century, Siena became one of the most important centers for the production of works using translucent enamel.

The painted figures on the reliquary door panels stand out against the midnight blue background with a narrative elegance that is reminiscent of contemporary Sienese painting. The reliquary houses a precious corporal, or eucharistic altar cloth.

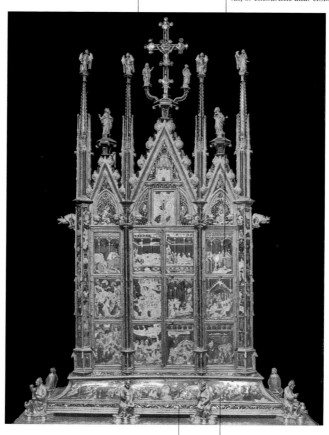

This reliquary is one of many goldsmiths' works that have a relationship with architecture; its general design, in fact, appears to be inspired by a church facade.

The translucent enamel takes on a more or less intense color depending on the thickness of the underlying relief, making it possible to create an extraordinary display of perspective effects.

golino di Vieri and workshop,
quary of the Corporal, 1338.
ieto, cathedral.

The eagle with open wings, its feathers made of precious stones in various colors, suggests that this was an imperial jewel.

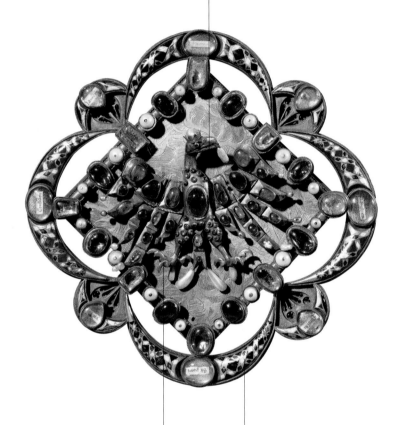

It was common in the 14th century for relics to be mounted as jewels and carried on the person to ensure protection by the saint concerned.

This clasp, made of silver, gilt silver, enamel, precious stones, and pearls, was probably for the cloak of some person of high rank, perhaps a Germanic emperor of Bohemia.

▲ Bohemian manufactory(?), Reliquary Clasp, mid-14th century. Paris, Musée National du Moyen-Âge.

► Jacobi da Siena Minucchio, Gold Rose, ca. 1330. Paris, Musée National du Moyen-Âge.

A number of Sienese goldsmiths came to the important art center of Avignon, bringing with them refined and innovative techniques that spread throughout Europe.

Every year, on the fourth Sunday of Lent, the pope used to offer a gold rose to some particularly devout individual. This rose, for example, was given by John XXII to Rudolf III of Nidau, Count of Neuchâtel, who had supported him against Emperor Louis of Bavaria.

This extremely refined rose from Avignon, in gold and colored glass, is evidence of the elegant naturalism to be found in Avignonese art, including painting.

The object has been individualized by putting the owner's coat of arms on the enameled shields at the bottom.

Fourteenth-century artists excelled at producing small ivory sculptures with refined features and harmonious lines. They were often intended for private devotion.

Ivory

Notes of interest
The beauty of this glistening white material, the difficulty of obtaining it, and the need to work it delicately with a graving tool made ivory a synonym for value and wealth from ancient times onward. It was no coincidence that Solomon's throne was made of ivory (1 Kings 10:18–20).

Elephant ivory, imported from Africa or the Middle East, was hard to obtain but highly regarded in the Middle Ages, and its use was particularly widespread during the Gothic period. Walrus ivory was sometimes used in northern Europe, while in Italy, in the 14th century, even the bones of large mammals were used. While some of the great sculptors of the age, such as Giovanni Pisano, produced outstanding masterpieces, products also became accessible to a broader public. Common items included caskets, mirror cases, and combs, all decorated with chivalrous and courtly subjects, as well as smaller objects such as knife handles and writing tablets, which were everyday items used by aristocrats or rich members of the bourgeoisie. The most important ivory importers in Europe in Gothic times were Italian: shiploads arrived at the ports of Genoa and Venice from Aden in Yemen via Cairo and Alexandria, or from Acre and Cyprus, but the most important center of production continued to be Paris, at least until the third quarter of the century. Workshops there produced the great diptychs of the Passion as well as caskets and reliefs that are influenced by the naturalistic style of contemporary miniatures. The enormous influence of Gothic art, which spread throughout Europe from the Île-de-France, makes it difficult to distinguish the characteristic of other production centers, such as England, Cologne, and Italy.

► Parisian workshop,
Madonna and Child,
ca. 1320–30. Assisi, Museo del Tesoro, San Francesco.

The mirror case is decorated with four veined leaves. Inside the frame are the figures of a lady and a young man riding through a wood.

The lady is wearing a long dress and a pointed hat, and she holds a small whip with which she urges on her horse. The man is wearing a loose, hooded cloak and holds a falcon on his left hand.

Riding is a common subject on mirror cases: throughout the 14th century, it was one of the most typical images of courtly love.

⌐ırisian workshop, Mirror Case
▪ a Courtly Scene of Horse-Riding,
⌐-6o. Paris, Louvre.

A mirror was one of the necessary items for a lady's toilet and could be carried at the belt or in a bag. The use of ivory for secular objects proved extremely successful in the 14th century.

Mirror cases consisted of two small panels that fitted together when rotated. The mirror was placed inside one of them.

Medieval artists moved from one country to another, and so did ivories. Even in the 14th century London was a cosmopolitan city whose inhabitants included artists and merchants from Paris, thanks partly to the presence of the royal court (where, let us not forget, the language in use was French). Hence it is difficult to be sure whether an ivory object is really "English."

In ivories made for John de Grandisson, Bishop of Exeter, one can see a certain artistic autonomy from the French style.

Nevertheless, the artists who produced these work in ivory clearly di not adopt the loc. artistic language finding their inspira tion in the late. French art instea.

▲ The Coronation of the Virgin and Saint John the Evangelist Writing the Gospel, polyptych panel, ca. 1340. London, British Museum.

The scenes shown here are the Coronation of the Virgin and Saint John the Evangelist Writing the Gospel, accompanied by his symbol, the eagle.

Typical of the production of the Embriachi workshop, which operated first in Florence and then in Venice, were small portable altarpieces and wedding caskets with classical scenes.

Among those who purchased from the Embriachi workshop were refined collectors such as Jean de Berry and the Duke of Burgundy. But the workshop also made a point of producing objects for a wider public.

Baldassarre Embriachi was a Florentine merchant who launched the large-scale production of ivories, which had hitherto been accessible to very few. This was made possible by a system of rapid manufacture involving standardized forms and the use of cheaper materials such as bone.

The commonest subjects on wedding caskets were the adventures of Paris, Jason, or Pyramus and Thisbe, or else pairs of figures.

Workshop of Baldassarre Embriachi, Wedding Casket, late 14th–early 15th century. Venice, Museo Correr.

Book production became increasingly widespread in the 14th century, thanks in part to the universities but also to the greater private use of religious and secular texts.

Miniature

Notes of interest
The 14th century was very important for literary production. One has only to think of Dante's *Divine Comedy*, Boccaccio's *Decameron*, Geoffrey Chaucer's *Canterbury Tales*, and the second part of *Roman de la rose*. All these works were highly regarded at the time and spread through manuscripts.

In the early medieval centuries, book production was almost exclusively the privilege of the Church. In Benedictine monasteries it was carried on collectively in large halls called scriptoria, whereas the Cistercians and Carthusians did this kind of work in their cells, and others used the cloisters. But by the 14th century lay workshops were quite common. The founding of universities helped expand the market for books. In university towns, lay workshops produced and sold books quite cheaply. Although most university manuscripts were quite modest in appearance, there were also fine specimens with high-quality miniatures for the richest students. Furthermore, a more intimate, private kind of religious devotion emerged in this period, increasing the popularity of books of hours and psalters for the use of monarchs, noblemen, and their wives. Wealthy laymen sought to enrich their libraries with sumptuous illuminated manuscripts: not only sacred writings or devotional texts, but also history books,

Tacuina sanitatis (studies of food and drink), chivalrous romances, stories, and poems, all richly decorated. Works of very high quality were produced in France, Italy, Spain, England, and the Holy Roman Empire. Some famous painters, such as Simone Martini, also worked as miniaturists. The fact that codices were easily transportable made them important vehicles of style.

▶ Illuminated page from *Cronica de los reyes de Judea*, 14th century. Madrid, Biblioteca Nacional.

The Master of the Saint George Codex produced one of the most astonishing illuminated codices in 14th-century Italy. It was commissioned by Cardinal Stefaneschi, a man of vast learning.

The secular, chivalrous tone of the narrative looks forward to the characteristic qualities of the same theme in International Gothic painting.

Master of the Saint George Codex, t George Killing the Dragon and ing the Princess, first half of the century, illuminated page from aint George Codex. Vatican City, oteca Apostolica Vaticana.

The subject of Saint George killing the dragon and rescuing the princess had been painted by Simone Martini in the porch of Avignon cathedral.

Miniatures and illustrations throughout Europe were much influenced by the art of Avignon, for a great many works of all kinds were decorated there and were destined to be widely disseminated.

Manuscripts produced in the east of England in the first half of the 14th century can be recognized by their style and layout: the borders take on increasing importance and are filled with numerous human figures, animals, and grotesques. The initial letter is highly decorated.

Until the time of the plague in 1348–50, miniatures were the most original art form in England. But the art declined around the midcentury, probably because the pestilence had decimated the workshops.

▲ Decorated Initial *B* of *"Beatus Vir,"* ca. 1330, illuminated page from the Saint-Omer Psalter. London, British Library.

In the lands of the Holy Roman Empire, miniature production was for a long time confined to the monasteries and remained anchored to a Byzantine style. But a break took place on the threshold of the 14th century, when French art managed to penetrate the area.

In the mid-14th century, demand for books from an increasingly numerous middle-class clientele led to the establishment of lay workshops. This missal is characteristic of the new style in which very slim figures seem to disappear within the drapery, which is delineated in rich, saturated colors.

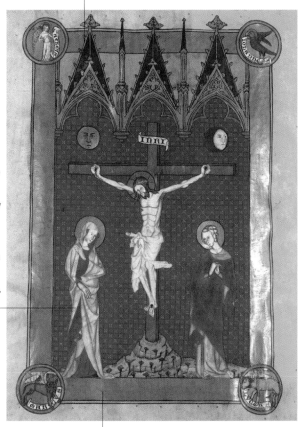

In order to render illuminated manuscripts more sumptuous, goldsmiths were sometimes commissioned to make the cover. The material and symbolic value of the manuscript was thereby increased, since it gleamed with gold and silver like a reliquary.

The Crucifixion, before 1357, illuminated page from the Missal of Konrad von Rennenberg. Cologne, Erzbischöfliche Diözesan- und Dombibliothek.

Ceramic objects were used to store or serve food, drink, and medicines. They could be mass produced or unique luxury items with elaborate decoration: objets d'art for the rich.

Ceramics

Notes of interest
Italian potters used the word *maiolica* to describe pottery in which colored metal oxides were applied over a tin-based white glaze. The piece was then fired at a relatively low temperature in a smoky kiln. The metallic reflections thus obtained increased the object's value.

The potter's art was one of the most important craft activities, involving the sort of mass production necessary for making objects for the table at moderate prices. Pottery workshops in fact produced a great quantity of vases and tiles at the wheel or in moulds, as we can tell from the ovens unearthed in archaeological excavations. Nevertheless, the best-known potteries did not confine themselves to the manufacture of ordinary terracotta or majolica ware for domestic use or export (the most significant proportion of their market) but also created beautiful individual items with elaborate decoration for an exclusive, rich clientele. The most common type of 14th-century pottery was majolica, which had an opaque tin glaze, applied using a technique brought to the West from Islamic Spain and Sicily at the beginning of the 13th century. It was in this century that ceramic production substantially increased as we can tell partly from an ever-increasing number of documents providing information about potters and their guilds.

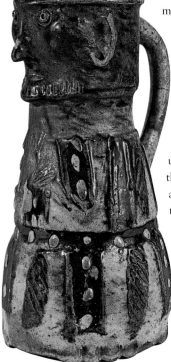

▶ Jug with a Human Face, 14th century. London, Guildhall Art Gallery.

What was known as maiolica arcaica *(old majolica)* became common in central and northern Italy. Its characteristic forms could be open or closed, and at first it was decorated in copper green and manganese brown, but later on in pale blue and cobalt blue, known as zaffera. These colors were used to depict fantastic subjects, vegetable ornamentation, and animals, or the figures of women wearing crowns.

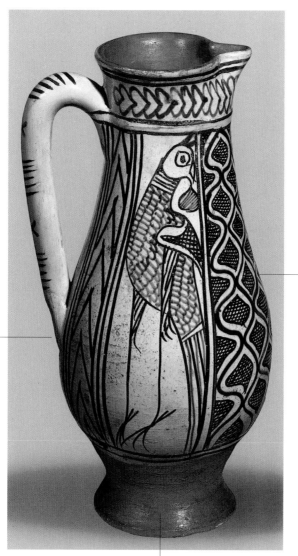

In the early 14th century, majolica was considered a luxury product for a select clientele, partly because of the high price of the tin in the glaze. Later increases in production levels came at the expense of quality.

, late 14th century. Paris, Louvre.

The commonest shape was that of a jug, which tended to have the same general characteristics everywhere, but with local variations. Until about 1350, jugs typically had a pedestal base.

Spain was responsible for making refined, lustered pottery, using a technique that created highly valued metallic effects. The majolica of Valencia and Andalucia, with its blue and luster decoration, was very successful and became a synonym for luxury in palaces throughout Europe.

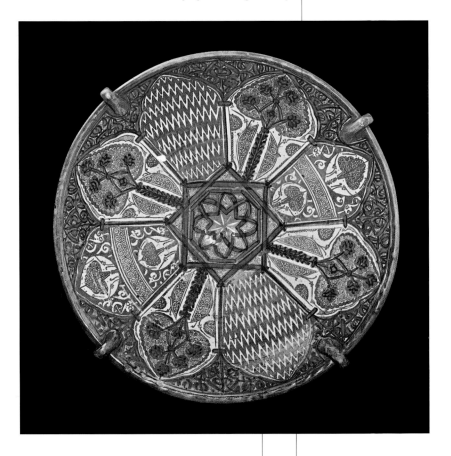

This bowl is a fine example of tin-glazed pottery, with its decorative metallic gleam ("luster"). This kind of pottery was common in Persia and went on to be produced in Spain from the 12th and 13th centuries onward. It is known as Hispano-Moorish pottery.

This very beautiful, brightly colored decoration adheres closely to the Islamic tradition.

▲ Valencian workshop, Bowl with Lustered Rings, late 14th century. New York, Hispanic Society of America.

Iconography can sometimes be of assistance in reconstructing situations or details of daily life that would otherwise have been lost.

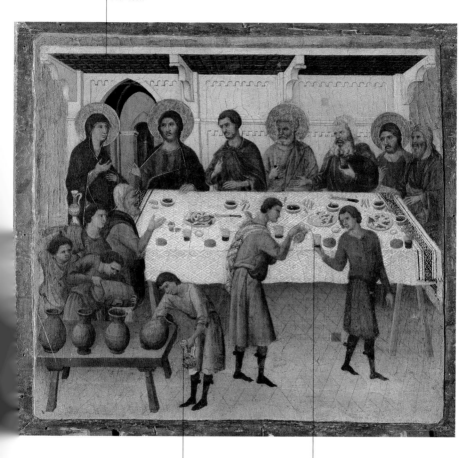

The jugs in this scene are made of Sienese-style maiolica arcaica. *The chief production centers for* maiolica arcaica *were Faenza, Pisa, and Orvieto, where the decoration was usually dark brown and green.*

The water that Jesus changed into wine is in earthenware containers and is transferred to finely decorated majolica jugs, from which it is poured into tumblers.

Duccio di Buoninsegna, *The Wedding Cana*, predella of *Maestà* (verso), 8–11. Siena, Museo dell'Opera Metropolitana.

"If thou wouldst glaze this window and engrave thereon thy name, / Thy soul should be the surer to go to heaven" (William Langland, Piers Plowman, 1360–90).

Stained Glass

Notes of interest
The manufacture of stained glass was very expensive, with the result that it was chiefly used in churches or princely homes. Rich members of the faithful, corporations, guilds, or confraternities donated stained-glass windows to churches, to enhance their own prestige and to save their souls.

Studies in recent decades have shown that stained glass was not a medieval invention but was in use continuously from Roman times to the early Middle Ages. But certainly the art of painting on glass flourished chiefly in France, England, and Germany in the late Middle Ages, when the innovations of Gothic architecture allowed an increasing number of windows. Stained glass became an integral part of architecture. In stained-glass production, glass sheets were made and then cut to the design of the window. The glass was then painted in grisaille, using a paste made from powdered glass and a coloring additive (iron or copper filings) with vinegar or urine as a binding agent. In the 14th century, "silver yellow" also came into use. This could be used

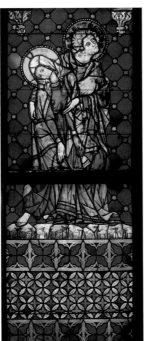

to make clear glass yellow, to make green or red glass paler, and to produce decorative details, such as ornaments or details of clothing against backgrounds of a different color, without the need for two separate pieces of glass and a strip of lead. After the painting was done, the pieces of glass were fired in a kiln and then positioned by the painter on the wooden board on which the design had been drawn. Here they were assembled using malleable lead rings, which allowed them to be connected together in a firm network. Once the panels had been fixed with lead, they could be mounted in the window.

▶ Stained-Glass Window with *Mary and Saint John* (detail of *The Crucifixion*), ca. 1340. Vienna, cathedral, choir.

This type of wooden board was prepared after the designer had drawn a small-scale model and shown it for approval to the person or group that had commissioned the window.

The wooden board was covered with white gesso, and the details of a window with an architectural framework were drawn full scale.

A stained-glass window required collaboration: the various stages of work involved a variety of skilled personnel, including someone with an understanding of theology who would choose the subject matter. Contact with the architects was essential in order to each agreement on the dimensions and form of the window.

The positioning of the lead and the colors of individual pieces of glass were traced on the model, which was sometimes drawn on parchment or paper instead of wood.

Preparatory Drawing for a ained-Glass Window, mid-14th ntury. Gerona (Spain), Museo de Catedral.

Stained Glass

This panel is decorated with grisaille flowers, including wild roses, buds, and lilies colored with "silver yellow," which allowed the addition of a new color to the overall shade of the glass.

The use of "silver yellow" made it possible to bring two different colors together on a single piece of glass.

▲ Stained-Glass Window from the Cathedral of Saint-Denis, chapel of Saint-Louis, ca. 1320–24. Paris, Musée National du Moyen-Âge.

Stained-glass windows had a practical as well as a spiritual purpose: they protected the faithful from bad weather, and the light that filtered through was a visible manifestation of an invisible God.

The choir windows show, on the left, Old Testament characters, and on the right, the apostles, the archbishops of Rouen, and the great monks of the Benedictine order. The two groups of figures converge on the central Crucifixion.

Grisaille and colored glass are brought together here. The fully painted pieces of glass are placed at mid-height in the windows.

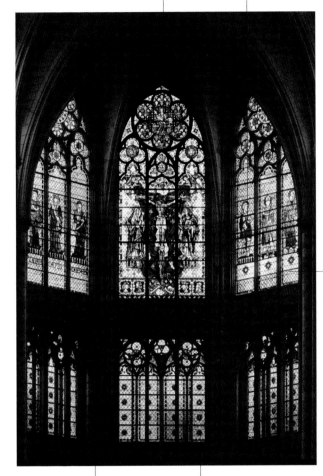

To make the sculptural details of the church interior more visible, the colored areas used smaller pieces of glass with alternating clear and delicately designed tones.

Stained-Glass Window in the Choir, 25–38. Rouen, Saint-Ouen.

The use of pale glass, which had already been taken up in Cistercian churches, became increasingly common in the 14th century.

One consequence of the success of the Rayonnant Gothic style, with its elongated proportions and dizzy heights, was that window openings were divided into tall, narrow lights.

French influence can still be detected in this little piece of glass (diam. 29.2 cm, or 11½ in.).

The angel appears to the shepherds through a cloud while the dog looks after the sheep.

The human figures and animals are yellow and white, whereas the foliage decoration is blue. The sun and stars are not original.

The standing shepherd wears a hood over a short tunic and leans on a stick as he looks up at the heavenly messenger. The seated shepherd is playing bagpipes.

▲ English workshop, *The Angel Appearing to the Shepherds*, ca. 1330–40. London, Victoria and Albert Museum.

► Florentine miniaturist, *The Birth of Saint John the Baptist*, second half of the 14th century, illuminated page from *Missale Romanum*. Florence, Biblioteca Medicea Laurenziana.

Fourteenth-century houses were sparsely furnished, but the homes of the wealthy might contain very expensive items. The greatest care was taken in furnishing sacred premises.

Furnishings

The homes of peasants and other workers were furnished with only the bare essentials—a cupboard and a bed frame—traces of which sometimes turn up in archaeological excavations. But luxury objects were manufactured for the wealthier classes. There was furniture for storing clothes and materials, for sitting or sleeping or storage, as well as thrones and canopies for court ceremonies, seats and urns for elections to communes or confraternities, and stalls and furnishings for religious purposes. In the Gothic period, such furniture was richly shaped and inlaid, and at least partly painted with decorative, figured motifs. Benches and tables (always collapsible affairs consisting of two trestles and a board) were used for banquets, and there would be little other furniture in the room, except perhaps a sideboard. The chief pieces of furniture in the bedroom were a bed and a storage chest. This was the most private room in the house, the place where upper-class ladies spent most of their time. The bed consisted of a sort of chest or raised cage that supported or confined the mattress. Sometimes the bed had a footboard, which could also be used as a table, as well as an overhead structure to support bedcurtains, which were essential for warmth and privacy. The storage chest was used principally for fabrics and extra clothes, and it was solid enough to serve as a seat. Clothes currently in use were hung on rods fixed to the walls. Wardrobes were common and were used for storing books and other objects.

Related entries
Fabrics, Tapestry, Ceramics

Notes of interest
At banquets, the noble host often had his riches on show: precious gold, silver, and ceramic objects were displayed, in addition to the abundant food. It was in fact in the 14th century that the idea arose of giving each guest his own crockery and that the use of forks became normal practice.

The joiner is shaping the wooden board with an ax, and there is another ax behind him.

In some cases, the manufacture of furniture was regulated by guild statutes.

Fourteenth-century statutes, such as those of the woodworkers in Florence, sometimes contained a series of very strict regulations about timber quality and the length, width, and height of each item. Anyone who wanted different, more elegant, or costlier styles had to obtain a license from the officers of the guild and pay a fee.

▲ Bolognese miniaturist of the second half of the 13th century, *Statutes of the Society of Woodworkers*, 1270. Bologna, State Archives.

The poet is shown in his study. Such rooms first appeared in the closing centuries of the Middle Ages as a result of an increasing tendency to divide up domestic space.

On his desk is a table lectern, a "book wheel," and writing materials. Behind his desk is a chest, and in the background is a cupboard full of books.

*he surface of the stall
ı which the poet is
ting is richly deco-
*ed with intaglio
ork.

Petrarch was fond of cats, which were common in medieval homes, and this one adds a touch of informality to the scene.

duan miniaturist, *Petrarch in His
·y*, late 14th century, from *De Viris
·ribus* by Francesco Petrarch (in
·alian translation by Donato degli
·nzani). Darmstadt, Hessische
·es- und Hochschulbibliothek.

Furnishings

The king is sitting on a faldstool, a type of folding chair. Its arms are sculpted with lions' heads and its feet with their paws, and a cloth is draped over it. The king's feet rest on a wooden stool.

The king's sons and the barons, both secular and religious, are sitting on chests used as seats—a very common practice at this period. The members of parliament are standing behind a bench.

Throughout the Middle Ages, furniture was used in a strikingly provisional way. Put a faldstool in the hall and you have a court of justice; lay a table and you are preparing for a banquet.

On April 8, 1332, King Philip IV of France summoned the court of peers to try Robert of Artois, who claimed the inheritance of the county of Artois on the basis of documents that subsequently proved to be forgeries.

The accused is represented by his coat of arms (lower right), which is surrounded by his lawyers.

▲ *The Trial*, 1336, from *The Record of the Trial of Robert of Artois*. Paris, Bibliothèque Nationale.

Of all wooden furniture, choir stalls are the most likely to have remained in situ. Other liturgical items of furniture are the bishop's throne and the imposing lecterns for reading the Gospel.

The choir stalls at Winchester cathedral have complex, refined intaglio work at the top that echoes the architectural forms of the cathedral.

There is a great deal of debate about the relationship between architecture and wooden items in England. Some joiners were certainly highly skilled, and it is possible that their work had an influence on particular architectural details.

The interior of the cathedral was furnished with the utmost care and magnificence. Minor furnishing items, gold objects, architectural furnishings, sculptures, painted panels, draperies, tapestries, frescoes, and, of course, furniture all contributed to the liturgy.

noir Stalls, 1308-10. Winchester, edral.

Furnishings

Inside the choir stalls there were supports called misericords, which allowed infirm or elderly monks to remain standing during the long hours of prayer.

Typical of the misericords in Winchester cathedral is the striking naturalism of the images: in this case, a cat has just seized a mouse and is holding it in its mouth. The fact that cats were skillful mousers made them welcome in medieval buildings.

The subjects carved on misericords are rarely religious in nature. In England and Germany we find scenes of everyday life, subjects taken from romances and legends, and animal and vegetable decoration.

▲ Cat with a Mouse, 1308–9. Winchester, cathedral, north choir-stalls, toward the east end.

"This Mino was a painter of crucifixes for the most part, especially those that were carved out and given relief" (Fr. Sacchetti, Il Trecentonovelle, *14th century*).

Wood Sculpture

Fourteenth-century sculptors used a great variety of materials in their work: ivory, stone, marble, and wood. Even great sculptors used wood, which was usually carved using the technique known as *taglio* in Italian. This involved the gradual removal of wood, following models that were often drawn. The work was usually carved out of a single block of wood, except in special cases, such as crucifixes, where separate arms might be added. Once it was completed, a piece of wood sculpture, like one in stone, would be painted. The paint or gilding would be applied either by the sculptor himself or by a different artist, the technique being the same as that adopted for panel painting. Wood sculptures were used primarily for liturgical purposes and semi-liturgical ceremonies. Thus monumental crucifixes, for example, might be placed in a prominent position on the altar table, so that they were very visible during Communion. Images of Christ and statues of the Virgin and of angels were used for the dramatic presentations that accompanied the rituals of Good Friday, the Assumption, the Ascension, and the Adoration of the Magi at Christmastime. They were no less than the stars of the mystery plays, giving the rituals a human face. At the funerals of English kings, moreover, fully dressed polychrome effigies were made to their likeness in wood and wax. Tomb effigies could also be made of wood in Germany and Spain.

Related entries
Mendicant Orders, Funerary Monument, Portrait, Clothing, *Vesperbild* or Pietà

Giovanni Pisano

Notes of interest
Wooden statues of saints became a means of communicating with the faithful, who could touch them, light candles before them, and address prayers to them. In the 14th century, a new form of spirituality also led to an increase in the production of artworks intended to promote personal meditation. In particular, wood sculptures of the Pietà, the skeletal figure of Christ on the Cross, Christ with Saint John, and the Madonna and Child became very common.

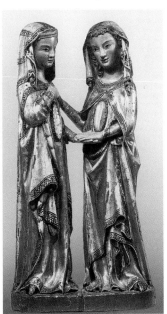

◄ Master Heinrich of Constance, *The Visitation*, ca. 1300. New York, Metropolitan Museum.

Wood Sculpture

This crucifix has movable arms, which means that it could be used for different liturgical purposes.

In addition to the carving itself, poly-chrome was used to show the signs of the savior's suffering, especially the blood flowing from his wounds.

The work is designed so that the nails could be removed from his hands and feet. Then the figure of Christ could be taken from the cross, his arms could be placed along his body and the Christ Crucified became a Deposition.

▲ Sienese sculptor, *Christ Crucified* or *The Deposition*, 1330–40. Palaia (Pisa), Sant'Andrea.

On Good Friday, throughout most of Europe, it was customary to show a Deposition on the altar by using a figure of Christ with movable arms. On Easter Sunday, the body was removed from the sepulchre in order to celebrate the Resurrection.

The face is serene and calm, and the composed attitude is very different from that of French or German Madonnas with their typically Gothic agitation, their arched bodies, and the rich folds of their draperies.

The Madonna is sculpted out of a single piece of wood, except for her arms and the top of her head.

The Virgin's arms may have been movable, and it is possible that the Child could be removed from the mother in order to use the statue for a variety of dramatic purposes.

̄ooden statues ⁻tended for liturgi- ⁻l purposes were ⁻essed in the ⁻othes of the day, ⁻d careful attention ⁻s paid to social ⁻rarchies: sacred ⁻ures could wear ⁻xury clothes that ⁻re prohibited by ⁻ptuary laws. In ⁻ case, the veil ⁻s prohibited by laws of Pisa.

⁻drea Pisano, *Madonna* ̄ *⁻hild*, ca. 1340. Molina ⁻osa (Pisa), Santissimi ⁻ and Fabiano.

Some very fine wood sculptures were also produced by some of the greatest Italian Gothic artists, such as Andrea Pisano, who was a famous goldsmith, stone sculptor, and architect.

The earliest examples of Vesperbild *are found at the beginning of the 14th century. They show the grief-stricken Virgin holding the racked body of her son in her lap.*

Vesperbild *or Pietà*

Notes of interest
The term *Vesperbild*, used to describe the group also known as a Pietà, contains an allusion to the custom of meditating, at the hour of Vespers on Good Friday, on the wounds in Christ's body as it lay on his mother's lap.

Profound changes in civil society in the late Middle Ages led to a striking spiritual ferment, a search for new ways of participating in the religious life of the Church. In this context, artists were required to adopt a new approach to religious subjects, one that would totally involve the faithful in religious ritual—in dramatized liturgies, mystery plays, and processions with statues—and would promote a more "private" kind of spirituality. Thus we commonly find devotional images that encouraged emotional involvement in prayer. They were usually made of wood, a material that seemed to lend itself well to the transfiguration of sorrow, just as polychrome was essential for conveying nuances of feeling. This new spiritual approach, in which the theme of Christ's Passion and the role of the Virgin as intermediary became of central importance, led to the birth of the *Vesperbild* iconography. The first examples appear in the Holy Roman Empire in the early 14th century and show a suffering Virgin—her features those of a mature woman—cradling the tortured, dead body of Christ in her lap. The *Vesperbild* enjoyed great popularity (especially in the second half of the 14th century, after the plague and the fear of death that followed it) but beyond the realms of the empire, the dramatic quality of the image was transformed into something elegant and without pathos, imbued with a kind of lyrical melancholy, which closely corresponded to the typical qualities of International Gothic.

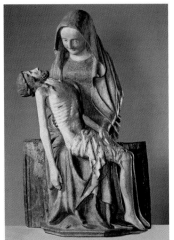

► Master active in Slovenia, *Pietà*, ca. 1370. Ljubljana, Narodna Galerija.

This polychrome wood sculpture, 88.5 centimeters (35 in.) high, is now thought to be the oldest surviving Vesperbild.

Mary's features are drawn with suffering, as she holds her son in her arms. His head is crowned with thorns and collapses backward.

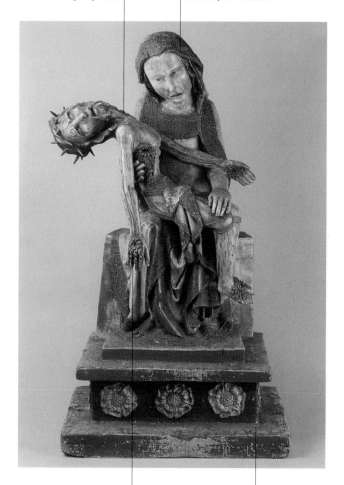

The theme of the Passion of Christ and Mary's role as intermediary became central to the meditations of the great 14th-century thinkers among the mendicant orders and the German mystics, both men and women.

The grape-like blood clots from Christ's wounds are an allusion to Christ as a mystic vine.

...e Roettgen Pietà, 1300–1305. ..., Rheinisches Landesmuseum.

PLACES

England
The North, East, and Midlands
The West Country
London

France
Burgundy
Normandy
Paris
Lorraine
The Midi, or South
Avignon

The Holy Roman Empire
Upper Rhine
Middle Rhine
Lower Rhine and Cologne
Hanseatic Towns and the North
Vienna and the Southeast
Prague and Bohemia
The Netherlands

The Iberian Kingdoms
Catalonia
Castile
The Kingdom of Majorca

Italy
Milan
Verona
Padua
Venice
Bologna
Florence
Siena
Pisa
Assisi
Rome
Naples

ichard of Haldingham, *Mappa
di* (detail), 14th century. Hereford,
edral.

England

*The outstanding events in 14th-century England were the
numerous wars (against Scotland, Wales, and Ireland, as well
as the endless Hundred Years' War against France), in addition
to famine, social uprisings, and the plague, which struck the
whole of Europe from the midcentury onward. But these
dramatic events did not prevent the arts from developing. In
spite of economic depression, in fact, the arts flourished in
England during the first half of the century. The most
progressive art center continued to be London, because the
royal court was there, but lesser cities such as York, Bristol,
and Norwich also stood out. Unfortunately, many English
works of art were destroyed during the suppression of the
monasteries (1536–40), and devotional images were also
destroyed by Protestant reformers in the 15th–17th centuries.
But many works of church architecture have survived, as well
as illuminated manuscripts, church furnishings, and funerary
monuments. Only a small number of paintings and examples
of the "decorative arts," such as textiles and goldwork, have
survived, though these arts must have flourished in their day:
the sources stress the importance of both the quantity and
quality of personal possessions—houses, clothes, silverware,
and so on—in establishing one's place in the social scale. There
were no great differences in the arts among the various English
regions. The so-called Decorated style (ca. 1250–1360) spread
almost everywhere, followed by the Perpendicular style
(ca. 1330–1550). But there were some towns or regions where
works of art had their own particular characteristics.*

An important school of miniature painting arose in England. In addition, the great cathedral building sites at York, Ely, and Norwich made innovations that were widely adopted.

The North, East, and Midlands

From the late 13th century, urban life in England developed considerably. New towns came into being, and the east coast ports of King's Lynn, Boston, Hull, and Newcastle prospered. Trade associations known as guilds became very important in 14th-century towns, and there was a growing class of rich merchants working in the wool trade. East Anglia stood out for its important production of illuminated manuscripts, in which exuberant, humorous images with many naturalistic touches contrasted with the typical court style. In the late 14th century, a series of manuscripts, psalters, and books of hours was produced (called the Bohun Group after the earls of Hereford, Essex, and Northampton, who commissioned them), in which the details of the figures, proportions, and depiction of clothing are very reminiscent of contemporary Italian, French, and Flemish miniatures. At York, outstanding stained-glass masters, including Masters Robert and Thomas, were responsible for the great stained-glass windows in the cathedral's west facade (ca. 1340); as documents reveal, they were strongly influenced by Jean Pucelle and French art. The skill and inspiration of British carpenters at Ely produced the splendid transept cross in the cathedral. Traditional timber architecture was clearly important for monumental buildings in England: pay records document the large proportion of carpenters relative to stonemasons.

Related entries
Building Site, Miniature, Stained Glass

Jean Pucelle

◄ Master Robert and Master Thomas, Stained glass in the west window of the cathedral, ca. 1340. York.

119

This is one of the most spectacular examples of the Decorated style, a style in which architecture and sculpture are closely linked, partly as a result of the use of tracery for decorating windows and walls.

The technique adopted here is original. The walls are pierced by an immense arch at the lower level and an equally large opening at the upper level, in a diagonal arrangement.

The woodwork used to create a unitary space was originally painted to look like stone. It was constructed by William Hurley, a royal carpenter.

The lantern is a splendid invention, for it simultaneously covers and illuminates the vast crossing. The whole complex project seems to have come into being with the collaboration of Alan of Walsingham, the monk who commissioned the work and who was also a skillful goldsmith.

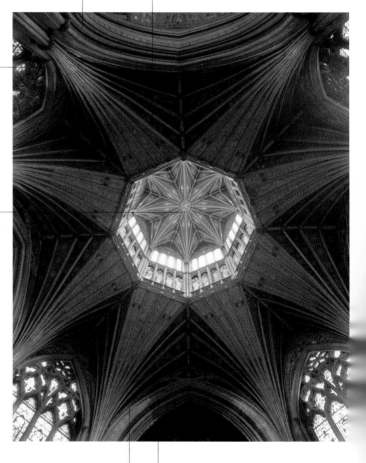

▲ Octagon and Lantern, 1322–40. Ely, cathedral.

The choir stalls must originally have been situated directly under the octagon.

The octagon was built after the collapse in 1322 of the Anglo-Norman tower at the crossing. The old piers were removed, and a large octagonal space was created, with stone piers but wooden vaulting and lantern.

This altar frontal has been cropped at the left-hand side, but its pictorial quality is very high. The elegant, elongated figures stand out against a background decorated with squares. What we see are scenes from the life of the Virgin.

That this work came from a Dominican church is confirmed by the iconography linked to the Virgin, who was much revered by the Dominicans.

This painting had an altarpiece above it: the central Crucifixion was flanked by figures of saints, including Saint Dominic and Saint Peter Martyr.

The subject of Saint Anne teaching the Virgin to read was very popular at the time, and it appears in miniatures as well.

glish school, Antependium
*Scenes from the Life of the
n,* ca. 1335. Paris, Musée
onal du Moyen-Âge.

Serious episodes of iconoclasm broke out in the 15th and 16th centuries, directed against religious images. As a result, few painted panels of the period survive in England. This is one of the most important.

The dossal tells the story of Christ's Passion, Crucifixion, Resurrection, and Ascension. There are obvious Italian and Flemish influences in the style, which one also finds in contemporary local miniatures.

In the scene of the Resurrection, Christ rests a foot on the shoulder of one of the sleeping guards as he comes out of the sepulchre. This was a common image in England and was probably influenced by the mystery plays that accompanied religious rituals.

▲ Anonymous Norwich master, *Dossal of the Passion*, ca. 1380–90. Norwich, cathedral, chapel of Saint Luke.

The monstrous animals, like this one with the head of a gryphon, are painted with the same refined technique that was used to represent nature.

This psalter exaggerates the characteristics of the East Anglian style: the letters are tall, the initials and edges are very elaborate, and the margins are full of figures and vegetable motifs. The whole composition extremely lively.

The painted subjects in these manuscripts are usually episodes of everyday life, religious themes, or comic scenes. Here we see ladies and knights on a journey, in a composition that is not without ironic overtones.

Illuminated page from the Luttrell Psalter, early 14th century. London, British Library.

Imposing cathedrals were built in the West of England in the 14th century. Wells, Exeter, Bristol, and Gloucester became the focus for interesting architectural and artistic developments.

The West Country

Related entries
Gothic, Chapel

London

▼ Transept crossing with double crossover strainer arches (detail), 1338. Wells, cathedral.

Over the course of the 14th century, southwest England produced a great deal of new architecture. Here, too, there are clear signs of a predilection for ornamentation, typical of the Decorated style, but it was combined with a new organization of space and a new way of decorating vaulting. At Exeter, Bristol, and Wells, the English master masons found interesting new solutions. In the north porch of Wells cathedral, there is evidence, for example, of their skill in working from the architects' plans, drawn on the floor, with a wealth of full-scale details. In the 1430s at Gloucester, another western city, they worked differently. In a sort of reaction to the excessive forms of the Decorated style, there was a prevalence of verticals, with simplified forms, enormous windows, and fan vaulting. Thus was born the new Perpendicular style, which reached its peak in 15th-century England. It was enormously successful in parish churches as well, its spread being facilitated by its simple, pragmatic architectural idiom. In this period, churches were always crowned with towers, symbols of the pride and wealth of the community.

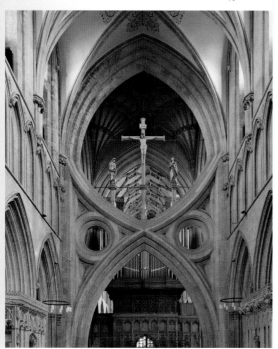

This building must have achieved con-siderable fame almost at once, for some of its design features seem to be echoed in Siena and Prague.

The ornamental motifs are not without origi-nality: where the ribs meet along the axis of the nave, there are large lozenges with projecting tracerylike ornamentation.

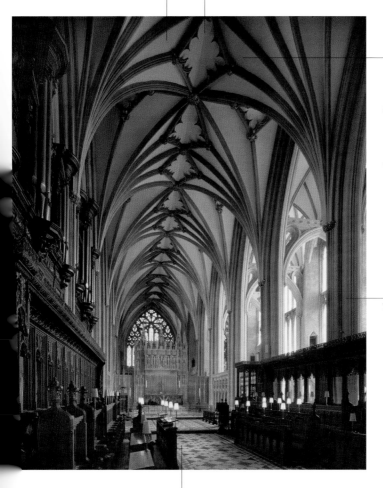

Above the aisles in the choir, a quite novel concept is shown in the trans-verse barrel vaulting supported by diaphragm arches, whereas the main vaulting seems to be a development from Saint Stephen's chapel at Westminster in London.

The piers in the nave rise up and merge into the great sepa-rating arches with-out capitals or imposts.

The church was partly intended to house the tombs of the powerful Berkeley family, whose funerary niches are covered in extravagant ornamental motifs.

Choir of the Cathedral of Saint Augustine, ca. 1298–1332. Bristol.

Thomas of Witney was responsible for some variations in four-centered arches and for new types of ribbing in the vaulting above the rood screen: he includes an extra rib in the cross vaulting that is not attached at the top of the vault.

The deeply cut vaulting gives great emphasis to the ribs.

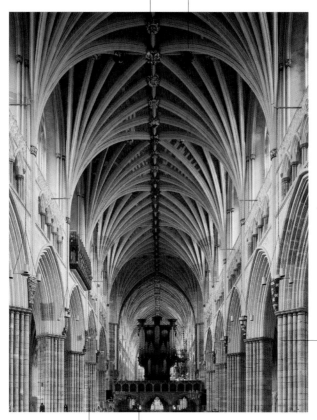

The nave walls are dominated by the compound piers and arches. The tracery windows are richly decorated, but the beauty of the windows merges into the general effect, in which the architectural structure predominates.

Exeter Cathedral is one of the best preserved Gothic buildings in England. Its rich sculpted decoration and 14th-century furnishings make it an interesting example of the Decorated style.

Thomas of Witney is also thought to have designed the pulpit and probably the wooden bishop's throne as well. The latter was made by Richard of Galmeton and is further evidence of the skill of medieval English joiners.

▲ Nave of the Cathedral (detail),
ca. 1318–50. Exeter.

The abbey church at Gloucester (it became a cathedral in 1541) is one of the earliest buildings in which the Perpendicular style makes its mark.

The barrel vaulting has lunettes and is covered with a close mesh of ribs; these are a development of the "paneling" concept.

In front of the heavy Romanesque piers and the women's galleries, there is a trellislike structure made up of vertical and horizontal colonnettes.

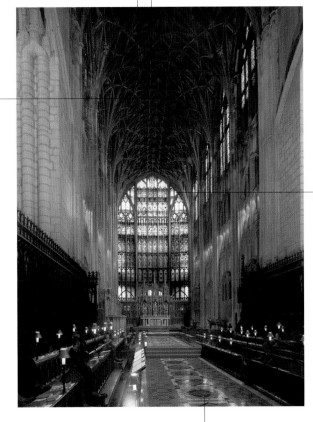

The modular architectural unit is a narrow rectangle, with tracery, forming a panel within which is a small projecting arch. This module is repeated in the monumental east window, which consists solely of glass and the colonnettes of the panel tracery.

There are echoes of local Decorated style architecture in the choir, but the structure is quite innovative, especially in the rectangular modules.

Choir of the Cathedral, ca. 1351–67.
Gloucester.

London was a growing metropolis in a state of continuous economic development. It also led the way in English art. New styles were created here as a result of royal court commissions.

London

Notes of interest
Among the important artistic achievements of 14th-century London are the masterpieces in *opus anglicanum* embroidery, which were much influenced by contemporary works of painting. The technical quality remained high until the mid-14th century.

Fourteenth-century London was a city of about forty thousand inhabitants (few other English cities had more than ten thousand). It was an important commercial center whose development was not impeded even by the plague of 1348 or the peasants' revolt of 1381, when the city was sacked. In the 1230s, the mendicant orders had begun building monasteries close to the walls, and great houses with battlements were appearing—such as that of Mayor John Pultney (1341)—as well as palaces for rich families, with large, well-illuminated halls and elegant wooden roofs. There were many parish churches as well as town houses for bishops from the kingdom's principal cities, but artistic activity in London depended largely on the royal court. While it was not the only center of the arts in the kingdom, it was undoubtedly their driving force. In architecture, sculpture, and painting, royal commissions fostered experimentation, and Westminster was the privileged place for the creation of new styles. Artists from all over gathered there, sharing their knowledge and skills in an effort to satisfy the royal family's demands. London was also the chief English center for the production of illuminated manuscripts, first in the Court style and later in the Queen Mary style. At the end of the century, the production of illuminated manuscripts in London increased substantially, thanks to the patronage of Richard II and the city's Church institutions.

▶ *Angel*, 1390–95. London, Tower of London.

128

At the end of the 14th century, it became increasingly common for nobles' residences to have large, well-lit halls suitable for banquets.

The most important part of the hall was the roof. Here we see a single-span wooden roof with massive trusses and protruding beams, the work of the royal carpenter, Hugh Herland.

The south wall was dominated by a large window, beneath which stood the marble throne occupied by the king at banquets and other ceremonies, or by the lord chancellor at meetings of the court.

The Palace of Westminster, originally built about 1097–99 but reconstructed under Richard II, houses Westminster Hall, one of the most important halls in England. It was the only room in the palace to survive a destructive fire in 1834.

Statues of six kings of England flank the throne and the window, emphasizing the presence of royal authority.

enry Yevele, Westminster Hall,
1–1401. London, Westminster Palace.

There seem to be echoes of Italian painting in this fragment: in the representation of perspective and architecture, and in the way the characters' faces are depicted. For the most part, the artistic environment at court was characterized by experimentation and close contact with Continental art.

The fresco shows scenes from the Book of Job: the banquet at which Job's sons and daughters were killed, and the meeting with his friends Eliphaz, Bildad, and Zophar.

Saint Stephen's chapel in the Palace of Westminster (begun in 1292) was richly decorated. Unfortunately, only a few fragments remain as evidence of the wall paintings in tempera and oils.

Fantasy and naturalism mingled freely in the narrative scenes painted on the walls. There were biblical scenes, angels, and a large scene showing the royal family kneeling at Christ's feet. Documents record Hugh of St. Albans as responsible for many of these paintings.

▲ Hugh of St. Albans(?), *Scenes from the Book of Job*, 1350–63. London, British Museum.

These manuscripts were produced in a workshop that was active over a long period and was most probably situated in London.

This very delicate miniature shows God the Father in a mandorla surrounded by angels playing musical instruments, and Adam and Eve tempted by the devil.

The characteristics of this miniature are common to a group of about twenty manuscripts illuminated by different artists in the second and third decades of the 14th century. The style is known as the Queen Mary style.

Eve is tempted, not by the serpent, which, as always, is twined around the tree trunk, but by a devil who shows her the fruit. Two other devils, of grotesque appearance, are tempting Adam. The nude figures of Adam and Eve are very advanced for the period.

ueen Mary Master, *God the Father* ajesty and the Temptation of Adam Eve, 1310–20, illuminated page Queen Mary's Psalter. London, sh Library.

Typical qualities of this style are the grace and delicacy of line, which is strongly influenced by Parisian manuscripts, and the combination of painting and watercolor drawing.

Westminster Abbey contains some very
important works of funerary sculpture—
an art in which 14th-century English
artists showed considerable originality.

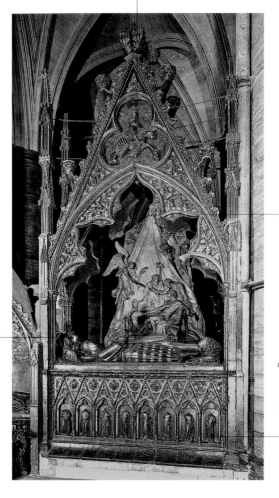

Some of the poly-
chrome has sur-
vived. Originally it
would have given
the monument all
the color and bril-
liance of an illumi-
nated manuscript.

The tomb of Edmund
Crouchback, Earl of
Lancaster and brother
of Edward I, is very
ambitious and may be
the work of the court
architect, Michael of
Canterbury.

This monumen
together with the tom
of Crouchback's wife
Eveline, has origina
features in both th
canopy and the row
statuettes in nich
along the bas

▲ Tomb of Edmund Crouchback,
ca. 1297, London, Westminster Abbey.

This diptych was probably commissioned by Richard II before his expedition to Ireland in the autumn of 1394. It is an important example of late-14th-century panel painting.

The diptych seems to commemorate the king's ascent to the throne and coronation in 1377.

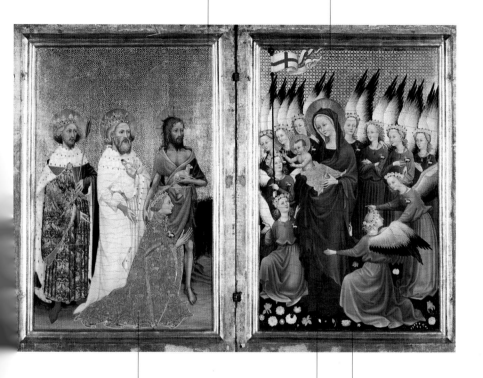

In the left-hand panel, the kneeling king is accompanied by Saint John the Baptist, Edward the Confessor, who holds a ring in his hand, and Saint Edmund.

In the right-hand panel, the Madonna is surrounded by eleven angels crowned with garlands of flowers. Their delicate facial features are very reminiscent of illuminated manuscripts. The Child turns with a gesture toward the king.

The artist is very skillful in arranging the scene and handling the foreshortening, as with the angel on the left. He also dwells on careful, naturalistic details, as we see in the flowers.

Unknown French master, *The Wilton Diptych: Richard II Presented to the Virgin and Child by His Patron Saint John the Baptist and Saints Edward and Edmund*, ca. 1390. London, National Gallery.

France

In the 14th century, France was profoundly affected by the Hundred Years' War, social uprisings, and, like the rest of Europe, the Black Death of 1348. Since the late 13th century, the monarchy under Philip the Fair had made considerable progress in organizing central and governmental administration, but the country had still not achieved political homogeneity. Some regions, although subject to the crown, were controlled by princes who enjoyed a great deal of independence. These regions developed substantially in the 14th century, adopting a process of imitatio regni: by behaving like kings, with their own courts and administrative and fiscal systems, they effectively limited the power of the Valois kings. The courts of the dukes of Anjou, Berry, and Burgundy rivaled that of the king of France in terms of art commissions as well. Artists consequently flocked to France from Italy, Spain, the Netherlands, and other parts of Europe, becoming active in Paris, Angers, Dijon, and other centers. The artistic experience of northern and southern Europe encountered Gothic refinement and court splendor in Paris, and their interaction produced a new synthesis and a new artistic idiom, which was linear, light, and rich.

Philip of Valois was an ambitious politician and an outstanding patron of the arts. He funded a new Carthusian monastery at Dijon, where the dukes of Burgundy would be buried.

Burgundy

Until 1361, Burgundy belonged to dukes of the Capet family, and then, after a brief period of annexation to the French crown, it fell to a cadet branch of the Valois. The Capetian dukes, who had direct links to the royal family, were also large feudatories of the kingdom and were often to be found at court and in the king's armies, sometimes extending their power beyond the frontiers of their duchy. But they were not noteworthy for their art commissions, being preoccupied with political problems and, above all, the English invasion. In the last quarter of the century, however, when Philip the Bold, brother of Charles V, became duke, the duchy saw an extraordinary artistic flowering, thanks to commissions from the duke, who wanted to make Dijon a brilliant art center that could rival Paris. In 1385, Philip the Bold signed the deed of foundation of the Carthusian monastery of Champmol, which was to be the burial place of the Valois dukes of Burgundy. Many artists gathered here, including the architect Drouet de Dammartin and the sculptor Jean de Marville, whose place was later taken by Claus Sluter. The painters were first under the direction of Jean de Beaumetz, then Jean Malouel, and finally Henri Bellechose. The presence of so many exceptional artists, as well as more modest local masters, had a profound effect on Burgundian art. Through their achievements, the art of Champmol would influence the region's artistic output for a century to come.

Related entries
Portrait

The Netherlands

Melchior Broederlam, Jean de Beaumetz, Claus Sluter

Notes of interest
The marriage of Philip the Bold to Margaret, the heiress of Flanders, brought a rich inheritance to the duchy in 1369; with the death in 1384 of Margaret's father, the count of Flanders, Franche-Comté fell to her as well. Political union with Flanders also gave Burgundy an outlet to the North Sea.

◀ Claus Sluter, Bust of Christ Crucified, 1395–99, from the Great Cross at the Carthusian monastery of Champmol. Dijon, Musée Archéologique.

135

Above the arcade is the tracery of the tall triforium and the high, bright windows, framed in moldings.

Characteristic of the cathedral nave, which was begun in the 1320s, are the robust piers framing the arches.

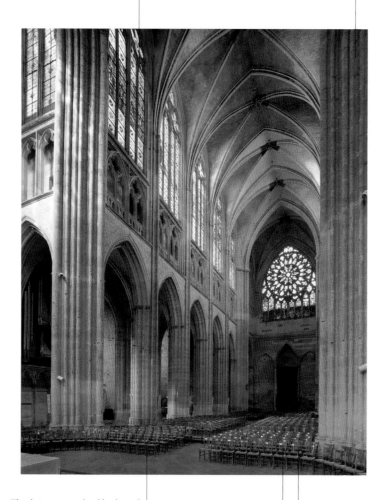

The choir was completed by the mid-13th century, but construction of the transept and nave dragged on into the 15th century because of a financial crisis and the Hundred Years' War.

A flat apse and square chapels beyond the transept arms are common in Burgundy and are also found in the architecture of the Cistercians, who took Burgundian art to all parts of the Christian world.

The architect responsible for the nave at Auxerre created a unique idiom by fusing elements from Parisian Rayonnant Gothic and more "classical" elements from the Norman style.

▲ Interior of the Cathedral of Saint-Étienne, ca. 1320–1400. Auxerre.

The figures on church portals were normally biblical characters. This is the first time we find the intensely realistic portraits of living people, providing them with a sort of elevated self-advertisement.

The Virgin is wrapped in rich draperies that create an illusion of movement.

The four statues stand out from their architectural frames. Philip the Bold (left) and Margaret of Flanders (right) are accompanied by Saint John the Baptist and Saint Catherine, respectively, as they kneel in the presence of the Virgin and Child on the central pier.

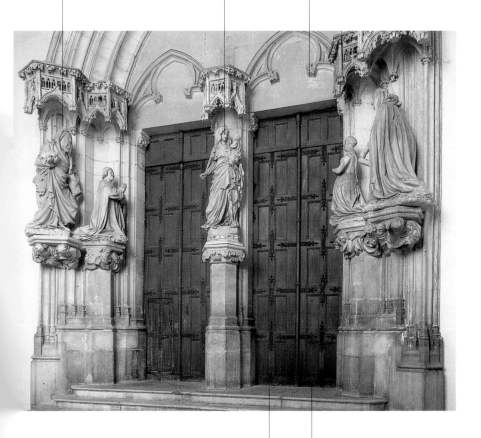

laus Sluter, Portal of the rthusian church at Champmol, 1390–93. Dijon.

The program of sculpture for Champmol was supervised by Jean de Marville. When he died in 1389, Claus Sluter took over as director of operations and gave the work his own personal imprint.

There is a theatrical quality to this work that is very reminiscent of the tableaux vivants of medieval processions. The duke and his wife have severe features. The draperies create an almost dramatic effect.

Burgundy

This work is attributed to Jean Malouel (uncle of the Limbourg brothers). He was one of the most important painters from northern Europe to be invited to Dijon. He subsequently became court painter to the duke of Burgundy.

The overall composition is elegant, the figures have flowing outlines, and the well-preserved pigments shine like lacquer.

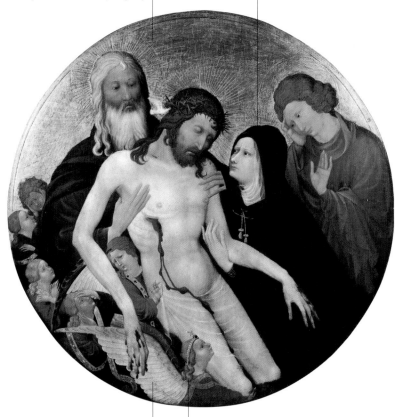

Mourning angels support the body of Christ from below.

This outstandingly beautiful panel was probably a commission from Philip the Bold for the Carthusian monastery at Champmol.

▲ Jean Malouel, *La Grande Pietà Ronde* (*Lamentation for Christ*), ca. 1400. Paris, Louvre.

The beds were arranged along the walls in such a way that the sick could see the altar at the far end of the hall.

A hospital was not only a place to receive the sick but also a hostel, in the sense that it offered hospitality. In the 14th century, and indeed throughout the Middle Ages, such places were run by religious orders.

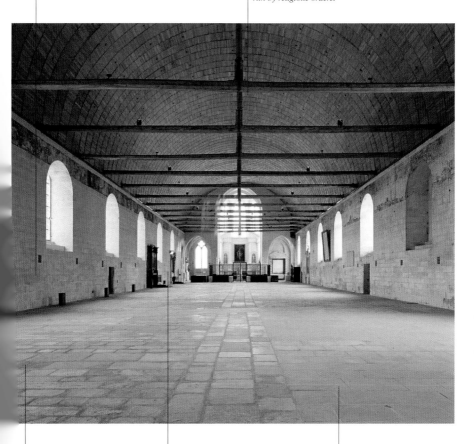

A hall's structure was quite common as an architectural form. It consisted of a large, covered, single-story room with one or more aisles and windows along the walls.

The great hall could house about forty patients. It was covered by an arched timber roof, and at one end lay the tomb of the founder, Queen Margaret of Burgundy.

Apart from the great hall, the hospital complex included kitchens, the founder's lodgings, and buildings for the management.

onnerre Hospital, 1293.

Normandy was devastated during the Hundred Years' War. It nevertheless enjoyed an interesting period of artistic and architectural creativity, with strong Parisian influence.

Normandy

Related entries
Building Site, Architect,
Stained Glass

Jean Pucelle

The duchy of Normandy became subservient to England in 1066 but was restored to France by Philip Augustus (1180–1223). In the 14th century it was affected by the terrible Hundred Years' War between France and England: it changed hands many times between 1346, when it was invaded by Edward III, and 1450, when Charles VII took it once and for all for France. The devastation of the war obviously discouraged construction, and the buildings at many 14th-century sites were not completed until the next century. Nevertheless, some interesting works of art were produced there, especially in stained glass; after 1260, increasing use was made of "mixed" stained glass, in which colored and grisaille panels were mingled. Architecture was influenced by the art of Paris and reached a peak of mastery in the church of Saint-Ouen at Rouen and the cathedral of Notre-Dame at Évreux, where we find an interesting variant of the Parisian Rayonnant style.

▶ Stained-Glass Window
with *The Annunciation*,
after 1339. Rouen, Saint-
Ouen, Chapel of the Virgin.

Abbot Jean Roussel, also known as Marc
d'Argent, was responsible for the rebuilding of
Saint-Ouen. He entrusted the work to an archi-
tect who must have been of considerable repute,
for he is buried in the abbey church.

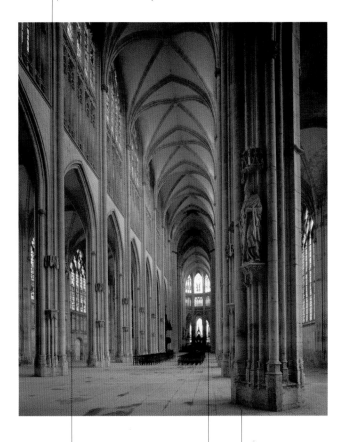

The large windows give
the impression of being
made entirely of glass: as
Marc d'Argent intended,
they are a kind of heav-
enly Jerusalem.

There are twenty-four
stained-glass windows in the
choir. With their profusion of
three-dimensional effects and
frequent use of "silver yel-
low," they clearly reveal the
influence of the great minia-
turist Jean Pucelle.

The ground plan of the
church is impressive: there is
a nave with side aisles
extending along nine arches
and closed off by an apse
that is itself surrounded by
five radiating chapels.

ave of Saint-Ouen, from 1318.
en.

The complex program of sculpture required the contribution of many artists, most of whom had probably trained at Parisian building sites.

The north and south facades of the cathedral transept at Rouen are an example of how Parisian Rayonnant architecture was received and developed in Normandy.

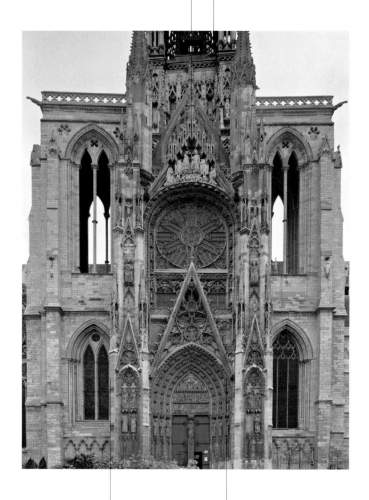

▲ South transept facade at the cathedral of Notre-Dame, ca. 1300–1330. Rouen.

The central portal is framed by the two buttress towers, which are decorated like tabernacles. The rose window is framed by an archivolt decorated with figures.

The whole facade is covered in sculpture. The lively figures in the Passion and Crucifixion in the tympanum stand out against the background.

The figure of the Virgin and that of the donor are both framed by architectural motifs.

The Virgin is shown nursing the Child, who is wrapped in a voluminous shawl. This iconography appeared in the first half of the century and was widely used in sculpture as well.

ained-Glass Window with *The* *in and Raoul de Ferrières*, 1325. *ux*, cathedral of Notre-Dame.

Canon Raoul de Ferrières is portrayed on almost the same scale as the Virgin. He turns toward her and offers up a model of the window.

Considerable use is made of "silver yellow" in this window, but there is no attempt to create three-dimensional effects, as there is in the choir windows of Saint-Ouen at Rouen.

Paris was not just the capital of France and an emporium city, but also an intellectual center of the Christian world. Under Charles V, it was an important locus of artistic innovation.

Paris

The history of Paris is closely linked to that of France as a whole. It is no coincidence that Paris was the scene of the most violent social uprising: the merchants' rebellion led by Étienne Marcel in 1357. In the 14th century, Paris nevertheless saw advances in architecture, as well as in trade, the arts, and its university. The city walls built by Philip Augustus were no longer adequate; by 1315–20 the population had reached about two hundred thousand (though it dropped by midcentury). A lot of construction was carried out for rich members of the bourgeoisie as well as for royalty: palaces and castles were built, churches and monasteries enlarged, hospitals founded, and university colleges built. Parisian artists excelled in the production of illuminated manuscripts during this century (outstanding masters such as Jean Pucelle worked there), and a new aesthetic led to an expanded use of gradations of black and white. The presence of the royal court favored the development, around the mid-14th century, of the art of tapestry making, and Paris became an important center for tapestry production and trading. Under Charles V (r. 1364–80), art clearly became an instrument of political policy. Many artists were employed at court, and the king was able to enforce a unity of approach. Courtly art was rejected, and a new style took hold, which in the 19th century was given the name Flamboyant

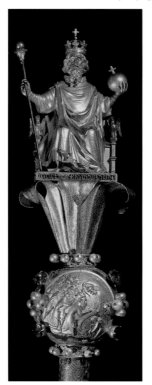

▶ Scepter of Charles V (detail), 1364. Paris, Louvre.

The whole complex is noteworthy for the quality of the decorative sculpture, which is still in a good state of preservation today.

The design of the west front is particularly dynamic, with its two superimposed pediments.

There was an extraordinary amount of artistic activity during the reign of Charles V. The city and its surroundings were transformed with large building projects, directly supervised by the king, that bolstered the prestige and power of the crown. New city walls were built, as well as the Bastille and the remote Château de Vincennes; many palaces were enlarged and modernized.

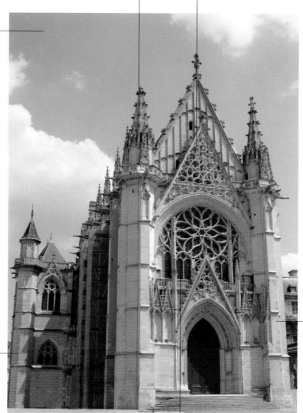

Charles V founded this chapel in 1379. Although not completed until the 16th century, the building respects the original 14th-century design in both plan and elevation.

The Château de Vincennes was old royal hunting lodge, built about 50, but Charles V wanted it as a re administrative center, far from the dangers the capital.

Construction of the chateau was carried out in stages. First, the seven-story central tower was raised, with the royal apartments and a defensive wall. Later, the wall was extended and nine defensive towers were added. And finally, construction of the royal chapel was begun.

The chapel is a rare example of the origins of the Flamboyant style. The internal space is very simple and is marked out by a tall base separated from the upper order by a horizontal band. The simplicity of the whole seems to draw one's attention to the design of the windows, where imaginative curves and reverse-curves create a sense of movement.

apel of Château de Vincennes, second half of the 14th century. Vincennes.

The king's face expresses intelligence, kindness, and grandeur. He is wearing a long, loose gown and holds a scepter in his right hand.

The queen's face has an expression of grace and serenity. She is dressed in accordance with contemporary fashion in a dress that hangs loosely at her hips. She too holds a scepter.

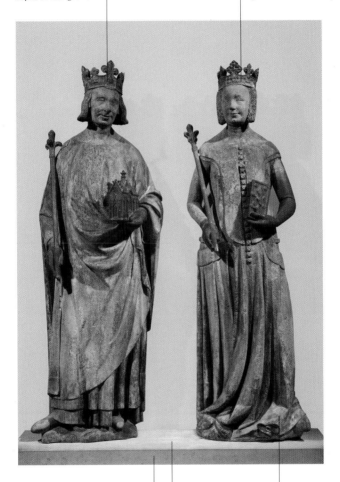

As with painting, there was a standard royal iconography in sculpture. Sovereign power is conveyed through the representation of the royal family, with accurate portrayals of their real physical features.

The provenance of these two statues of Charles V and Jeanne of Bourbon is much debated. They reveal evidence of a stylistic renewal leading toward a more monumental concept of sculpture.

The lower part of the dress is full but simple and creates a strong sense of her three-dimensional physical form. The gestures of king and queen are barely suggested.

▲ *Charles V* and *Jeanne of Bourbon*, 1365–80. Paris, Louvre.

The woman standing behind the Virgin, perhaps a servant, enriches the scene with a touch of the ordinary.

The scene is treated in two blocks. In one, Simeon recognizes Christ in the child presented to him; in the other, Mary holds up the Child in his swaddling clothes to the elderly saint.

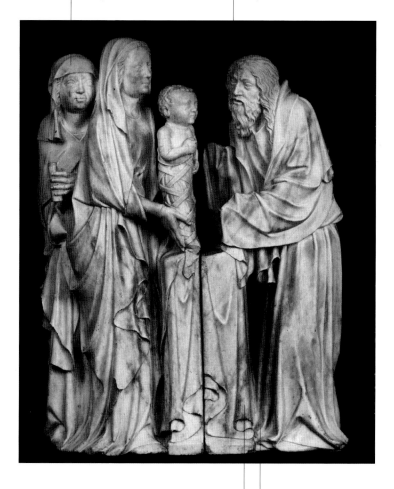

tributed to Jean de Liège or André neveu, *The Presentation of the st Child in the Temple*, 1370–ca. . Paris, Musée National du en-Âge.

The psychological sensitivity and careful execution of detail in this excellent work suggest that it may be by Jean de Liège or André Beauneveu.

In Paris, there was a tendency for sculpture to present real portraits and to convey a sense of monumentality through the treatment of draperies.

The translucent enameling is of very high quality and must be the work of a skilled goldsmith and an equally skilled enameler who knew exactly how to interpret a model by a great painter.

This cup was given by Duke Jean de Berry to King Charles VI on the occasion of his birthday in 1391.

There were many goldsmiths working at Paris in the 14th century. The city was after all a very important commercial center, which meant that artists and their clients gathered there from all over Europe.

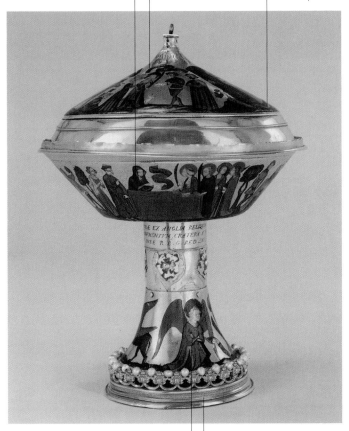

On the cup are representations of the life and miracles of Saint Agnes, together with some inscriptions. The symbols of the evangelists are seen on the foot. Inside the bowl and cover are the figures of God in Majesty and Saint Agnes receiving instruction.

The technique of opaque enameling spread in Paris during this period, and it proved very successful in court circles.

▲ Paris workshop, The Royal Gold Cup, ca. 1370–80. London, British Museum.

In the center is the Crucifixion, with the figure of King Charles V (who may have commissioned the work) on the left and that of his wife, Jeanne of Bourbon, on the right.

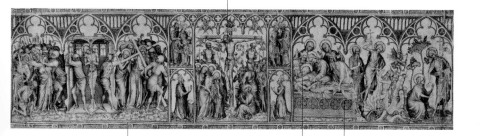

This is the work of an outstanding artist who is influenced by Jean Pucelle. His work reflects the figurative developments in 14th-century Paris.

Clarity of form, elegance, and expressiveness are the outstanding qualities of this work. The plastic treatment of the figures reveals a knowledge of Italian art, but there are also signs of contacts with northern art in the taste for detail in facial features.

This decorative hanging was probably intended to cover the top and back of an altar. The grisaille gives emphasis to both the outlines of the design on silk and the treatment of volume.

aster of the Parement de Narbonne,
Parement de Narbonne, ca. 1375.
, Louvre.

Paris

In her right hand the Virgin holds the fleur-de-lis, the emblem of France. It is made of rock crystal and gold decorated with pearls and carbuncles. The piece was used as a reliquary.

The Child gently caresses Mary's face as she stands enveloped in ample draperies. The figure is solid silver with gilding, without a wooden armature.

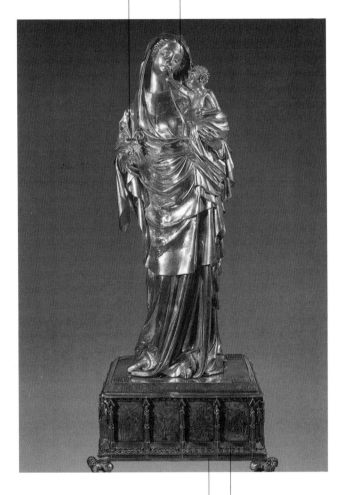

▲ Paris workshop, *Virgin and Child of Jeanne d'Évreux*, ca. 1339. Paris, Louvre.

This gilt silver and enamel statue was given to the abbey of Saint-Denis by the widow of Charles IV. It is one of very few surviving examples of fine gold artifacts made in the mid-14th century.

The Virgin stands on a plinth in the form of a casket designed to look like a small piece of architecture. Its fourteen panels, flanked by tiny statuettes, portray scenes from the Passion.

The figures are in high relief, and the scenes are separated from each other by elegant colonnettes that are linked at the top by trefoil arches.

The relief is part of the thoroughly 14th-century decoration of the south side, which shows Christ's post-Resurrection appearances. Here we see Christ meeting two of his disciples on the road to Emmaus, and on the right is the meal at which he is recognized.

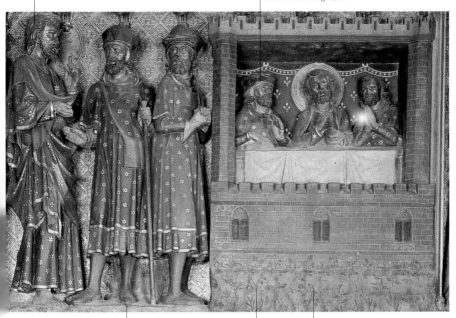

The jubé was widely used in France, Germany, and Flanders. It closed off the choir area in the middle of the church and, by impeding a direct view of the altar, emphasized the difference between the space reserved for the clergy and that occupied by the congregation.

The long, flat surfaces of the jubé (choir screen) were well suited to high relief, but only two sides of this work have survived as evidence of the sculpture being produced at French workshops in the early 14th century.

This work was begun in 1296 but not finished until 1351. Various artists contributed to it, under the direction of Pierre Chelles (master of works), Jean Ravy (a mason), and Jean le Boutiller, who brought the site to completion.

Christ Appearing to the Disciples at Emmaus (detail of the jubé), early 14th century. Paris, cathedral of Notre-Dame.

151

Occupying a frontier position between German and Romance culture, Lorraine was an important meeting point for the art of the Île-de-France and that of the Rhine valley.

Lorraine

Lorraine (medieval Lotharingia) spanned the upper basins of the Meuse and Moselle, in a border area between Germanic and Romance cultures. In the waning Middle Ages it was torn by continual conflicts among its five principalities: the duchy, the county of Bar, and the three bishoprics of Metz, Toul, and Verdun. In 1356, Metz was granted a Golden Bull by Charles IV of Luxembourg, but in subsequent years imperial policy was more concerned with other regions, and Lorraine came increasingly under French influence. In art, the region mingled the influences of Cologne and the Île-de-France, where the French court held sway. Gothic art permeated the region, with a flourishing output of illuminated manuscripts at Metz—especially books of hours and Apocalypse manuscripts, which were popular with the rising bourgeoisie. The region also produced important sculptures (figures of the "Beautiful Madonna" as well as architecture (Metz and Toul Cathedrals).

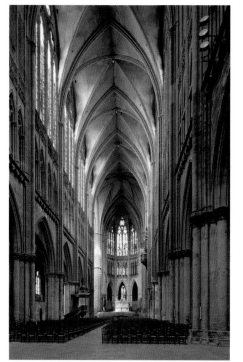

▶ The Nave of the Cathedral of Saint-Étienne, 1360–80. Metz.

The Virgins of Lorraine
are typically stocky, and
Mary's head is always
veiled and crowned.

The iconography of the
Child reading a bre-
viary is original and
very unusual.

The Madonna may be
shown seated or stand-
ing, and the figure of the
Child may be somewhat
elongated and a little
rigid. The draping of the
Virgin's robe is usually
much accentuated. She
either looking straight
ahead or gazes at her
son with a smile.

Paris was the most
important production
center for devotional
objects of this kind. The
standing Madonna was
extremely common
throughout Christian
Europe in the 14th cen-
tury, probably originat-
ing in Prague.

School of Lorraine, *Madonna
Child*, 1325–50. Paris, Musée
onal du Moyen-Âge.

Figures of the Virgin and Child were produced
in great quantities in the 14th century. The most
important examples were produced by skilled
artists for princes and kings, but many minor
works were made for rich members of the bour-
geoisie, often inspired by famous models.

*The French Midi diverged from the Île-de-France in both archi-
tecture and sculpture. Important works in sculpture were pro-
duced at Toulouse for Jean Tissandier.*

The Midi, or South

Related entries
Mendicant Orders, Chapel,
Architect, Commission

The architecture of the mendicant orders had spread through-
out Europe, with its large and simple spaces clearly defined by
linear surfaces. But it developed differently in the Midi, where
architects found alternative ways of decorating churches, whose
inner spaces remained simple, with a single nave, while illumi-
nation from outside was reduced to avoid harsh light. Albi
cathedral exemplifies the skill of Gothic architects in finding
original solutions for individual cases. Both sculpture and archi-
tecture sometimes reveal echoes of the art of northern France,
probably because of the presence of artists who had trained
there. But around 1350, the art of the Midi took a new and

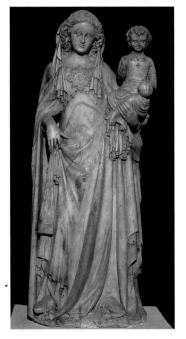

quite original turn. The sculptures
for the funerary monument in the
Franciscan convent at Toulouse,
commissioned by Bishop Jean
Tissandier of Rieux-Volvestre, can
be dated to this period. The artists
there worked under the direction
of a skillful master, and they pro-
duced a type of monumental
sculpture in which the human
body can be discerned beneath
flimsy fabrics, faces have expres-
sive features, and heads are
steeply bent in an almost man-
nered way. The originality dis-
played in these sculptures
profoundly influenced contempo-
rary artists, with the result that
echoes of the new idiom can be
found in other regions.

▶ *Madonna and Child,*
1350–75. Narbonne,
cathedral of Saint-Just-et-
Saint-Pasteur, chapel of
Notre-Dame de Bethléem.

The cathedral was built at the behest of Bernard de Castanet, who became bishop of Albi in 1276, in order to illustrate his dual role as spiritual and temporal ruler of the city.

The interior has a single nave and no transept. Although the interior space is thus left open, the ogee-shaped spans are separated by supports on either side, thereby creating shadow effects.

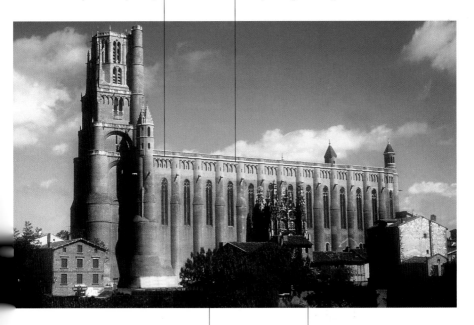

On the exterior, the building looks like a fortress. The whole building is set on a high, featureless base, while the flat wall surface is interrupted by alternating buttresses and narrow windows.

The use of brick creates a sense of plastic austerity.

Albi Cathedral, ca. 1287–1400.

The bishop's head is bent, his face is lively and full of humanity, yet his gaze seems detached from worldly things. The intense realism of the portrait is completed by the polychrome.

This is a statue of Jean Tissandier. He holds a model of the chapel for which he was the donor. The statue is not without a certain monumental quality.

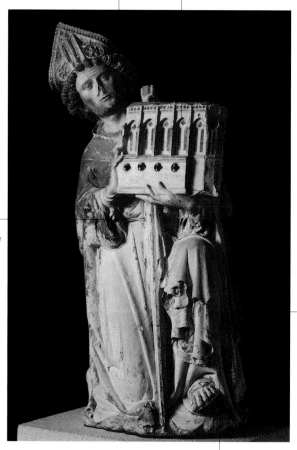

Jean Tissandier was a Toulouse Franciscan and bishop of Rieux-Volvestre. He was responsible for starting work on the Chapelle de Rieux at the Franciscan monastery in his diocese, and it was his wish to be buried there.

Jean Tissandier is wearing a Franciscan habit, tied at the waist with the characteristic cord of the Toulouse Franciscans (hence they were known as Cordeliers). He also wears the episcopal insignia (pastoral, miter, pastoral ring, and gloves).

The Chapelle de Rieux was destroyed in the first half of the 19th century, but some stone statues were rescued and placed in the Musée des Augustins.

▲ Attributed to the Master of Rieux, *Jean Tissandier as Donor*, 1333–34. Toulouse, Musée des Augustins.

These paintings were executed as part of a renewal in the church architecture in the early 14th century, and they display a mature and original style.

These mural paintings extended onto the choir walls.

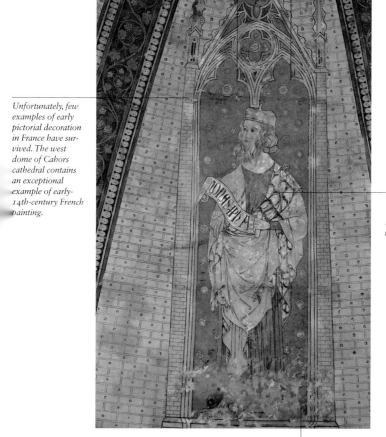

Unfortunately, few examples of early pictorial decoration in France have survived. The west dome of Cahors cathedral contains an exceptional example of early-14th-century French painting.

Enormous figures of prophets with scrolls bearing their names were painted on the dome vaulting and inside painted architectural niches.

The Prophet Jonah, ca. 1320. Paris, Musée National des Monuments français.

The prophets' ample draperies are reminiscent of sculpture, but even more of stained glass; the architectural framing is also similar to that used by stained-glass painters to integrate their works into the buildings concerned.

The papal court's move to Avignon changed the face of the area, transforming a small, tranquil commune into a European capital, where a variety of artistic idioms mingled.

Avignon

Clement V was elected pope in 1305 and moved his residence to Avignon in 1309, partly to escape the factious atmosphere of Rome and the intrusive power of its great families, but also to strengthen the special ties between the papacy and the French crown that had developed in earlier centuries. But the establishment of the papal court at Avignon took place gradually. It was in fact John XXII, successor to Clement V in 1316, who made the definitive move to Avignon. The rich, powerful cardinals who surrounded the pope summoned artists to Avignon from all over Europe, and encouraged learning, literature, and the arts. Under Benedict XII (1334–42), Italian painting was introduced into Avignon and southern France, and work began on a palace for the papal curia offices as well as the papal residence. It sought to compete with Rome in its imposing magnificence. French, English, and Italian artists gathered at Avignon, along with miniaturists and stained-glass masters from the north. Simone Martini decorated the cathedral porch. Clement VI, a cultivated man much concerned with the prestige of his court, bought the city from Joanna of Anjou, Queen of Naples, making Avignon the definitive papal residence and the new capital of Christendom. This it remained, through good times and bad, until 1417.

▶ *Bird Cages*, 1336–37. Avignon, Palace of the Popes, Tower of the Angels, papal chamber.

Benedict XII's palace is austere and imposing. Its towers are striking for their tall buttresses and projecting embrasures.

The palace was begun by Benedict XII, but over time its dimensions became unusually large. It impressed both contemporaries and those of later ages and became a symbol of the new papacy.

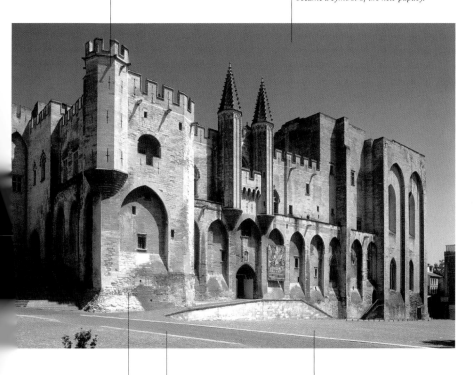

Construction took little more than twenty years, thanks to the use of stone blocks of standardized dimensions, a revolutionary building technique that saved a great deal of time.

During the papacy of Clement VI, the Provençal architect Jean de Loubières added an imposing new extension, embellished with sculptures, frescoes, splendid stained-glass windows, and sumptuous furnishings.

At this period, the papal court was the most splendid and cosmopolitan in Europe. Great celebrations were held there, as well as entertainments, ceremonies, and tournaments at which the most important members of the nobility gathered.

ılace of the Popes,
ı 1336. Avignon.

Avignon

The Chamber of the Stag (Chambre du Cerf),
near where Clement VI had his bed installed,
was on the upper floor of the Wardrobe
Tower (Tour de la Garderobe). Among the
French and Italian artists who worked in the
chamber was Matteo Giovanetto.

Italian painters brought to Avignon a new skill in
representing space and volume, and here they met
northern artists and found themselves in a new
social situation. The resulting works became mod-
els throughout Europe.

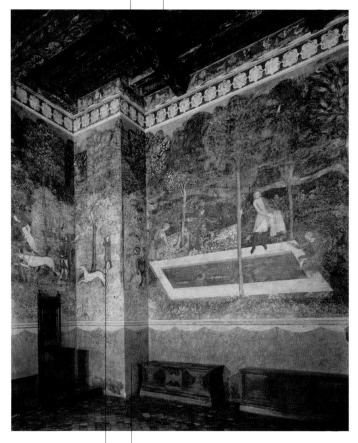

The walls are covered with
scenes of hunting, fishing,
and other country sports,
and there is a magical land-
scape in the background.

This fresco cycle was admired by the kings and
high church dignitaries who had access to the
intimacy of the pope's chambers. It was to have
a considerable influence on secular painting in
the International Gothic style.

▲ Papal workshop, Chamber of the Stag
(detail of the frescoes), 1343. Avignon,
Palace of the Popes, Wardrobe Tower.

The illumination on the frontispiece of this book, which had been the property of Petrarch, displays the same feeling for the rediscovery of nature and the same careful description of plants and animals that one finds in the frescoes at the Palace of the Popes.

Virgil is shown in an attitude of inspiration. He is protected by a curtain, which has just been drawn aside by Servius.

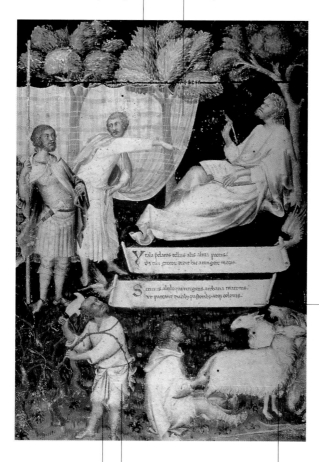

In his famous lines "Mantua Virgilium qui talia carmina finxit / Sena tuli Symonem digito qui talia pinxit," Petrarch was comparing Simone Martini to Virgil, thereby challenging the traditional view that those who practiced the mechanical arts and "worked with their hands" were inferior to men of letters and philosophers.

In the climate of Avignon, the refined style of Simone Martini achieved a kind of naturalism that was intimately inspired by the text and by Petrarch's culture.

This work is clearly the fruit of the fertile climate created at Avignon when artists and men of letters and culture from all over Europe gathered there.

Around the poet one can see a soldier, a shepherd, and a peasant. They symbolize Virgil's Aeneid, Bucolics, and Georgics, respectively.

none Martini, *Virgilian Allegory*, inated frontispiece of a codex of works of Virgil, ca. 1340. Milan, oteca Ambrosiana.

In this lunette, the Virgin sits on the ground with the Child in her arms rather than on a throne. This iconographic novelty was to be exported to the rest of Europe.

The cathedral of Notre-Dame-des-Doms is important evidence of Avignon before the arrival of the popes. Simone Martini painted a series of frescoes there at the request of Cardinal Stefaneschi.

Among the frescoes painted by Simone Martini is the decoration in the lunette of the portal tympanum.

▲ Simone Martini, *Madonna of Humility*, 1341. Avignon, Musée du Petit Palais.

The divine figure sitting in judgment at the top of the picture dominates the court of angels sitting in two rows of stalls. The stalls on the right are now empty, having been vacated by the rebel angels.

The extraordinary pictorial qualities of this panel are paired with an original compositional treatment of the subject, in which new discoveries in perspective are applied.

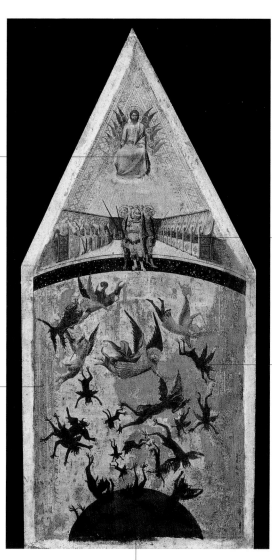

This work is by an anonymous master who was active at Avignon in the 14th century. It is definitely in the style of Simone Martini and may have been executed by Simone himself.

The rebel angels are represented as terrifying devils. They are being thrown down into the darkness of Hell by the elegant figures of sword-wielding warrior-angels, who fly weightlessly across the gold background.

Master of the Rebel Angels, *The Fall of the Rebel Angels*, ca. 1340. Paris, Louvre.

This work enjoyed considerable success. In the early 15th century, a perspective view of paradise was used by the Limbourg brothers in a miniature on a similar subject in Les Très Riches Heures du Duc de Berry.

The Holy Roman Empire

In the late Middle Ages, the region occupied by the German empire did not have a unitary national tradition. The emperors had always been elected and often came from outlying regions, far from the Rhine valley. But the material bases of sovereign power gradually shrank, and two types of territorial power became consolidated, namely, the electoral principalities and certain cities. A number of great electors, both ecclesiastical and secular, had in fact been consolidating their positions, and it was they who were called on to appoint the kings of Germany. The electoral college had seven members: the archbishops of Mainz, Trier, and Cologne; the Duke of Saxony, the Marquis of Brandenburg; the count Palatine; and the King of Bohemia. In 1356, Charles IV of Luxembourg's Golden Bull set out the electoral procedure and regulations for ensuring the indivisibility of the electoral principalities, together with their royal rights, such as those of issuing coins and presiding over a court of final appeal. The German emperors in the 14th century still had universal ambitions, but up to midcentury they were effectively tempered, in part by papal policy; as a result, their plans and powers faltered (one only has to think of the purely formal role the emperor played in Italy during that century). The basic territorial units created during the 14th century were the Länder. Each territory was generally compact geographically, included both cities and the landed estates of the nobles, and was governed by a single lord. Foreign artists from France, England, and Italy—came to the various Länder bringing new artistic impulses; regional differences became increasingly accentuated.

In the 14th century, both Zurich and the region around Lake Constance were part of the Upper Rhine sphere.

Upper Rhine

The Upper Rhine covers the regions of Basel, Ortenau, Breisgau, and Alsace, and in the late Middle Ages it had close relations with the Lake Constance region. Strasbourg (now in France) was then in the historical region of Alsace; having been a key center for Gothic art in the 13th century, it continued to be an important reference point for the art of the region. Furthermore, cross-regional links and artistic exchanges were encouraged by the many building commissions from the mendicant orders, which had settled in the cities of the Upper Rhine since the 1230s. In the monasteries of southwest Germany and around Lake Constance, there developed in the 14th century a new vision of the relationship between God and the human soul, based on their mystic union. This led to a new, subjective religiosity that found figurative expression in the sacred images of the Pietà, the group of Christ and Saint John (a subject portrayed with great mastery at the lively art center of Constance), and the *crucifixus dolorosus*. At this period, the cities of the Upper Rhine were also key centers in painting, to witness the beautiful illustrations in the manuscript collections of *Lieder*, including the Manesse Codex of *Minnesänger* (poets), whose style left its mark on painting and manuscript illumination in the region. A more plastic style, influenced by Bohemian art, also became widespread.

Related entries
Chivalry, Mendicant Orders, Miniature, Stained Glass, *Vesperbild* or Pietà

Peter Parler

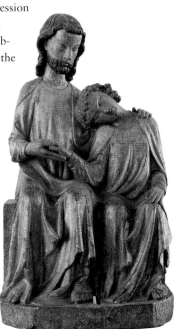

◀ Attributed to Master Heinrich of Constance, *Christ and Saint John*, ca. 1330. Berlin, Skulpturensammlung und Museum für Byzantinische Kunst.

This work was clumsily restored in the early 19th century, but one can still appreciate the illusion of sculpture in the round and the gentle flow of the draperies.

At the center, on the pilaster that divides the portal in two, is a statue of the Virgin. At either side of her are figures of prophets, and below are scenes from the Passion of Christ.

From 1280 to about 1300, Strasbourg cathedral saw the completion of one of the greatest iconographic programs in the Gothic world.

The three tympanums in the facade are devoted to the life, Passion, and Resurrection of Christ. The central portal assumes particular importance both for its larger dimensions and for its privileged position.

The complex iconography must have been worked out by a great theologian who conceived the project and passed on his ideas to the sculptors.

▲ *The Passion of Christ* and *Prophets*, 1280–1300. Strasbourg, cathedral, west front, central portal.

The church was commissioned by the noblemen of the city, and building began in the 13th century. Work on the choir and transept began in 1354 under Johann von Gmünd. He was the son of Heinrich Parler, founder of a family of architects and sculptors who were active in the lands of the empire in the second half of the 14th century.

After 1370, building work on the choir came to a halt. Johann von Gmünd saw to completion only the low radiating side chapels and the portal. We do not know, therefore, whether he conceived the choir as having a German-style hall plan, or whether it was to have the basilican form that it was given a century later.

Upper Rhine churches can be distinguished by their use of compound piers and an elevation of only two tiers, with enormous walls between the ground floor arches, tall windows, and — unlike in French churches — no triforium.

In order to limit the number of supports required, the pillars of the middle arches are arranged in a wedge shape, with one in the center instead of an axial chapel.

The shape of the choir is unusual. The ground plan is elongated, with a polygonal extremity surrounded by an ambulatory and twelve radiating chapels.

Outside is a very fine tower on an octagonal plan, built between 1250 and 1320. Its spire is decorated with tracery and was much imitated.

Johann von Gmünd, Choir of the Cathedral, from 1354. Freiburg im Breisgau.

The Meistersinger *is
directing a group of
musicians with viole da
gamba, flutes, and bells.*

*The artist uses
opaque colors that
stand out against the
plain background.*

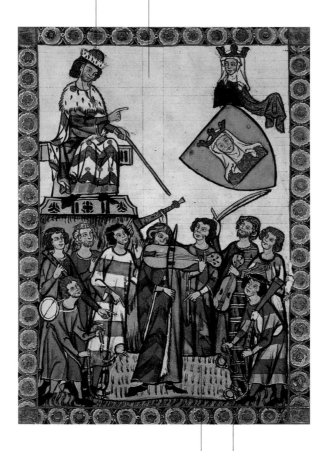

*The 137 full-page minia-
tures portray scenes of
chivalry, war, and love. They
illustrate certain typical
court customs in a delicate
and slightly ironic way.*

*The gently flowing
but linear style of
these illustrations is
evident in the art of
the Upper Rhine over
a long period.*

▲ *Meistersinger Heinrich Wromvenhol*,
early 14th century, illuminated page from
the Manesse Codex of *Minnesänger*.
Heidelberg, Universitätsbibliothek.

The cathedral has the most outstanding group of late-13th- and early-14th-century stained-glass windows in Germany.

Many of the windows in the side aisles still have stained glass dating to the early decades of the 14th century. In most cases the windows were commissioned by trade guilds or individual donors from the city.

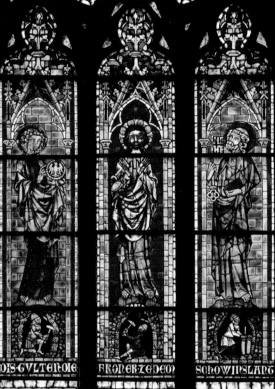

One characteristic of the Upper Rhine style is in the painted architecture above the niches, occupying the upper part of the single-light windows. The use of blue and red is particularly common in the first half of the century.

The many stained-glass windows donated in the 13th century by the artisan and merchant classes are evidence of their increasing importance.

The plasticity of the figures in the Freiburg cathedral windows is emphasized by the use of grisaille.

DIS·GVLTER·OIE FROLER·ZE·DEO) SCHOWINSLANT

The style of this stained glass can be linked to that of the Strasbourg cathedral workshop and in some cases suggests contact with the important cathedral site at Cologne.

The silver miners of Schauinsland, who donated the window, are represented with the tools of their trade.

...tained-Glass Window commissioned
...he miners of Schauinsland, 1310–20.
...burg im Breisgau, cathedral.

Although the Middle Rhine was not a political unit in late Gothic times, architecture and sculpture flourished there, the latter much influenced by work going on at Cologne Cathedral.

Middle Rhine

Notes of interest
At the beginning of the 14th century, Mainz, the capital of Rhineland-Palatinate, had between twenty and twenty-five thousand inhabitants. It was a prosperous city, thanks to its trade and to the export of farm products, cloth, and goldwork.

The Middle Rhine marks the boundary between Hessen and Rheinland-Pfalz. In the 14th century, the region was split into small independent units, which included the important bishopric-principalities of Mainz (capital of Rhineland-Palatinate), Speyer, Worms, and Trier. Many buildings in the late Gothic style were erected, such as the church of Saint Catherine at Oppenheim—a free imperial city near Mainz with a flourishing wine trade— where one can detect echoes of building work at Cologne, Strasbourg, and Freiburg. In Rhineland-Palatinate, however, the influence of Cologne was stronger than that of Strasbourg cathedral. Since the 12th century, numerous castles had been erected in the area to control the land and river routes of the region's bustling trade. Alongside the stone-built church and public architecture were civil buildings, which, in the late Middle Ages, were for the most part wood-frame houses. From the second quarter of the 14th century onward, the influence of building work at Cologne cathedral, where figures were typically clothed in ample draperies, was also felt in sculpture. Toward the end of the century, Middle Rhine sculptors also produced a particular type of Madonna, known as the Madonna of the Vine.

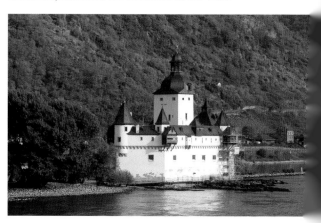

► The Fortress of Pfalzgrafestein, 1327. Kaub.

The church stands out for its eclectic style, with echoes of the cathedrals of Cologne (the transept), Strasbourg (the rose window), and Freiburg im Breisgau (the lancet windows).

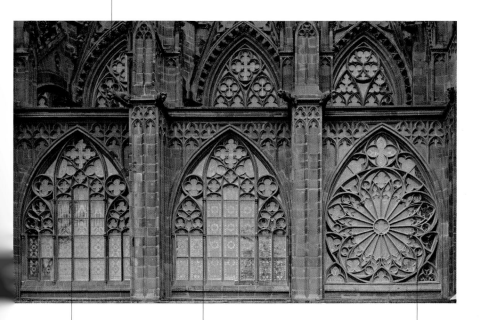

The body of the church was completed by 1340, whereas the choir was built in the last quarter of the century by a master from Marburg.

The building was originally a parish church but later became the collegiate church of the diocese of Mainz.

The south side was begun in 1317 and completed around 1340. It is noteworthy for its rich tracery.

Church of Saint Catherine (detail the windows), 14th century. penheim.

The crown tells us that
Mary is represented as
Queen of Heaven.

This Madonna type is
identifiable by the tree-
cross she holds in her
right hand. In some
cases it is a vine (a sym-
bol of Mary) laden
with bunches of grapes
(a symbol of Christ's
life squeezed out on the
cross).

Because this Madonna
type—slightly bent as
though about to take a
step forward, and with a
broad face framed in
wavy hair—was very
common at the time, it
probably derives from an
important devotional
image that is now lost.

Around the tree-cross,
some angels are collect-
ing the blood issuing
from Christ's wounds.
In addition to the
angels, there is a peli-
can pecking at its own
breast—an allusion to a
popular legend in the
Middle Ages, which
told that the female pel-
ican feeds its young
with its own blood.
This was seen as a sym-
bol of Christ's sacrifice
for the human race.

In the late 14th and early
15th centuries, Middle
Rhine sculptors produced
a group of Madonnas
known as "of the Vine,"
"of the Burning Bush,"
and "of the Cruciform
Scepter.

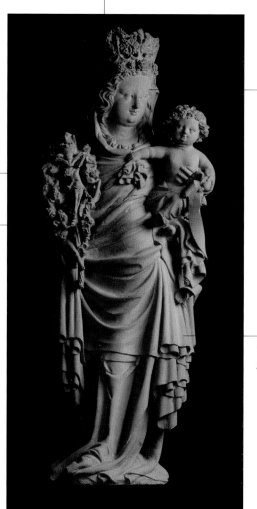

▲ *Madonna and Child*, ca. 1390.
Mainz, Carmelite church.

In the 14th century, the Cologne cathedral site found itself at the center of a vast international network of artistic links.

Lower Rhine and Cologne

After the Swabian period, the historical region of northern Rhineland was divided up into small units, and, as imperial power waned, the archbishop of Cologne was left as the most important authority. From 1288 onward, Cologne, with its massive defensive walls, was in the hands of the patricians, and its population of about forty thousand made it one of the largest cities in Europe. Its trading economy was flourishing, there were numerous religious institutions in the city, and in 1388 the university was founded on the initiative of the citizens themselves. These were favorable circumstances for the production of artworks, the most imposing of which was the Gothic cathedral (begun in 1248, but not completed until the early 16th century), which became an important center for the exchange of artistic ideas. In the early 14th century, some art workshops in the city specialized in the production of small divided altarpieces, probably for private devotion. Gothic architecture also underwent an interesting development in the Lower Rhine area in the Cistercian abbey of Altenberg. The choir has some important surviving fragments of the original grisaille windows that are typical of Cistercian architecture and can also be found at the collegiate church in Xanten. Late medieval churches in northern Rhineland tend to be richly decorated. Workshops of Cologne and other Lower Rhine cities also specialized in the production of reliquaries, including the reliquary-bust, made of wood and finely painted.

Related entries
Building Site, Stained Glass, *Vesperbild* or Pietà

The Holy Roman Empire, Upper Rhine, Middle Rhine

Bertram von Minden

Notes of interest
Cologne was also an important center for cloth production: one particular blue linen was known throughout Europe as *filum Coloniense*. When Petrarch visited Cologne in 1333, he described it as a "regal city."

◀ Reliquary-Bust, 14th century. Cologne, Schnütgen-Museum.

The important series of sculptures in the choir displays a new style, with expressive faces, elongated forms, and clusters of draperies whose folds tend to flatten out.

The insistent vertical lines in the choir give it a tense rhythm. The stained-glass windows in the radiating chapels have been much restored. The better-preserved upper windows have representations of a series of kings who were Christ's ancestors.

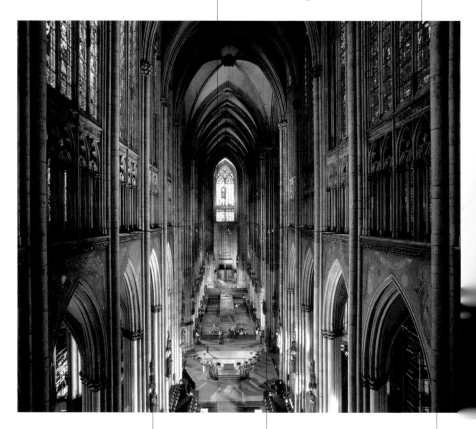

The site was an important meeting place and one where new techniques were tried out. The new flavor it gave to local taste echoed certain typically French features, and it is in fact probable that skilled French workers were employed in Cologne.

In plan, the cathedral has a nave and double aisles, with a simple ambulatory embellished with a series of identical radiating chapels.

The nave has compound piers, which are typical of Rayonnant architecture. The traceried triforium is closely linked to the tall windows.

▲ Master Gerhard, Cathedral Interior, from 1248. Cologne.

This altar with double compartments is the largest to survive in Germany. It was made for the church of the Franciscan nuns of the abbey of Saint Clare at Cologne, and it combines sculpture and painting. It could also be used as a reliquary.

Various hands have been identified as involved in his work, including the so-called older master— perhaps Wilhelm von Herle—who was praised by the Limbourg brothers as the finest painter in Germany.

The elongated figures stand out against a decorated gold background. One can see links with northern French painting in the compositional arrangement and the minimal spatial depth.

The scenes at the bottom represent the Massacre of the Innocents, the Return from Egypt, and Christ among the Doctors.

ight Wing of the Altar of the Poor
es, 1355–60. Cologne, cathedral.

The scenes are arranged in rectangles framed in painted architecture, which recalls the windows found in this region—an example of the continuous and fruitful interaction among the arts.

While the custom of framing scenes in painted architecture is typical of local tradition, the style of painting shows the influence of England, Paris, and northern France.

Along the bottom are figures of Roman emperors (from Julius Caesar onward) and archbishops of Cologne (from Maternus onward). They show the continuous evolution of the church of Cologne from its Roman inheritance.

Typical of painting in Cologne at this period is its fusion of elements from a variety of sources.

This large cycle of wall paintings decorates the inner side of the choir screen in the cathedral. The paintings show scenes from the life of the Virgin, the Magi, Saints Felix and Nabor, the emperor Constantine, and Saint Gregory of Spoleto. On this side are scenes from the lives of Constantine and Pope Sylvester.

▲ *Scenes from the Legend of Pope Sylvester, Sylvester and Constantine Screen*, ca. 1332–49. Cologne, cathedral.

A crown of thorns weighs down Christ's bent head, his almost flesh-less arms are stretched out in the shape of a Y, and his body is so tense with pain that his ribs are visible.

In the early 13th century, the figure of Christ Crucified was a symbol of victory over death, but in the 14th century his features are shown tense with pain and his body racked with suffering in such a way as to arouse compassion in the viewer.

In the early 14th century in Rhineland and Westphalia, the figure of Christ Crucified undergoes a fundamental transformation into the Crucifixus Dolorosus, *in which the suffering Christ endured at death is given particular expression.*

The fact that the cross is in the shape of a bifurcated tree trunk (Y) recalls the tree of life, combining into a single symbol of salvation the figure of Christ and the cross that is supporting him.

rucifix, 1304. Cologne,
.t Maria im Kapitol.

Among the artistic expressions of the powerful Hanseatic towns, the many brick buildings erected for religious and secular purposes stand out for their original, artistically unified style.

Hanseatic Towns and the North

In the 12th and 13th centuries, the term *Hanse* begins to appear in German sources to describe leagues of merchants that banded together to set up joint emporia in the main commercial markets. Toward the end of the 13th century, the *Hanse* took on a new appearance: the merchants within a given city began to work together, local authorities became their representatives, and the groups began to cooperate, thus creating what is known as the Hanseatic League. Membership in the league was always fluid: it was based on a union of about seventy towns, with which others became associated. Lübeck and the other league towns enjoyed considerable military power, and for many decades they dominated trade in the Baltic region. In rich Baltic towns from Lübeck to Riga, church and secular buildings, whether private or public (such as the Rathaus, where the town council met and which acted as the center for local community life), acquired common characteristic in what is known as *Backsteingotik* (Brick Gothic). The model fo this style was the chur of the Virgin in Lübec built at the urging of t rich bourgeoisie of the town.

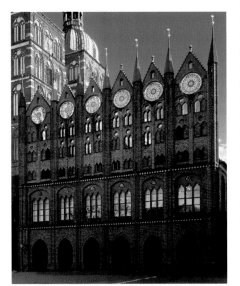

▶ Facade of the Town Hall, 14th century. Stralsund (Germany).

The levels of the two towers are articulated by means of cornices with circular or quatrefoil friezes leading up to triangular pediments. The building is surrounded by flying buttresses.

A number of turrets and the pyramidal copper roofing surmounted by small copper standards give the impression that the town is permanently decorated with flags for some celebration.

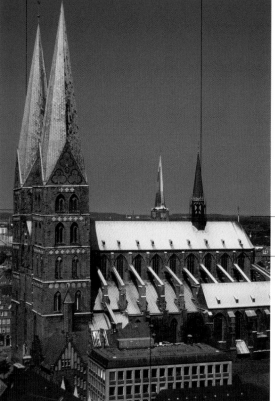

A group of powerful merchants wanted the church of the Virgin to be built to rival the cathedral. It stands in the town center, next to the town hall.

The original plan was for a hall church with a tower. Shortly before finalization, however, the design was changed to something more grandiose, with a much larger basilica and two towers.

The interior of the basilican church has no transept, but there is an ambulatory with radiating chapels. The elevation has no triforium. The central nave is 40 meters (131 feet) high and is illuminated through large arches and the upper windows.

A particular characteristic of this church, which was much imitated along the Baltic coast, is the presence of an ambulatory with radiating chapels grouped around the chapels of the ambulatory itself under hexagonal vaulting.

Church of the Virgin, first half of the century. Lübeck.

The verticality of the walls is accentuated, and they are embellished by means of tympanums with Gothic pediments made of brick, which rise above roof level and are decorated with blind tracery.

In northern Germany, when Gothic architecture is made of brick—much used from the late 12th century onward—it acquires its own particular characteristics.

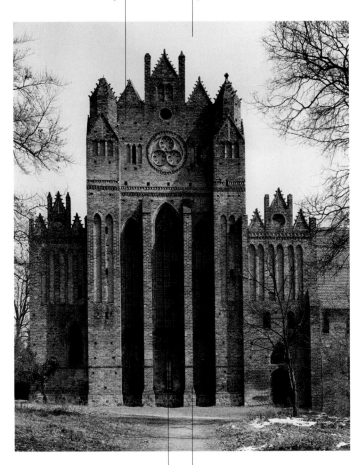

The church has a cruciform basilican ground plan with vaulted bays. The elegant choir is polygonal. The walls rise in two tiers, without a triforium.

The Cistercian abbey of Chorin (northeast of Berlin) is the greatest achievement in the Gothic style of the region.

▲ West Front of Chorin abbey, late
13th–early 14th century.

The tall tympanum rises above the roof line, creating a monumental effect.

The bricks were sometimes used in their natural color, or they might be covered over with a different color.

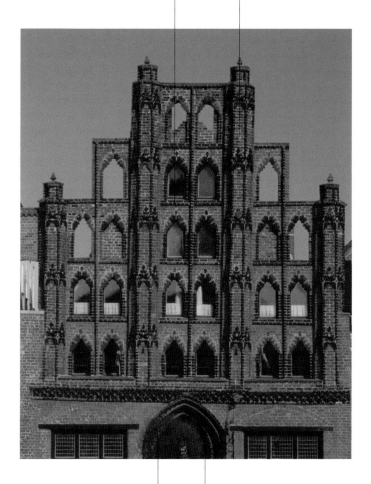

Gothic architecture in brick also left its mark on the houses of the wealthy bourgeoisie.

The reliefs and statuettes that embellish the exterior walls are also made of clay.

acade of the Alter Schwede, 1380.
mar (Germany).

The arts in the southeastern region of the empire developed considerably in the 14th century, thanks in part to the generous and widespread patronage of the Habsburgs.

Vienna and the Southeast

▼ *Scenes from the Passion,*
ca. 1340, central panel
of an altarpiece of the
Passion. Klosterneuburg
(Austria), Stiftsmuseum.

In this region of the empire, a number of important art centers grew up in the 14th century, including Sankt Florian and Klosterneuburg, where there were Augustinian monasteries, and Vienna, which had been the capital of the duchy of Austria since 1288 and was the residence of the Habsburgs. The Habsburgs supported a number of building projects, such as the Augustinian church, the Franciscan church, and the choir in the cathedral nave. In 1365, moreover, Rudolph IV founded a university in Vienna, which made a substantial contribution to the cultural and spiritual climate in the city. Art at the Austrian court had close links with that of France, but artists from the Upper Rhine were also working there, and they were responsible for a nobility of style in sculpture, goldwork, and manuscript illumination. This elevated tendency was accompanied, however, by a characteristic sensitivity to Tuscan influences. Echoes of Italian models are fairly common in Austrian art in the first half

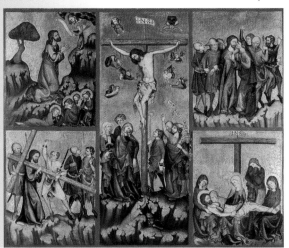

of the century, whereas Viennese and Austrian art in general displays close links with Bohemian art in the second half. Under Emperor Charles IV, Rudolph IV's father-in-law, the art of Bohemia, and that of Prague in particular, exerted a strong influence on the arts in the imperial lands. Interesting examples are the stained-glass windows in Vienna cathedral (1380), and the portrait of Rudolph IV, the earliest individual portrait in German painting.

The greatest architectural achievement of the Habsburgs in the 14th century was the rebuilding of Vienna cathedral. The work was partly financed by the wealthy bourgeoisie of the city.

The ground plan of the choir is quite original: it has three apses, but no ambulatory with radiating chapels. The choir is illuminated by tall windows in the apses.

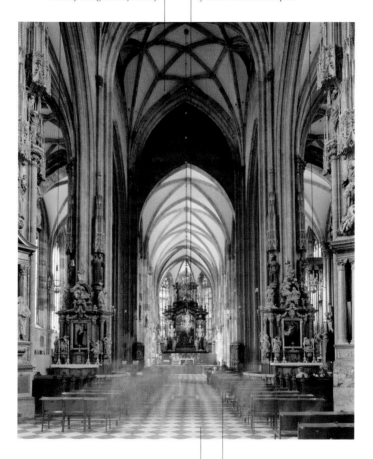

Interior of the Stephansdom (cathedral), early 14th century. Vienna.

This type of choir is called a Hallenchor *(hall choir) because the nave and aisles are all the same height and there are no flying buttresses. It became very common in Austria.*

The influence of the work of the Parlers in Prague can be seen in both the nave, which has been constructed as a "hall," and the fact that there are two towers.

This panel comes from what is called the Verdun altar and was probably made in a Viennese workshop.

This and other painted panels formed the outer wings of a large altarpiece.

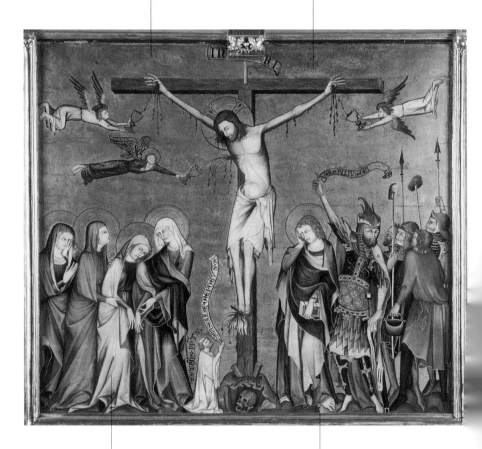

The influence of Italian art is clear in the iconography, but it is interpreted in terms of northern sensibility, as can be seen in the artist's decision to isolate his elongated figures against the gold background.

Other paintings in the altar show the Crucifixion, the Holy Women at the Sepulchre, Christ and Mary Magdalen, Death, and the Coronation of the Virgin.

▲ Viennese workshop, *The Crucifixion*, ca. 1330–35. Klosterneuburg, Stiftsmuseum.

This is the earliest surviving individual portrait in German painting.

The inscription on the frame bears the name of Rudolph IV, son-in-law of Emperor Charles IV.

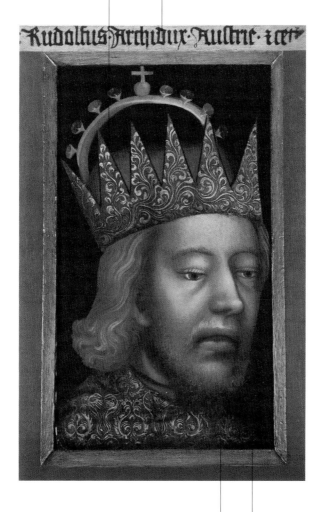

Rudolfus Archidux Austrie etc.

...rague Master, *Portrait of ...dolph IV*, ca. 1365. Vienna, ...bischöfliches Dom- und ...zesanmuseum.

Rudolph probably had this portrait painted in order to elevate his image and that of his family to a position of prestige relative to the other princes of the empire.

The portrait was painted by an artist who trained in Prague—a city that had a profound influence on the Viennese art of the time.

Vienna and the Southeast

The church of the Franciscan monastery of Königsfelden, Switzerland, was built at the request of the widow and children of Emperor Albert I of Habsburg near the place where he was assassinated in 1308.

The windows in the walls depict figures of apostles and scenes from the lives of Saints Francis and Clare.

Here, in medallions placed one above the other, is an episode from the life of Saint Clare, in which she and her nuns pray for the protection of the monastery from the invading Saracens, who can be seen preparing to scale the walls.

Along with French stylistic elements, these windows have Italian features such as corbels, canopies, sarcophagi, and townscapes in the background.

▲ Saint Clare Praying for the Convent to Be Saved from the Saracens, ca. 1325–30. Königsfelden (Switzerland), abbey church.

The building was conceived as a family church. It is illuminated by magnificent stained-glass windows in the choir. That they were made over a period of about five years can be deduced from the figures of the donors.

► Crown of the Kings of Bohemia, 1346. Prague, treasury of the cathedral of Saint Vitus.

Prague was transformed by Charles IV into a second Rome and became one of the most important European art centers in the 14th century.

Prague and Bohemia

During the reigns of Charles IV and his son Wenceslas IV in the 14th century, Prague enjoyed a period of substantial artistic prosperity. It became not merely the capital of the kingdom but the political and cultural center of the empire. Thanks to its convenient links to the main European cities by road and river, it also became a flourishing commercial and financial center. The highly cultured Charles IV summoned artists of all nationalities to his court, and many exceptionally talented artists made their mark there: Peter Parler, who succeeded Mathieu d'Arras as architect for the cathedral; the Master of the Vyšší Brod Cycle, considered the most important exponent of the Italianate style in Bohemian painting; Master Theodoric, court painter responsible for the paintings in the chapel of the Holy Cross in Karlštejn Castle; and the Master of Wittingau. The king also founded a university in Prague in 1347–48. In his attempt to create a new Rome, the king built a new city on the right bank of the Moldau, which embraced the ancient citadel and was endowed with broad streets and new squares. New stone houses and public buildings were erected; the city hall, two markets, and two hospitals were protected by a surrounding wall; and the two urban areas were linked by the Charles Bridge. Numerous religious foundations also came into being. Finally, Karlštejn Castle, the court's new seat, was built in a dominant position on the far side of the river, along with the cathedral of Saint Vitus, symbol of imperial policy.

Related entries
Castle, Artist, Commission

Tomaso Barisini, Master of Wittingau, Master Theodoric, Peter Parler

Notes of interest
In 1348, twelve Prague masters formed the Confraternity of Saint Luke, one of the earliest associations of painters in Europe. The city had a population of about 85,000 in the 14th century and was one of the largest in Europe at the time. From 1348 to 1357, as many as 1,650 houses were built of stone.

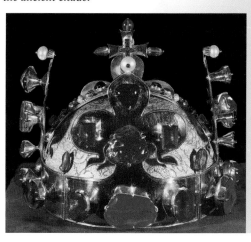

The choir has been conceived as a completely open Hallenchor (hall choir), thanks to the columns supporting the net vaulting.

The cathedral was built on the orders of Charles IV and his father, John of Luxembourg, and stands inside the castle walls, at the top of a hill that dominates the left bank of the river.

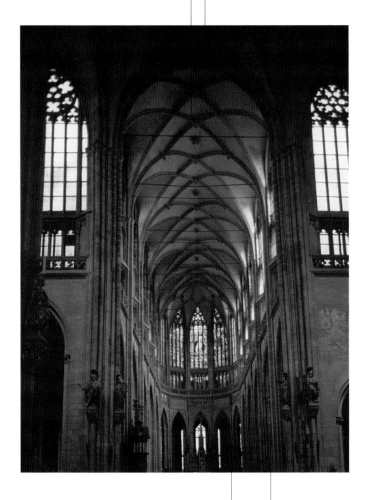

▲ Choir of the Cathedral of Saint Vitus, from 1342. Prague.

The building was originally intended to be a palace church, but it subsequently became the seat of an archbishop. It was where the members of the imperial family were crowned and buried. The crown jewels were also kept there.

As architect of the building, Mathieu d'Arras was succeeded by Peter Parler, whose design involved undulating forms, accentuated verticality, and a roof that tends to bring the arcades closer together.

The horse twists round, offering the spectator a view from various angles. The horse's effort is emphasized by means of its tense muscles and swollen veins.

The saint's eyebrows are raised and his brow furrowed to indicate his effort and concentration in killing the dragon, whose tail is wound around the horse's leg.

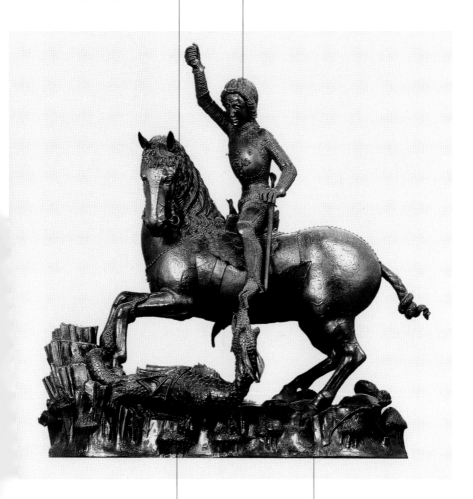

arler workshop master, *Saint* *rge and the Dragon*, 1373. gue, Národní Galerie.

The sculptors working at the Prague cathedral site were responsible for the birth of the so-called Schöner Stil — a new style that emphasized volume and liberated forms.

The statue was modeled by a master in the Parler workshop and cast in bronze by the brothers Martin and Georg in 1373.

Italian influence is evident in this panel. Certain elements derive from Giotto's frescoes in the Scrovegni chapel in Padua, but there are also more typically northern qualities in the linear conception of the figures.

This panel is one of nine showing scenes of Christian redemption from the Annunciation to Pentecost. They have all been brought together in modern times to form an altarpiece.

▲ Master of the Vyšši Brod Cycle and assistants, *The Nativity*, ca. 1350. Prague, Národní Galerie.

The Master of the Vyšši Brod Cycle is a major figure who contributed significantly to the development of arts at midcentury.

The work was commissioned for the Cistercian monastery of Vyšši Brod by a member of the Romzberk family, who is shown kneeling on the right beside his coat of arms.

Master Theodoric has a personal style in which light is suspended over objects and becomes a powerful means of expression.

In the chapel of the Holy Cross, he and a number of assistants painted 120 panels depicting the Army of Christ. They were flanked by wall paintings.

Master Theodoric, *The Adoration of Magi* (detail), 1365. Prague, Karlštejn tle, chapel of the Holy Cross.

> *Burgundian domination had a very strong unifying effect on the region, leading to substantial cultural, artistic, and economic development, especially in the German-speaking provinces.*

The Netherlands

Notes of interest
The political development
of this vast region was
complex: before being
called the Netherlands,
these provinces were sim-
ply referred to as *par deça*
("of the duke") in relation
to the duchy of Burgundy,
where the original ruling
dynasty was based.

The historical region of the Netherlands (roughly present-day northern France together with Belgium and Holland) was a single cultural unit in medieval times, in spite of political and linguistic boundaries. Flanders, where Flemish was spoken, was controlled by France, whereas French-speaking Hainaut belonged to the empire, as did Brabant and Holland. In the 14th century, however, the expansion of cloth and wool production and flourishing trade led to the creation of powerful city oligarchies, which used the construction of enormous, ornate buildings as one way of expressing their power. The city communes in the Netherlands busied themselves with building projects such as city walls, *Hallen* (warehouses with meeting rooms), and city halls whose towers rivaled those of churches and were a visible expression of political power. The region made a substantial contribution to International Gothic, although it had no court to promote the arts. Since there were no nobles willing to spend on the arts,

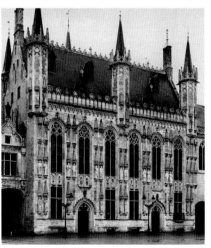

▶ The City Hall, 1377–87.
Bruges.

many artists emigrated up to the end of the 14th century. Claus Sluter, Jean Malouel, and Jan Boudol are just three artists from the Netherlands who worked at the royal court in Paris and for the dukes of Burgundy. At the end of the century, however, the increasing power of the Netherlandish cities offered new opportunities to artists.

In the 14th century, illuminated manuscript production was concentrated in Flanders and Brabant. The influence of French art is often to be found in the style of illustration used in these codices.

The king who is besieging the city can be seen on the left: he is raising his sword and giving orders with his right hand. All around, swords are being unsheathed, while stones, lances, and arrows are being let fly.

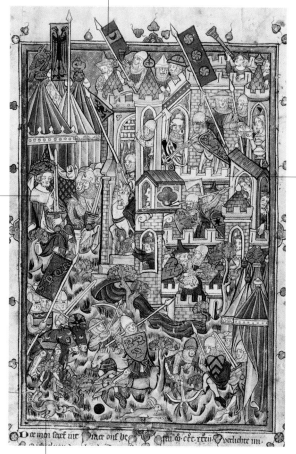

This richly figured page shows the Siege of Jerusalem. Various scenes, arranged on different planes, are taking place from top to bottom.

At the bottom, a small dragon and a rabbit seem to be frightened at all the confusion and noise, which is emphasized by the sounding of trumpets and waving of standards at the top.

▲ Michiel van der Borch, *The Siege of Jerusalem*, 1332, illuminated page from the Bible of Jacob van Maerlant. The Hague, Rijksmuseum.

The darkened sun and moon in the top corners of the epitaph are to show the relationship between the Old (moon) and New (sun) Testaments, as explicated by Saint Augustine.

The style of this work reveals links with Cologne painting and contemporary Bohemian art.

The donor is accompanied by Saint John, the patron saint of the church where the donor was provost. Saint John is commending him to the Virgin, who stands on the left in her role as intercessor.

Kneeling at the foot of the cross is the figure of the canon who commissioned the altarpiece. This is the earliest portrait of its kind to have survived in the region.

The inscription at the bottom bears the name of the deceased, together with his title and the date of his death, and reminds us that he was the donor of the altarpiece.

▲ Anonymous artist from the northern Netherlands (Utrecht), *Epitaph of Provost Hendrik van Rijn*, ca. 1363. Antwerp, Musée Royal des Beaux-Arts.

Saints John the Baptist and Andrew stand behind the donor in their roles as patron saints and intercessors.

The right-hand page shows the Madonna and Child enthroned. She is represented as mother and Sedes Sapientiae (Seated Wisdom): she holds in her lap her son, who is a symbol of the Word and of Wisdom.

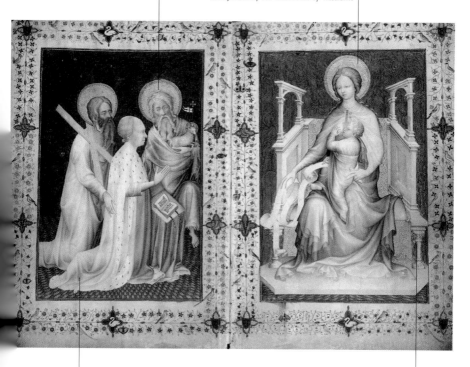

The left-hand page shows the figure of the man who commissioned and donated the work: Jean de Berry, brother of Philip the Bold. He is kneeling in prayer and wears a white robe trimmed with ermine.

The Madonna's throne seems to be suspended in the celestial spheres, whereas the duke and the two saints are on the terrestrial sphere. This arrangement is typical of the courtly ideal.

ndré Beauneveu, *Duke Jean de* *y with His Patron Saints John and* *ew before the Madonna and* *l Enthroned*, ca. 1390, illuminated from *Les Très belles heures de* *e-Dame du duc de Berry*. Brussels, othèque Royale Albert Ier.

The Iberian Kingdoms

Catalonia
Castile
The Kingdom of
Majorca

The Reconquista was completed in the mid-13th century, except for the kingdom of Granada, which remained in Muslim hands until 1492. The Iberian Peninsula thus consisted of four kingdoms: Castile-Léon, Portugal, Navarre, and Catalonia-Aragon. As in the rest of the European West in the 14th century, here there was a certain consolidation of central and territorial structures, with a greater use of representative assemblies and increasing power for urban elites. Here more than elsewhere, however, the balance between nobility, monarchy, and emerging citizen classes proved to be very fragile. The kingdoms appeared to be politically fragmented, and their economies were not homogeneous. Catalonia-Aragon, which included the city of Barcelona, was a mercantile region that made its political presence felt in the Mediterranean, but the other territories were prevalently rural and feudal. Catalonia also stood out as the liveliest art center. After the Reconquista, art gradually opened up to the principal European movements. Artists arrived from France, the Low Countries, and Italy and made their mark from time to time on local arts and architecture, although the latter had a continuing relationship with Islamic culture.

In the 14th century, Catalan art was particularly lively. It was sensitive to the principal art developments in Europe but reworked them into quite original forms.

Catalonia

Catalonia, in northeast Spain, belonged to the kingdom of Aragon and Majorca (the latter enjoyed independence from 1276 to 1349), and the 14th century was a period of particular artistic splendor there. Especially during the reign of Peter the Ceremonious, the institutionalization of the court, local government, and diplomacy abetted the consolidation not only of administration and territories but also of production and trade; in addition, Mediterranean expansion continued with the establishment of commercial links with Pisa and other initiatives in southern Italy. Art and architecture flourished and were open to the principal developments in Europe, especially Italian, French, and Flemish art and painting, which were given new forms in Catalonia. Local authorities, especially in Barcelona, promoted important architectural and art projects, including the construction or restoration not only of church buildings (such as the cathedrals of Barcelona and Gerona) but also of secular buildings (the construction or enlargement of palaces, merchants' loggias, hospitals, and so on). Sculpture from the early years of the century displays strong links with France and Italy, thanks in part to the flow of talent from those regions. The outstanding artists of the midcentury were Master Aloy, Jaume Cascalls, and Jordi de Déu, all of whom worked at the royal pantheon of Poblet. The most important school of painting at this period grew up in Barcelona, with Ferrer and Arnau Bassa, Ramon Destorrents, and the Serra brothers.

Related entries
Burgundy, The Kingdom of Majorca

Ferrer Bassa, Jaume Cascalls, Ramon Destorrents, Pedro Serra

▼ Interior of the Cathedral, 1328–83. Barcelona.

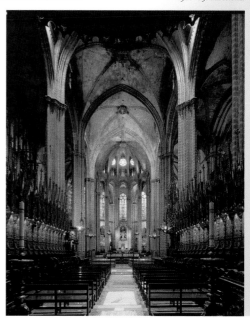

The hall is covered by a single nave with broad, massive diaphragm arches, which almost reach the ground (they are more than 33.5 m, or 110 ft. wide); above them stretch the wooden trusses of the roof.

The great Tinell Hall was built inside the principal royal palace in Barcelona, which was enlarged on the orders of the crown.

The king used Tinell Hall to receive ambassadors and hold banquets.

▲ Guillem Carbonell, Tinell Hall, 1359–62. Barcelona, Royal Palace.

There is no triforium, and the windows are arranged on three levels. In order to make the interior more spacious and better illuminated, the tall octagonal piers have plain shafts and are reduced in number, thereby creating an impression of open space.

The commonest type of church in Catalonia at this period had a single nave and a wood beam or vaulted roof, but there now grew up alongside it a more imposing kind of building based on a concept of openness, with supports reduced to a minimum, thus creating the illusion of a single space.

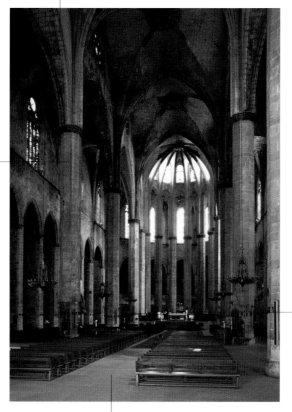

The architect Berenguer de Montagut (with Ramón Despuig) adopted a ground plan in which the aisles have chapels that continue around the choir and along the end interior wall.

The church of Santa Maria del Mar replaced the previous parish church of the ship-builders and merchants: they wanted a building that would rival the major city churches.

Interior of Santa Maria del Mar, 1328-83. Barcelona.

The low reliefs depict scenes from the life and Passion of Christ and include earlier elements that are completely enameled, in accordance with a typically Sienese tradition.

Catalonia and Aragon produced many gold artifacts. In this field, too, they had close links with other European regions.

The Gerona retable was begun by Master Bartomeu and continued by Pedro Bernec of Valencia and Master Andreu. It is one of the most important artifacts of the period in Catalonia.

▲ High Altar Retable, 1325–80.
Gerona, cathedral.

The effigy of the Infanta Joana, eldest daughter of Peter the Ceremonious, lies on the sloping lid. Scenes from the funeral ceremony are shown on the sarcophagus.

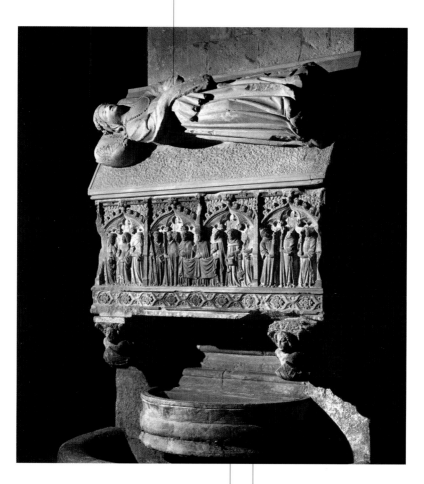

Jordi de Déu worked beside Jaume Cascalls on the royal tombs in the Cistercian monastery of Santa Maria de Poblet. It was here that he completed his training, and here that he carried on Jaume's work after the latter's death.

Italian art was very influential in Catalan sculpture at the time, and its echoes can be detected in this work by Jordi de Déu.

rdi de Déu, Recumbent Effigy of
Infanta Joana de Empúries, 1386.
et, Monastery Museum.

This extremely large retable was made for the Confraternity of the Holy Spirit at Manresa. It depicts scenes from the life and death of Christ.

The Serra brothers were active in Catalonia in the second half of the 14th century. Their retables are larger than any that had previously been made, and the scenes within the composition are arranged differently.

▲ Pedro Serra, *Retable of the Virgin and Child with Saints*, 1394. Manresa, cathedral, chapel of the Holy Spirit.

Pedro Serra painted a number of retables, typically in pale colors. They were made for confraternities, guilds, and monasteries, but not for the royal court.

In the 14th century, the art of Castile was rather lacking in momentum. But there was a rise in the production of sacred images and the adoption of the interesting Mudéjar style.

Castile

After the death of Alfonso X, known as the Wise (r. 1252–84), under whom the region had flourished culturally, the kingdom of Castile was torn by internal conflict between the monarchy and the nobles. While the monarchy was strengthening its administrative and fiscal institutions, and the nobility was steadily increasing its political and social influence, the arts stagnated. Building begun at the great sites in the 13th century continued, but few new projects were started, though Palencia Cathedral was one of them. There was a rise, however, in the production of sculpted sacred images for devotional purposes; a new, more narrative style developed, and the image of the *Crucifixus Dolorosus* enjoyed a certain success with the spread of mystical literature on the Passion of Christ. Few paintings of the period have survived, but those in "linear" Gothic style from the tomb of Sancho Saiz de Carrillo in San Andrés de Mahamud (Burgos) date to the early 14th century. The wall paintings at Peñafiel are quite interesting, showing a subject widespread in Europe at that time: the meeting between three living and three dead men. The 14th century also witnessed the development of Mudéjar art, a term coined in the 19th century to describe a style springing from centuries-old links with Islamic culture.

Related entries
Castle, Plague, Wood Sculpture

▼ *Christ on the Cross* (detail), ca. 1300. Palencia, cathedral.

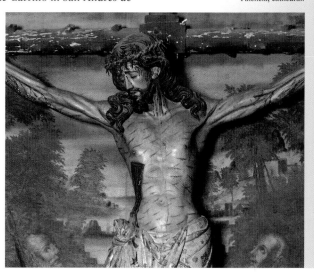

The three portals in the west front have sculptures representing Hell (on the left), the Last Judgment (on the right), and Pardon (in the middle).

At this period, Castilian sculpture seems to have been little affected by external influences.

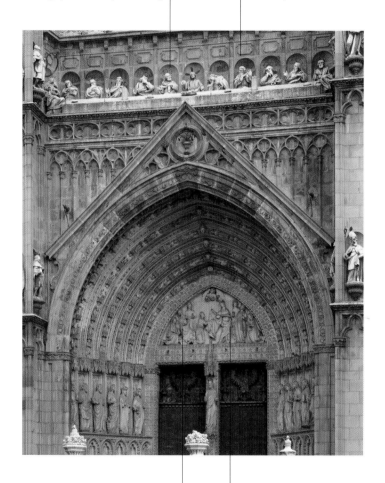

The statues stand out against the flat background, with a decorated arch above.

The figures on the Portal of Pardon are elongated, their bodies beneath the draperies seem to move, and their faces are expressive.

▲ The Portal of Pardon, before 1337.
Toledo, cathedral, west front.

The funeral ceremony called correr las armas *involved bearing the coffin, followed by the deceased's horse and insignia, between lines of manifestly grieving relatives, friends, and servants.*

This scene is part of a group of paintings that decorated the tomb of Sancho Saiz de Carrillo in the hermitage of San Andrés de Mahamud at Burgos.

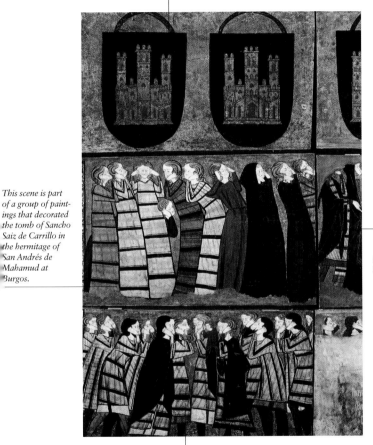

The figures have hard outlines, and expressions and gestures of a traditional kind. There is also something Gothic about the arrangement of the figures and the drawing. This is one of the earliest examples of "nonlinear" Gothic in Castile.

The scene depicts the moment of the planctus, *that is, the moment when relatives and friends exhibit their grief.*

Spanish school, *Mourners* (detail of tomb of Sancho Saiz de Carrillo), 1300. Barcelona, Museo Nacional Arte de Catalunya.

The independent kingdom of Majorca was established in 1298, but lost its autonomy in 1344. During its short life it was the scene of intense artistic activity.

The Kingdom of Majorca

The kingdom of Majorca consisted of the Balearic Islands and various territories in France. It came into being through the will of James the Conqueror, king of Aragon, who split the crown into two kingdoms (1276), one of which was given to his second son, James I. The division caused discord between the two kingdoms, but political and commercial rivalry came to an end in 1349 with the defeat and death of James II, nephew of James I, and the return of the Balearic Islands to the kingdom of Aragon. During the half century or so of its life, the kingdom of Majorca enjoyed intense artistic activity. The kings pursued a very prestigious arts policy, some of its most outstanding results being the construction of castles at Perpignan and Palma, as well as Palma cathedral. Two splendid manuscripts were also produced, their style revealing the clear influence of Siena: the *Libro de privilegios* and the *Leyes Palatinas*. In addition, there were notable developments in goldwork, including the production of translucent enamels at Montpellier. As in many other parts of Europe at this period, the arts were also much supported by the mendicant orders, which built new monasteries or rebuilt old ones on a grander scale.

▼ *The Assault on Palma in Majorca and the Camp of King James I*, 1285–90. Barcelona, Museo Nacional de Arte de Catalunya.

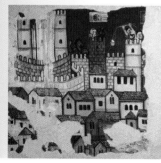
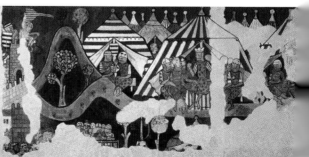

The frontage is divided into a system of massive supports and flying buttresses placed close together. This gives a combined impression of solidity and linearity.

The interior has a nave and two aisles and is illuminated by a large rose window at the west end. The small difference in height between the principal arcade (42 m, or 138 ft.) and those of the aisles (30 m, or 98 ft.), together with the breadth of the nave (20 m, or 66 ft.), creates a sense of spatial unity and simplicity in the cathedral interior.

The whole building is elegant and grandiose. It reveals the influence of French art, but with a decidedly local flavor.

The building was conceived as a kind of extraordinary divine pantheon.

The cathedral was built on the site of an Arab mosque and looks almost like a fortress from the outside.

ɨerenguer de Montagut (?) and
ɨers, Cathedral of Santa Maria,
ɪ300–69. Palma, island of Majorca.

*Bellver Castle was a summer resi-
dence for the kings of Majorca. It
has a circular ground plan, is well
fortified, and is flanked by four
massive towers.*

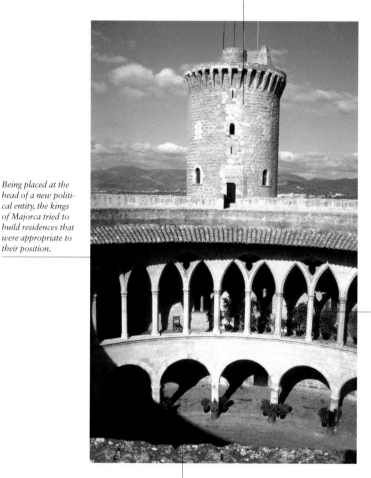

*Being placed at the
head of a new politi-
cal entity, the kings
of Majorca tried to
build residences that
were appropriate to
their position.*

*The inner court-
yard of the palace
is framed in Gothic
arches, which give
it a very charming
atmosphere.*

*Pedro Salvá's aim was to create
a building of perfectly regular
shape. In some ways it is remi-
niscent of Frederick II's Castel
del Monte in Apulia.*

▲ Pedro Salvá, Bellver Castle, 1309–14.
Palma, island of Majorca.

The king is shown at the center surrounded by angels, some of whom are placing the crown on his head, while others are playing musical instruments.

This famous miniature, in which we notice a certain lack of perspective, shows James I on the throne, in a composition that is reminiscent of Simone Martini's Maestà *at Siena.*

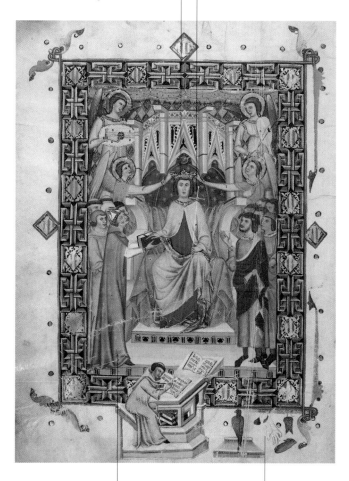

Below and on either side of the king stand a representative of the church (left) and another of the nobility (right)—the two branches of power.

The so-called Master of the Privileges echoes certain qualities of Sienese art, but scholars do not think he was of Italian origin.

aster of the Privileges, *King James I,* –39, from the *Libros de privilegios y uicias de Mallorca.* Palma, Archivo eino de Mallorca.

Italy

In the second half of the 13th century, the communes of central and northern Italy slid into a state of political crisis, but the tradition of monarchy continued in the south. The role of the emperor became increasingly formal, although he was called in occasionally to settle factional disputes or to appoint various lords as imperial vicars, thereby giving them official status. The removal of the papacy to Avignon and the crisis in the Church made the idea of universal papal power increasingly remote. At the beginning of the century there was substantial population growth and the economy flourished, thanks to the textile industry and international trade; but social tensions were increasing at the same time, factional strife often led to tyranny, and then, in midcentury, the Black Death cut through Italy, like the rest of Europe, decimating the population. Nevertheless, this was the century in which the communes and seigniories made use of art to convey their political messages and to display their own greatness to the outside world. The number of art-producing centers increased substantially, and cities competed for the services of the best artists: painters such as Giotto, Simone Martini, Duccio, and the Lorenzetti brothers and outstanding sculptors such as Nicola Pisano, as well as architects, goldsmiths, and miniaturists. The art of the period reached heights that even the plague could not completely undermine, and artists and their works moved from one city to another, so that comparisons were made and new solutions found. Florence is an outstanding case in point. It was now an economic power at the international level and an accepted leader in the field of culture, with truly original geniuses such as Dante, Arnolfo di Cambio, and Giotto working within its walls.

"Counting its own citizens and people from outside . . . it is reckoned to have a total of more than 200,000 men" (Bonvesin de la Riva, Le meraviglie di Milano, *early 14th century).*

Milan

After the Della Torre family had returned to power between 1302 and 1311, the lordship of Milan was seized by the Visconti family, which had already consolidated its position at the end of the 13th century, occupying posts such as those of "elders" or "captains" of the people. By the early 14th century, the Visconti held sway over almost all present-day Lombardy, and when Gian Galeazzo Visconti came to power in 1385, he took steps to increase his dominions at the expense of neighboring states. In Milan, the Visconti embarked on prestigious building projects, reinforcing external defenses, digging a new moat (the Redefossi, which was protected by fortifications), and erecting new palaces. In 1386, work began on an ambitious new cathedral. Many artists worked at the Visconti court: Giotto's arrival at the invitation of Azzo Visconti in 1335 was a turning point in the history of Lombard art. Giovanni Balducci of Pisa made his mark on Lombard architecture when he designed the portal of Santa Maria a Brera in 1347. His work influenced the Campione masters, among whom Bonino da Campione was responsible for the funerary monument of Bernabò Visconti. In addition, one of the Parler family from Gmünd was at work at the cathedral from 1392. The refinement of the Visconti court, together with new ideas brought by Giotto, produced particularly fine results in manuscript illumination.

Related entries
Seigniories, Chivalry,
Funerary Monument,
Building Site, Miniature

Bonino da Campione,
Giovannino de Grassi,
Giotto

Notes of interest
The Visconti court, which had a network of matrimonial links with other European rulers, made an enormous contribution to the development of International Gothic. That Giotto was at Milan in the years 1335–37 is known almost solely from documentary sources. He painted a Worldly Glory in the Visconti palace and a Crucifixion in San Gottardo, but both are now lost. Gian Galeazzo took Padua, Verona, and Vicenza in 1387, Pisa was ceded to Milan in 1399, Siena and Perugia also submitted in 1399, and Bologna was acquired in 1400.

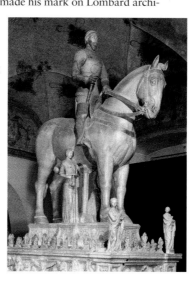

◄ Bonino da Campione, Funerary Monument of Bernabò Visconti (detail). Milan, Castello Sforzesco, Museo d'Arte Antica.

The project to build the cathedral is thought to have involved the collaboration of local and foreign architects. At the end of the 14th century, the site director was Giovannino de Grassi, who increased the amount of sculpted decoration.

The cathedral site was supported and financed by Gian Galeazzo Visconti, and for about thirty years it was the driving force in the social and economic life of the region.

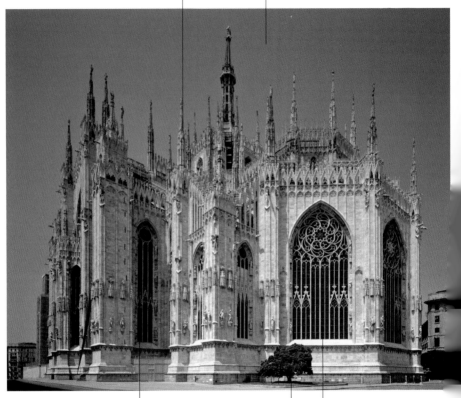

The exceptionally large size of the cathedral is indicative of the city's desire to use it as a symbol of the city's greatness.

The ground plan has a nave and four aisles, a projecting ambulatory with side aisles along its edge, and a shallow choir. The very broad transverse arches had to be provided with numerous supports.

The exterior of the cathedral is striking for its exuberant ornamentation and a highly original overall effect.

▲ Apse and south transept of the cathedral, from 1386. Milan.

The monument consists of a sarcophagus supported by columns and caryatids on a plinth, and on the top is a cuspate tabernacle closely decorated with sculptures.

The sculptures on the sarcophagus lid depict those who commissioned, financed, or otherwise supported the work.

The tomb was commissioned by the Dominicans, with financial contributions from Azzo and Giovanni Visconti among other Milanese noblemen.

Certain particularly expressive and realistic figures stand out among the crowd of those in the sculpted scenes on the sarcophagus. Skilled workers from Tuscany and Campione were responsible for these scenes.

The sarcophagus itself is decorated with eight sculpted panels, which narrate the life and miracles of Saint Peter Martyr.

Saint Peter Martyr reposes in a sarcophagus supported by the Virtues with their symbols. A sculpted figure of the saint himself is in the tabernacle, beside the Madonna and Child.

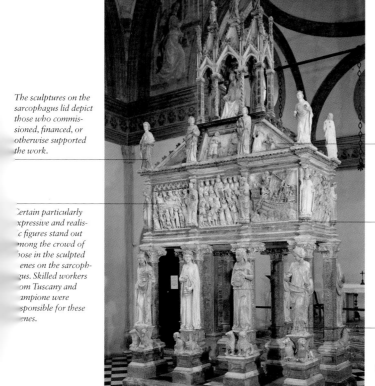

Giovanni Balducci, Tomb of Saint Peter Martyr, 1339. Milan, Sant'Eustorgio.

The delicate, thin layers of paint make the scene particularly evocative. The artist takes great care in describing environment and costumes.

The style of these miniatures is striking for the extraordinary fusion of realism and the kind of formal elegance that is typically aristocratic and courtly.

The extraordinarily high quality of Milan manuscript illumination is clear from works such as the Missal *of Roberto Visconti (ca. 1327), the* Liber pantheon *of Goffredo da Viterbo (written in Milan in 1331 and dedicated to Azzo Visconti), the* Chronica Mediolani *(ca. 1378), the* Tacuina sanitatis *(a typically Lombard creation), and chivalrous romances such as* Lancelot du Lac.

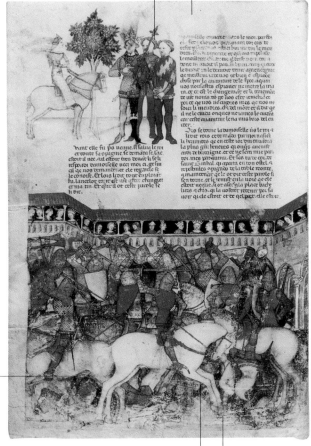

▲ Illuminated page from *Lancelot du Lac,* ca. 1380. Paris, Bibliothèque Nationale.

The painted scenes are in the lower part of the parchment, and sometimes spread beyond the written columns into the margins. The paint is applied directly to the untreated parchment surface.

The work was carried out by more than one hand, as was usual in scriptoria, but it must have been supervised by a highly talented master.

"Barons and Marquises, . . . noble and chivalrous men arrive here. / Astrology, with philosophy / and theology are what you will hear being discussed . . ." (The Bisbidis of Manuello Giudeo, 14th century).

Verona

In the mid-13th century, Verona fell under the power of the Della Scala family, which already controlled the city's chief corporate institution, the *domus mercatorum*. It was the *domus* and its associated popular party that supported the rise of Mastino della Scala and his appointment first as *podestà* and then as *capitano del popolo* in the years 1259–62. In 1311, Cangrande obtained the title of imperial vicar, which provided some legitimacy for his lordship of the city. As the Della Scala family reached its apex, Verona came to mirror its power: imposing walls with six gates and twenty-one turrets were built around the city, and a number of civilian, military, and religious works were begun. This was perhaps when Giotto was in Verona. In the 1340s and 1350s, however, painting at Verona was chiefly influenced by Lombard and Venetian art, and the splendor of the Visconti court in nearby Milan. Two of the most important painters working in Verona after the midcentury, Turone and Altichiero, trained in Milan. Lombard sculptors had long been fashioning the appearance of Verona. It was Cansignorio della Scala himself who appointed Bonino da Campione, a favorite artist of Bernabò Visconti, to design the splendid monument that was to be the crowning glory of the whole group of Scaligeri tombs.

Related entries
Seigniories, Funerary Monument

Milan

Altichiero, Bonino da Campione, Giotto

Notes of interest
It was Vasari who wrote that Giotto went to Verona, and this has been thought quite possible. Nothing remains of the frescoes he painted, according to Vasari, in Cangrande's palace and the church of San Fermo, but there are numerous echoes in Verona of Giotto's Paduan style.

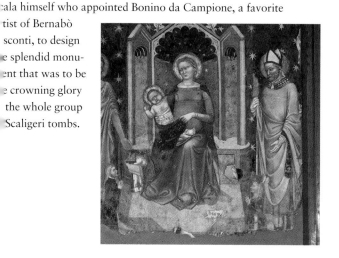

◀ Turone, *Virgin and Child Enthroned between Saint John the Baptist and Saint Zeno, with Donors*, ca. 1362. Verona, Santa Maria della Scala.

The first sculpted sarcophagus probably dates to 1330 and was to be the first tomb of Cangrande I.

The Scaligeri tombs were both funerary monuments and equestrian statues. They are among the most spectacular artworks commissioned by the nobility in the whole of the 14th century.

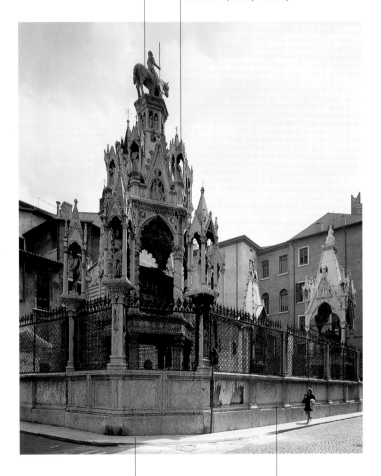

▲ Scaligeri Tombs, late 13th–early 14th century. Verona, Santa Maria Antica.

Bonino da Campione, who designed the tomb for Cansignorio, started with the type of funerary monument already being produced by local sculptors and developed it further by adding tabernacles, cusps, and columns to create a spectacular effect.

The group of Scaligeri tombs has been the subject of much study, and arguments about it continue to this day. Unsculpted sarcophagi were made from the late 13th century onward, but without any clear plans for their use.

Guglielmo holds a model of the church to which he was so devoted. The almost heraldic aspect of the figure reveals a certain nostalgia for Gothic art on the part of the painter.

The paintings in San Fermo Maggiore constitute some of the earliest evidence of Verona's awareness of Giotto's recent achievements in the Scrovegni chapel in Padua.

The painter stresses certain facial features: the thick eyebrows, the protruding lip, the wart on his cheek, and even the hairs in his nose, with a rather stiff and almost caricatural touch.

The Redentore Master's painting echoes Giotto's latest achievements in the plastic treatment of surfaces and the creation of volumes, but in other ways the work is still Gothic.

Redentore Master, Portrait of Guglielmo di Castelbarco (detail of the triumphal arch), 1319–20. Verona, San Fermo Maggiore.

These frescoes come from one of the Scaligeri residences in Verona. They bear witness to the widespread popularity of the Tacuina sanitatis and the Visconti predilection for Gothic art, even in outlying regions.

Illustrated manuscript copies of the Tacuinum sanitatis (an 11th-century medical treatise from Baghdad) began to be made around 1380 in Lombardy and are noteworthy for their elegance and high artistic quality. Because the material in the text was based on a doctor's advice to his reader (about matters of health, diet, and so on) in relation to the calendar year, the commonest subjects represented are doctors, plants, and scenes of everyday life, such as the one seen here.

The images are accompanied by the corresponding text, as though a manuscript page were being transferred to a wall.

▲ Veronese artist, *Dill*, 14th century. Verona, Museo di Castelvecchio.

Thanks to the presence of Giotto, Padua became one of the most important cities in Italy for painting, which also gained from the promotion of the arts by the Carrara family.

Padua

From 1337 to 1405, Padua was governed by the Carrara family. Like the other chief Italian cities of the period, Padua had been an independent commune governed by an oligarchy of merchants and lawyers before becoming a seigniory. The new regime reached its high point under Francesco il Vecchio after 1355. Francesco's wife, Fina Buzzacarina, was an active patron of the arts in the city. Despite the wars that Padua waged from 1370 onward in an effort to gain control of surrounding territories, and despite the Black Death, which struck Padua in a number of waves beginning in 1347, this was a period of splendor in the arts, thanks to lavish commissions from court circles. At the time of the commune, the Franciscan church of Sant'Antonio and important civic buildings such as the Palazzo della Ragione had been erected, but now such initiatives tended to be private. The baptistery, which Fina intended as a funerary chapel for herself and her husband, was decorated with an elaborate fresco cycle by Giusto de' Menabuoi. The basilica of Sant'Antonio was embellished with sculptures and paintings. According to the sources, these included contributions from Giotto (who had already painted the Scrovegni chapel frescoes). In the second or third decade of the century, a close follower of Giotto worked there, and then Menabuoi worked in the Conti chapel and Altichiero in the chapel of San Giacomo. Meanwhile, Guariento was working for the Carrara family.

Related entries
Seigniories, Plague, Chapel, Commission

Altichiero, Giotto, Guariento

Notes of interest
The Black Death so devastated the population of the city that in 1349 all the chairs of medicine and surgery at Padua's university—one of the most famous of its day—were vacant. In the late 13th and early 14th centuries, when the commune was at its largest, an intellectual movement grew up outside the traditional schools. Among its exponents were lawyers and scholars of philosophy and the classics. One of the most outstanding was Marsilius of Padua.

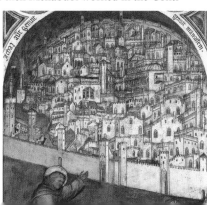

◀ Giusto de' Menabuoi, *The City of Padua* (detail of *Saint Antony of Padua Appearing to the Blessed Luca Belludi*), before 1383. Padua, Sant'Antonio, Conti chapel.

219

According to early sources, Giotto worked not only at the Scrovegni chapel but also at Sant'Antonio and, after 1306, on the decoration of the Palazzo della Ragione, which was destroyed in a fire in 1420. The paintings were restored in the 15th century.

The grand iconographic program seems to have been inspired by the astrologer Petrus de Abano.

In essence, the paintings represent the activities associated with each month, or else the conditions attributable to the influence of the zodiac and planets.

During this period, astrology had a kind of political dimension. Consequently, an astrological cycle was considered appropriate for a hall where political meetings were held.

▲ Giotto, *The Sign of Aquarius*, from 1306. Padua, Palazzo della Ragione, great hall, east wall.

The chapel was built for Bonifacio Lupi, Marquis of Soragna, who belonged to the court of Francesco il Vecchio.

The frescoes in the chapel illustrate stories and legends from the life of Saint James, while the end wall has a magnificent Crucifixion spanning all three arches, as though in a triptych.

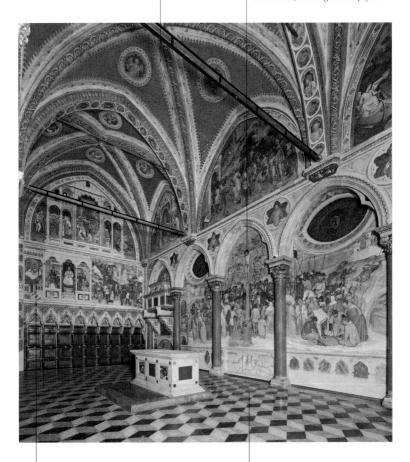

The chapel was built between 1372 and 1376 by Andriolo de Santi and was decorated by Altichiero, who completed the work in as little as three years. The first four and the sixth lunettes are now attributed to Jacopo Avanzi.

Altichiero's art is graceful and elegant. He uses luminous and delicate colors, has a strong narrative sense, and pays attention to the description of his characters.

Altichiero, frescoes in the chapel
an Giacomo, 1376–79. Padua,
e'Antonio, south transept.

Padua

The frescoes converge on the vision of paradise, where close concentric circles of angels and saints culminate in the tondo with Christ in Judgment. The huge, luminous figure of the Virgin stands in the midst of the circles of saints.

Giusto de' Menabuoi came from Florence but was working in the Padua area in the second half of the 14th century. He settled in Padua shortly after 1370, probably because the court atmosphere there favored the arts.

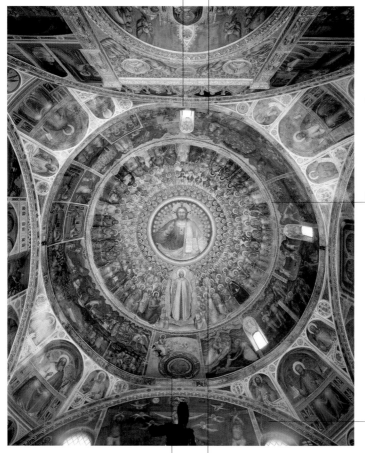

Biblical episodes from Genesis appear in the drum. They are depicted with extraordinary naturalism and often update the iconography to the 14th century.

Giusto lavishe care on th details. Animal and everyda items ar painted wit great accurac

The whole baptistery space has been transformed into the Carrara family tomb, and it is covered in frescoes that narrate sacred history from Genesis to Revelation, but with particular emphasis on scenes from the life of Christ.

Although Giusto's painting is contemporary with that of Altichiero, it seems more archaic. But Giusto pays attention to refinement of color, as well as considerations of optics and perspective.

▲ Giusto de' Menabuoi, Frescoes in the baptistery dome, ca. 1375. Padua.

"The noble city called Venice is now the most beautiful and charming in the world, full of all kinds of beautiful and good things" (Martin da Canal, Storia di Venezia, *13th century).*

Venice

The history of the commune of Venice in the 13th and 14th centuries is unique. There was no social conflict per se but rather a gradual assimilation of wealthy, influential families into the circle of "nobles" and government power. Over the course of the 14th century, membership in the governing class became increasingly limited and was protected by ever-stricter rules; finally it became hereditary. Venetian art reflected the city's unique historical and geographical position and its continuing contacts with the East and the Byzantine tradition. In the mid-14th century, a serious economic crisis, combined with an earthquake, weather disasters, and the plague, produced a kind of nostalgia for the fascinating East and stronger Byzantine influence in art. It is no coincidence that the work of Paolo Veneziano, the greatest Venetian painter of the period, was more Western and Gothic at the beginning of his career, around 1335, but had acquired decidedly Byzantine characteristics by the end. It was around midcentury that Doge Andrea Dandolo had the Pala d'oro in San Marco refashioned; commissioned the mosaics for the baptistry of San Marco and the Chapel of San Isidoro; and had the Palazzo Ducale redesigned, entrusting the decoration of the Sala del Maggior Consiglio to the Paduan artist Guariento.

Related entries
Guariento, Paolo
Veneziano

Notes of interest
Around 1338, the population of Venice was about 120,000. In the early decades of the century, there were about 150 noble families, with about 1,200 members.

◀ Paolo Veneziano, *Saint Mark Saving the Ship Carrying His Body to Venice* (detail of The *"Pala feriale"* with *Scenes from the Life of Saint Mark),* 1343–45. Venice, San Marco, Museo Marciano.

Above the lower portico rises the compact principal wing of the building, containing the council halls. The general effect is one of extreme lightness, thanks to the arches and tracery decoration.

The upper story has the appearance of a compact block. It has large windows and is decorated with marble in tones of white, pink, and gray.

Although on a larger scale, the Doge's Palace is in the same style as Venetian civil architecture, its exterior being opened up by means of porticoes and loggias.

The construction and sculptural decoration of the building are attributed to Filippo Calendario, who was hanged for his involvement in the Marin Faliero conspiracy in 1355.

▲ Facade of the Doge's Palace, ca. 1340–1442. Venice.

Around the corner from the figure of Noah are his two sons, separated from him by the tree trunk.

The first son is compassionately trying to cover his old father's body, whereas the other son's face and gestures express indignation.

The scene on the capital at the corner overlooking the Ponte della Paglia represents the biblical episode of the drunkenness of Noah. Noah is inebriated, and as he staggers beside the tree, the wine cup slips from his hand, spilling its contents into a bush.

These marble sculptures were made in the mid-14th century by Filippo Calendario. They are among the most interesting of that period in Venice.

Filippo Calendario, *The Drunkenness of Noah*, mid-14th century. Venice, Palazzo Ducale.

In addition to the redesigning of the Palazzo Ducale, the 14th century also witnessed the construction or reconstruction of the churches of the mendicant orders: Santa Maria Gloriosa dei Frari, San Zanipolo, and Santa Maria dei Servi.

The ground plan has a nave and two aisles with very elegant cylindrical piers, a large transept, and a central apse flanked by three small apses on each side. The choir has two tiers of windows with decorative tracery.

The construction of this Franciscan church began in 1330, on the site of a church dating from the previous century.

The building remained incomplete for more than a century. This church and San Zanipolo are the most prestigious and typical Venetian Gothic churches.

▲ Santa Maria Gloriosa dei Frari, 1330–1417. Venice.

"Fat Bologna, which teaches you how to get round the law, and contorts lawsuits into so many folds that wrongs become rights" (Barthélemy [Reclus de Molliens], 13th century).

Bologna

In the 14th century, Bologna was first a people's commune, then under the control of various lords, and finally governed by the papacy. A number of 13th-century town-planning and architectural initiatives were completed in the 14th century, including the city walls designed by the architect Antonio di Vincenzo. Mendicant order churches were enlarged, and numerous chapels were built. Noteworthy among these are the six chapels built in 1337–47 in the church of San Domenico on the orders of Taddeo Pepoli, lord of Bologna, who did much to promote the arts and architecture in the city. But the most significant building is the basilica of San Petronio, built by the people of Bologna to commemorate the liberty they regained in 1390. The city enjoyed international fame and cultural traffic thanks to its celebrated university, one of the most important in Europe, which was involved in the substantial production of high-quality illuminated manuscripts. The university also inspired works of sculpture, mostly funerary monuments, which repeat the iconography of the professor surrounded by his students. Bolognese sculpture in the first half of the century seems to be almost entirely devoted to works of this kind; this colloquial, expressive style is also found in painting. In the 1390s, innovation was brought to Bolognese art by Pier Paolo and Jacobello dalle Masegne, who made the funerary monument of the jurist Giovanni da Legnano.

Related entries
Funerary Monument,
Building Site, Architect,
Goldwork, Miniature

Tomaso Barisini,
Vitale da Bologna

▼ Pier Paolo and Jacobello
dalle Masegne, Funerary
Monument of the Jurist
Giovanni da Legnano
(detail), ca. 1386. Bologna,
Museo Civico Medievale.

The artist responsible for the
Matricola dei merciai *(Tradesmens'
Register)*, perhaps a certain Master
Pietro, is noteworthy for his sensitivity
to the innovations of Giotto.

The importance of Bologna University,
which was continually expanding, meant
that the town scriptoria had to meet very
diverse demands, including those for reg-
isters of guild members.

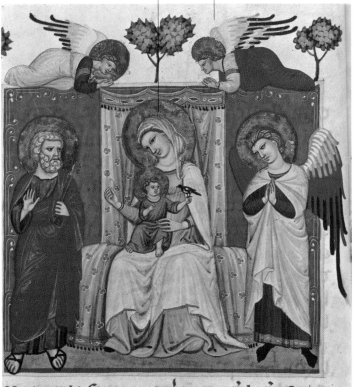

From the second decade of
the 14th century onward,
Bolognese manuscript illumi-
nation tended to take over
certain compositional ideas
from large-scale painting, iso-
lating figured scenes by fram-
ing them inside a rectangle.

▲ Bolognese School, *Madonna and
Child Enthroned*, illuminated page from
Matricola dei merciai del 1328, 1328.
Bologna, Museo Civico Medievale.

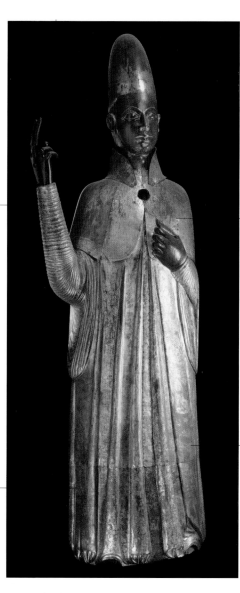

This monumental statue of Boniface VIII (it is 2.65 m, or 8.7 ft. high) is a masterpiece of the goldsmith's art, which flourished in Bologna.

The statue is made of embossed copper, and the hand raised in blessing is bronze. The statue was made by Manno di Bandino, a Sienese goldsmith living in Bologna.

In 1301, this statue was placed on the facade of the Palazzo Pubblico as a way of thanking the pope for his help in settling disputes that had arisen among the city's political factions.

*he king of France ccused the pope of idol-ry for having had 1ages of himself placed churches and at city ıtes—a place where ols were put in ancient *ies.*

Manno di Bandino, *Pope Boniface* *, before 1301. Bologna, Museo co Medievale.

The people of Bologna were very keen to have this church built to commemorate their restored freedom. The first stone was laid on June 7, 1390.

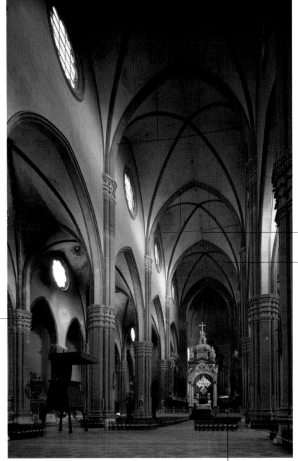

Antonio di Vincenzo's plan was for a church with a nave and two aisles. The stone building was to have side chapels, and at the end of the nave there was to be a crossing with a dome.

Antonio di Vincenzo was a caput magister *who had engineering and organizational responsibilities as director of the building site. He illustrates the multi-faceted role of the medieval architect.*

When Antonio d‹ Vincenzo died ir 1400, only the firs‹ two arches hac been built. Work o‹ the transept an‹ choir was neve completec

▲ Antonio di Vincenzo, Interior of the Basilica of San Petronio, from 1390. Bologna.

The costly materials used and the striking spatial breadth of the church bear witness to Antonio di Vincenzo's creative skill. This building became a point of reference for Lombard and Tuscan architecture.

The paint quality and the profusion of precious materials in the plaster—it is decorated with lozenges, pieces of polished glass, and strips of gilded metal—make the room as splendid as a palatine chapel.

Bolognese painting and manuscript illumination were influenced by the northern Gothic and took some note of the innovations of Giotto.

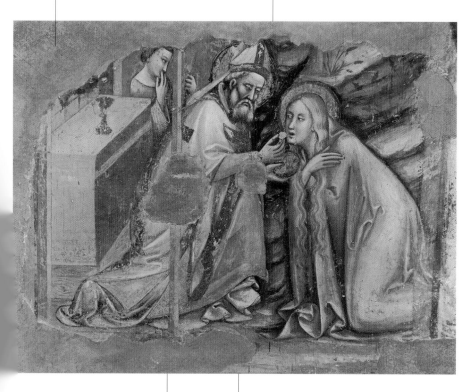

Vitale's art remains close to Gothic culture but suffuses it in an original kind of gentle naturalism. He worked within a large workshop employed in large-scale undertakings.

The frescoes in Santa Maria dei Servi are Vitale's last work. They demonstrate his ability to assimilate into his own style stimuli from French Gothic manuscript illumination (particularly evident in the vault), and Giotto's naturalism (in the treatment of volumes).

Vitale da Bologna, *The Communion ∕Aary Magdalen*, ca. 1359, from ∵es from the Life of the Virgin and ∵y Magdalen. Bologna, Santa Maria ∵ervi, chapel of Mary Magdalen.

*"Inside it . . . was endowed with many beautiful houses . . .
churches, cathedrals, . . . and there was no citizen who was not
building in the land outside the walls" (G. Villani, Cronica,
14th century).*

Florence

Notes of interest
The Florentine commune
experienced many complex
vicissitudes in the 14th cen-
tury, leading to the brief
tyranny of Walter of
Brienne in 1342–43. A
popular uprising quickly
led to his departure, after
which the government
gathered strength with the
aid of an increasingly well-
organized bureaucracy. But
the Peruzzi and Bardi
banks had been lending
enormous sums in Europe,
and when they failed, the
ensuing financial crisis,
coupled with a fall in pop-
ulation after the Black
Death, contributed to
increasing social tension,
which found an outlet in
the 1378 uprising of the
Ciompi, the urban
proletariat.

In spite of the unending social turmoil in the city from the late
13th century onward, Florence became the most admired
Western city in the 14th century, with exemplary new town-
planning initiatives. Now that the economy was flourishing
(thanks to the cloth trade and banking), the population grow-
ing, and the building trade booming, Florence became a leading
force in the artistic culture of the Italian peninsula. Many new
buildings went up, from the churches of the mendicant orders
(Santa Croce, Santa Maria Novella, Santo Spirito) to the
Palazzo del Capitano del Popolo, Orsanmichele, the Palazzo dei
Priori, and the new cathedral, not to mention private palazzi.
Great artists were working in Florence: sculptors (Arnolfo di
Cambio, Tino di Camaino, Andrea Pisano, Orcagna), gold-
smiths, miniaturists, and painters. At the beginning of the 14th
century, Giotto gave painting a leading role among the figura-
tive arts, creating a "Florentine school" of skillful followers.
But the crisis that followed the Black Death of 1348 witnessed
a decrease in creative potential, although high levels of achieve-
ment were reached by Giottino and Giovanni da Milano.

▶ Unknown artist, *Madonna
del Ringraziamento* (detail),
1342. Florence, Museo del
Bigallo.

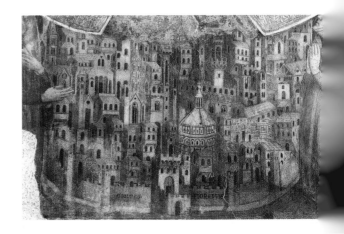

Giotto was put in charge of work on the bell tower in 1340. He and Andrea Pisano, who succeeded him in the post, devoted themselves to its construction.

Arnolfo di Cambio was put in charge of the cathedral site, but the present-day church went through various stages of construction. It was completed in the 15th century, when the dome and lantern were built.

The lower third of the bell tower is to Giotto's design. There are cycles of reliefs along the base, and above them are sixteen niches with monumental statues.

Around 1366, a plan was made to enlarge the church, and Francesco Talenti also completed the bell tower. It has three stories, with richly decorated two-light and three-light windows.

In 1294 it was decided to rebuild the cathedral of Santa Reparata, and by means of expropriation and demolition, a large square was created, so that the cathedral and baptistery could be seen from all sides. The new cathedral was founded in 1296 and took the name Santa Maria del Fiore.

Cathedral and Bell Tower,
n 1296. Florence.

Florence

In the mid-14th century, the
walls of Santa Croce were
covered in fresco cycles by
pupils of Giotto.

Giotto's best pupil is traditionally held
to be Taddeo Gaddi. He was a loyal
collaborator and seems to have spent
twenty-four years in Giotto's workshop.

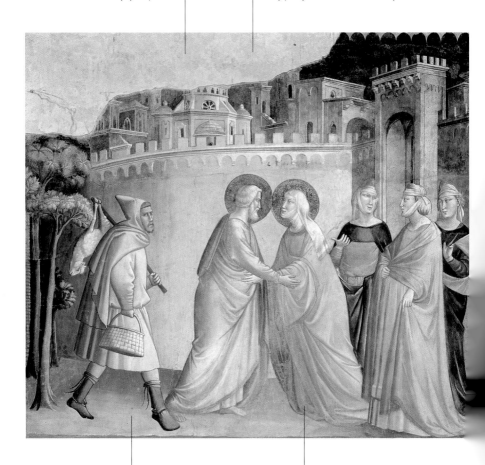

In the Baroncelli chapel, Gaddi
tries out new figurative ideas in cer-
tain nocturnal effects and in skillful
still lifes in the niches (seen in per-
spective), which are reminiscent of
Giotto's work in Padua.

Gaddi's personal interpretation of
Giotto's artistic language is evident
in this fresco cycle: the slightly
elongated figures, together with the
architecture in three-quarter view,
create an almost magical effect.

▲ Taddeo Gaddi, *The Meeting at the
Aurea Gate*, ca. 1328, from *Scenes from
the Life of the Virgin*. Florence, basilica
of Santa Croce, Baroncelli chapel.

The artist attends carefully to certain details in this fresco: the coal carrier, the bellows for stirring up embers, and two people looking down on the scene with open curiosity.

In the mid-1330s, Daddi's art underwent a change: his stronger use of color is of Sienese origin.

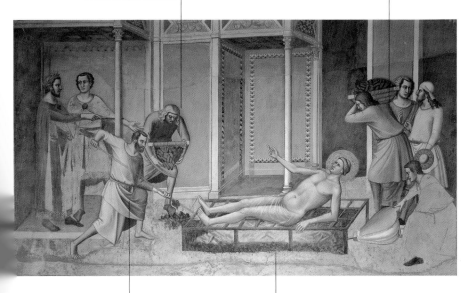

In his early years, Daddi made use of the compositional elements in Giotto's figurative repertoire but added touches of more strictly realistic observation.

Bernardo Daddi was at the head of a flourishing workshop. His work echoes Giotto's use of plasticity in painting, but he added to this certain aspects of courtly art and certain totally Gothic elements, which seem almost to clash with Giotto's poetics.

Bernardo Daddi, *The Martyrdom aint Lawrence*, ca. 1330. Florence, ta Croce, Pulci Berardi chapel.

Florence

Maso paints skillfully constructed, serene images. His choice of limpid colors allows him to create figures that have an almost architectural quality, placed in frontal or profile positions.

The fresco cycle of Scenes from the Life of Saint Sylvester, *taken from Jacopo da Voragine's* Golden Legend, *is considered a central work in the career of this pupil of Giotto.*

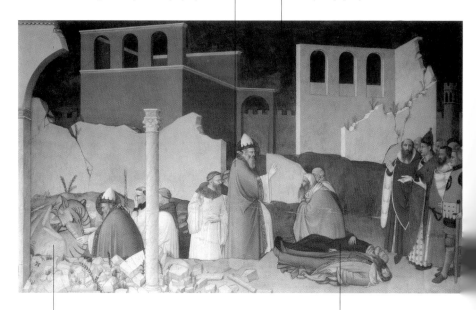

The episode illustrated here brings two moments in the story into a single image: Saint Sylvester is first (on the left) shown closing the jaws of the dragon that has killed the two magi, and then (on the right) reviving them.

The magi are shown lying dead (before the miracle) and then kneeling, as they thank the saint.

▲ Maso di Banco, *Saint Sylvester Tames the Dragon and Raises Two Magi*, ca. 1340–45, from *Scenes from the Life of Saint Sylvester*. Florence, Santa Croce, Bardi di Vernio chapel.

Giottino was a pupil and perhaps a great-nephew of Giotto. His high-quality painting is very original and includes echoes of Maso di Banco's use of color.

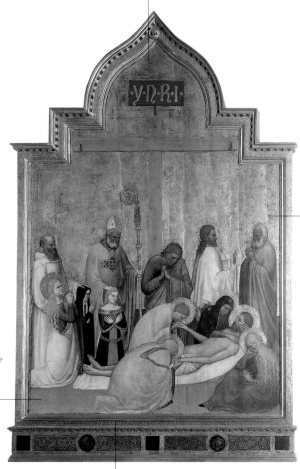

The only two works of certain attribution to Giottino are this panel painting in tempera and the fresco of Madonna and Saints *that decorated the tabernacle in Via del Leone.*

Vasari called post-Giotto painting "a very sweet and unified style," but did not have a great following in Florence, where the style of Orcagna (Andrea di Cione) held sway.

The perception of light is intensified here by means of chiaroscuro, using soft and elegant impasto colors.

Giottino, *Pietà*, 1360–69.
Florence, Uffizi.

"The city was enjoying great peace and tranquillity, and every-one focused on making a living, and the same was true in the countryside" (Agnolo di Tura Del Grasso, Cronaca senese, *14th century).*

Siena

Notes of interest
Around the 1320s and 1330s, Siena had a population of 47,000–50,000, and was hence one of the most densely populated cities in Europe. The tower of the Palazzo Pubblico is called the Torre del Mangia, because a profligate bell-founder who worked there was nick-named *Mangiaguadagni* (spendthrift).

From 1287 until 1355, when a rebellion led to the government of the Twelve, Siena was governed by a Guelph merchant oligarchy called the Nine. During that period the city's appearance was completely transformed. Its beauty was both an instrument and an expression of political power: streets were widened, churches built and embellished, squares and fountains planned, and palaces, new city walls, and a new aqueduct erected. The great Piazza del Campo was completed around 1297 as a place for citizens' assemblies, and it is an effective symbol of the union between the center of power (the monumental Palazzo Pubblico, built in the early 14th century) and city life, represented by the open space. The palazzo interior was decorated with frescoes: Simone Martini's *Maestà*, dating to 1315, and Ambrogio Lorenzetti's *Good Government* cycle of the late 1330s, are the greatest medieval masterpieces of "political" painting. The painters, sculptors, miniaturists, and goldsmiths who worked there took Sienese art beyond the confines of the republic. After the plague of 1348, Sienese painting began to stress the humanity of the holy figures portrayed, in order to arouse the emotions of the faithful. The naturalistic elements and magical tones found in the work of Bartolo di Fredi (ca. 1330–1410) anticipat International Gothic.

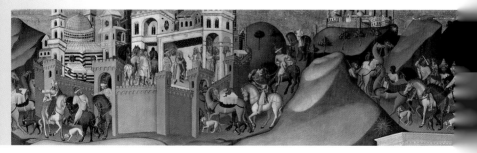

In 1325, work began on the Torre
del Mangia. It was to be as tall as
the cathedral bell tower in order to
affirm that civil power was equal
to that of the Church.

The Palazzo Pubblico stands at the edge
of the square. It was built in the years
1298–1310 to house the government,
magistracy, and city council, and it
became a model civic building.

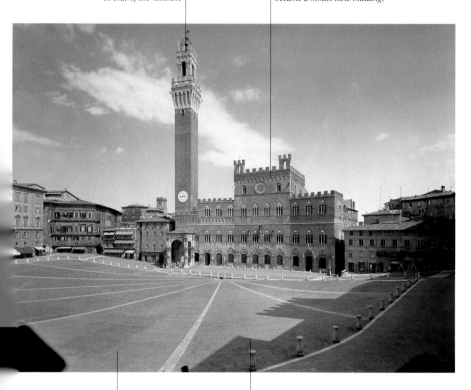

Piazza del Campo
occupies a valley slope
and stretches out in
the shape of a seashell.

The square is paved in brick and stone
and is divided into nine segments (corre-
sponding to the nine members of the
Sienese government). The medieval mind
also saw in it an echo of the Virgin's cloak.

artolo di Fredi, *The Three Magi*
re Herod (detail of *The Adoration*
e Magi), ca. 1380. Siena, Pinacoteca
ionale.

▲ Piazza del Campo and the Palazzo
Pubblico, late 13th–early 14th century.
Siena.

The cathedral complex, consisting of the old and new cathedrals and the baptistery of Saint John the Baptist, was built in the 13th and 14th centuries.

It was necessary to build a substantial substructure beneath the baptistery, just visible behind the cathedral, in order to compensate for the slope of the land on which the cathedral was constructed.

The lower part of the facade is the work of Giovanni Pisano. The sculptural program called for a series of statues of biblical and historical characters that were tied in one way or another to the Madonna.

Giovanni Pisano's intention was that sculpture and architecture be linked, as in French cathedrals, but at the same time each was to have a certain autonomy.

▲ Cathedral, 13th–14th century. Siena.

The design or cartoon was the work of Duccio, but the stained glass was made by master glaziers. Duccio then put the finishing touches to the grisaille images.

The Virgin's throne is represented as being made of marble. Up to that time, in accordance with the Byzantine tradition, such thrones were usually depicted as being made of turned and gilded wood.

uccio di Buoninsegna, Stained-Glass dow with *Scenes from the Life of /irgin*, ca. 1288–90. Siena, cathechoir.

From left to right and from top to bottom, the characters and scenes represented are Saint John the Evangelist, the Coronation of the Virgin, and Saint Matthew; Saint Bartholomew and Saint Ansanus, the Assumption, and Saint Crescentius and Saint Savinus; Saint Luke, the Burial of the Virgin, and Saint Mark.

The window was commissioned by the Opera del Duomo, but the glass was paid for by the commune.

The image of the Virgin and saints under a canopy is reminiscent of a tournament pavilion and has a courtly tone—very different from Duccio's Maestà.

The scene is framed by a band containing twenty medallions with busts of Christ, the evangelists, and the doctors and prophets of the Church. The medallions are separated by plant volute motifs with the emblems of Siena and its people at their centers.

The text at the foot of the Virgin's throne is in the vernacular so that everyone can understand it. It is a clear warning to the powerful families that were supporting plots, compromising the peace, and threatening the public good.

The Virgin is shown enthroned beneath a broad canopy held up by angels and saints. Kneeling at the bottom are the patron saints of Siena: Ansanus, Savinus, Crescentius, and Victor.

The Christ child is holding out a scroll (a real piece of paper stuck to the wall) on which are written, in Latin, the words from the Bible: "Love justice, you who judge the world."

The Maestà is an extraordinary work, not only for its political message, but also for the technique used to enhance its richness: the painting is interspersed with precious objects, using gold, glass, halos, and stamps; the Virgin's robe has a crystal button.

▲ Simone Martini, *Maestà*, 1315. Siena, Palazzo Pubblico, Sala del Mappamondo.

By the early 14th century, Pisa had lost its position as leader of the arts in central Italy, but it maintained contact with the principal art centers in Tuscany.

Pisa

For three centuries Pisa had been queen of the seas and had declared herself to be a "new Rome," but the city's development came to a halt in the 14th century. The defeat at Meloria in 1284, and above all the loss of Sardinia in 1325, together with numerous political crises around the midcentury, were stages in a decline that first put the city in the hands of Milan and finally, in 1406, saw it taken over by Florence. (Florence bought Pisa from Gabriele Maria Visconti for eighty thousand florins and then besieged it for more than a year.) In the second quarter of the 14th century, the city experienced a brief revival under the lordship of Fazio di Donoratico: new shelters were built for the galleys, public and private enterprises were set in motion, and new palaces, gardens, and loggias were constructed. Pisa never had a prestigious city hall like those of Siena and Florence; the building that acted as a symbol of the city was the cathedral. It was begun in the 11th century and was completed at the end of the 14th when the baptistery (1365), the cathedral dome (1383–88), and the Camposanto loggia were finished. Giovanni Pisano and Tino di Camaino both worked at the cathedral complex, as did Andrea Pisano in the 1340s. Andrea set up an important workshop that continued to operate under his son Nino. Giovanni Balducci also worked at Pisa; he apprenticed here before going to Lombardy. In the 1330s, work began on decorating the Camposanto with frescoes. The work lasted for more than a century, and among those involved at an early stage were Buffalmacco, Stefano Fiorentino, and Taddeo Gaddi.

Related entries
Plague, Artist, Commission, Wood Sculpture

Milan

Andrea Pisano, Giovanni Pisano, Tino di Camaino

Notes of interest
The Torre delle Ore (Clocktower) was built in 1320. It was placed close to the river, in the middle of the right embankment (Lungarno) and not, as customary, near the buildings that housed the commune. This was so that the striking hours could be clearly heard in the area where trade was carried on and life was at its busiest.

◄ Giovanni di Simone, Interior of the Camposanto Cloister, 1277–1463. Pisa.

On the left, a group of elders and mendicants call upon Death, who flies around the world in the guise of a woman wrapped in long veils and with disheveled hair (center), catching young people unawares with her scythe.

These frescoes are very suggestive of the Decameron but they predate it. They convey very well the widespread fear of death that was intensified in the 14th century by a strong, secular attachment to life and its pleasures.

On the extreme left is the famous story of the meeting between three living and three dead men, and it is placed beneath a serene scene of hermits.

The painter seems to dwell on the macabre aspects in his work, paying great attention to realistic detail so that the spectator might be roused to strong emotion.

The scene presented by Buffalmacco is divided into narrative units within a landscape setting, and there is no attempt to give an impression of unity.

▲ Buffalmacco, *The Triumph of Death, the Last Judgment, the Lives of Anchorites, and Christological Scenes,* 1336–40. Pisa, Camposanto.

Death has something of the angel, for she flies and takes human form, but also something devilish and bestial, for her wings are those of a bat.

Buffalmacco trained in Florence in the first decade of the 14th century in circles not closely linked to Giotto. His name crops up in 14th-century literature: in the Decameron *and Sacchetti's* Trecentonovelle, *he is mentioned as a painter who is something of a joker.*

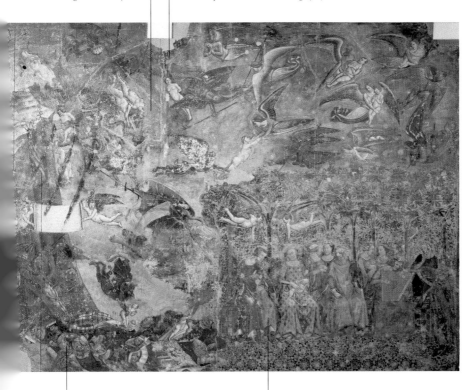

The narrative tone swings from the comic to the dramatic, and from the noble to the grotesque. In so doing, the work goes beyond the limits of medieval allegory and opens up new possibilities.

On the right a group of young people are busy playing musical instruments and flirting, while next to them a battle is raging between angels and devils for the souls of the dead. The angels carry the elect off to heaven, and the devils hurl the damned into hell.

The exterior is completely sheathed in two shades of marble. The sides are embellished with an arcade surmounted by pyramidal spires and tabernacles with statues to add an extra touch of elegance.

The oratory is a small rectangular church, as lovely in shape and decoration as a jewel case. It guards a fragment of Christ's crown of thorns, which the city acquired in 1333.

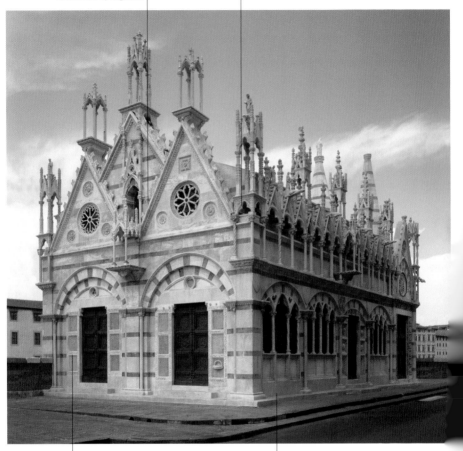

The twin facade is made up of rectangles, triangles, and circular rose windows. As in French churches, the sculpture is an integral part of the architecture.

The oratory of Santa Maria della Spina was begun in 1325 and continued in stages, first under the direction of Lupo di Francesco and then under Giovanni and Nino Pisano.

▲ Oratory of Santa Maria della Spina, from 1325. Pisa.

Pisa had placed great political hopes in the emperor, and when he died, the city gave him an imposing tomb in the cathedral.

The tomb was originally given the most prestigious position possible, in the apse. Furthermore, a statue of the emperor was positioned below the figure of Christ in the apse mosaic.

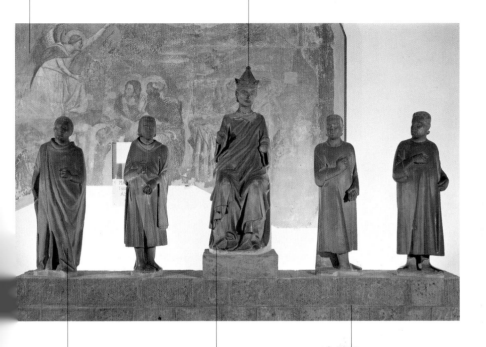

The broad, smooth shapes of the counselors are quite original.

Tino di Camaino created a dramatic tomb, in which the recumbent effigy of the emperor was accompanied by another statue that showed him alive, on the throne, and surrounded by his counselors.

There are two figures of the emperor, suggesting that the monument was originally in two tiers.

Tino di Camaino, Funerary
Monument of Henry VII (detail),
5. Pisa, cathedral.

Thanks to commissions from the Franciscans, Assisi became the "cradle" of Italian painting. The lower church at Assisi can be regarded as an anthology of 14th-century painting.

Assisi

Notes of interest
Throughout the 14th century, Assisi was not only a magnet for artists but also a place of pilgrimage, and one where bequests and donations went to fill the priceless church treasury. Some very refined art objects are preserved there, such as the chalice of Pope Nicholas IV made by Guccio di Mannaia (p. 84). Apart from being the "cradle" of Italian painting, Assisi was also an important early point of reference for the art of stained glass.

The cult of Saints Francis and Clare launched Assisi into European fame, for the places associated with Francis's life took on significance as relics. In 1288, only two years after his death, Francis was canonized, and work immediately began on the basilica, which was completed in 1380. The building, arranged as two superimposed churches, each with a single nave and vaulted roof, became a meeting point for the most advanced trends in 13th- and 14th-century art. In the 13th century, masters in stained glass from Germany and France joined the most advanced Italian painters to decorate the place where Saint Francis was buried. The frescoes in the upper church are rightly considered the highest achievement of the 13th century, for it was here that figurative Christian images became humanized, and the illusion of space was rediscovered, culminating in the

▶ Simone Martini (cartoon), Stained-Glass Window with *Figures of Saints*, ca. 1317. Assisi, lower church of San Francesco, chapel of San Martino.

highly original work of Giotto. In the early 14th century, the upper church frescoes were considered works of modern painting that every artist had to see, and those who had worked at the Assisi cathedral site were much sought after elsewhere. Another period of intense artistic activity began with the frescoes in the lower church, which had been enlarged at the end of the previous century. All the great talents in Italian painting were working there in the 1310s: Giotto's followers, bu also Sienese artists Simone Martini and Pietro Lorenzetti.

Esau approaches his father to feed him and seek his blessing, but the aged Isaac, who reclines like a figure on a Roman urn, rejects him, because he has already blessed Esau's brother, Jacob.

The painter dwells on descriptive details, such as Esau's hands and hairy neck, as described in Genesis.

Behind Esau, the scene is observed by Rebekah, who is responsible for the deception practiced on the dying Isaac.

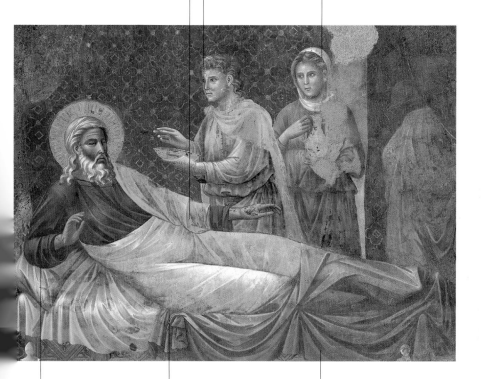

There are highly original elements both in the three-dimensional concept of space and in the figures, which take on an almost plastic monumentality.

This fresco is part of a diptych with Scenes from the Life of Isaac, another part being Jacob Receiving the Birthright (damaged). The diptych figures move within a coherent three-dimensional space. They and the buildings seem to have been inspired by models from classical antiquity.

The authorship of this work has been much debated, even today. Is it an early Giotto, the work of an anonymous master known as the Isaac Master, or by Arnolfo di Cambio, since the figures seem to echo sculptural models deriving from his work?

Isaac Master (Giotto?), The Rejection of Esau, ca. 1290, from Scenes from the Life of Isaac. Assisi, upper church of S. Francesco.

The representation of the architectural setting reaches a high level of complexity in the image of the painted cross, which is boldly inclined at a steep angle, very successfully conveying a sense of depth.

At this time, as was customary, a screen closed off the choir in the middle of the church, in order to prevent the congregation from having a direct view of the altar and women from entering that part of the church.

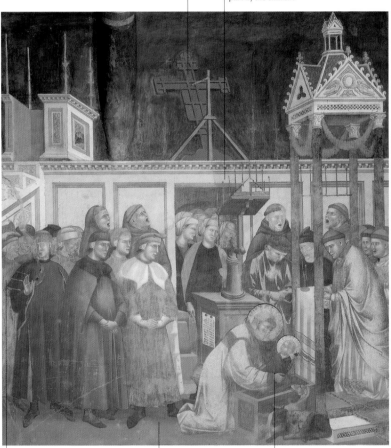

We can observe in this fresco cycle some of the qualities that made Giotto famous: perspective and the representation of contemporary everyday objects and buildings.

▲ Giotto, *Christmas Crib at Greccio*, late 13th century, from *Scenes from the Life of Saint Francis*. Assisi, upper church of San Francesco.

The cycle consists of twenty-eight episodes from the life of Saint Francis, based on the Legenda major of Saint Bonaventure. The Latin captions that accompany each scene come from the same work.

Here we see an episode in which Saint Francis ordered that a crib be set up for Christmas celebrations. While he was holding the figure of the Child in his hands, a knight saw Jesus in flesh and blood.

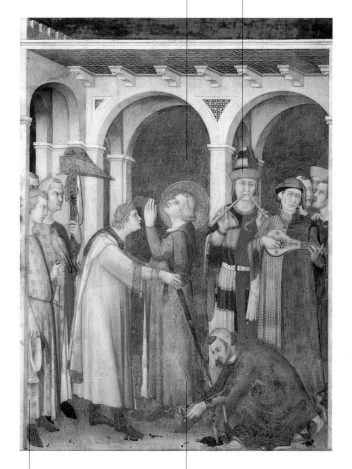

ₘone Martini, *The Knighting of*
ᵗ Martin, ca. 1317. Assisi, lower
ᵣch of San Francesco, chapel of San
ᵣtino.

In this scene, Pietro Lorenzetti shows great skill in creating a moonlit and starry night sky, which illuminates the calm nocturnal landscape of chalk hills and occasional olive trees.

On the right, the group of apostles fleeing behind the mountain is shown from behind, thereby suggesting a continuation of space beyond them.

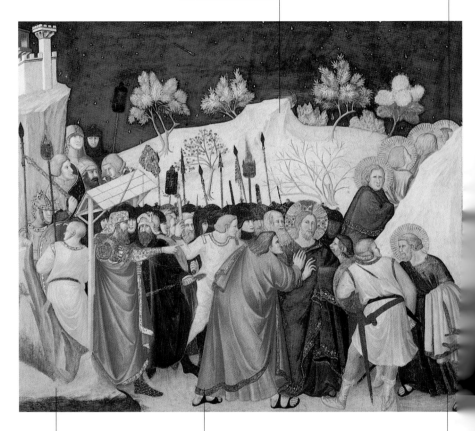

Lorenzetti uses intense, bright colors, and his imposing figures have all the solidity of statues, reminding us of the sculptures of Giovanni Pisano.

Among the crowd in the foreground, the almost rectangular figure of Judas stands out as he approaches Christ.

Beside Jesus we see Malchus, the servant of the high priest, and Peter, who is about to strike Malchus with his sword, cutting off his ear.

▲ Pietro Lorenzetti, *The Capture of Christ*, 1315–19, from *Scenes from the Passion of Christ*. Assisi, lower church of San Francesco.

"I think Rome in ancient times was worthy of being called caput mundi *and the church of God"* (G. Sercambi, *Novelle,* late 14th–early 15th century).

Rome

The 14th century began in Rome with the great jubilee proclaimed by Boniface VIII. At the end of the previous century, many artists had gathered in Rome to prepare for the event, and Arnolfo di Cambio, Giotto, and Pietro Cavallini were all involved in work on St. Peter's Basilica. From about 1250 onward, Rome had enjoyed a flourishing artistic climate, thanks in part to commissions from the Orsini pope Nicholas III; but few of the resulting works have survived. The only names we can confidently put to works by Roman artists in the late 13th century are those by Cavallini, Jacopo Torriti, and Francesco Rusuti, who were considered the avant-garde in Roman painting around the time of the jubilee. Rome, like Assisi, was most likely an interesting meeting place for artists, one where new ideas were worked out; and even though Giotto's influence in Rome is still a matter of debate, it seems unlikely that his presence in the city went unnoticed. Work went on apace in the 14th century. When the popes left Rome, papal commissions came to an end, but not those of the great families such as the Colonna and the Stefaneschi. Important works were created for the principal city churches, and, during the exile of the popes, the Vatican church received numerous donations and commissioned works.

Related entries
Avignon

Arnolfo di Cambio, Giotto,
Matteo Giovannetto,
Giovanni da Milano

▼ Giovanni Sercambi,
Pilgrims in Rome during the Jubilee, ca. 1400, illuminated page from the *Croniche.*
Lucca, State Archives.

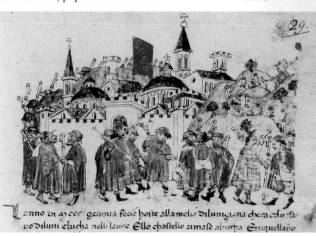

The strongly three-dimensional treatment of space is particularly evident in the architecture, and there is a strong sense of plasticity in the figures.

There are obvious Cosmati echoes in the treatment of the ciborium and the classicizing ornamentation of the buildings.

In spite of the gilded background, the figures are arranged in space with a sense of volume that marks a clear change from Byzantine linearity.

Pietro Cavallini worked mainly in Rome and Naples in the last quarter of the 13th and the first decade of the 14th century. His workshop was one of the most important in Rome in medieval times.

The use of delicate shades, such as pink, white, and pale blue, recalls classical painting.

This mosaic was commissioned by Bertoldo Stefaneschi. The artist who made it is still influenced by the ideas of the Cosmati, but they are modernized with clear echoes of the contemporary art of Arnolfo di Cambio.

▲ Pietro Cavallini, *The Presentation of the Virgin in the Temple*, 1291, from *Scenes from the Life of the Virgin*. Rome, Santa Maria in Trastevere.

Against a seascape background, two groups of three saints turn toward Mary and Jesus. On the left are Saints Peter, Paul, and Francis, and on the right are Saints John the Baptist, John the Evangelist, and Anthony.

The Virgin is crowned by her son, who sits beside her on a throne within a pale blue roundel supported by angels.

At the top, beautiful vine scrolls are inhabited by peacocks, pelicans, and other creatures with Christian symbolism.

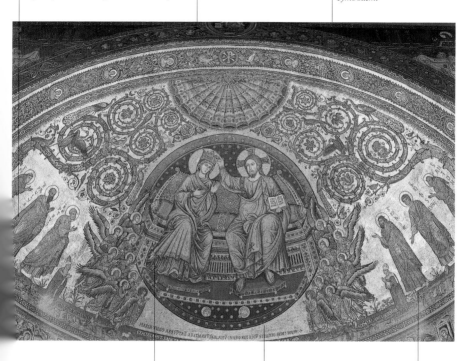

Characteristic of Torriti's work is a refined taste in the use of color and a style in which the classical and Byzantine tradition of Roman art is combined with new elements from French Gothic that were becoming well known in Rome.

The mosaic was made by Torriti after he had worked in Assisi, and there are clear echoes of Cimabue's style.

Kneeling in front of the saints are Pope Nicholas IV and Cardinal Giacomo Colonna, protector of the Franciscans. In the corner is the signature, "Iacopo Turriti."

copo Torriti, The Coronation of Virgin, 1295. Rome, Santa Maria giore, apse.

Rome

Giotto's works in St. Peter's were a mosaic (The Navicella), some frescoes, and an altarpiece on panel for the high altar. Only the altarpiece has survived; little remains of the other works.

Giotto's knowledge of Roman artists and of statuary and ancient architecture can be seen not only in his concern to paint solid, imposing figures but also in the occasional "quotation."

The altarpiece was an enormously prestigious work: it was to stand on the high altar and had been commissioned by Cardinal Stefaneschi, who was a great patron and promoter of the arts.

On the verso side (not pictured) are Saints James and Paul, Saint Peter Enthroned, Cardinal Stefaneschi Offering a Model of the Painting, Pope Celestine V Presenting a Codex, and then Saints Andrew and John the Evangelist. Only one panel of the predella survives: it shows three busts of saints.

▶ Giotto, *The Stefaneschi Altarpiece* (recto), ca. 1330. Vatican City, Pinacoteca Vaticana.

The altarpiece has three panels and a predella and is painted on both sides.

On this side, the recto, are the Crucifixion of Saint Peter, Christ Enthroned, the Martyrdom of Saint Paul, and, in the predella, the Madonna and Child Enthroned between Saints.

It is likely that the side of the altarpiece displayed to the congregation was that with Saint Peter, to whom the altar was dedicated, and that the figure of Christ was on the side facing the clergy.

"And any merchant who brings goods to Naples by sea or land can take them anywhere in the kingdom" (F. Balducci Pegolotti, *La pratica della mercatura, first half of the 14th century).*

Naples

Notes of interest
The Angevin court at
Naples was in effect the
only truly great Italian
court. Under Robert of
Anjou, there were strong
political and cultural con-
tacts with Tuscany and the
Guelph communes of cen-
tral Italy, but many
influences in fashion and
the arts from north of the
Alps persisted, not only in
architecture, but also in
dress, jewelry, and ceramic
tableware.

In 1266, King Charles I of Anjou approved the transfer of his capital from Palermo to Naples, which became one of the chief Guelph cities in 14th-century Europe. The city of Naples was still structured along Roman lines and was deeply influenced by its Eastern contacts, but the new reigning dynasty gave it a fresh look. Starting in 1279, Charles built a new royal residence, the Castel Nuovo, around which rose up the residences of the Angevin princes, those of the court, the royal archives, and the other buildings necessary for governing the city. In the early 14th century, new fortresses were built, as well as new districts for merchants and artisans who had been attracted to the capital. The Angevin kings also founded a number of churches and convents, such as Santa Chiara, Santa Maria Donnaregina, San Lorenzo, and Santa Maria Incoronata, thus promoting the revival of art and culture in the city. The court's ambitious projects competed with those of the great European monarchies.

Goldsmiths, sculptors, and architects from north of the Alps imported the latest trends from the Île-de-France: a workshop of French artists was responsib for the reliquary-bust of Saint Januarius, commissioned by Charles II in 1304, involving the art of both goldsmith and sculptor. At a later stage, th most innovative Italian masters arrived, among them Cavallini, Tino di Camaino, Giotto, Lippo Vanni, some Sienese goldsmiths, and perhaps Simone Martini, whose work inspired local artists such as Roberto d'Oderisi and Cristofor Orimina.

The Angevin kings and queens promoted the construction of a number of religious buildings. Santa Maria Donnaregina, for example, was built at the request of Mary of Hungary, wife of Charles II of Anjou.

The church has a single nave and a spacious choir. The nave has an enormous tribune, which means that the church is in effect on two levels.

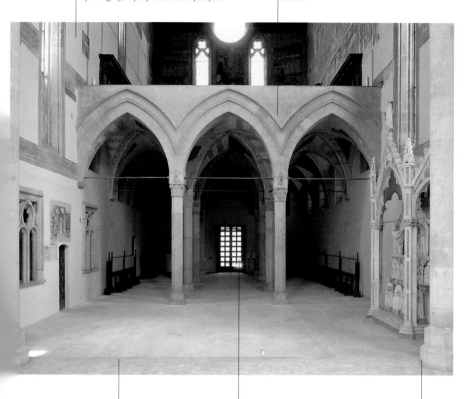

The church frescoes were painted by a Cavallini team. Pietro Cavallini had arrived in Naples around 1308 in the service of Robert of Anjou.

The apse is illuminated by five two-light windows. Many of the characteristics of this church, such as the style of the capitals, are reminiscent of northern Gothic.

The Donnaregina frescoes are considered to be the high point of the Cavallini style in Naples, but Giotto was in Naples from 1328 to about 1333, and his influence there was also considerable.

anco-Angevin goldsmiths' work-
in Naples, Reliquary in the
e of a Vine Leaf, ca. 1294–95.
ale del Friuli, Museo Civico.

▲ Interior of Santa Maria Donnaregina, 1307–16. Naples.

In this monument, the typically Tuscan qualities of Tino di Camaino are combined with a more noticeable adherence to Gothic forms, thanks to the presence in Naples of many skilled French masters.

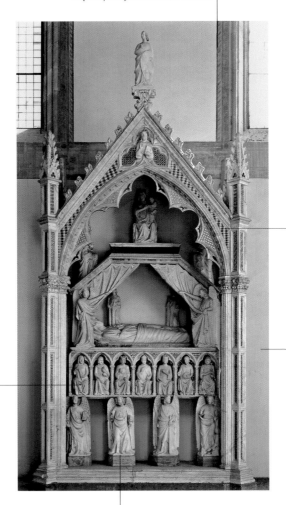

Tino di Camaino was responsible for a number of funerary monuments, including those of Catherine of Austria, Charles of Calabria, and Mary of Valois.

Tino di Camaino's sculptures seem to be enlivened by subtle pictorial effects in which the dramatic qualities of Giovanni Pisano's sculpture are combined with the monumentality of Arnolfo di Cambio.

Tino di Camaino was court architect and sculptor in Naples for more than ten years, beginning in 1323/4.

▲ Tino di Camaino, Funerary Monument of Mary of Hungary, 1324–26. Naples, Santa Maria Donnaregina.

The design of the monument is very much in the style of Arnolfo di Cambio, but in this case there is a series of figures (angels) instead of architectural elements to support the sarcophagus.

Everything about this painting is precious, aristocratic, and refined. Its ostentatious sumptuousness is typical of the Angevin court.

Louis is placed frontally in a hieratic pose, his Franciscan habit covered by a splendid cloak with a gold border. He is wearing gloves, holds a pastoral, and sits on an imposing throne with lion's feet.

This is a real disc of verre églomisé (that is, it has gold or metal foil placed behind a sheet of glass to create elegant effects of light and color) used as a fastening for the cope.

On the right is a true likeness of his brother Robert, kneeling as he receives the crown.

This altarpiece constitutes a reply to those who had contested the legitimacy of Robert's rule. Simone Martini's task was to provide political confirmation of that ascent: at the same moment when Saint Louis is crowned in heaven, his brother is crowned by him and so acquires divine legitimacy.

Simone Martini, *Saint Louis of Toulouse Crowning Robert of Anjou and Scenes from the Life of Saint Louis*, . Naples, Museo di Capodimonte.

Louis of Toulouse, a Franciscan spiritual, had renounced the throne of Naples in favor of his brother Robert of Anjou.

The predella depicts scenes from the life of Saint Louis.

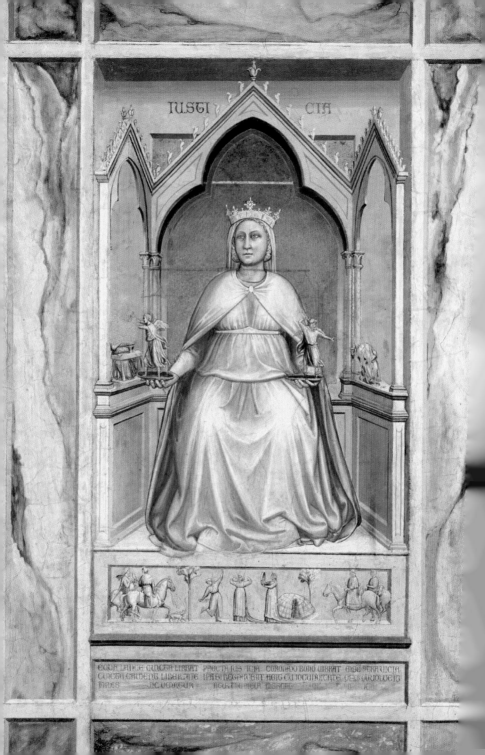

IVSTI CIA

LEADING ARTISTS

Altichiero
Andrea di Cione (Orcagna)
Andrea Pisano
Arnolfo di Cambio
Jacopo Avanzi
Tomaso Barisini
Ferrer Bassa
Bertram von Minden
Bonino da Campione
Melchior Broederlam
Puccio Capanna
Jaume Cascalls
Giovannino de Grassi

Ramon Destorrents
Duccio di Buoninsegna
Giotto
Matteo Giovannetto
Giovanni da Milano
Giovanni Pisano
Guariento
Jan Boudolf
Jean de Beaumetz
Jean Pépin de Huy
Jean de Liège
Jean Le Noir
Konrad von Soest

Ambrogio Lorenzetti
Pietro Lorenzetti
Lorenzo Maitani
Master of Wittingau
Master Theodoric
Simone Martini
Juan Oliver
Paolo Veneziano
Peter Parler
Jean Pucelle
Pedro Serra
Claus Sluter
Tino di Camaino
Vitale da Bologna

Altichiero worked in Verona and Padua in the lively cultural milieu of the Della Scala and Carrara courts. His extraordinary pictures make him one of the leading artists of the century.

Altichiero

Province of Verona
ca. 1350–ca. 1393

Where he worked
Verona, Padua

Principal works
Fragments of heads of emperors and empresses from the Sala Grande in the former Scaligeri palace (Verona, 1364?); votive fresco in the Cavalli chapel (Verona, Sant'Anastasia, 1369); frescoes in the chapel of San Giacomo (Padua, Sant'Antonio, 1376–79); frescoes in the oratory of San Giorgio (Padua, 1379–84)

Links with other artists
Jacopo Avanzi

Altichiero was born in a small town near Verona. We have few documents about him other than records of payments he received: one dated 1379 is for work in the chapel of San Giacomo in the church of Sant'Antonio in Padua, and another, dated 1384, is for work in the chapel of San Giorgio. A document of 1393 refers to him as deceased. Sources such as Savonarola (*Libellus*, ca. 1447), Marcantonio Michiel (*Notizie*, ca. 1540) and Vasari (*Lives*, 1550) link his name to that of Avanzi. Nowadays it is thought that before his successes in the Po valley, he trained in Verona, a city whose links with the Visconti court in Milan would account for the strong Lombard element in his work. The antiquarian, prehumanist atmosphere at the courts of Verona and Padua where he worked influenced the archaistic, classicizing characteristics of his style. According to the sources, Altichiero painted frescoes in the Della Scala and Carrara palaces, but little remains of them today. Around 1371, he was in Padua decorating the Dotti tomb in the Eremitani church (destroyed in 1944), and around 1372 he began work on the frescoes in the chapel of San Giacomo in the church of

Sant'Antonio. Together with his frescoes in the oratory of San Giorgio, they are his only surviving works in the city, and evidence of his greatness as an artist. His frescoes in Sant'Anastasia in Verona were probably painted soon after his work on the Dotti tomb. His Gothic style is extremely refined, combining strongly dramatic features with classical elements.

The crucifix in the center seems almost isolated from the crowd, as do the figures of Mary and Mary Magdalen, wrapped as they are in their cloaks and their grief. The treatment of volumes is very reminiscent of Giotto.

The scene is played out in tones of green, pink, and white. Its outstanding qualities are the elegant description of costumes and the attention to detail in facial features.

At the same time, the artist dwells on small features of everyday life, such as the woman holding a child by the hand.

This Crucifixion is a highly dramatic scene. The crowd seems to behave like a character in and of itself, moving within the picture space with intermingling glances and gestures.

A document of 1379 records payment of Altichiero's fee for decorating this chapel. The work was commissioned by Bonifacio Lupi di Soragna, a member of a powerful family linked to the Carraras.

Altichiero, *Saint George, Saint Martin, and Members of the Cavalli Family* (detail), 1369. Verona, Sant'Anastasia, Cavalli chapel.

▲ Altichiero, *Crucifixion*, 1376–79. Padua, Sant'Antonio, chapel of San Giacomo.

The Crucifixion is depicted on the back wall of the oratorio, with the Coronation of the Virgin above it. On the entrance wall there are scenes from the infancy of Christ.

There are two tiers of paintings on the side walls, with scenes from the lives of Saints George, Catherine of Alexandria, and Lucy.

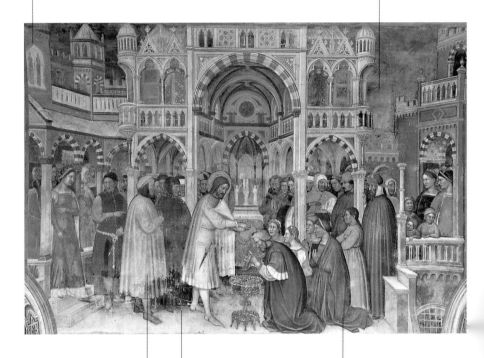

Petrarch can be seen standing behind Saint George with his secretary, Lombardo della Seta.

The tones used here are darker than those in the chapel of San Giacomo, and there is also more of a narrative intent, with references to the history of the city and to the Lupi family, which commissioned the oratory.

These frescoes are painted in limpid colors, and the scenes are presented almost as theatrical events. Some of the faces are portraits of outstanding Paduans of the day.

▲ Altichiero, *Saint George Baptizing the King of the City*, 1379–84. Padua, oratory of San Giorgio.

"He made the marble tabernacle for Orsanmichele. . . . He was a very great architect, and carried out that whole work himself"
(L. Ghiberti, I commentari, 15th century).

Andrea di Cione (Orcagna)

The name "Orcagna" derives from the significant nickname "Arcagnolo" (archangel) given him by his contemporaries. He was one of the most important mid-14th-century Florentine artists. He was born between 1315 and 1320 and became a painter, sculptor, and architect, working chiefly in Florence, where he was enrolled in the guild of doctors and chemists between 1343 and 1346. In his works, Orcagna managed to balance two artistic tendencies reflecting the contemporary spiritual trends of the Dominicans and Franciscans: the one more abstract and conceptual, and the other naturalistic and plastic. In 1343, he was working for the Compagnia di Gesù Pellegrino in Santa Maria Novella, and in 1352 he was making a panel painting of a Madonna (now lost) for the Compagnia of Orsanmichele, which commissioned him in that same year to make a tabernacle for the church. It has a splendid Gothic baldachin embellished with intarsia and sculptures. In 1354, Tommaso di Rosello Strozzi commissioned him to paint a polyptych for the family chapel in Santa Maria Novella. At this period he was also working at the Santa Maria del Fiore site. In 1359 and 1360 he was master of works at Orvieto cathedral; he also acted as consultant here in the years 1364–67. In 1367 he was asked to paint a Saint Matthew panel with two wings for one of the piers at Orsanmichele, but the work was carried out by his brother Jacopo, also a painter, because of Andrea's ill health, which led to his death in 1368.

Florence (?) 1315/1320–Florence 1368

Where he worked
Florence, Orvieto

Principal works
Expulsion of the Duke of Athens (Florence, Palazzo Vecchio, ca. 1343); *Annunciation* (private collection, 1346); decoration of the main chapel in the choir, Santa Maria Novella (Florence, 1348); tabernacle (Florence, Orsanmichele, 1355–59); *Strozzi Altarpiece* (Florence, Santa Maria Novella, Strozzi chapel, 1357); frescoes in the refectory of Santo Spirito (Florence, ca. 1360)

Links with other artists
Giotto

Notes of interest
Orcagna's brothers Nardo and Jacopo were also painters, and a third brother, Matteo, was a sculptor. The paintings of all three brothers display echoes of the style of Giotto and Taddeo Gaddi.

◀ Andrea di Cione (Orcagna), Tabernacle, 1355–59. Florence, Orsanmichele.

Andrea di Cione (Orcagna)

Christ is placed frontally in the center, inside a mandorla surrounded by cherubim. He is handing a book to Saint Thomas Aquinas, who kneels on his right (a position of privilege).

In this altarpiece, Orcagna has eliminated the usual twisted colonnettes used to separate the individual panels. By doing so he gives unity to the painted surface; the framing also becomes an integral part of the representation.

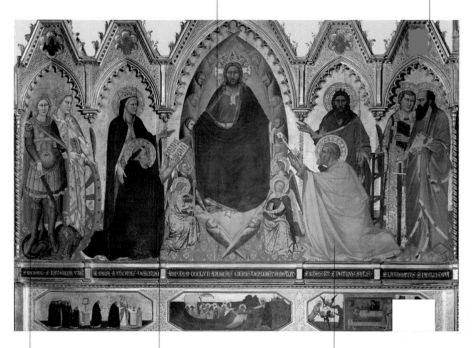

On the left are Saints Michael and Catherine of Alexandria, and on the right, seen at an angle, one behind the other, are Saints Paul and Lawrence.

The painter has tried to achieve a balance between abstraction and plasticity. The figures are conveyed with a strong sense of volume, but there is only the slightest attempt at a third dimension.

Saint Peter, on Christ's left, is receiving the keys, symbol of the Church's authority. Mary and Saint John the Baptist are behind Saints Thomas and Peter.

▲ Andrea di Cione (Orcagna), *The Strozzi Altarpiece*, 1357. Florence, Santa Maria Novella, Strozzi Chapel.

"In the bell tower he did seven works of mercy, seven virtues, seven sciences, and seven planets" (L. Ghiberti, I commentari, 15th century).

Andrea Pisano

Andrea Pisano was born at Pontedera around 1295 and became a goldsmith and sculptor. His only signed and dated (1330) work is the bronze door at the south portal of the Florence baptistery, for which he made figured reliefs with scenes from the life of Saint John the Baptist. There are no documents about his life or work before 1330, but in Florentine documents for the period 1330–36 he is described as a goldsmith. The bronze reliefs on the baptistery door therefore came at the end of a period of artistic activity about which we know nothing, but there seem to be Sienese and Giottesque influences. It has been suggested that he apprenticed under Andrea di Jacopo d'Ognabene, a goldsmith of Pistoia with Sienese contacts. The baptistery door commission tested his skills as a goldsmith to the limit, so it is likely that from 1333 onward he broadened his activities to include sculpture. In 1334, under the direction of Giotto, he made at least twelve reliefs for the base of the cathedral bell tower in Florence. When Giotto died in 1337, Andrea took over the direction of the site, and it is to this period (1337–41) that scholars have dated his Madonna and Child relief for the lunette above the north portal of the bell tower and the statue of Saint Stephen for the Orsanmichele tabernacle. It is likely that he left Florence for Pisa around 1341, perhaps taking along his sons Nino and Tommaso, both sculptors. In 1347 he went to Orvieto, where he took over direction of the cathedral site, but he died there, probably of the plague. We can detect in his sculpture a movement away from Gothic and toward the Renaissance.

Pontedera ca. 1295–Orvieto(?) 1348/49

Where he worked
Florence, Pisa, Orvieto

Principal works
The door at the south portal of the baptistery (Florence, 1330–36); reliefs on the base of the cathedral bell tower (Florence, 1334–37); *Saint Martin and the Beggar* (Pisa, San Martino, ca. 1341); *Orvieto Madonna* (Orvieto, Museo dell'Opera del Duomo, ca. 1347)

▼ Andrea Pisano, *Madonna and Child*, 1342–43. Florence, Museo dell'Opera di Santa Maria del Fiore.

Andrea Pisano

The compositions in the panels are somber. The figures are situated in an enclosed space, which either has been constructed architecturally or else is suggested by the relief of the figures themselves.

The bronze door in the south portal (originally the east door) of the baptistery in Florence consists of twenty-eight reliefs and forty-eight lions' heads.

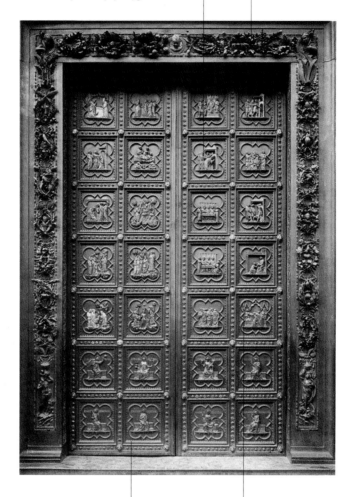

The two leaves of the door were designed and crafted by the Florentine goldsmith Piero di Jacopo. The reliefs were made by Andrea Pisano, and they reveal an awareness of the art of Giotto.

There are twenty scenes from the life of Saint John the Baptist, and eight figures of virtues in the bottom panels.

▲ Andrea Pisano, Door in the South Portal of the Baptistery, 1330–36. Florence.

▶ Arnolfo di Cambio, The Paralitic, 1277–81. Perugia, Galleria Nazionale dell'Umbria.

Documents concerning the pulpit in Siena cathedral refer to Arnolfo di Cambio as a discipulus *of Nicola Pisano. He was one of the most original artists working in the period.*

Arnolfo di Cambio

Arnolfo di Cambio was an architect and sculptor, and probably a painter as well. He was a pupil of Nicola Pisano and appears to have trained at a Cistercian building site. He must have been famous by the late 1270s, when the commune of Perugia formally asked Charles of Anjou for the services of this *ingeniosus magister*, who was evidently working for the Angevin court at the time. Perugia wanted Arnolfo for the "Fontana Minore," of which only five marble sculptures have survived, including one of the paralytic in the act of uncovering his stricken limb. This image reveals the typical qualities of Arnolfo's art: classical and Gothic forms used to interpret the "real." In Arnolfo's sculpture, certain aspects of Parisian plasticity, probably encountered through the Angevin court, are combined with a typically Cistercian rigor in the rendering of volumes. There are also echoes of themes from classical antiquity and the paleo-Christian and Romanesque eras. These qualities can be found in his later funerary monuments and Roman ciboria, and his treatment of volumes acquires greater solidity as a result of his encounter with Giotto, perhaps at the Assisi building site or in Rome. After a period in Rome, Arnolfo went to Florence, where, as architect to the commune, he gave the city a new appearance, opening a number of building sites, including those of Santa Croce and Santa Maria del Fiore, the new cathedral.

Colle Val d'Elsa
1240/45–March 1302/10

Where he worked
Siena, Naples, Perugia, Viterbo, Orvieto, Rome, Assisi (?), Florence

Principal works
Five marble sculptures from the "Fontana Minore" (Perugia, Galleria Nazionale dell'Umbria, 1277–81); funerary monument of Cardinal De Braye (Orvieto, San Domenico, 1282); ciborium (Rome, San Paolo fuori le Mura, 1283); Annibaldi monument (Rome, Saint John Lateran, ca. 1290); *Scenes from the Life of Isaac* (?) (Assisi, upper church of San Francesco, ca. 1290); chapel of the Christmas Crib (Rome, Santa Maria Maggiore, 1290–92); ciborium (Rome, Santa Cecilia in Trasteverel, 1293); Santa Croce (Florence, from 1294); votive chapel of Boniface VIII (Rome, 1296); cathedral (Florence, from 1296)

Links with other artists
Giotto

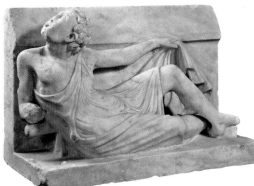

Arnolfo di Cambio

The Virgin is enthroned with the Child on her lap at the top of the monument, between and above Saint Dominic (right) and Saint Mark (left), who is accompanied by the kneeling figure of the resurrected cardinal.

In a typically Cosmatesque way, Arnolfo includes marble from ancient monuments among the materials he uses.

Arnolfo's treatment of the funerary monument is innovative. The recumbent effigy in the funeral chamber becomes part of a complex architectural structure whose celebratory purpose is quite clear.

The sarcophagus with the recumbent effigy of the dead man is presented as a funeral chamber whose curtains are being closed by two youths. They are symbolically closing the curtains of earthly death.

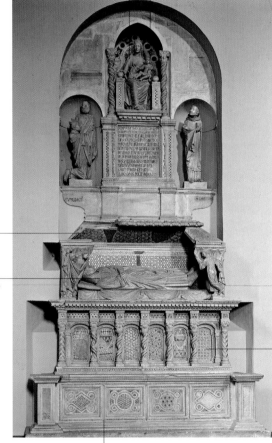

Sculpture, architecture, and painting are closely linked here. The whole work was completely painted, and the tall base is embellished with mosaics and inlays of a Cosmatesque type.

In representing the dogma of the resurrection of the flesh, the monument reflects the lively debates on the subject that were then going on in Roman circles.

▲ Arnolfo di Cambio, Funerary Monument of Cardinal De Braye, 1282. Orvieto, San Domenico.

Architecture and sculpture are skillfully blended here. A Gothic idiom is evident in the trefoil pointed arches, triangular tympanums with tracery rose windows, pinnacles, and tabernacles occupied by statues.

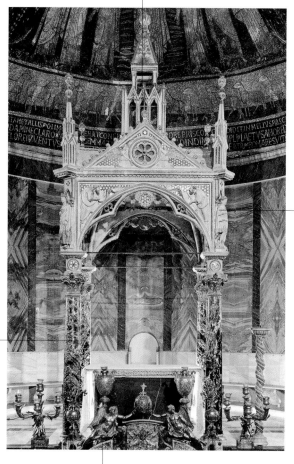

As he had already done with funerary monuments, Arnolfo took a new approach to the ciborium type, reworking the traditional tabernacle on columns in a Gothic idiom.

The low reliefs of the evangelists and the corner figures of Saint Urban and Saint Tiburtius on horseback (not visible) are the work of Arnolfo himself.

The ciborium in Santa Cecilia in Trastevere is signed and dated by Arnolfo, who also made a ciborium in San Paolo fuori le Mura around 1283.

Arnolfo di Cambio, Ciborium, 3. Rome, Santa Cecilia in Trastevere.

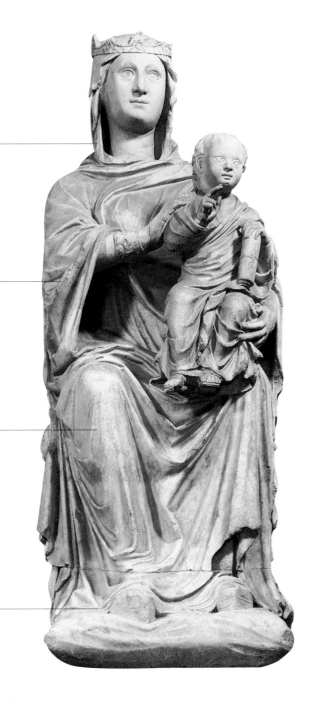

The figure of the Virgin Enthroned is imposing and iconic in an almost Byzantine manner, but the sense of plasticity and volume are parallel to those in Giotto.

Giotto, Andrea Pisano, and Francesco Talenti, who were successively capudmagistri *(chief masters) of the cathedral site, adhered largely to Arnolfo's original design.*

This is one of the few surviving statues from Arnolfo's cathedral facade. It was placed on the portal lunette and was flanked by Saint Zenobius, patron saint of Florence, and Saint Reparata.

How much remains of Arnolfo's design for Florence cathedral is a matter of debate. In particular, the lower facade was destroyed in 1587, and it is known to us only through a few surviving fragments, some literary descriptions, and paintings and drawings in which it appears.

▶ Arnolfo di Cambio, *Madonna and Child Enthroned*, ca. 1300. Florence, Museo dell'Opera di Santa Maria del Fiore.

Avanzi's paintings are typically lively and full of narrative, with bourgeois and popular tones. His colors are jewel-like, and there are some classical echoes.

Jacopo Avanzi

This Bolognese artist is considered one of the most interesting in late-14th-century northern Italian painting; but we know little about him. His name and city of origin are known from a panel (*Crucifixion*, Rome, Galleria Colonna), which is signed "Jacobus de Avanciis de Bononia." He is frequently mentioned, however, in the earliest sources, from the 15th-century *Libellus* of Savonarola to Michiel's *Notizie* (ca. 1540) and Vasari's *Lives* (1550). Many theories have been advanced about his artistic career, various works have been attributed to him, and he has sometimes been confused with Altichiero. Recent studies suggest that he began his career around the 1360s at the Mezzaratta oratory, where he painted *The Slaughter of the Idolatrous Jews*, which has the typical qualities of Bolognese painting. Toward the end of the 1370s, it is suggested, he went to Padua and came into contact with the work of Guariento and Giotto. An echo of these contacts may be discerned in the frescoes at Montefiore Conca, near Rimini (1370–72), and in the Colonna *Crucifixion* mentioned above. Finally, he is thought to have returned to Padua in 1376 or 1377 and painted some of the lunettes in the chapel of San Giacomo in the church of Sant'Antonio. They have a lively narrative content with occasional fabulous tones.

Then we lose track of him altogether. He may have returned to Emilia, and some guardedly propose that he frescoed the Malatesta chapel in San Giovanni Evangelista at Ravenna.

Active at Bologna in the second half of the 14th century

Where he worked
Bologna, Verona(?), Padua, Rimini, Ravenna(?)

Principal works
The Slaughter of Idolatrous Jews (Bologna, Pinacoteca Nazionale, ca. 1370); frescoes (Montefiore Conca, castle, 1370–72); *The Crucifixion* (Rome, Galleria Colonna, ca. 1372); frescoes in the first four and the sixth lunettes in the chapel of San Giacomo (Padua, Sant'Antonio, 1376–77)

Links with other artists
Altichiero

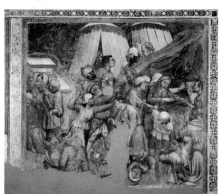

◀ Jacopo Avanzi, *The Slaughter of Idolatrous Jews*, ca. 1370. Bologna, Pinacoteca Nazionale.

275

These frescoes have certain strongly classical elements. However, the scene is populated not by heroes but by ordinary people, who crowd around and strike one another amid general confusion.

The frescoes in the large castle chamber were commissioned by Galeotto Malatesta, known as the Hungarian, who died in 1372.

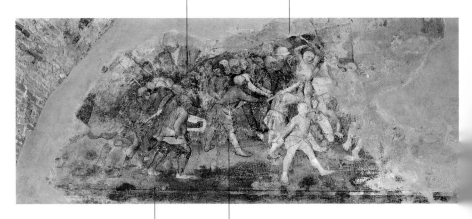

The Montefiore frescoes must have been painted by 1372, and they can be viewed as a point of transition between Avanzi's Bolognese and Paduan periods.

These frescoes are unfortunately in very poor condition, but we can see fragments of a battle scene with characters in Roman dress, framed by architectural features.

▲ Jacopo Avanzi, *Battle*,
1370–72. Montefiore Conca
(Rimini), castle.

He was indebted to the art of Vitale and Bolognese culture but transformed what he acquired into something more composed, creating frescoes that are true "stories," full of vitality.

Tomaso Barisini

Tomaso's father, Barisino Barisini, was a painter and notary. It is thought that Tomaso served his apprenticeship in his father's workshop and that he also went to Bologna, since the works of his youth seem to be influenced by certain stylistic aspects of Vitale's art. Documents show that he settled at Treviso in 1348, and it was here that he made his career as an artist until 1358, when he returned to Modena. In Treviso, Barisini found a flourishing city with plenty of refined patrons of art, including the powerful Dominicans, Franciscans, and Augustinians. Here, in 1352, he painted frescoes in the chapter house of the San Niccolò monastery. These forty portraits of illustrious Dominicans have a lively sense of humanity, striking realism, and a freshness reminiscent of Bolognese miniatures. His success there led to many commissions and a substantial fortune. Charles IV of Bohemia, perhaps when he came to Italy for his coronation (1354–55), commissioned two panels to take to Prague. In these years or shortly afterward Barisini painted his lovely *Scenes from the Life of Saint Ursula* in the apse of the church of Santa Margherita (now destroyed). Barisini treats the theme of the Breton virgin martyrs in an elegant way, with psychological insight and lively naturalistic observation, conveyed in warm colors with a narrative tone. There are many works attributed to Barisini in his Treviso period, but little is known of his activities from his return to Modena until his death, perhaps in 1379.

Modena 1325/26–1379 (?) also called Tommasso da Modena

Where he worked
Modena, Treviso

Principal works
Portraits of Illustrious Dominicans (Treviso, San Niccolò, chapter house, ca. 1352); *Triptych with Madonna and Child*, Prague, Karlštejn Castle, chapel of the Holy Cross, 1356–65); *Scenes from the Life of Saint Ursula* (Treviso, Museo Civico, 1360–66)

Links with other artists
Vitale da Bologna

Notes of interest
Barisini was settling in Treviso as Vitale da Bologna was arriving in Udine. These two artists were to be important points of reference for painters in the Treviso area and Friuli. Aspects of their styles became intermingled, so that it is very difficult to distinguish painters influenced by Vitale from those influenced by Barisini.

◄ Tomaso Barisini, *Saint Ursula's Farewell*, 1360–66, from *Scenes from the Life of Saint Ursula*. Treviso, Museo Civico.

277

Each of the forty eminent members of the order is shown in his cell, busy studying or reading or meditating on the scriptures.

Each Dominican is given an individual gesture or attitude, and each is surrounded by the common tools used by the intellectuals of the time: a magnifying glass, spectacles (a recent invention), a lectern, scissors, or an hourglass.

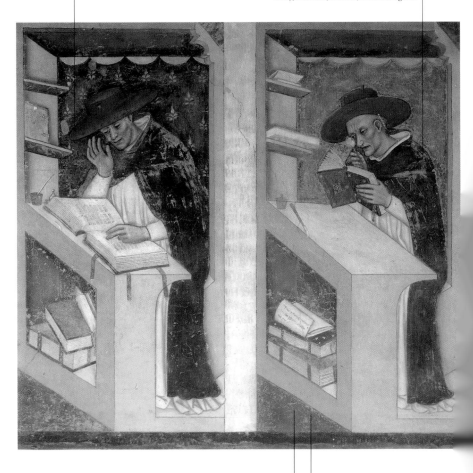

Instead of relying on the usual symbolic and allegorical approach to conveying the history and glory of the Dominican order, Barisini does so by producing a gallery of its most illustrious members.

Although these are not real portraits, a great deal of attention has been paid to psychological characterization, visual appearance, and personal details, in a style that is both naturalistic and elevated.

▲ Tomaso Barisini, *Cardinals Walter of England and Nicholas of Rouen,* from *Portraits of Illustrious Dominicans,* ca. 1352. Treviso, San Niccolò, chapter house.

The artist seems to echo the elevated, aristo-
cratic Sienese style, perhaps to satisfy Emperor
Charles IV, who commissioned the painting and
was an admirer of Simone Martini's style.

The triptych stood on the chapel
altar. It shows the Virgin with the
Child in her arms, flanked by
Saints Wenceslas and Palmatius.

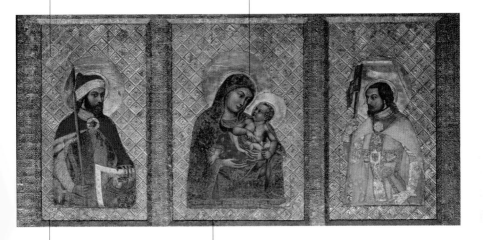

The figures painted by Barisini
were removed from the original
polyptych and set in a frame that
stands on the altar of the chapel
of the Holy Cross.

The inscription below the Madonna
reads: "Quis opus hoc finxit, Thomas
de Mutina pinxit. Quale vides lector
Barisini filius autor." It seems to echo
the lines written by Petrarch on the
title page of his Virgil manuscript.

Tomaso Barisini, Triptych with
Madonna and Child, 1356–65.
Prague, Karlštejn castle, chapel of
Holy Cross.

Ferrer Bassa was the favorite painter of Peter the Ceremonious and Mary of Navarre. He was one of the artists chiefly responsible for introducing Italianate taste into Catalonia.

Ferrer Bassa

Active in Catalonia
between 1321 and 1348.

Where he worked
Barcelona, Saragossa,
Perpignan, Palma
(Majorca), Tarragona,
Lerida; he is thought to
have spent some time in
Italy between 1324 and
1333

Principal works
Frescoes in the convent of
Santa Maria de Pedralbes
(Barcelona, 1346); *The
Book of Hours of Mary of
Navarre* (Venice, Biblioteca
Nazionale Marciana, first
half of the 14th century)

Bassa was active in Catalonia between about 1321 and 1348. Many documents record his activities and the importance of his works, mostly done for the royal family and its circle. We first hear of his presence in the Barcelona area between 1321 and 1324; there is further news of him in 1333, and from then on there are continual reports of his activity until 1348, when he probably died of plague. Some suggest that in the interim he went to Italy, coming into contact with Tuscan painting as well as that of southern Italy and the kingdom of Naples. The influence of Neapolitan art in his painting is certainly strong. Thus Bassa is considered the most important of the artists who introduced Italian taste into Catalonia. In 1339, he settled in Barcelona in the service of Peter the Ceremonious, for whom he painted retables for the royal chapels in Saragossa, Perpignan, and Barcelona. A well-organized workshop grew up around him, including his son Arnau, whose style was very similar (he outlived his father by only a few months). Although many works are documented, few have survived. Among them are the paintings in the chapel of San Miguel in the convent at Pedralbes and *The Book of Hours of Mary of Navarre*, Peter's wife, who died very young. The latter is a work of very high quality and has been attributed to three different masters, including Ferrer Bassa and his son.

► Ferrer Bassa, *The Adoration of the Magi*, illuminated page from *The Book of Hours of Mary of Navarre*, first half of the 14th century. Venice, Biblioteca Nazionale Marciana.

In the frescoes in the convent of Poor Clares at Pedralbes, it is clear that Bassa has a profound knowledge of 14th-century Tuscan painting, and especially of the Sienese art of the Lorenzetti brothers.

The iconographic program for the chapel of San Miguel was laid out in the contract and includes scenes from the Passion of Christ, the Seven Joys of the Virgin, and figures of saints and Christ.

Ferrer Bassa, *The Adoration of Magi*, 1346. Pedralbes ‑celona), Santa Maria, chapel of Miguel.

The pictorial quality does not reach the high level of the artist's sources and, although it displays a powerful creative vein, it was probably painted by workshop assistants (under Bassa's supervision).

The three Magi kneel before the Virgin, who is holding the Child on her lap, against a background that is highly reminiscent of Sienese painting.

Although he is recorded in the sources and must have been renowned in 14th-century Hamburg, only one work solidly attributed to him has survived.

Bertram von Minden

Minden (or its surroundings) ca. 1340–ca. 1415

Where he worked
Hamburg; a visit to Lübeck in 1375 and a pilgrimage to Rome in 1390 are documented

Principal works
Altarpiece for the high altar in the church of Saint Peter (Hamburg, Kunsthalle, 1379–ca. 1383)

Master Bertram was born in or near Minden in Westphalia and was active as a painter at Hamburg between 1367 and 1387. From 1367 onward, he is mentioned almost every year in the city registers and chronicles as receiving official commissions. In 1383, the chronicle of Hamburg refers to him as responsible for a large painted and sculpted polyptych intended for the high altar in the church of Saint Peter: the only work that can definitely be attributed to him. Although some aspects of his painting are reminiscent of contemporary painting in Bohemia and other parts of northern Europe, his style is thoroughly original. The polyptych wings are painted on both sides, with a complicated iconographic program of scenes from the Old and New Testaments. The sculptures are on two tiers and can be seen only when the wings are open; they were probably the work of another artist. Other works tentatively attributed to Master Bertram are *The Passion Altarpiece* in Hanover (of uncertain provenance)—whose firs panel depicts Christ's Entry into Jerusalem amid joyful and gesticulating figures—three miniatures in *The Missal of Johannes Wusthorpe*, and a polyptych with *Scenes from the Life of the Virgin* for the monastery at Harvestehude. Records show that he went on a pilgrimage to Rome in 1390, and that he made a will in 141c By May 13, 1415, he was dead: there is a letter of that date from claimants to his estate.

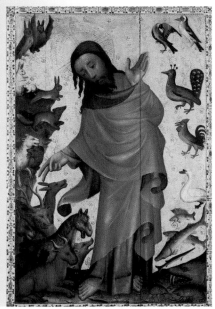

This winged polyptych is made of oak and has been repeatedly restored and repainted. Inside are seventy wood sculptures of saints, prophets, the wise and foolish virgins, and a Crucifixion (a later addition).

Characteristic of Bertram's art is the strong plasticity of his painted figures, which stand out against the gold background, together with a certain playful poetic quality.

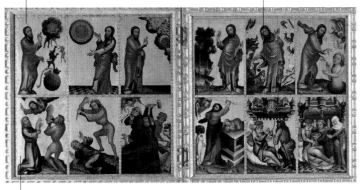

In the predella there is an Annunciation, together with figures of Church fathers and the founders of the mendicant orders.

The iconographic program was probably dictated by Canon Wilhelm Horboch of Hamburg, a theologian and jurist. Its theme is the redemption of man in Christ through the mediation of the Church.

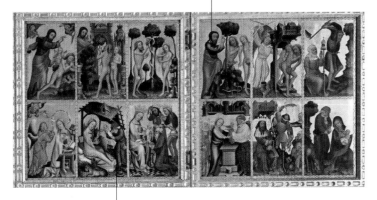

Bertram von Minden, *The Creation the Animals*, ca. 1379–73, from the lyptych for the high altar in the urch of Saint Peter. Hamburg, nsthalle.

The twenty-four polyptych panels painted by Bertram von Minden depict scenes from Genesis and the New Testament, the latter ranging from the Annunciation to the Rest on the Flight to Egypt.

▲ Bertram von Minden, Polyptych, originally for the high altar in the church of Saint Peter, ca. 1379–83. Hamburg, Kunsthalle.

In the upper corners, against the gold background, two angels accompany the event with music.

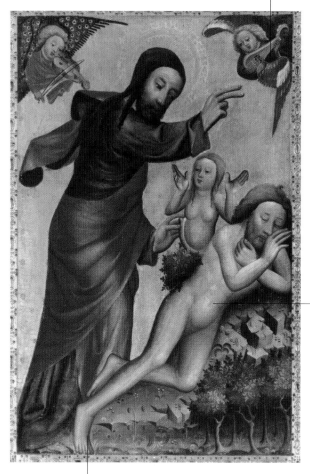

As told in Genesis, God has just taken a rib from Adam, who lies sleeping. The half-bust figure of Eve emerges from the rib with her hands raised as though in prayer.

▲ Bertram von Minden, *The Creation of Eve*, ca. 1379–83, from the altarpiece for the high altar in the church of Saint Peter. Hamburg, Kunsthalle.

Bertram narrates events with poetic simplicity. The figures stand out against the gold background with sharp outlines, large heads and hands, and almost exaggerated plasticity. This was to make it easier for them to be viewed from a distance.

Bonino was a sculptor in the Lombard tradition. He created some masterly funerary monuments thanks to commissions from Bernabò Visconti and Cansignorio della Scala.

Bonino da Campione

Bonino came from Campione on Lake Lugano and was active as a sculptor in the second half of the 14th century at Milan and other nearby cities (Bergamo, Cremona, Verona). He was the major representative of his day of those "masters from Campione" who were active as architects, sculptors, and stonecarvers in the Po valley area in the late Middle Ages. His name first appears in an inscription on the sarcophagus of Folchino degli Schizzi (d. 1357) in the cathedral at Cremona, a city where Bonino had made another tomb in the church of Sant'Omobono (now lost). Later, Bernabò Visconti, the lord of Milan, commissioned a funerary monument for himself, and Bonino worked on it at intervals over a long period, from about 1360 until 1385, when Bernabò died. The equestrian group was polychromed and hewed closely to the rules of the Campionese statuary tradition. Longhi called it "a masterpiece of ancestral Lombard humor," because of the authoritarian, almost uncouth figure of Bernabò on horseback. Around 1370, Bonino was called to Verona by Cansignorio della Scala to design his tomb in the Scaligeri burial ground. It is striking for its architecture, embellished with decidedly Gothic cusped taber-nacles. Bonino returned to Milan in 1376, but his commissions seem to have diminished when Bernabò died. Bonino himself probably died in March 1397. Among other works attributed to him is an early funerary monument of Bishop Lambertini (d. 1349) in the old cathe-dral at Brescia.

Campione (Lake Lugano); active in the second half of the 14th century

Where he worked
Milan, Verona, Brescia, Cremona

Principal works
Funerary Monument of Bishop Lambertini (Brescia, old cathedral, before 1349); Funerary Monument of Folchino degli Schizzi (Cremona, cathedral, before 1357); Funerary Monument of Bernabò Visconti (Milan, Castello Sforzesco, Museo d'Arte Antica, 1360–85; Tomb of Cansignorio della Scala (Verona, Santa Maria Antica, Scaligeri tombs, 1370–75)

◄ Bonino da Campione, Tomb of Cansignorio dell Scala, 1370–75. Verona, Santa Maria Antica.

A Flemish painter in the service of Philip the Bold, Count of Flanders, Broederlam stands out for his refinement. He is a prominent representative of International Gothic in that region.

Melchior Broederlam

Active at Ypres between
1381 and 1409

Where he worked
Ypres, Dijon, Paris, Hesdin

Principal works
Retable of the Crucifixion
(Dijon, Musée des Beaux-
Arts, 1392–99)

Born at Ypres, Broederlam is documented in the service of Philip the Bold from 1381 to 1409. He was *valet de chambre* to Philip when the latter became Count of Flanders in 1384. His outstanding qualities are the refinement and elegance of his drawing and his painstaking painting technique. While in the count's service, he painted works of various kinds, including stage scenery for Hesdin Castle (1386–92). When the barons of France gathered in Flanders in 1386 to invade England, he painted their coats of arms and insignia on their ships. He was also called to Dijon and Paris to set the stage for splendid court festivities. Through all of this, Broederlam continued to live and run a workshop at Ypres, where he worked with pupils and assistants, absenting himself when necessary. At Ypres he carried out the gilding and polychrome decoration of the only work that can be confidently attributed to him: his *Retable of the Crucifixion* for the Carthusian monastery of Champmol, whose wood inlay was executed by Jacques de Baerze. The work was finished in 1399. He painted four scenes for the retable, two for each panel: *The Annunciation and the Visitation*, and *The Presentation in the Temple and the Flight into Egypt*. It is a work in which Flemish naturalism seems fused with courtly art and accompanied by echoes of Sienese art. It has been interpreted as valuable evidence of the presence of International Gothic in Flanders at the end of the 14th century.

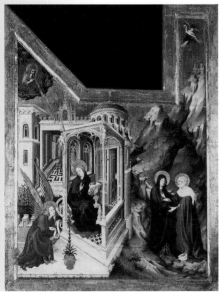

The Presentation in the Temple is inserted in an architectural framework in order to separate it from the scene next to it, which takes place in a rocky natural landscape.

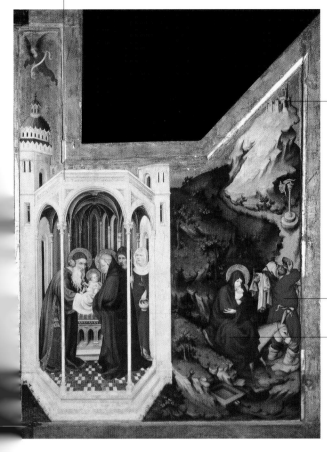

Broederlam uses certain symbolic details to underline the significance of the events represented: an idol falling from its pedestal in the background is an allusion to the saving powers of the Redeemer.

In painting the Flight into Egypt, the artist dwells on an aspect of ordinary life: Joseph, who is represented as a 14th-century Flemish peasant, is caught drinking greedily. This seems to refer to an apocryphal story that a spring suddenly gushed forth at Mary's feet, allowing them all to quench their thirst.

The gold background and chiaroscuro create a poetic, unreal atmosphere, in spite of the characteristic naturalism of the scenes, as seen, for example, in the way Mary clutches the Child to her bosom to protect him.

Melchior Broederlam, Jacques de rze, *The Annunciation and the tation*, outer side of the left wing *he Retable of the Crucifixion*, 2–99. Dijon, Musée des Beaux-Arts.

▲ Melchior Broederlam, Jacques de Baerze, *The Presentation in the Temple and the Flight into Egypt*, outer side of the right wing of *The Retable of the Crucifixion*, 1392–99. Dijon, Musée des Beaux-Arts.

Puccio Capanna

Active at Assisi in the first
half of the 14th century

Where he worked
Assisi, Florence

Principal works
Coronation of the Virgin
and *Scenes from the Life
of Saint Stanislas* (Assisi,
lower church of San
Francesco, cantoria, ca.
1330); *Annunciation* and
Crucifixion (Assisi,
monastery of San
Giuseppe, ca. 1334);
*Madonna and Child
between Angels and Saints*
(Vatican City, Pinacoteca
Vaticana, ca. 1335);
Crucifixion (Raleigh [NC]
Museum of Art, ca. 1335);
Crucifixion and Saints
(Assisi, Franciscan convent,
chapter house, ca. 1335);
*Madonna and Child with
Four Saints* (Assisi, church
of Santa Chiara, chapel of
San Giorgio, ca. 1335);
Crucifixion and *Deposition*
(Assisi, Museo e Archivio
Capitolare, ca. 1341)

Links with other artists
Giotto

► Puccio Capanna, *The
Coronation of the Virgin*,
ca. 1330. Assisi, lower
church of San Francesco,
cantoria.

Capanna was active in Assisi and Florence in the first half of th
14th century. He is mentioned by Vasari in his *Lives* (1550) as
one of Giotto's most important followers, and by Ludovico da
Pietralunga (*Descrizione della Basilica di S. Francesco*, 1570) a'
native of Assisi; a list of his paintings is provided. A group of v
fine paintings is now attributed to him, such as the frescoes in t
cantoria of the lower church at Assisi (commissioned by one of
the Soldani family of Assisi around 1330)—*The Coronation of
the Virgin* and *Scenes from the Life of Saint Stanislas*—and *Th
Crucifixion and Saints* in a lunette in the chapter house of the
Franciscan convent. The artist's debt to Gothic culture is eviden
in *The Coronation*. His work is a kind of development from
Giotto's paintings in Assisi toward the Gothic and the naturalis
tic. He displays a refined sensibility, soft forms, warm colors, a
a naturalism imbued with profound human understanding. Ot
paintings attributed to him are a mural polyptych (*Madonna a
Child with Four Saints*) in the chapel of San Giorgio in the
church of Santa Chiara; *The Annunciation* and *The Crucifixio*

in the monastery of San
Giuseppe; *The Crucifixion* a
The Deposition now in the
Museo Capitolare; the dipty
of which the only surviving
parts are the little Raleigh
Crucifixion and *Madonna a
Child between Angels and
Saints* in the Pinacoteca
Vaticana. Capanna apparent
also worked in Florence,
where his fame persisted for
long time.

Space is defined by the church architecture, and the volumetric weight of the bodies is defined by dense impasto paint, which succeeds in creating a strong naturalistic impression.

In the 1330s, Puccio Capanna became established as the most modern of Giotto's followers, and his art was much admired up to the time of Vasari for its refined naturalism.

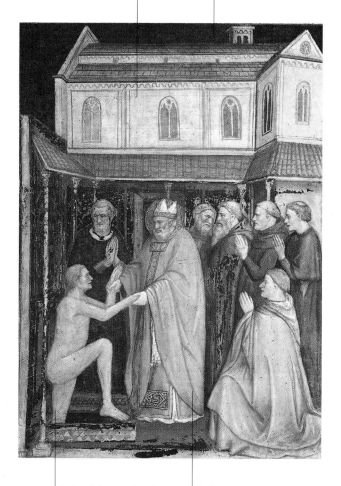

In these little scenes from the life of Saint Stanislas, the artist is extremely successful in portraying the human form.

In this scene, Saint Stanislas is miraculously raising a man from the dead.

▲ Puccio Capanna, *A Miracle of Saint Stanislas*, ca. 1330, from *Scenes from the Life of Saint Stanislas*. Assisi, lower church of San Francesco, cantoria.

He was a versatile artist who played an important part in Catalan art in the mid-14th century. He designed the royal tomb for Peter the Ceremonious at Poblet.

Jaume Cascalls

Berga ca. 1340–(?); active in Catalonia in the mid-14th century

Where he worked
Saragossa, Poblet, Lerida, Tarragona, Cornella-de-Conflent, Gerona, Barcelona

Principal works
Retable of the Virgin (Gerona, Museo Diocesano, 1345)

Links with other artists
Ferrer Bassa

Notes of interest
Jaume Cascalls had a considerable influence on contemporary sculptors, including Jordi de Déu (a slave whom he subsequently freed), Bartolomeu Rubió, and Pedro Aquilas.

Cascalls was born at Berga in Catalonia, and abundant documentary evidence shows that he was active there in the middle of the 14th century. As a young man he seems to have alternated between sculpture and painting, sometimes collaborating with his father-in-law, the painter Ferrer Bassa. In 1349, Peter III the Ceremonious commissioned him, together with Master Aloy, to make a funerary monument for him and his three wives in the royal pantheon at the Poblet abbey church. In 1360, Aloy withdrew, and Cascalls took over the project. Crown patronage also led to some collaboration on paintings and retables with Jordi de Déu, Pere de Lena, and Jaume Mateu. Records suggest that in 1361 Cascalls was appointed *magister operis* at Lerida cathedral. He was at Tarragona in 1375 redesigning the west portal of the cathedral. In spite of much surviving documentation about him, his only extant signed work is the alabaster retable dedicated to the Virgin in the church at Cornella-de-Conflent. Scholars, on the basis of the few available stylistic data, have attributed other works to him: the statue of Saint Charlemagne in Gerona cathedral, and the figure of Christ in the Holy Sepulchre group in the collegiate church of Saint Felix, also at Gerona. Comparison suggests that he was also responsible for a beautiful head of Christ, once painted, belonging to a Holy Sepulchre group (left). Cascall's career marks an important development in Catalan Gothic sculpture, his personal idiom being a synthesis of French and Italian influences.

▶ Attributed to Jaume Cascalls, *Head of Christ*, ca. 1352. Barcelona, Museo Nacional de Arte de Catalunya.

This alabaster retable is the only surviving signed work by Jaume Cascalls. He made it before he was commissioned by King Peter the Ceremonious to make the royal tombs at Poblet.

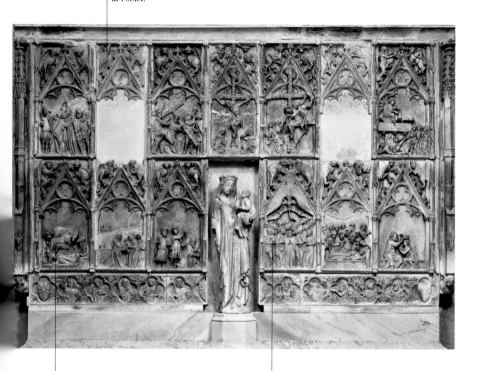

Within these rectangles framed in Gothic architecture, Cascalls has narrated, in a placid style, scenes of the Passion and Resurrection of Christ in the upper tier, and scenes from the life of the Virgin in the lower tier.

In some of these framed episodes, such as the Dormitio Virginis or the Descent of the Holy Spirit, Cascalls has created crowded scenes that are reminiscent of French art.

ıume Cascalls, *Retable of the Virgin*, 5. Gerona, Museo Diocesano.

He was a painter, miniaturist, sculptor, architect, and goldsmith. He is famous both for his skill in observing nature and for having been architect in charge of the Milan cathedral building site.

Giovannino de Grassi

Milan (?)–1398

Where he worked
Milan

Principal works
Offiziolo of Gian Galeazzo Visconti (Florence, Biblioteca Nazionale Centrale, from 1370); *Sketchbook of Giovannino de Grassi* (Bergamo, Biblioteca Civica A. Mai, ca. 1370); frescoes (Campomorto presso Siziano, Rocchetta dei Mantegazza, ca. 1370); sculptures and capitals inside the cathedral (Milan, from 1390); *Breviarium Ambrosianum* known as *Beroldus* (Milan, Biblioteca Trivulziana, 1396–98)

Notes of interest
At the death of Giovannino de Grassi, the administrator of the cathedral site arranged for the completion of the wooden model of the cathedral that De Grassi had begun, in order that those in charge of future work should have it as a guide.

The information we have about Giovannino de Grassi mostly concerns his activities at the Milan cathedral site, where he worked from May 5, 1389, until his death in 1398. We know nothing of his life before about 1370. His works over those two decades, at any rate, show that he was highly versatile and a leading interpreter of the Lombard version of the international style then taking hold in most European art centers, which found some of its strongest support at the Visconti court. To 1370 or slightly earlier we can date the first of four fascicules of a parchment sketchbook signed by De Grassi, now in Bergamo. It contains drawings of animals and human figures from the courtly repertoire. Then or shortly afterward, Gian Galeazzo Visconti commissioned him to decorate the *Offiziolo*, for the date 1370 appears in the Presentation in the Temple scene. He seems to have worked at this manuscript on and off until about 1390; he became chief architect at the cathedral site from 1391.

His duties at the site were various, but he seems to have concentrated principally on the gilding and painting of interior sculptures as well as on the architectural design. It was during his tenure as chief architect that the form and structure of the building's internal space (windows, capitals, pier styles, and use of color) were established, giving Milan cathedral the characteristics it has today.

► Giovannino de Grassi, *Two Female Musicians*, ca. 1370, from *The Sketchbook of Giovannino de Grassi*. Bergamo, Biblioteca Civica A. Mai.

This complex, encyclopedic book of divine offices remained unfinished when the artist died in 1398.

In De Grassi's miniatures, there is a magical universe of flowers, plants, and rocks, in which the realistic aspects of nature are combined with a striking narrative flow.

Giovannino de Grassi apparently devoted himself personally to the Offiziolo rather than giving the work out to assistants. In doing so, he created one of the most fascinating works of Gothic culture.

This page of the Offiziolo *shows* two episodes in the story of Joachim. In the first he is at prayer, and in the second he is being expelled from the Temple by the priests because he has no children and is therefore "cursed by God."

A cornice of delicate flowers surrounds the scene, which takes place within magical architecture.

▲ Giovannino de Grassi, *Joachim Expelled from the Temple*, after 1370, from *The Offiziolo of Gian Galeazzo Visconti*. Florence, Biblioteca Nazionale Centrale.

This Barcelona painter was a pupil of Ferrer Bassa and appears in some documents as teacher of Pedro Serra. He exemplifies the Italianate trend in 14th-century Catalan painting.

Ramon Destorrents

Barcelona 1325–before May 1391

Where he worked
Barcelona

Principal works
Retable for the chapel of Sant'Anna in Almudaina Castle at Palma (Majorca): *Saint Anne and the Virgin* (Lisbon, Museu Nacional de Arte Antiga, 1353–58), and *Crucifixion* (Palma, Museu de Mallorca, 1353–58)

Links with other artists
Ferrer Bassa, Pedro Serra

There is documentary evidence of Destorrents in Barcelona and elsewhere in Catalonia from 1351, when there is a record that Peter III the Ceremonious paid him for a psalter. That same year, he signed a receipt in which he described himself as an illuminator and citizen of Barcelona. Other documents from the following years record payments by the crown for retables for the royal chapels in Majorca and Valencia, and for a cover for the retable commissioned from Ferrer Bassa in 1343 for the chapel in Lerida Castle. This latter work is evidence of the link between the two artists, and we can see that Destorrents completed the work that Bassa had left unfinished. There is also evidence of his relationship with Pedro Serra (a member of the principal retable workshop in Barcelona in the 1370s) in a document of April 14, 1357, in which Serra is listed as an apprentice of Destorrents. The only document after 1362 is one dated May 22, 1391, from which we deduce that he had died. The only work that can be confidently attributed to Destorrents is the retable in the chapel of Sant'Anna in Almudaina Castle at Palma on the island of Majorca. The surviving parts are the main panel with the Virgin in the arms of Saint Anne, who is teaching her to read, and a Crucifixion. The Catalan-Aragonese royal insignia and the emblems of Peter III's three wives on the panel with *Saint Anne and the Virgin* confirm that it comes from the only royal chapel in Catalonia dedicated to Saint Anne.

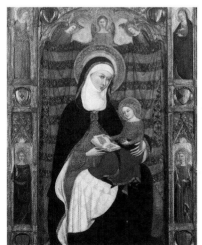

► Ramon Destorrents, *Saint Anne and the Virgin*, 1353–58. Lisbon, Museu Nacional de Arte Antiga.

"There was also Duccio in Siena, and he was a very noble artist who painted in the Greek manner. He painted the principal panel in Siena cathedral" (L. Ghiberti, I commentari, 15th century).

Duccio di Buoninsegna

The first document to record Duccio as a painter dates to 1278, so he must have been working for years before April 15, 1285, the date of a commission from the friars of Santa Maria Novella in Florence to paint a large panel in honor of the Madonna. This painting is now identified as *The Rucellai Madonna*, formerly attributed to Cimabue. Critics still discuss the relationship between the two artists. There is a gap of more than twenty years between *The Rucellai Madonna* and his *Maestà* for the high altar in Siena cathedral (the only other documented work by him), and it is hard to reconstruct Duccio's career during this interval. Two works thought to date to his early years, fairly close to *The Rucellai Madonna*, are *The Crevole Madonna* (a sort of Byzantine icon, but softened by a rhythmic flow of draperies) and *Madonna of the Franciscans*. Other works are also ascribed to the period before *Maestà*: some panels of *Madonna Enthroned*, tabernacles with the Crucifixion, the circular stained-glass window for the apse in Siena cathedral, and the fresco discovered in 1980 in the Sala del Mappamondo in the Palazzo Pubblico, the subject of which has been interpreted as the taking of the castle of Giuncarico. If this fresco is indeed by Duccio, as some scholars think, it is his only known fresco; but then he, like the other artists of his day, were adept at a variety of techniques. Duccio died in 1318. He can be considered the founder of the Sienese school, and his reputation spread far beyond his city.

Siena ca. 1255–1318

Where he worked
Siena, Florence

Principal works
Rucellai Madonna (Florence, Uffizi, 1285); *Crevole Madonna* (Siena, Museo dell'Opera Metropolitana, ca. 1285); *Madonna of the Franciscans* (Siena, Pinacoteca Nazionale, ca. 1285); Stained-Glass Window with *Scenes from the Life of the Virgin and Saints* (Siena, cathedral, 1287–88); *Maestà* (Bern, Kunstmuseum, 1288–ca. 1290); *Stoclet Madonna* (formerly in Brussels, Stoclet Collection, ca. 1300); *Crucifixion and Saints* (Boston, Museum of Fine Arts, ca. 1300); *Maestà* (Siena, Museo dell'Opera Metropolitana, ca. 1308–11); *Taking of Giuncarico Castle* (Siena, Palazzo Pubblico, 1314).

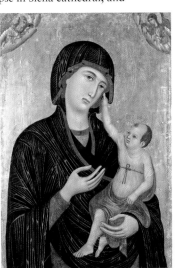

◄ Duccio di Buoninsegna, *The Crevole Madonna*, ca. 1285. Siena, Museo dell'Opera Metropolitana.

295

Duccio di Buoninsegna

What is striking about this altarpiece is its reinterpretation of the example set by Cimabue: the back of the throne is a light silk hanging, the color combinations are subtle, and the figures seem weightless. The robes of the angels are little more than veils.

Compared with the serious, melancholy figures of Cimabue, these are more refined, and their facial expressions are sweeter, with a hint of a smile. The typical chiaroscuro of Byzantine painting has only secondary value here.

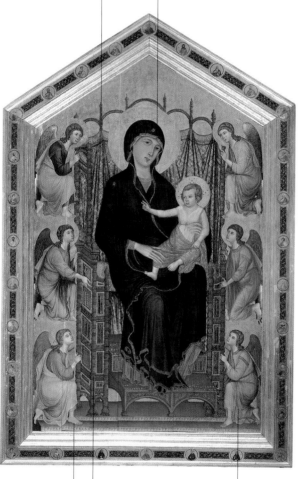

Compared with the late Byzantine cultural tradition that one still finds in Cimabue, Duccio's work has a new Gothic component.

▲ Duccio di Buoninsegna, *The Rucellai Madonna*, 1285. Florence, Uffizi.

This altarpiece has some close similarities to Cimabue's Paris Madonna: in the Virgin's throne, the frame decorated with tondini containing busts of prophets and saints, and even the worked gold background.

Duccio goes beyond the Byzantine tradition thanks to his knowledge of Gothic trends north of the Alps. He may have come into contact with them through works arriving from France, such as ivories and illuminated manuscripts.

This little panel (23.5 × 16 cm, or 9¼ × 6⁵⁄₁₆ in.) has all the fascination of a French manuscript illumination. The gold background is partly covered by a piece of cloth with a fine pattern of green and white squares.

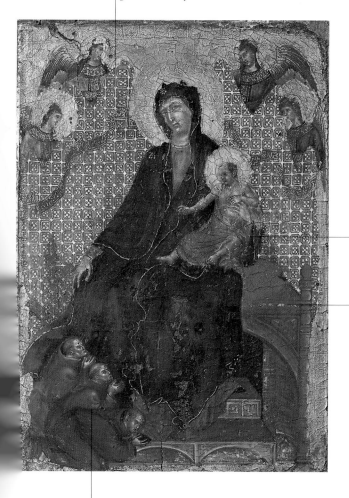

Duccio's way of going beyond the Byzantine tradition lies in his emphasis on free, calligraphic lines, and on color.

The blue robe, edged with the tiniest of gold threads, covers the Virgin's body as lightly as a veil. The throne has no arms and a very wide seat, and it is almost completely lacking in depth.

The oblique arrangement of the figures is original. The Virgin's robe flows down to protect the three little Franciscans, who are spread out like a fan.

▲ Duccio di Buoninsegna, *Madonna of the Franciscans*, ca. 1285. Siena, Pinacoteca Nazionale.

Duccio di Buoninsegna

On June 9, 1311, the panel for the high altar in the cathedral was transported from Duccio's workshop, accompanied by a crowd of ordinary people and a company of musicians ("trumpeters and shawms and kettledrums").

The representation of the Madonna as a queen surrounded by her heavenly court of angels and saints is thought to be a Sienese invention, and this altarpiece is the prototype.

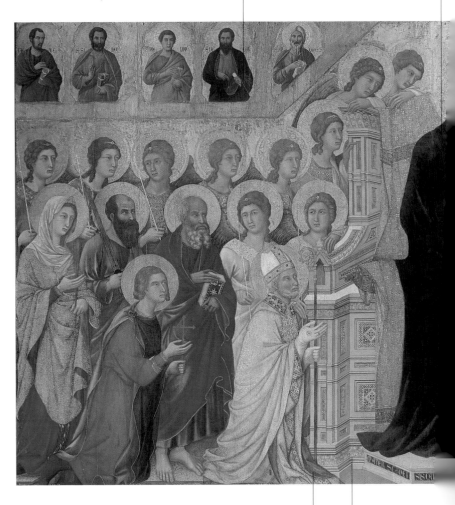

▲ Duccio di Buoninsegna, *Maestà* (recto), ca. 1308–11. Siena, Museo dell'Opera Metropolitana.

This large altarpiece (370 × 450 cm, or 12 × 15 ft.) is painted on both sides and includes no less than fifty figures, quite apart from the Maestà on the front and the little figures of apostles, saints, and angels.

The Virgin's architectural throne is evident of Duccio's knowledg of Giotto's way of co veying space.

The Virgin's throne is surrounded by ten angels on each side, plus a group of saints. In the foreground the four patron saints of Siena—Ansanus, Savinus, Crescentius, and Victor—are interceding on behalf of the city.

Duccio has created an atmosphere of classical gravity in this painting. While it involves a return to the neo-Byzantine rather than the Gothic, its color range is very rich.

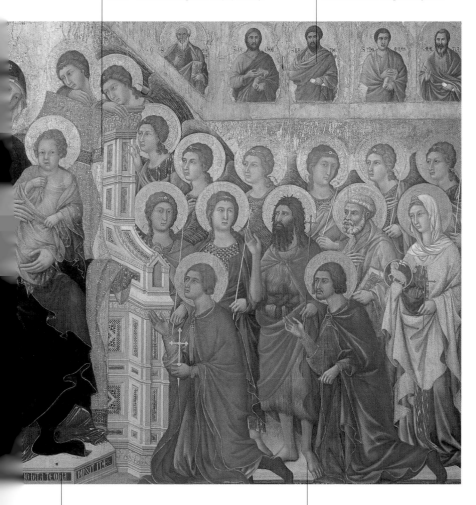

The inscription on the step of the throne ("O Holy Mother of God, be a cause of peace for Siena, be life for Duccio, because he has painted you thus") conveys the civic importance of the panel and the artist's awareness that he has created a masterpiece.

This panel had immense significance for Siena. The city was keenly devoted to the Virgin, who had been chosen by the Sienese as their heavenly protectress on the eve of the battle of Montaperti (1260).

Duccio di Buoninsegna

On the verso of the altarpiece are Scenes from the Passion of Christ *in twenty-six small-format episodes. It must have been intended that they be viewed from close up.*

Of particular note in some scenes, such as the Entry into Jerusalem, is the representation of the landscape and the city with its walls and buildings.

Careful attention to nature later became a characteristic of an important trend in 14th-century Sienese painting, partly due to the city's political interest in the depiction of conquered land.

The scenes provide an accurate narrative of the episodes as they appear in the four canonical Gospels, and the apocryphal Gospel of Nicodemus in the case of Christ's Descent into Limbo.

The scenes are arranged in two tiers, one above the other, and the lower tier is to be read first.

Within each tier, the scenes are to be read from left to right and from bottom to top.

▲ Duccio di Buoninsegna, *Maestà* (verso), 1308–11. Siena, Museo dell'Opera Metropolitana.

"Since he brought back to light that art, which for many centuries . . . had remained hidden, he can rightly be called one of the beacons of Florentine glory" (G. Boccaccio, Decameron).

Giotto

Florence (or Vespignano nel Mugello) ca. 1267–Florence January 8, 1337

Where he worked
Florence, Rome, Assisi, Padua, Rimini, Naples, Bologna, Milan

Principal works
Scenes from the Life of Saint Francis (Assisi, upper church of San Francesco, end of the 13th century); frescoes in the Scrovegni chapel (Padua, 1303–4); *Stefaneschi Altarpiece* (Vatican City, Pinacoteca Vaticana, ca. 1320–30); frescoes in the Peruzzi chapel (Florence, Santa Croce, ca. 1328); cathedral bell tower (Florence, 1334–37)

Notes of interest
Giotto's fame was enormous, even among his contemporaries. There is evidence for this in Dante's homage: "Cimabue thought to hold the field in painting, but now the cry is for Giotto."

The Florentine painter and architect Giotto was already very famous in his own lifetime: his way of "depicting every figure and action as they are in nature," as Villani wrote at the end of the 14th century, his search for "depth" (perspective) in his paintings, and the humanity of the figures that people his scenes—these are the original qualities that struck his contemporaries and marked a turning point in the history of painting. In spite of the wealth of sources, little is certain about his life, and fewer than twenty works survive of the forty mentioned in reliable sources. We know that he died in Florence on January 8, 1337, at the age of about seventy, so we deduce that he was born around 1267. What we know of his career suggests that it was one of constant activity. He was probably a pupil of Cimabue, and he was in Rome at the close of the 13th century, but we know little else about this period. In the 1290s he was working in the upper church at Assisi and painting panels for Florentine churches, including the revolutionary *Crucifix* for Santa Maria Novella, where the heavy body nailed to the cross is a genuinely human figure. Between 1303 and 1305 he was in Padua, where, among other works, he painted the frescoes in the Scrovegni chapel. He visited Rimini and returned to Rome more than once. In 1328, Robert of Anjou summoned him to Naples, and while few traces of his works there remain, they must have influenced the local painting culture. In 133 he was appointed master of works at the Florence cathedral site and superintendent of public work for the commune. The following year, the commune itself sent him to work for Azzone Visconti, lord of Milan.

▶ Giotto, *Crucifix*, ca. 1300. Florence, Santa Maria Novella.

The fresco cycle in the Arena chapel, commissioned by Enrico Scrovegni, is considered an opus of fundamental importance in Giotto's career and, more than any other, the work of his own hand.

The treatment of space in strict perspective is the most striking innovation in 14th-century painting. Thanks to the skillful use of chiaroscuro, the figures have a plastic, monumental quality.

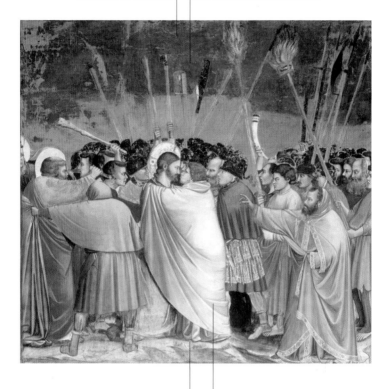

The lives of the Virgin and of Christ are presented in thirty-seven episodes. On the inside wall of the facade is a Last Judgment, and the figure of God Almighty appears on the apsidal arch.

As narrated here by Giotto, the scenes acquire a particular emotive power, which reaches a dramatic climax in the kiss of Judas.

Giotto, *The Capture of Christ*, 03–4. Padua, Scrovegni chapel.

Giotto

Above the Cosmatesque throne is a Gothic canopy, the sides of which are painted at a particularly daring angle.

Compared with the 13th-century Maestà type, there are important innovations here in the psychological relationship between the figures, a certain freedom of movement, and the depth conveyed by means of the throne in perspective.

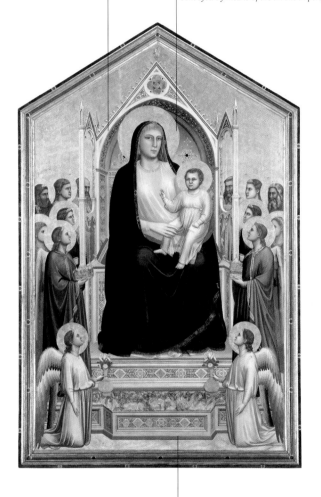

This large altarpiece (3.25 × 2 m, or 128 × 78¾ in.) from the Ognissanti church has a sense of depth, which means that it must have been painted after the frescoes in the Scrovegni chapel.

▲ Giotto, *The Ognissanti Madonna*, ca. 1310. Florence, Uffizi.

Once work on the upper church at Assisi was completed, decoration continued in the chapels of the lower church, where many of Giotto's pupils were engaged.

Noteworthy in this scene are the soft modeling and the spatial breadth within which the figures move in a kind of theatrical performance.

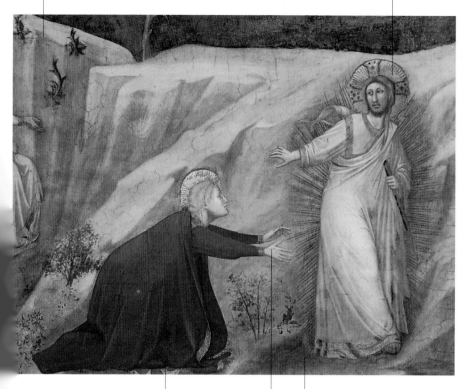

The involvement of Giotto has been detected in some scenes, such as the Noli me tangere, *but compared with the monumentality of the Padua frescoes there is a certain lightness here.*

The sense of movement is created by the direction of the characters' gazes, their hand gestures, and their facial expressions.

Giotto worked with his assistants in the Maddalena chapel, painting scenes from the life of the saint herself as well as of Lazarus and Martha.

Giotto, *Noli me tangere*, ca. 1309, in *Scenes from the Life of Saint Mary Magdalen*. Assisi, lower church of San Francesco, Maddalena chapel.

Giotto

The paintings in the Peruzzi and Bardi chapels in Santa Croce are the last examples of Giotto's work in fresco, because his Neapolitan and Milanese works are now lost.

It is thought that the decoration of the Bardi chapel was carried out after that of the Peruzzi chapel. In the Bardi chapel, Giotto painted scenes from the life of Saint Francis. They take up the theme of the earlier frescoes at Assisi, but with many modifications.

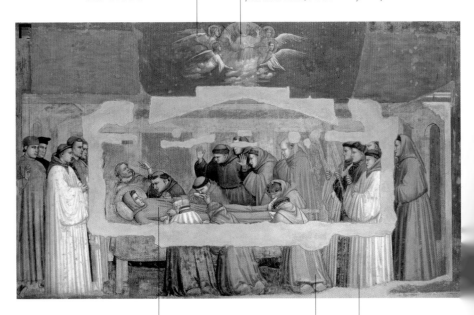

It is interesting to note a change from the Assisi frescoes in the way Saint Francis is represented: here he is beardless.

The human figure has become the real protagonist in these frescoes, as is clear in this scene where Giotto demonstrates that he has now mastered the laws of perspective.

There is a kind of classical simplification in the solemn attitude of the characters and their measured gestures.

▲ Giotto, *The Funeral of Saint Francis and the Verification of the Stigmata*, ca. 1328. Florence, Santa Croce, Bardi chapel.

▶ Matteo Giovannetto, *Saint John the Evangelist, Saint John the Baptist, and Their Ancestors*, 1346–48. Avignon, Palace of the Popes, chapel of Saint John.

He created a highly original style in which an intensely Gothic linearity is accompanied by attention to naturalistic detail and a real portraiture in the faces of his figures.

Matteo Giovannetto

A leading artist in papal Avignon, Giovannetto was superinten-
dent of artistic work in the city during the papacy of Clement VI,
and for twenty-five years the major artistic enterprises there
were linked to him. We have little information about his life.
Documents show that he was a cleric, that he was probably born
around the turn of the 14th century, and that he was at Viterbo
when the antipope had his court there. Giovannetto was about
forty when he went to Avignon, where he played an important
part in the decoration of the Wardrobe Chamber. His earlier
work as a painter is still a matter of study and debate, but his
known work at Avignon was considerable. The sources tell us
that he was responsible for the decoration of the chapel of Saint
Martial from 1344 on and of many rooms in the palace and
other papal buildings in Avignon, as well as the Consistory Hall,
the adjacent chapel of Saint John, the Great Audience Chamber,
and the splendid Villeneuve Charterhouse. He also painted some
panels. When Giovannetto came into con-
tact with French Gothic and the rich cul-
tural atmosphere of the court of Clement
VI, he developed an original style in which
there is a certain taste for the illusionistic
use of space and a keen interest in nature,
facial features, a range of rare, delicate
colors, and the representation of luxury
fabrics—all of which betray his fascination
with the luxury and ostentation of the
papal court. In 1367, he followed Urban V
to Rome, and documents show that he was
involved in the decoration of two Vatican
chapels. He died in 1368 or 1369.

Viterbo (?)–Rome 1368/69

Where he worked
Avignon, Rome

Principal works
Frescoes in the Palace of
the Popes (Avignon,
1343–52); chapel at the
Villeneuve Charterhouse
(Avignon, 1355)

Notes of interest
The acceptance of the new
kind of portrait that
Simone Martini had intro-
duced to Avignon was
confirmed by Matteo
Giovannetto

Matteo Giovannetto

Apart from a Crucifixion painted on the altar, all the scenes tell the story of Saint Martial. The narrative begins in the vaulting, which is divided into four cells, with two scenes in each cell.

Beneath a sky illuminated by gold stars, we see a succession of wealthy laymen, clergy, and ordinary people: a free and lively crowd from the multicolored world of Avignon, gathered around the papal court.

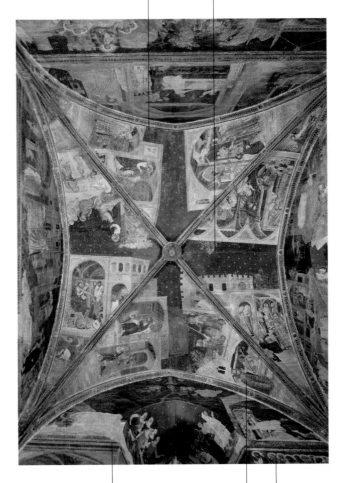

By exalting Saint Martial, who evangelized Gaul, Clement VI was seeking to justify the removal of the papal seat to Avignon.

▲ Matteo Giovannetto, *Scenes from the Life of Saint Martial* (detail), 1344–45. Avignon, Palace of the Popes, chapel of Saint Martial.

The artist was clearly fascinated by the ostentatious luxury of the papal court: he carefully depicts the rich hangings, floors, carpets, brocades, and highly refined clothing.

The pseudo-architectural decoration originally came down to ground level: illusionistic floors, loggias, and piers make it seem that the scenes are viewed from large windows.

The cycle spans the chapel walls and vaulting. The chapel is on the ground floor of the Tower of Saint John (Tour St.-Jean).

On the north and east walls are scenes from the life of Saint John the Baptist, while on the south and west walls are scenes from the life of Saint John the Evangelist. The two saints and their ancestors appear on the vaulting.

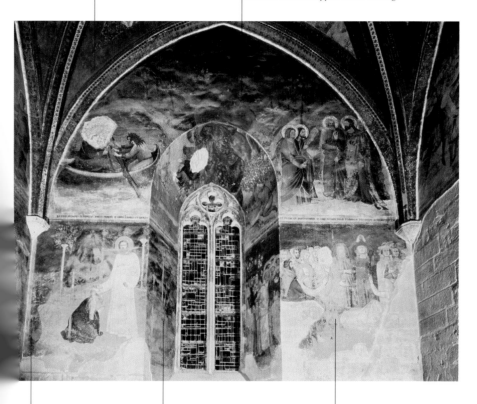

These paintings are more orderly than those in the chapel of Saint Martial. The scenes are less crowded, and instead of interiors we see mostly rural landscapes, rich in vegetation.

The flowing treatment of draperies, beards, and scrolls is clear evidence of a stronger Sienese element in this work, perhaps as a result of a more substantial contribution from assistants.

The artist is trying out new color ranges, which were to have a great influence on courtly art. Once again he dwells on facial features, giving them sufficient individuality to be recognizable.

Matteo Giovannetto, *Scenes from the of Saint John* (detail), 1346–48. gnon, Palace of the Popes, chapel aint John, south wall.

Matteo Giovannetto

The figures are elegant, the beards are curly and soft, the fabrics are luxurious, and the artist uses a palette of costly, delicate colors that emphasize the "courtly Gothic" aspect of the whole and create an almost musical harmony of forms.

All that is left of the decoration is the series of twenty figures of prophets, kings, and patriarchs painted on two large arches of the vaulting (they were announcing the Last Judgment on the back wall, since destroyed), together with the sinopia for a Crucifixion on the east wall.

In the splendid figures of the prophets, the two artistic cultures that mingled in Avignon—the Tuscan, with its massy, solid figures, and the French Gothic, with its ethereal, flashing lines—find their deepest fusion.

The decoration of the Great Audience Chamber was completed after the death of Clement VI (1352) and was paid for under the new pope, Innocent VI.

Matteo's paintings were intended for a cultivated public that had no difficulty in grasping the connection between the various texts and the corresponding images.

This was the room in which the Tribunal of the Rota met. This is where cases concerning benefices were discussed, and the iconographic program of the paintings had a specific didactic purpose, with copious use of quotations from holy scripture.

▲ Matteo Giovannetto, *Prophets* (detail), ca. 1352. Avignon, Palace of the Popes, Great Audience Chamber (Salle de la Grande Audience).

He blended the style of Giotto with French Gothic trends, but added the typically Lombard attention to nature and the exploration of feeling, plus a taste for narration.

Giovanni da Milano

Giovanni was born about 1320 in the Como area and was active in Lombardy and Tuscany in the latter half of the 14th century. Numerous documents of 1346 bear witness to his activity as a painter in Tuscany, and in 1363 he is recorded as a member of the Florentine guild of doctors and chemists. It seems that by then he had already been living in Florence for some time: among other things, he was granted Florentine citizenship in April 1366. Although most of his career as an artist was spent in Tuscany, he is thought to have started out in Lombardy as an adherent of that Giottesque trend that appeared in Milan around the 1340s. In Lombardy he encountered Gothic art through illuminated manuscripts from Bologna and north of the Alps and through links with the papal court at Avignon. Between 1363 and 1369, he painted *The Ognissanti Polyptych* in Florence (its seven panels being intended for the high altar in the Ognissanti church). It has typically Gothic touches in the attention to fashion, the careful portraiture, and the depiction of complex ritual. He also painted a Pietà and frescoes in Santa Croce. Documents show that he was in Rome in 1369 and 1370, where he seems to have worked on frescoes in two chapels in the Vatican palace, in collaboration with Giottino, Giovanni and Agnolo Gaddi, and probably Matteo Giovannetto.

Caversaccio (Como)
ca. 1320–after 1370

Where he worked
Mendrisio, Milan, Florence, Rome, Montecassino(?)

Principal works
Madonna and Child, Saint John the Baptist and a Female Saint (Mendrisio, Santa Maria delle Grazie, 1348–50); *Madonna and Child Enthroned with an Angel, Saints, and Gospel Stories* (Rome, Galleria Nazionale d'Arte Antica, ca. 1350); *Ognissanti Polyptych* (Florence, Uffizi, 1363–69); *Scenes from the Life of the Virgin and Saint Mary Magdalen* (Florence, Santa Croce, Rinuccini chapel, 1365); *Pietà* (Florence, Galleria dell'Accademia, 1365)

Notes of interest
During his career as an artist, Giovanni da Milano achieved a synthesis of Po valley realism and the Tuscan treatment of space, which left its mark on Lombard painting from the 1370s onward.

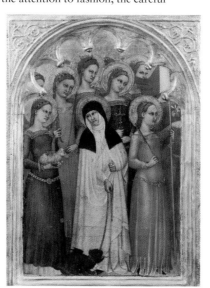

◀ Giovanni da Milano, *The Chorus of the Virgin*, (detail), from *The Ognissanti Polyptych*, 1363–69. Florence, Uffizi.

Giovanni da Milano

The chapel was founded and frescoed as stipulated in the will of Lapo di Lizio Guidalotti, who died in 1350. The frescoes were commissioned from Giovanni da Milano by the capitani of Orsanmichele, who had been left a substantial bequest by Lapo.

Giovanni painted scenes from the life of the Virgin on the left-hand side of the chapel, and scenes from the life of Saint Mary Magdalen on the right. The two lunettes show the Expulsion of Joachim from the Temple and the Feast in the House of Levi.

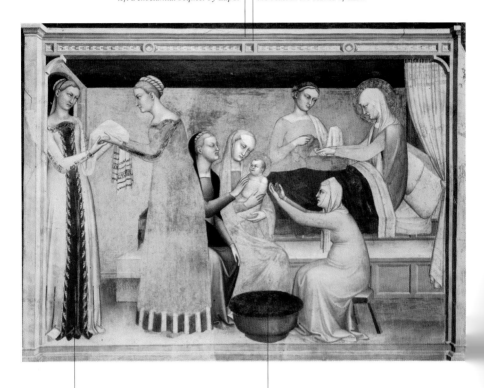

The human figures in these frescoes help to define space. The bright color range, the taste for detail, and the luxury materials foreshadow International Gothic.

The cycle was painted almost entirely in true fresco, a considerable area of wall space being covered in each day's work. Giovanni painted a large proportion of the cycle himself with surprising speed and skill, adapting to plaster the techniques typical of panel painting and manuscript illumination.

▲ Giovanni da Milano, *The Birth of the Virgin*, 1365, from *Scenes from the Life of the Virgin and Saint Mary Magdalen.* Florence, Santa Croce, Rinuccini chapel.

The tears of Mary and Mary Magdalen are made of varnish in relief.

This is a severe composition, in which the figures are erect and full size, portrayed in three-quarter view, and forming a single block.

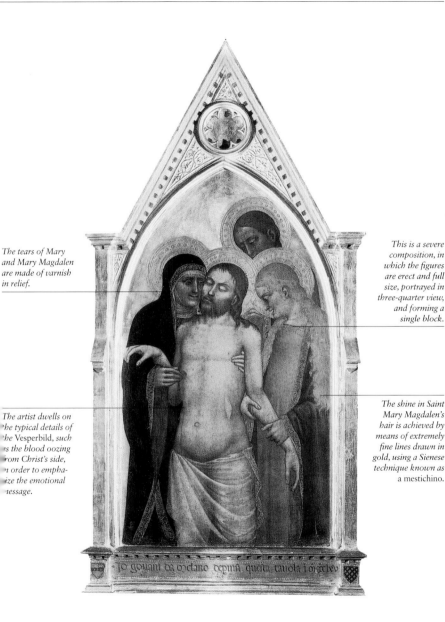

The artist dwells on the typical details of the Vesperbild, such as the blood oozing from Christ's side, in order to emphasize the emotional message.

The shine in Saint Mary Magdalen's hair is achieved by means of extremely fine lines drawn in gold, using a Sienese technique known as a mestichino.

Giovanni da Milano, *Pietà*, 1365.
Florence, Galleria dell'Accademia.

Giovanni Pisano

Pisa 1245/48–Siena 1318

Where he worked
Pisa, Perugia, Siena, Pistoia, Padua, Genoa

Principal works
Sculpture project for the cathedral facade (Siena, ca. 1285–ca. 1297); pulpit (Pistoia, Sant'Andrea, completed in 1301); pulpit (Pisa, cathedral, 1302–10); funerary monument of Queen Margaret of Brabant (Genoa, Galleria di Palazzo Bianco, 1312–13)

Notes of interest
As the inscription on Pisa Cathedral pulpit records, he also made goldwork and wood sculpture, a field in which he is considered one of the most important innovators.

We have no documentary records about the early years of Giovanni, son of Nicola Pisano, but it seems very likely that he trained with his father; a document of 1265 announces the beginning of work on the Siena cathedral pulpit, at which time Giovanni was listed as one of Nicola's assistants. In Giovanni's work one can clearly see an increase in dramatic tension, and his artistic career moved gradually from early inspiration in the classical toward the decidedly Gothic. We know little about his early works (1269–75), but he was certainly working at important sites: the Pisa baptistery (early 1270s) and the "Fontana Maggiore" at Perugia (1267–68), one of the first city fountains of medieval times. When the work at Perugia was finished, Giovanni returned to Pisa, where he was made master of works for the baptistery site. In 1284 or 1285 he obtained Sienese citizenship, and a document of 1287 records him as *capomastro* of the Siena cathedral site, where he designed an important cycle of monumental statues for the facade. In 1296 or 1297 he left Siena, although the cathedral facade had not been completed. Around 1298 he was hired to make the pulpit for the church of Sant'Andrea in Pistoia. When that was finished, he was asked by the chapter of Pisa cathedral (where in 1297 he had been appointed *caput magister*) to make a new pulpit; this he completed in 1310. Other important works include the funerary monument of Queen Margaret of Brabant in Genoa and some splendid works in ivory and wood.

► Giovanni Pisano, *Crucifix*, late 13th century. Pisa, Museo dell'Opera della Primaziale Pisana.

The nine reliefs tell the story of salvation in twenty-four scenes. Ten figures are placed at the corners between the scenes. In the intermediate area are ten sibyls as representatives of paganism who foretold the coming of Christ.

The narrative flows without interruption, creating a circular effect that enhances the plasticity of the figures.

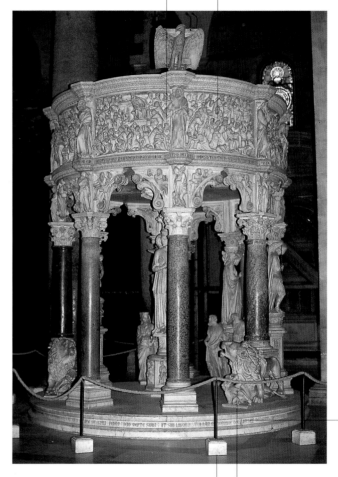

Of the original inscription that ran along the pulpit, only a fragment remains, but the rest is known from the sources. In it, Giovanni stresses the personal nature of the work and complains that he was not sufficiently compensated for its real value. This is a very important inscription because it shows that the artist is aware of the prestige of his own work.

Giovanni Pisano, pulpit, 1302–10. a, cathedral.

The Pisa pulpit was used for readings from the Gospels and Epistles, for displaying relics, and, during the period of the commune, for knighthood investitures.

The evident Gothic qualities are accompanied by some explicitly classical thinking in the composition and iconography (the figure of Prudence recalls Hellenistic Venuses).

315

Giovanni Pisano

Characteristic of Giovanni Pisano's Virgins is a composition based on the emotional relationship between Mary and the Child: the exchange of glances between them is both tender and dramatic. The style of these works is clearly innovative.

The compositional arrangement of the Madonna and Child derives from his knowledge of French sculpture, but Giovanni adds a new tension in their bodies and greater humanity.

During his thirty-five years of artistic activity, Giovanni Pisano made a series of whole or half-figure Madonnas, mostly in marble, but some in ivory.

▲ Giovanni Pisano, *Madonna and Child between Two Angels*, ca. 1306. Padua, Scrovegni chapel.

A Paduan painter who trained at the Carrara court, Guariento took account of Giotto's art but reinterpreted it in an elegant, Gothic manner and finally adopted a kind of Byzantine style.

Guariento

Guariento probably trained at Padua, which was a lively art center thanks to the patronage of the Carrara family and Giotto's numerous visits. His earliest known work is the Bassano del Grappa *Crucifix*, signed by the artist and dated by scholars to about 1332. It echoes the style of Giotto but has Gothic elements in the use of light and the richer draperies. Guariento first appears in documents in 1338 as working in the Eremitani church in Padua, where he probably carried out the decoration of the second chapel on the right, but only parts of a few figures of saints have survived. Over the years his style became increasingly Gothic. This is evident as early as 1344 in his *Coronation of the Virgin Altarpiece*. It was commissioned by Alberto, archpriest of Piove di Sacco, who was a friend of the Carrara family, to which Guariento became a kind of court painter. Thus in 1350–51 he frescoed the tombs of Ubertino and Jacopo II, lords of Padua. Only fragments of the decoration have survived, but they are enough to reveal that his artistic language was almost Venetian, with particular echoes of Veneziano. These new features appear again in the decoration of the Carrara palace chapel, ca. 1354. In the years that followed, Guariento obtained prestigious commissions at both Padua and Venice, among them frescoes in the presbytery of the Eremitani church in Padua and in the Sala del Maggior Consiglio in the Doge's Palace in Venice.

Piove di Sacco (Padua) ca. 1310–before 1370; documented from 1338 to 1367

Where he worked
Bassano del Grappa(?), Padua, Venice

Principal works
Crucifix (Bassano del Grappa, Museo Civico, ca. 1332); *Coronation of the Virgin Altarpiece* (Pasadena, Norton Simon Museum of Art, 1344); decoration of the private chapel in the Carrara palace (Padua, Accademia Patavina di Scienze, Lettere e Arti, ca. 1354); frescoes for the Sala del Maggior Consiglio (Venice, Doge's Palace, 1365–68)

Links with other artists
Paolo Veneziano

Notes of interest
When Guariento was hired to decorate the Sala del Maggior Consiglio, it was the first time in the history of Venice that such a prestigious job had gone to an artist who did not belong to the Venetian guild of painters.

◄ Guariento, *Crucifix*, ca. 1332. Bassano del Grappa, Museo Civico.

317

Guariento

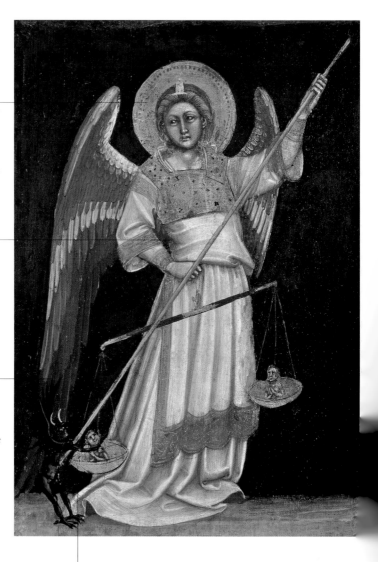

The delicate lines of the angel's face, the richly embroidered robe, and the refined painting technique all tell of Guariento's close relationship with the world of Venice.

The almost dance-like movement of the angel and the delicate color variations in the robes belong to a more modern and decidedly Gothic artistic vision.

The chapel walls were decorated with frescoes of scenes from the Old Testament. Panels with figures of angels were placed in the upper part of the chapel, and there was a painting of the Madonna and the four evangelists on the wooden ceiling.

The decoration of the private chapel in the Carrara royal palace was extraordinarily striking: displayed all together, these exquisitely colored and preciously detailed panel paintings created a brilliant vision of the heavenly hierarchies of angels.

▲ Guariento, *An Archangel Weighing Souls*, ca. 1354. Padua, Musei Civici.

Jan Boudolf was a Flemish artist of consummate skill and profound artistic culture. He was in the service of King Charles V of France in the second half of the 14th century.

Jan Boudolf

Records show that Jan Boudolf, also called Hennequin de Bruges and Jean Bondol, was in the service of King Charles V of France in the second half of the 14th century. His Flemish origin is confirmed by the fact that he is sometimes referred to in documents as Jehan de Bruges and signed himself "Johannes de Brugis" on his only surviving work. He must have been highly regarded at the French court—in 1368 the king awarded him a house—but his only surviving work is a very famous miniature in a manuscript of the *Bible historiale* given to Charles V by his counselor Jean de Vaudetar. In it the king is seen receiving the precious manuscript from the hands of his counselor; an inscription in gold letters records that the work was painted in honor of Charles V in the year 1372, and that "Johannes de Brugis, pictor Regis predicti, fecit hanc picturam propria sua manu." Another important work attributed to Jan is the series of Apocalypse tapestries at Angers—the largest surviving series of medieval tapestries. The series was commissioned by the Duke of Anjou, brother of Charles V. The numerous scenes are introduced by the monumental figure of an old man sitting at a lectern on the extreme left of each tapestry. Jan probably made the sketches and at least some of the full-scale cartoons on which the tapestries were based.

Bruges, first half of the 14th century–(?); documented from 1364 to 1380 in the service of Charles V

Where he worked
Paris

Principal works
Illuminated page from the *Bible historiale* (The Hague, Rijksmuseum, 1372); Apocalypse tapestries (Angers, castle, Galerie de l'Apocalypse, ca. 1380)

Notes of interest
The extent of Jan Boudolf's involvement in the cartoons for the Angers *Apocalypse* is still debated. A document of 1378 shows that he had prepared *portraitures et patrons* for the tapestry series. This term was used to refer to full-scale models on which the weaving was based. It seems clear, at any rate, that Jan was responsible for designing and preparing the series.

◀ Jan Boudolf, *An Angel Announcing the Good News* (detail), ca. 1380, Tapestry 4 in the Apocalypse series. Angers, castle, Galerie de l'Apocalypse.

Jan Boudolf

Charles V sits in a pavilion decorated with the gold fleur-de-lis of France. He is wearing a soft robe, and Jean de Vaudetar, in a tight-fitting gray costume, is presenting him with the rich and carefully painted manuscript.

One can see Italian innovations in the miniature in its organization of space, and a kind of naturalism in the depiction of reality.

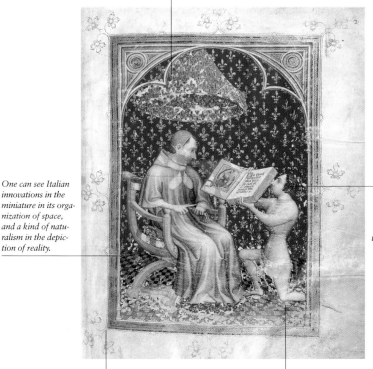

The two faces are particularly expressive and are painted with close attention to the facial features.

The miniature is signed and is painted on a double leaf that is independent of the rest of the codex. These pages differ quite substantially from the rest of the manuscript, but they have been bound in.

The scene is represented as though seen through a window, and the floor in perspective is reminiscent of Sienese painting.

▲ Jan Boudolf, *Jean de Vaudetar Presenting the Bible to Charles V,* illuminated page from the *Bible historiale* of Guiart des Moulins, 1372. The Hague, Rijksmuseum.

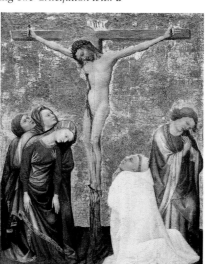

Jean de Beaumetz was court painter to the dukes of Burgundy. His sober, refined works make him the last exemplar of an aristocratic aesthetic that was already being called into question.

Jean de Beaumetz

The activities of Jean de Beaumetz are documented from 1361, when he is recorded as working at Valenciennes, to 1396, the year of his death. He worked chiefly at the court of Philip the Bold in Burgundy. The name "Beaumetz" suggests that his birthplace was in northern France. He lived in Paris around 1371 and in 1376, when he became painter and *valet de chambre* to Philip the Bold. But in that same year, he left Paris for Dijon, where he remained until his death. His activities were very varied, ranging from the decoration of the duchess's carriage and a sundial sculpted by Claus Sluter to important works such as the decoration of the oratory in the duke's palace at Dijon (1381) and of other ducal castles. However, he focused chiefly on the Carthusian monastery at Champmol, which housed the mausoleum of the dukes of Burgundy. In 1387–88, he painted the church vaulting at Champmol, and the following year he began work on twenty-six panels for the cells of the prior and monks. Today, we know of only two of these, both depicting *The Crucifixion with a Carthusian Monk in Prayer*. They display clear echoes of Sienese painting in the gestures of Saint John and the Virgin and in a certain fastidiousness, as well as a kind of northern ascendancy in the rendering of fabrics and flesh tones and the mystic expressions of the two Carthusians. In 1389, he began work on decorating the ducal oratory at the monastery.

Beaumetz(?) before the mid-14th century–Dijon October 16, 1396; documented in Burgundy from 1361 to 1396

Where he worked
Paris, Dijon

Principal works
Decoration of the oratory in the ducal palace (Dijon, to 1381); at the Carthusian monastery of Champmol: decoration of the vaulting in the church (Dijon, 1387–88), panels for the monks' cells (Dijon, from 1389); decoration of the ducal oratory (Dijon, 1389)

Notes of interest
Like all winged altars, the triptych that Jean de Beaumetz painted in 1390 for the oratory at the Champmol monastery was used to draw attention to the importance of certain days in the liturgical calendar: its wings were opened only on major feast days.

◄ Jean de Beaumetz, *The Crucifixion with a Carthusian Monk in Prayer*, 1389. Paris, Louvre.

Jean Pépin de Huy was a sculptor and alabaster engraver in the service of Countess Mahaut d'Artois. He also made several important funerary monuments for her.

Jean Pépin de Huy

Huy late 13th century–(?);
documented in the service
of Countess Mahaut
d'Artois from 1311 to 1329

Where he worked
Northern France

Principal works
Funerary monument of
Duke Otto of Burgundy
(1311–12; the only
remnant is a pleurant at
Vesoul in the Cousin
collection); funerary
monument of Robert
d'Artois (Saint-Denis,
cathedral, 1318); funerary
monument of Margaret
of Clermont (1326; lost);
Madonna and Child (from
the Carthusian monastery
of Mont-Sainte-Marie at
Gosnay, Arras, Musée des
Beaux-Arts, 1329)

Active in northern France in the early 14th century, Jean Pépin de Huy came from the Meuse valley region (Huy is near Liège). His name often appears in Countess Mahaut d'Artois's ledger of expenses as "alabaster engraver" and designer of funerary monuments. He seems to have depended heavily on her patronage and we hear no more of him after her death in 1329. In 1311–12, at her request, he made an alabaster tomb for her husband, Duke Otto of Burgundy, but all that survives is the figure of a pleurant (a person weeping). These figures were to become increasingly common in Burgundian funerary sculpture. In 1318, he made a tomb for the countess's son Robert; formerly in the church of the Cordeliers in Paris, it is now at Saint-Denis. The last documented work of Jean de Huy is a small marble *Madonna and Child*, dated 1329, which the countess gave to the Carthusian monastery of Mont-Sainte-Marie at Gosnay. Documents concerning payments to the goldsmith Étienne de Salins show that the statue was to have been given a gilt silver crown with precious stones and enameling, as well as a plinth and a black marble canopy. Jean de Huy was also responsible for other works that are now known only through documents, including the tomb for Jean, another son of Mahaut d'Artois, and six alabaster statues that the countess gave to various convents. Finally, Jean de Huy was responsible for the funerary monument of Margaret of Clermont. Formerly the church of the Jacobins in Paris, it is his only known work that was not commissioned by the countess.

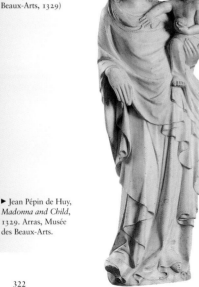

▶ Jean Pépin de Huy,
Madonna and Child,
1329. Arras, Musée
des Beaux-Arts.

The tomb of Robert, son of Countess Mahaut d'Artois, was originally to have been in the church of the Cordeliers in Paris. It is now at Saint-Denis, among the French royal tombs.

Although this is still a fairly anonymous statue and does not faithfully portray the facial features of Countess Mahaut's son, it nevertheless has a certain fascination.

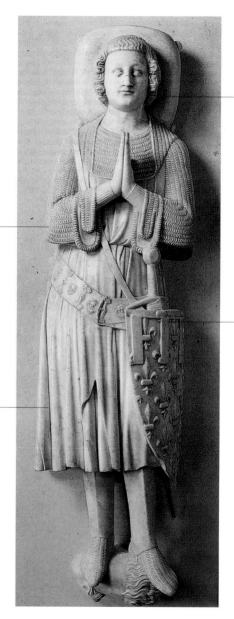

In this period, artists and those who commissioned funerary monuments preferred an idealized figure of the deceased person.

The recumbent figure of Robert d'Artois is dressed as a knight, with sword and shield decorated with fleurs-de-lis. As with Otto of Burgundy's monument, his feet rest on a lion.

Jean Pépin de Huy, Funerary Monument of Robert d'Artois (detail), 8. Saint-Denis, cathedral.

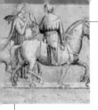

He was a sculptor in the service of King Charles V of France and brought the innovations of French sculpture to England, where he was responsible for the tomb of Philippa of Hainault.

Jean de Liège

Liège second quarter of the
14th century–Paris 1381

Where he worked
Paris

Principal works
Funerary Monument of
Philippa of Hainault
(London, Westminster
Abbey, 1367); *Gisants
of Jeanne d'Évreux and
Charles IV the Fair* (Paris,
Louvre, ca. 1370–1372);
Bust of Marie de France
(New York, Metropolitan
Museum, 1380–81)

Links with other artists
Jean Pépin de Huy

Notes of interest
This sculptor in the service
of Charles V should not
be confused with another
Jean de Liège, who was
carpentarius and architect
to the counts of Savoy
between 1383 and 1393
and then worked in Paris.
A third Jean de Liège is
recorded at Dijon in
the 1380s and then at
Champmol, where he
was responsible, around
1399–1400, for the stalls
for the officiants.

▶ Jean de Liège, Bust of
Marie de France, 1380–81.
New York, Metropolitan
Museum.

This sculptor came from Liège in the Meuse valley and was in Paris in 1361, working on the tomb of Jeanne de Bretagne in the chapel of the Orléans Dominicans. In 1364 he was evidently working under the direction of Guy de Dammartin in the Louvre, where he was responsible for statues of the king and queen, and he may have been in London around 1367, making the tomb of Philippa of Hainault, wife of Edward III. He may not have been in England himself, for while he appears as "Hankinon de Liège de Francia" in the accounts for the queen's tomb, it is almost certain that the tomb came directly from France. From 1368 onward, his work was closely linked to commissions from King Charles V of France and his court. For the king, Jean de Liège made a "heart tomb" (this custom, begun by Charles IV, involved burying the heart and entrails separately from the rest of the body). Around 1370, he was working on the *gisants* (recumbent figures) for the entrails of Jeanne d'Évreux, wife of Charles IV, and of Charles IV the Fair for the abbey at Maubuisson. At the same period, he was arranging the installation of the queen's "heart tomb" in the Jacobin church and the tomb for her body at Saint-Denis. Jean de Liège died in 1381. From his bequests we can deduce that he was very productive as an artist and that he was probably related to Jean Pépin de Huy. In view of his long career in Paris in the service of the French king and his court, a great many works have been attributed to him, such as the tombs of Blanche and Marie of France, which are also at Saint-Denis.

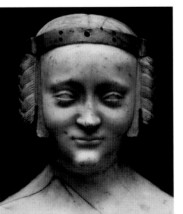

There is considerable
suffering in the face of
the deceased queen, but
this is deliberately not a
portrait: it is rather the
"personification" of a
tomb figure.

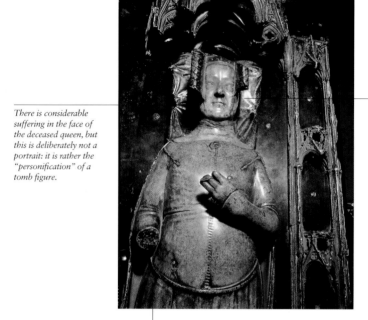

The style of Jean de
Liège contains an
echo of courtly art
and considerable
sensitivity in the
portrayal of facial
features.

Jean de Liège's funerary monuments
contributed to the development of
a new concept of plasticity and a
more realist idiom, which had been
unknown in the artistic circles of
London up to that time.

Jean de Liège, Funerary Monument of
Philippa of Hainault, 1367. London,
Westminster Abbey.

Certain details, such as the king's refined face and hands, are admirably executed.

In each case, the left hand is raised to the chest and holds a small bag containing the entrails. This is a reminder of what is buried there.

These two small statues (107 and 112 cm, or 42 and 44 in.) are thought to be largely the work of Jean de Liège's workshop, because of a certain attachment to conventional formulae.

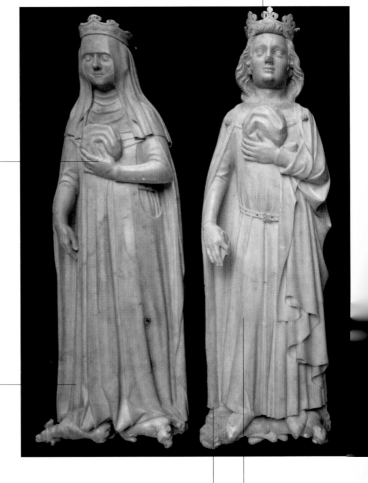

Charles IV had requested that after his death his body be laid to rest at Saint-Denis, but that his heart be in the care of the Paris Dominicans and his entrails deposited at Maubuisson.

The king's robe is draped with perfect mastery and falls softly over his knee with only the slightest fold.

▲ Jean de Liège, *Gisants of Jeanne d'Évreux and Charles IV the Fair*, ca. 1370–72. Paris, Louvre.

Jean Le Noir inherited both the style and workshop of Jean Pucelle. He was a great miniaturist, and his style is characteristically more dramatic and ornamental than that of his master.

Jean Le Noir

He worked as a miniaturist in Paris and Bourges from about 1335–40 to 1380. A 1338 document records that he and his daughter Bourgot, also a miniaturist, were given a house by then prince regent Charles as reward for work carried out at the court of his father, John the Good. The same document tells us that Jean had worked at the court of Yolande of Flanders. In 1372 and 1375, his name appears as miniaturist to the king in a list of payments made by Duke Jean de Berry. Debate has long raged regarding the attribution of works to Jean Le Noir, and his identity as well (he has been confused with the Master of the Passion). Today, Jean Le Noir is generally recognized as a pupil of the great Jean Pucelle, whose elegant, refined style he inherited, adding his own concept of space and a way of representing landscape that derives from Sienese art. His hand has been recognized in the most important pages of *The Book of Hours of Yolande of Flanders* (ca. 1355); in the cycle of the Virgin and that of the Passion in *The Book of Hours of Joanna of Navarre* (1336–40), and in *The Psalter of Bonne of Luxembourg* (before 1349). Between 1364 and 1370, he also illuminated *The Breviary of Charles V*, in which he took up a number of ideas from Jean Pucelle's *Belleville Breviary*, but gave them a decidedly personal, more dramatic interpretation. He died around 1380, still working on *Les Petites Heures du Duc Jean de Berry*.

Active in Paris and Bourges from 1335–40 to ca. 1380, the probable year of his death

Where he worked
Paris, Bourges

Principal works
Cycle of the Virgin and the Passion, *Book of Hours of Joanna of Navarre* (Paris, Bibliothèque Nationale, 1336–40); *Psalter of Bonne of Luxembourg* (New York, Metropolitan Museum, The Cloisters, before 1349); *Book of Hours of Yolande of Flanders* (London, British Library, ca. 1355); *Breviary of Charles V* (Paris, Bibliothèque Nationale, 1364–ca. 1370); *Petites heures du duc Jean de Berry* (Paris, Bibliothèque Nationale, 1375–ca. 1380)

Links with other artists
Jean Pucelle

◀ Jean Le Noir, *Arma Christi*, before 1349, illuminated page from *The Psalter of Bonne of Luxembourg*. New York, Metropolitan Museum, The Cloisters.

The coffered ceiling, the architecture around the image, and Mary's protective curtain all give depth to the room, in a spatial arrangement that is influenced by Italian art.

This image catches Mary just as she receives the news from the archangel. At the same time she is bathed in divine light to indicate conception.

Many of the 243 miniatures in the breviary are inspired by Jean Pucelle, but the difference between them can be seen in Jean Le Noir's greater use of color and a sense of space influenced by Italian art.

This manuscript was probably commissioned by King Charles V of France, whose features can be discerned in the royal figure in the last miniature in the psalter.

▲ Jean Le Noir, *The Annunciation*, 1364–ca.1370, illuminated page from *The Breviary of Charles V*. Paris, Bibliothèque Nationale.

Peter, standing at the left in pink, is sheathing the sword he has just used to strike Malchus, who has collapsed in a heap. There is something of the caricature in the figure of Malchus, which is reminiscent of northern painting.

The figures in the Capture of Christ crowd around Judas and Jesus with a succession of gestures and glances.

The miniatures in this manuscript, which belonged to Jean de Berry, are Jean Le Noir's last known work. It was begun around 1375 and completed by Jacquemart de Hesdin.

The cycle of the Passion is entirely the work of Jean Le Noir and reveals a particular attention to facial expression and gesture.

The narrative carries on in the bas-de-page with a kind of caricatural realism.

Jean Le Noir, *The Capture of Christ*, 1375, illuminated page from *Les Petites Heures du Duc Jean de Berry*. Paris, Bibliothèque Nationale.

Konrad von Soest is one of the most significant late-14th-century artists in northern Germany, and the most authoritative exponent of the Weicher Stil, *the international style of the time.*

Konrad von Soest

Dortmund(?)
ca. 1360/70–after 1422

Where he worked
Dortmund

Principal works
The Passion Altarpiece
(Bad Wildungen, parish church, 1403); *The Mary Altarpiece* (Dortmund, church of Saint Mary, ca. 1420)

Notes of interest
Only fragments of the Dortmund Mary altarpiece survive: the wings and the central panel with *The Death of the Virgin* were trimmed at the edges and inserted into a Baroque altarpiece in 1720.

Konrad was probably born at Dortmund in Westphalia around 1360–70, and it was there that he married Gertrud von Münster in 1394. The second of his major works, *The Mary Altarpiece*, of which only fragments survive, is at Dortmund. It seems likely that citizens of the nearby Hanseatic town of Soest commissioned works from him. His name is inscribed on the frame of *The Passion Altarpiece*, a winged altarpiece now in the parish church at Bad Wildungen in Hessen, which tells us that the work was executed by "Conradum de Susato." His name also appears a number of times between 1413 and 1422 in the lists of members of the confraternity of the Nikolaikirche at Dortmund. *The Passion Altarpiece*, which survives in its entirety, is considered the masterpiece of Konrad's early career. Two other panels from Soest, depicting Saints Dorothea and Odilia in a meadow (now in the Westfälisches Landesmuseum at Münster), are thought to belong to a slightly later period, as does the much-debated panel of *Saint Nicholas and Four Saints* (in the Nikolaikapelle at Soest). His second masterpiece, the Dortmund altarpiece, is thought to be one of his last works and

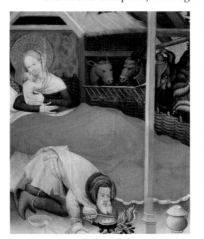

▶ Konrad von Soest, *The Nativity*, 1403, panel from *The Passion Altarpiece*. Bad Wildungen (Germany), parish church.

may date to shortly before his death in the 1420s. Konrad found his inspiration in the art of western Europe and especially in that of northern France, which may have reached him in the form of manuscript illuminations. He had considerable influence on painting in Westphalia and neighboring regions.

The altarpiece is still in its original location. It has thirteen scenes from the life of Jesus.

The characteristics of Konrad von Soest's painting are its vitality, the concern for detail, and his great skill in composing a scene.

His attention to luxurious details, such as the fabrics, the plants, and the little greyhounds, transform the drama of the Crucifixion into a courtly scene.

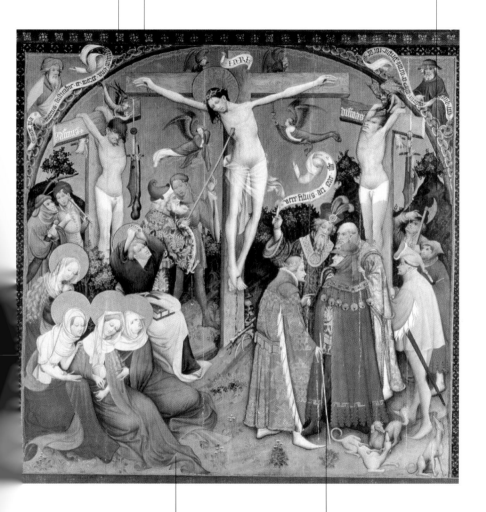

Konrad von Soest, *Mount Calvary*, ◌3, central panel of *The Passion* ◌arpiece. Bad Wildungen (Germany), ◌ish church.

Below the cross, from the left, are the three Marys, Saint John raising his arms in grief, and Longinus with his spear.

On the right, a group of people has gathered around the good centurion, close to whom is a scroll with the words "vere filius dei erat iste."

"A very fine artist, and a man of great genius. He was an excellent draughtsman and very expert in the theory of that art" (L. Ghiberti, I commentari, 15th century).

Ambrogio Lorenzetti

Siena(?) late 13th century–1348(?)

Where he worked
Florence, Siena

Principal works
Four Miracles of Saint Nicholas (Florence, Uffizi, 1332); frescoes in the Montesiepi chapel (1334–40); *Maestà* (Massa Marittima, Municipio, ca. 1335); frescoes in the Palazzo Pubblico (Siena, 1337–39); *Annunciation* (Siena, Pinacoteca Nazionale, 1344)

Links with other artists
Arnolfo di Cambio, Giotto, Pietro Lorenzetti

Notes of interest
In 1345, Ambrogio made a rotating world map for the Palazzo Pubblico, which showed, on cloth or parchment, the territories of the Sienese republic and probably "the whole habitable world" as Ghiberti puts it. The fame of this work (now lost) was such that the room where it was located is still called the Sala del Mappamondo.

▶ Attributed to Ambrogio Lorenzetti, *Coastal City*, ca. 1340. Siena, Pinacoteca Nazionale.

332

Lorenzetti was a deeply cultured artist with wide intellectual horizons, as Ghiberti and Vasari inform us: the latter describes him as a painter, philosopher, and man of letters. We have evidence, too, that Ambrogio was keenly interested in antiquity, and classical themes and motifs found expression in his works. He was a keen student of nature, as we can see in his many landscapes and depictions of weather phenomena such as hail. Little is known about his life and works. From an inscription below the frescoes (now lost) on the facade of the hospital of Santa Maria della Scala in Siena, we know that he was the son of a certain Lorenzo and brother of Pietro, who was also a painter and probably older than Ambrogio. The first date we can attach to Ambrogio is that on a *Madonna and Child* from Vico l'Abate near Florence (1319). Documents place him there in 1321, and from 1328–30 he was inscribed in the local guild of doctors and chemists. Ambrogio's career as an artist lasted for about thirty years and is marked by innovative works such as *The Miracles of Saint Nicholas* (1332), the frescoes in the Montesiepi chapel (1334–40), the *Maestà* painted for the church of Sant'Agostino at Massa Marittima (ca. 1335), the frescoes on the exterior of the hospital of Santa Maria della Scala (1335), which he painted with his brother Pietro, and finally the great fresco decoration of the hall where the Nine held their meetings in the Palazzo Pubblico in Siena (1337–39). He probably died of the plague in 1348.

This Madonna is the earliest work attributed to Lorenzetti. It is dated 1319. It is unsigned but is attributed to him on the basis of a comparison with other thoroughly authenticated works.

The solemn arrangement of the Madonna seems to echo Romanesque and Byzantine models, but volumes are rendered in a way that is already that of Giotto and Arnolfo.

Although this is the first work attributed to him, Ambrogio already has his own personal idiom and total stylistic coherence.

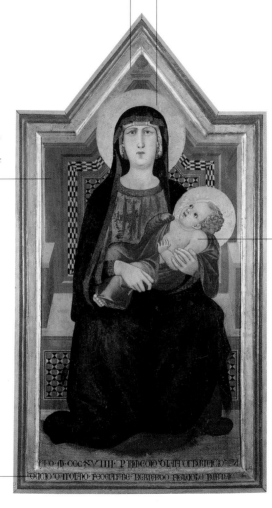

The restless Child is very different indeed from those found in Byzantine icons.

The inscription running along the bottom explains that the work was commissioned by Bernardo, son of Burnaccio da Tolano, to redeem the soul of his father. Tolano is in the Chianti region, not far from the church of Sant'Angiolo at Vico Abate. That is probably where the panel was placed.

Ambrogio Lorenzetti, *Madonna and Child*, 1319. San Casciano Val di Pesa (Florence), Museo di Arte Sacra.

Ambrogio Lorenzetti

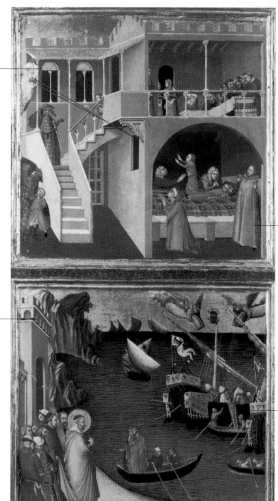

The scene of the Miracle of the Child Suffocated by a Devil is set in a complex architectural structure, with stairs, loggias, balconies, and rooms in which the various stages of the action unfold.

The cycle depicts a total of four scenes: the Miracle of the Child Suffocated by a Devil (left), Saint Nicholas Giving a Dowry to Three Poor Spinsters, the Miracle of the Grain (below), and the Consecration of Saint Nicholas.

Characteristic of these miracles is the boldness with which the painter treats the perspective of the view. This was so admired in Florentine circles that, according to Vasari, the work "increased his fame and reputation enormously."

In the depiction of the Miracle of the Grain, which saved the city of Myra, the seascape is given an extraordinary sense of recession into the far distance.

▲ Ambrogio Lorenzetti, *The Miracle of a Child Suffocated by a Devil* and *The Miracle of the Grain*, 1332, from *The Four Miracles of Saint Nicholas*. Florence, Uffizi.

The Massa Marittima Maestà
seems to take up the theme of
Duccio's painting in Siena cathe-
dral and interpret it in a more
modern way.

*The Virgin sits with the Child on a high
throne, surrounded by angels playing
musical instruments and bearing
flowers, and accompanied at the bot-
tom by the three theological virtues.*

*Behind the angels is a
court of saints, apostles,
and prophets who are wor-
shipping the Madonna.*

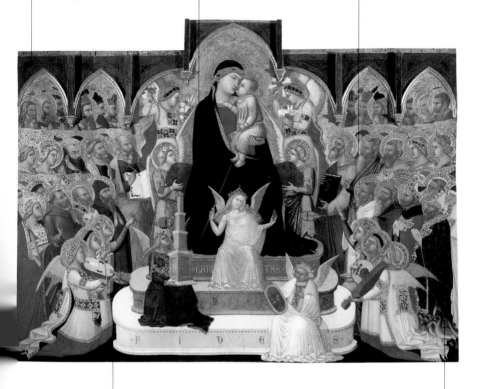

*The composition
takes up the whole
surface and seems to
advance from the
back toward the
spectator.*

*Among the saints one can
recognize Saint Cerebonius,
patron saint of Massa
Marittima, with the geese
that accompanied him
when he presented himself
to the pope.*

Ambrogio Lorenzetti, *Maestà*,
1335. Massa Marittima, Municipio.

Ambrogio Lorenzetti

Instead of the Virtues, we have a court of Vices taken from a stock of infernal images, personifications of the particular demons of society in the communes: Treachery, Discord, and War.

There are verse inscriptions in the vernacular to assist one in reading the work: Bad Government exists where Justice does not reign. Here she lies bound at the feet of a fearsome horned monster: Tyranny.

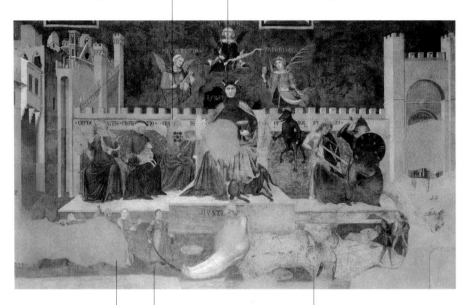

The Good Government cycle (see p. 14) is a kind of political tract spread across three walls of the Sala dei Nove, the center of Sienese political power.

On the central wall of the Sala dei Nove is the Allegory of Good Government. The right-hand wall provides a description of its effects in town and country, while the left-hand wall deals with Bad Government.

The city is prey to destruction and pillage, and the streets are infested with soldiers. The abandoned countryside is left to armed soldiers bent on looting.

▲ Ambrogio Lorenzetti, *Allegory of Bad Government*, 1337–39. Siena, Palazzo Pubblico, Sala dei Nove.

There are unusual iconographic details in this scene: the angel has three wings and holds a palm leaf instead of a lily.

The Madonna's gaze is directed toward the divine figure depicted between the two arches, and she utters the words "Ecce ancilla domini": this is the moment when Mary accepts her divine mission.

In his continual search for new ways of rendering perspective, Ambrogio has here created a floor that coordinates the relationship between the frame, the picture plane, and the solid figures of angel and Virgin.

The fact that the Virgin's semicircular throne is seen at an angle contributes to a sense of depth. But the scene is denied three-dimensionality by the featureless gold background.

Ambrogio Lorenzetti, *The Annunciation*, 1344. Siena, Pinacoteca Nazionale.

The statuesque central figures of the Madonna and Saint Joseph, with their companions, are placed in a cross section of a church with a nave and two aisles, surmounted by a polygonal lantern.

▲ Ambrogio Lorenzetti, *The Presentation of Jesus in the Temple*, 1337–42. Florence, Uffizi.

The floor tiles create a strong impression of recession in perspective, and it is accentuated by the series of piers behind the altar leading to a distant choir in semidarkness.

Ambrogio was commissioned by the commune of Siena to paint this large panel for the altar in the chapel of San Crescenzio in the cathedral.

"Pietro Lorenzetti . . . experienced that great contentment which comes to those who excel, when they see that their talents are desired by all men" (G. Vasari, Lives, 15th century).

Pietro Lorenzetti

Together with his brother Ambrogio, Pietro Lorenzetti contributed much to the development of the "modern" pictorial language that Giotto had created, producing a personal vision that was also affected by the spiritual climate of Siena. The earliest document referring to a painter who was probably Pietro dates to 1306; because this painter was paid personally, he must have been at least twenty-five at the time, which puts his birth around 1280. His first recorded work is a polyptych for Santa Maria della Pieve in Arezzo (1320), but it is thought that he began his career as an artist at Assisi, where he painted *Scenes from the Passion of Christ "ante mortem"* in the lower church (ca. 1315 to 1319). The earliest of these may be *Madonna and Child between Saint John the Baptist and Saint Francis* in the Orsini chapel. They are noted for their exceptionally bright colors and experimentation in rendering space, based on the study of Giotto. The work was interrupted in 1319, but it was resumed no later than 1322 with the *"post mortem"* scenes, which are among the highest achievements of 14th-century Italian painting. There are many works by Pietro in Siena, its dependent territories, Florence, and Arezzo. At some points, his artistic career seems to have linked up with his brother's, and they may have run a workshop together. Pietro died around 1348, probably of the plague.

Siena(?) ca. 1280–1348(?)

Where he worked
Assisi, Siena, Arezzo, Florence

Principal works
Scenes from the Passion of Christ "ante mortem" and *"post mortem"* (Assisi, lower church of San Francesco, ca. 1315–19 and ca. 1322); *Madonna del Carmine Altarpiece* (Siena, Pinacoteca Nazionale, 1329); *Altarpiece of Blessed Humility* (Florence, Uffizi, 1341)

Links with other artists
Ambrogio Lorenzetti, Simone Martini

Notes of interest
An inscription under some frescoes (now destroyed) at the hospital of Santa Maria della Scala in Siena provides evidence that Ambrogio was his brother ("eius frater").

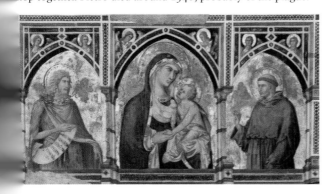

◀ Pietro Lorenzetti, *Madonna and Child between Saint John the Baptist and Saint Francis*, 1310–15. Assisi, lower church of San Francesco, Orsini chapel.

Pietro Lorenzetti

The frescoes of Scenes from the Passion of Christ "ante mortem" *are in the left transept of the lower church. They stand out for the pure, enamel-like quality of the colors, the scrupulous attention to detail, and the psychological and dramatic intensity of the scenes.*

The scene is set inside an elegant hexagonal pavilion, in which the ceiling beams and corbels create a complex perspective view.

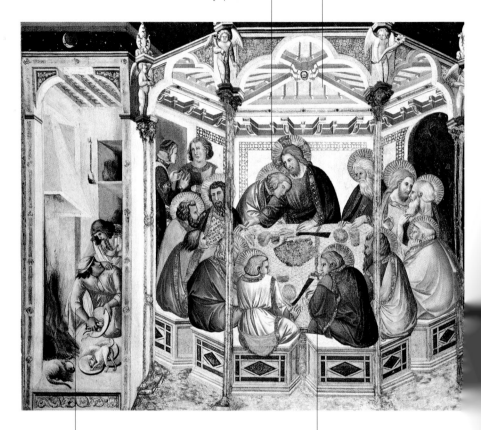

Our glance is drawn to a kitchen on the left, where a saucepan is on the boil in the fireplace, while a kitchen boy throws some leftovers to a dog and a cat. All this creates an unexpected scene of everyday medieval life.

The solid figures of the apostles, wrapped in their robes, are gathered round a sparsely laid table.

▲ Pietro Lorenzetti, *The Last Supper,* 1315–19, from *Scenes from the Passion of Christ "ante mortem."* Assisi, lower church of San Francesco.

The date of this second series of frescoes in the lower church is much debated, but they must be later than the frescoes of Scenes from the Passion of Christ "ante mortem."

The intensely dramatic quality of the scene is achieved through the original and monumental composition, based on the contrast between the verticality and stillness of the cross and the collapsing body of Christ.

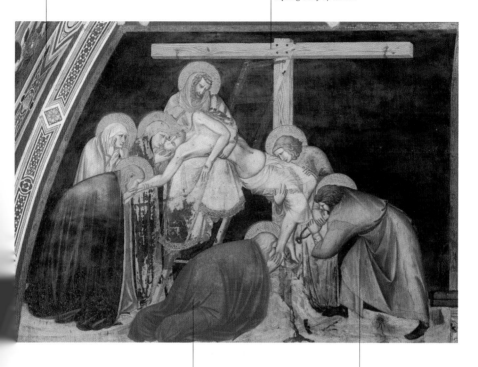

In Scenes from the Passion of Christ "post mortem," one of the greatest achievements of 14th-century painting, Pietro displays a more mature attention to composition and a more powerful dramatic tension, reminiscent of the statues of Giovanni Pisano.

All the figures are striking for their plasticity: the clearly outlined body of Christ, the prostrate figure of Mary Magdalen kissing his feet, and Nicodemus busy removing the nails with a pair of pincers.

Pietro Lorenzetti, The Deposition, 1322, from Scenes from the Passion Christ "post mortem." Assisi, lower rch of San Francesco.

Pietro Lorenzetti

Pietro has painted a kind of Sacra Conversazione here by eliminating the traditional isolation of the figures in triptychs.

This fresco has a gold background and a predella because it takes the place of an altarpiece. Noteworthy is the "conversation" between mother and son, which can also be found in other works by Pietro.

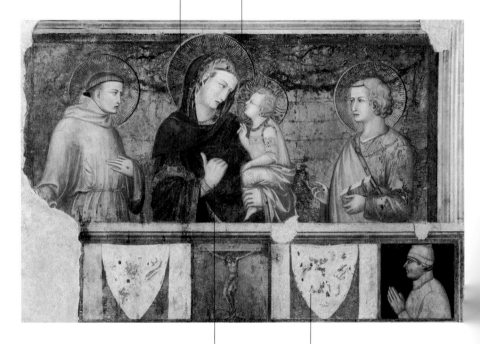

Mary turns to the Child to point out to him the stigmata and the wound in the side of Saint Francis, on the left, while Saint John, on the right, echoes the Virgin's gesture, as though to add emphasis.

This little fresco is below the large Crucifixion that Pietro painted in the transept of the lower church and belongs to the group of frescoes with Scenes from the Passion of Christ "post mortem."

▲ Pietro Lorenzetti, *Madonna and Child between Saint Francis and Saint John the Evangelist*, 1320–22. Assisi, lower church of San Francesco.

The main panel shows the Virgin seated on a throne with open sides covered in a luxurious red brocade with a green and gold pattern.

The Child turns toward Elijah with a lively movement. Behind the throne, four austere angels dressed in white robes embroidered with gold observe the scene and, on the left, Saint Nicholas keeps watch over Mary.

The figures have a statuesque quality and are immersed in a broad, calculated space. The rich colors are spread over broad areas.

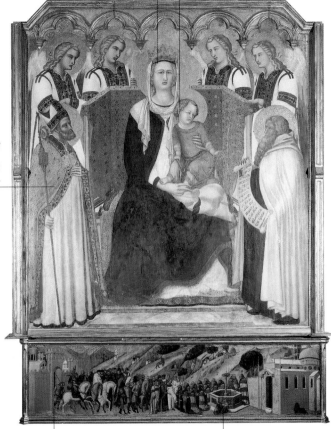

The five panels of the predella show scenes of the Carmelite order in which Pietro is experimenting with the depiction of perspective and space. In the center, Saint Albert is handing the rule of the order to Saint Brocard.

Of particular interest is the care with which the artist dwells on the description of each detail, from the clear water gushing from the fountain to the clothes and gestures of those taking part in the procession.

Pietro Lorenzetti, *Madonna del Carmine Altarpiece*, 1329. Siena, Pinacoteca Nazionale.

Pietro Lorenzetti

The scene unfolds in three separate spaces: the center and the right made up a single room, whereas the left-hand panel is arranged in depth, with a succession of spaces leading back to a courtyard.

This panel is the central part of a polyptych for the altar of Saint Savinus in Siena cathedral. On either side were panels with the figures of Saints Savinus and Bartholomew (now lost). There was also a predella, of which only one panel survives.

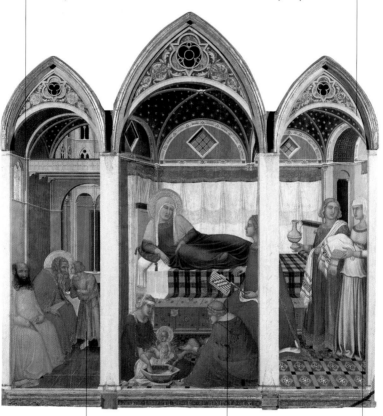

On the left, a youth is announcing the birth of a daughter to an anxious-looking Joachim, while in the room where the birth has taken place two crouching women are bathing the new-born baby.

In the middle of this scene is another woman, with a fan in her hand. She serves to unite the central and right-hand panels, and her ample red robe, which spans both panels, gives continuity to the scene.

On the right, two statuesque figures are bringing food for the mother. The reclining figure of Anne on the bed is depicted with solid monumentality and in a pose that is reminiscent of Arnolfo di Cambio's Madonna della Natività.

▲ Pietro Lorenzetti, *The Birth of the Virgin*, 1335–42. Siena, Museo dell'Opera Metropolitana.

An architect and a sculptor, Lorenzo Maitani represents the most aristocratic Sienese taste. He served as master of the works for the cathedral of Orvieto.

Lorenzo Maitani

The Sienese architect and sculptor Lorenzo Maitani was the son of Vitale di Lorenzo, known as Maitani. He is first documented in 1290 at Siena but left for Orvieto, where, in 1310, he was appointed *capudmagister universalis* (cathedral and city architect). He was so highly regarded at Orvieto that the commune granted him and his family citizenship for life, together with exemption from all civic obligations. He was responsible for designing the cathedral facade with its pure Gothic qualities: strong verticality of cusps and pinnacles, and elegant outlines that transform it into a rich jewelcase. He and his workshop are also thought to have made the four pilasters that ornament the lower part of the facade. They are covered in sculptural decoration, with scenes from Genesis, the Life of Christ, and the Last Judgment elegantly narrated in the branches of the "tree of life." Documents suggest that he also worked as a sculptor, casting bronzes, and he is thought to have made the symbols of the four evangelists (1329) and the six angels who are holding open the curtain of the baldachin in the central portal lunette, beneath which is his *Madonna and Child Enthroned*. He died in 1330, still working on the cathedral building site.

Siena ca. 1270–
Orvieto 1330

Where he worked
Siena and its territory,
Orvieto

Principal works
Design for the cathedral
facade (Orvieto, from
1310); sculptures on the
cathedral pilasters with
*Scenes from Genesis, The
Life of Christ,* and *The
Last Judgment* (Orvieto,
from 1310)

◀ Lorenzo Maitani,
Pilasters on the Lower Part
of the Cathedral Facade,
from 1310. Orvieto.

Lorenzo Maitani

The "tree of life" consists of vine tendrils that separate the various episodes: the Resurrection of the Dead, the Last Judgment, Paradise, and Hell.

The sculpted reliefs are of high quality. They reveal the influence not only of French but also of antique sculpture, and of the work of Giovanni Pisano.

The third panel shows angels guiding the blessed into paradise. There are saints in the fourth, and Christ sits in judgment in the fifth.

An analysis of the sculpture on the pilasters shows how the work was divided up. Maitani was definitely responsible for the more complicated parts and less skilled craftsmen were given the less important parts.

Note the anatomical details of the naked men in the scene of hell: ribs can be made out, as well as muscular tension in the legs and the veins carrying blood around the body.

In the bottom panel and the one above it are the Resurrection of the Dead, Hell, the Separation of the Saved and the Damned, and Satan Crushing the Damned. In the lower right we see the Descent of the Damned Souls into Hell.

▲ Lorenzo Maitani, *The Last Judgment*, fourth facade pilaster, from 1310. Orvieto, cathedral.

His identity is still unknown but he was an important exponent of Bohemian and European painting in the 14th century. He painted the Třeboň altarpiece, which can be dated to about 1380.

Master of Wittingau

We know nothing of this master's life; he is sometimes called Master of the Třeboň Altarpiece after his masterpiece. The surviving parts of this altarpiece reveal an outstanding, original personality who occupies an isolated position within the artistic milieu of central Europe. From a stylistic and spiritual point of view, the work has decidedly Gothic characteristics. But it is ahead of its time in its strikingly unitary composition, as the artist skillfully ties together all the features of the painting through the play of light and shade. Because of the broadly sweeping folds of his draperies, he is considered a precursor of the *Faltenstil* (Fold style), which took hold in Bohemia around the 15th century and became characteristic of the sculptures of the so-called *Schöner Stil* (Beautiful style). The three surviving panels of the Třeboň altarpiece are *The Agony in the Garden*, *The Resurrection*, and *The Deposition*, with figures of saints on the back. Also attributed to this artist are *The Adoration of the Child* (Hluboká nad Vltavou) and three panels depicting the Virgin now in Prague, to which *The Vyšší Brod Crucifixion*, also in Prague, seems to be connected.

Active in Prague or southern Bohemia in the late 14th century

Where he worked
Prague(?), southern Bohemia(?)

Principal works
Třeboň Altarpiece (Prague, Národní Galerie, ca. 1380); *Vyšší Brod Crucifixion* (Prague, Národní Galerie, second half of the 14th century); *Adoration of the Child* (Hluboká nad Vltavou, Alsova jihoceska Galerie, second half of the 14th century); *Roudnice Madonna and Child* (Prague, Národní Galerie, second half of the 14th century)

◀ Master of Wittingau, *The Agony in the Garden*, ca. 1380. Prague, Národní Galerie.

347

Master of Wittingau

The figure of Christ rises from the sarcophagus like a timeless, incorporeal apparition.

Thanks to his use of color, the Master of Wittingau succeeds in creating scenes of great intensity.

The amazed and troubled soldiers look up at Christ from below, still half asleep.

A top panel must have contained a Crucifixion, and the left panel was that with the Agony in the Garden and the Resurrection. The outer panels would have shown figures of male and female saints, martyrs, and apostles.

▲ Master of Wittingau, *The Resurrection*, ca. 1380. Prague, Národní Galerie.

Theodoric is the first Bohemian artist whose name, position, and activities can be identified. His work made an important contribution to the development of 14th-century painting.

Master Theodoric

His name appears for the first time in 1359 in the books of the Prague guild of painters, where he is entered as "Theodoricus de Praga primus magiste." In the books of the city of Prague for the same year he is described as painter to the emperor. From 1357 to 1367 he was court painter to Charles IV, for whom he made a number of panels and decorated the chapel of the Holy Cross and the imperial chapel in Karlštejn Castle. It is thought that in 1359 Theodoric painted panels depicting Western and Byzantine Roman emperors for the imperial palace (now lost), and that he worked at the cathedral of Saint Vitus. There is still much debate about the sources of his inspiration, especially Italian and Franco-Flemish influences. Some suggest that Theodoric was in the entourage of Charles IV during his visit to Italy, where he could have encountered the latest trends in central and northern Italian painting. He probably trained in the workshop that decorated Karlštejn Castle, which was headed by the so-called Master of the Genealogy. Records suggest that he was responsible for about 130 panel paintings. He was still alive in 1381, when he was mentioned in a note about the decoration of the Karlštejn chapel.

Probably born in Prague, and active there in the second half of the 14th century at the court of Charles IV.

Where he worked
Prague, Karlštejn Castle near Prague

Principal works
Decoration of the chapel of the Holy Cross (Prague, Karlštejn Castle, ca. 1360–1365)

Notes of interest
The chapel of the Holy Cross, where the imperial regalia were kept, must have been an extraordinary place. The interior walls were covered in semiprecious stones, while the dome and windows shone with gilded bombé glass discs. In the vaulting Theodoric painted a fresco of *The Adoration of the Magi*, and his panel paintings, *Portraits of the Army of Christ*, were used to link the vaulting and the walls with their precious stones.

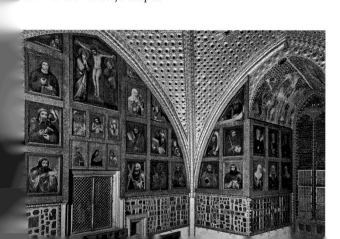

◄ Master Theodoric, *Portraits of the Army of Christ*, ca. 1360–65. Prague, Karlštejn Castle, chapel of the Holy Cross.

Master Theodoric

The gold background and brilliant color of the robe emphasize the figure's plasticity, which is further enhanced by the play of light and shade.

Typical of Theodoric's figures is a deliberate, repeated use of similar gestures; spiritual and secular elements seem to be in a state of harmonious equilibrium.

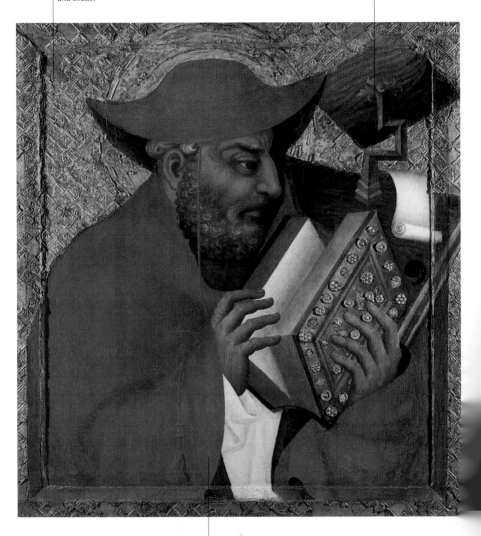

▲ Master Theodoric, *Saint Jerome*, before 1365. Prague, Národní Galerie.

Like all the other figures in the panels depicting the Army of Christ in the chapel of the Holy Cross in Karlštejn Castle, Saint Jerome is shown half-bust—a quite original choice for the time, and one that creates the illusion that the figure is emerging from the painting.

"But surely my Simone was in Paradise, / Where this gentle lady has gone to dwell; / There he saw her and there he drew her portrait" (Petrarch, Canzoniere, *14th century).*

Simone Martini

Simone was probably born in Siena around 1284. In 1315, he appended his name to the bottom of a frescoed *Maestà* in the Palazzo Pubblico in Siena. This is the first evidence we have of his work, but he must have been well established by that time: the task entrusted to him was substantial. The *Maestà* had been started long before the recorded date of completion, and it is likely that by this time Simone had begun work on the chapel of San Martino in the lower church at Assisi, where he was in a position to study the work of Giotto and his assistants. Another prestigious commission, from Charles II of Anjou, King of Naples, dates to 1317: *Saint Louis of Toulouse Crowning Robert of Anjou.* His growing fame was such that when Duccio died in 1318, Simone became the most renowned Sienese painter. He made a number of works for the mendicant orders and the commune of Siena up to 1333, when he and Lippo Memmi signed the *Annunciation* altar-piece for the altar of Saint Ansanus in the cathedral. In 1335 or 1336 he left for Avignon. Here Simone worked for a very ele-vated circle of patrons, including Cardinals Orsini and Stefaneschi, and it was here that he met Petrarch, who wrote two sonnets about him. For Petrarch, Simone painted *Portrait of Laura* and the famous title page of the Virgil manuscript.

Siena (or San Gimignano)
ca. 1284–Avignon 1344

Where he worked
Siena, Assisi, Naples(?),
Avignon

Principal works
Maestà (Siena, Palazzo
Pubblico, Sala del
Mappamondo, ca.
1312–15); frescoes in the
chapel of San Martino
(Assisi, lower church of
San Francesco, ca.
1315–17); *Saint Louis of
Toulouse Crowning Robert
of Anjou* (Naples, Museo
di Capodimonte, 1317);
Guidoriccio da Fogliano
(Siena, Palazzo Pubblico,
Sala del Mappamondo,
ca. 1330); *Annunciation*
(with Lippo Memmi,
Florence, Uffizi, 1333);
frescoes in the cathedral of
Notre-Dame-des-Doms
(Avignon, 1340–43)

Notes of interest
Characteristic of Simone's
work was his use of pre-
cious materials. He seems
to have invented punch
decoration.

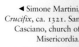

◀ Simone Martini,
Crucifix, ca. 1321. San
Casciano, church of
Misericordia.

351

Simone Martini

In the absence of architectural structures here, the sense of space is provided by the plasticity of the conical tents and the moonlit mountains.

In the ten scenes from the life of Saint Martin, there are clear echoes of Giotto's plasticity and spatial vision, but the scenes are set in a courtly world with quite novel tones.

Simone Martini uses rich colors. He dwells on the description of details in his convincing depiction of the event itself and the psychology of the characters involved.

▲ Simone Martini, *Saint Martin Renouncing Arms*, ca. 1315–17. Assisi, lower church of San Francesco.

The saint is seen clutching a small cross as he sets off toward the barbarian camp behind the rocks, in a world whose qualities are decidedly medieval. The profile of the emperor Julian is reminiscent of classical portraits.

The landscape is particularly interesting. There is something very Sienese about the courtyards, the streets with overlooking balconies, and also the bare "chalk hills" around the city.

The Blessed Agostino is shown standing with a book in his hand as a little angel whispers in his ear. The surrounding landscape with trees and birds is an allusion to his hermitage.

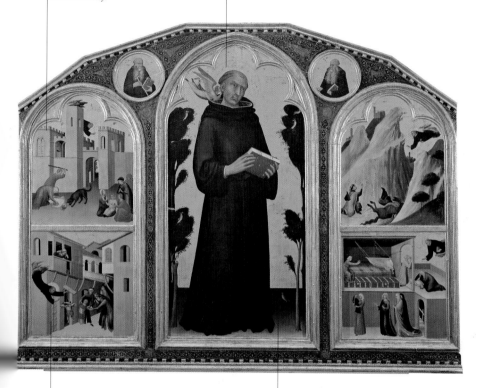

These scenes are striking for their representation of aspects of ordinary life, such as the mother at the window screaming because her child has fallen from the balcony.

Simone depicts four posthumous miracles in which Agostino providentially intervenes, flying down from above.

Simone Martini, *The Blessed Agostino Novello and Four of His Miracles*, 25–28. Siena, Pinacoteca Nazionale.

Simone Martini

The left-hand side with the castle was repainted in the 15th century, probably based on a tracing of the original. The whole fresco is a magnificent representation of what the countryside outside a Tuscan town must have looked like in the 14th century.

On May 2, 1330, Simone Martini was paid for painting the castles of Montemassi and Sassoforte in the Palazzo Pubblico. It is generally thought that this is the fresco in question.

This fresco occupies the top section of the wall in the Sala del Mappamondo opposite the Maestà. It shows the Sienese military leader Guidoriccio da Fogliano on horseback, against the background of the castle of Montemassi, which had just been taken.

▲ Simone Martini, *Guidoriccio da Fogliano*, ca. 1330. Siena, Palazzo Pubblico, Sala del Mappamondo.

On the right is a structure made of wood and masonry, surrounded by a moat. It can be identified as a battifolle (temporary fortification), and a war machine is visible inside. The two principal towers are flying the flag of Siena (left) and the insignia of Guidoriccio (right).

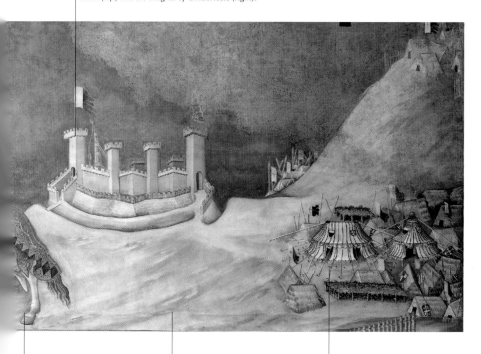

The date 1328, which appears on the framing band, is a reference to the taking of Montemassi.

The purpose of the fresco was to publicize the republic's achievements, and it constitutes another important stage in Simone's "civic art."

In the bottom corner the artist has painted a military camp, with tents and two vineyards within its domain.

In this work, Simone achieves extreme formal abstraction. Space is suggested by the movement of the slender, immaterial figures of the angel and the Virgin, and by the placing of the few solid objects, namely the throne and the vase of lilies.

The whole scene is suffused with the courtly ideals of beauty, elegance, and harmony.

The angel's words are in punched relief, running along the gold background from the angel's mouth. Above the words, at the center, is the dove of the Holy Spirit, surrounded by eight seraphim.

The punched, striated, and worked gold is the true protagonist of the painting, and it is found not only in the background but also in clothes, haloes, and the raised letters of the angel's words.

This work bears the signatures of both Simone Martini and Lippo Memmi. The two artists were brothers-in-law, often worked together, and may have run a workshop with other relatives.

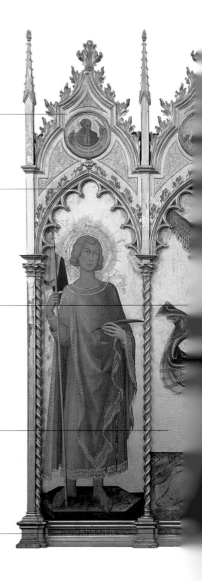

▲ Simone Martini and Lippo Memmi, *The Annunciation*, 1333. Florence, Uffizi.

Oliver painted a cycle of the Passion in the Pamplona cathedral in Navarre, giving expression to a new, modernized style, based on the latest great artworks of England and France.

Juan Oliver

We know little about Juan Oliver. He probably came from Navarre and is thought to have trained in England, where he would have seen East Anglian illuminated manuscripts. He probably went to France later on and seems to have worked alongside Pierre du Puy at Avignon around 1316. In 1330, his name appears in some documents in which Juan Pérez de Estella, archdeacon and trusted assistant of the bishop of Pamplona, commissioned some paintings from him for the cathedral refectory. In a document of 1332, he is described as a "painter of Pamplona," which suggests that he had been in the city for a number of years. For the refectory, Oliver painted the very fine frescoes of the *Mural Retable of the Passion*, which are framed by two bands of prophets and heraldic coats of arms, alternating men with women, jesters with musicians. The fresco brings together the various stages in the Passion of Christ: the Flagellation and the Ascent to Calvary are in the topmost tier; the Crucifixion is in a single panel in the middle, and in the bottom tier are the Deposition, the Holy Women at the Sepulchre, and the Resurrection. It is thought that Juan Oliver died at Pamplona; unfortunately, no works of his survive there. A document of 1379 there refers to a painter of the same name, perhaps his son.

Navarre(?) late 13th century(?)–Pamplona (?)

Where he worked
He may have trained in England; he probably then worked in northern France, at Avignon, and at Pamplona

Principal works
Mural Retable of the Passion (Pamplona, Museo de Navarra, ca. 1330–32)

▼ Juan Oliver, *Mural Retable of the Passion* (detail), ca. 1330–32. Pamplona, Museo de Navarra (formerly in the cathedral).

Juan Oliver

The artist lays the paint on in patches, and his way of treating the faces and gestures of his figures shows that he was acquainted with contemporary English and French illuminated manuscripts.

The narrative unfolds at a leisurely pace, allowing the artist to dwell on the description of his characters' emotions, and sometimes on the sanguinary aspect of events as well.

The paintings are framed at the sides by figures of prophets, and finish at the bottom with the coats of arms of those who sponsored the work. Painted in courtly style on either side of the shields are men and women, jesters and musicians.

The figures, with their sinuous lines and delicate shades of red and blue, stand out against the pale background.

The refectory painting belongs stylistically to the typical advanced linear Gothic of the early 14th century.

▲ Juan Oliver, *Mural Retable of the Passion*, ca. 1330–32. Pamplona, Museo de Navarra.

*Paolo Veneziano was the greatest Venetian painter of the early
14th century. He created a pictorial language in which Byzantine
tradition and Gothic innovation found a subtle equilibrium.*

Paolo Veneziano

Born around 1300, Veneziano is documented as working in
northern Italy, Istria, and Dalmatia from 1333 to 1358. Hence
he trained in Venice in the 1310s, when the artistic climate in
the city had been enlivened by a new wave of architecture and
sculpture, while painting was still anchored in the Byzantine
tradition. Although his roots lay deep within that tradition,
Paolo moved toward a new pictorial language that was rich in
Gothic elements and aware of Giotto's innovations. There is
early evidence of this balance between the Byzantine elements
and the Gothic and modern ones in the fragmentary altarpiece
from the Franciscan church of San Lorenzo at Vicenza, his first
signed and dated work (1333). His subsequent artistic develop-
ment led him toward an elegant form of Gothic, but one full of
striking observations of everyday life. An example is the Venice
Coronation of the Virgin, where the crowned head of the Virgin
tilts slightly, in a setting full of ornamentation, jewels, flowers,
and rich fabrics. He turns again to the Byzantine tradition in
the cover of the Pala d'Oro in San Marco, which he finished in
1345, and in the grandiose polyptych for the Augustinian
church of San Giacomo in Bologna, where his Byzantine classi-
cism is enlivened by more
typically Gothic features.
One can see this in *Saint
George and the Dragon*,
where a strong sense of
plasticity suffuses the
lively, imaginative compo-
sition and makes it stand
out against the gold
ground.

Venice (?) ca.
1300–1358/1362

Where he worked
Venice, northern Italy,
Istria, Dalmatia

Principal works
Altarpiece (Vicenza, Museo
Civico d'Arte e Storia,
1333); *Madonna and Child*
(Venice, Istituto Pie Suore
Canossiane, 1335–40);
lunette above the tomb of
Doge Francesco Dandolo
(Venice, Santa Maria dei
Frari, ca. 1339); *Scenes
from the Life of Saint
Nicholas* (Florence, Contini
Bonaccossi Collection, ca.
1340); *Crucifix* (Venice,
Santo Stefano, ca. 1340);
polyptych (Bologna, San
Giacomo Maggiore, ca.
1344); *"Pala feriale" with
Scenes from the Life of
Saint Mark* (Venice, San
Marco, Museo Marciano,
1345); *Coronation of the
Virgin Altarpiece* (Venice,
Gallerie dell'Accademia,
1355); *Coronation of the
Virgin* (New York, Frick
Collection, 1358)

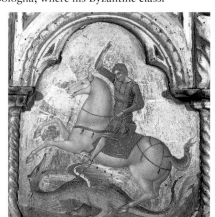

◄ Paolo Veneziano, *Saint
George and the Dragon*
(polyptych detail), ca.
1344. Bologna, San
Giacomo Maggiore.

Paolo Veneziano

The Pala feriale, *a protective cover over the Pala d'Oro, consists of fourteen panels: seven in the upper tier, with Christ on the Cross, the weeping Virgin and saints, and seven in the lower tier, with scenes from the life of Saint Mark.*

The upper tier is more closely linked to the Byzantine tradition, although the gestures, soft robes, and choice of colors betray a decidedly Gothic interpretation.

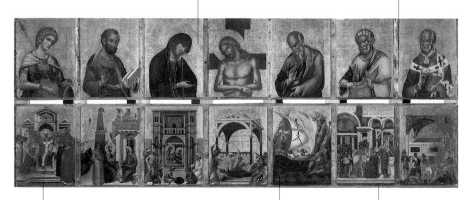

The Pala d'Oro is shown to the faithful only on solemn feast days. It was made in 1105 and enlarged in 1209 with enamels that were probably part of the Fourth Crusade booty from Constantinople. Doge Andrea Dandolo had it reconstructed, enlarged, and embellished with goldware and jewels. It was completed in 1345 with this painted cover, which is signed by Paolo and his sons Luca and Giovanni.

The synthesis of Byzantine features and a modern interpretation reflects the Po valley and Veneto painting, which was familiar with the work of Giotto.

In Scenes from the Life of Saint Mark, with its lively narrative, spacious architectural backgrounds, and bright colors, the hand is predominantly that of Paolo himself.

▲ Paolo Veneziano, *"Pala feriale"* with *Scenes from the Life of Saint Mark*, 1345. Venice, San Marco, Museo Marciano.

*One of a family of architects and sculptors, he was called to
Prague by Charles IV. He took charge of many building sites,
including the very important site of the cathedral of Saint Vitus.*

Peter Parler

Born in 1333 at Schwäbisch Gmünd, Peter Parler presumably
apprenticed in the workshop of his father, Heinrich, who was in
charge of the building site at the local church of the Holy Cross.
It is probable that young Peter visited parts of central Europe,
including Strasbourg, Cologne, and perhaps Paris, for his work
betrays familiarity with the architecture of those cities. In 1352
he became a *parlier* (chief assistant to the site director) and
stand-in for his father at the site of the church of Our Lady at
Nuremberg, where his first sculptures are found. He probably
also worked as a sculptor at nearby Lauf Castle, which, like Our
Lady, had been commissioned by Charles IV. In 1356 he was
called by the emperor to Prague, where he took over direction of
the cathedral site (from Mathieu d'Arras) until 1397. The fact
that the emperor entrusted the direction of the most prestigious
building site in the empire to such a young architect is indicative
of his outstanding talent. Apart from the cathedral site, where a
portrait bust of him can still be seen, he also supervised the
building of the Charles Bridge (from 1357), the monumental
gate leading to the Old City (from ca. 1373), the Palatine chapel
in the castle (now destroyed),
and the choir of Saint Bartholo-
mew at Kolin (1360–78). As a
sculptor, Peter made the ceno-
taph for Ottokar I in Prague
Cathedral and designed the busts
of the royal family and of the
two architects and master
builders for the cathedral trifo-
rium. Peter Parler was granted
citizenship in Prague in 1379. He
died on July 13, 1399.

Schwäbisch Gmünd
1333–Prague July 13, 1399

Where he worked
Schwäbisch Gmünd,
Nuremberg, Prague, Kolin

Principal works
Cathedral of Saint Vitus
(Prague, from 1356);
Charles Bridge (Prague,
from 1357); choir of Saint
Bartholomew (Kolin,
1360–78); monumental
gate at the Charles Bridge
(Prague, from ca. 1373)

Notes of interest
The German term *parlier*
describes the profession of
chief assistant to the site
director, and during the
course of the 14th century
it became a surname. Not
all the members of Peter
Parler's family used that
name, but all of them
seem to have used the
double-hinged rod as a
stone mark, a signature,
and a seal.

◄ Peter Parler and assis-
tants, Portrait Bust, ca.
1385. Prague, cathedral
of Saint Vitus.

Peter Parler

Thanks to the patronage of Charles IV of Luxembourg, a man of rare intelligence and modernity, Parler was allowed to develop his own innovative ideas within the artistic circles of the court.

Peter designed and supervised the decoration of the tower on the Charles Bridge. Inside, the tower is covered in a network of ribbing that penetrates into the walls without the aid of corbels. On the outside, architecture and sculpture blend harmoniously.

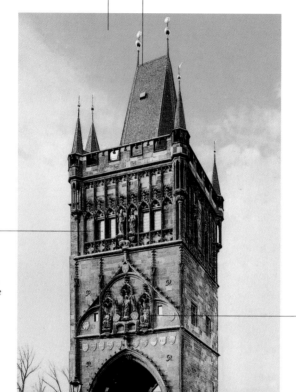

The upper floor is made lighter by a series of arches and columns, in the middle of which are statues of Saints Adalbert and Sigismund, both patron saints of the Czech people.

Lined above the arch giving access to the bridge are the insignia of Charles IV. Above these are statues of Saint Vitus, Wenceslas IV, and Charles IV, portrayed with the insignia of power.

Peter Parler's work had a decisive influence on the later development of northern European art.

▲ Peter Parler, Monumental Gate at the Charles Bridge on the Old City side, from ca. 1373. Prague.

In the 1370s Peter Parler and his
workshop assistants made the royal
tombs in the choir chapels in Prague
cathedral.

In Parler's figures we can see that he has broken away
from courtly art and reached a new concept of the
plastic, which tends to accentuate volume; and at the
same time he pays a good deal of attention to detail
and to psychological characteristics.

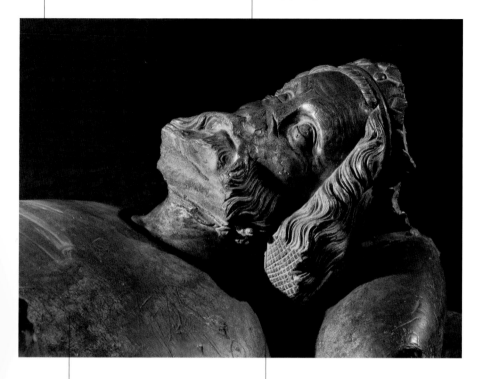

There are two types of recum-
bent effigy on these tombs: either
the figure is wrapped in an ample
cloak, or else the appearance of
the effigy is determined solely by
the figure's own volume in the
block of stone.

The sense of volume domi-
nates the sculpted form, as
can also be seen in the cycle of
busts in the cathedral trifo-
rium. This is an important
step forward toward the birth
of the modern portrait.

Peter Parler, Recumbent Effigy of
ttokar I (detail), before 1377. Prague,
athedral of Saint Vitus.

This great Parisian miniaturist was one of the most significant artists in 14th-century Europe. He was an original interpreter of the new rendering of space found in Tuscan painting.

Jean Pucelle

Paris late 13th century(?)–1334

Where he worked
Paris, northern France, Tuscany(?)

Principal works
Belleville Breviary (Paris, Bibliothèque Nationale, ca. 1323–26); *Book of Hours of Jeanne d'Évreux* (New York, Metropolitan Museum, 1325–28); Bible signed by Robert Billyng (Paris, Bibliothèque Nationale, 1327); *Breviary of Blanche of France* (Vatican City, Biblioteca Apostolica Vaticana, ca. 1330); *Miracles de Notre-Dame* of Gautier de Coincy (Paris, Bibliothèque Nationale, 1330–35)

Links with other artists
Jean Le Noir

Notes of interest
The mold for the seal of the confraternity of the Hôpital de Saint-Jacques-aux-Pèlerins was found in the Seine in the 16th century, but then disappeared again.

▶ Jean Pucelle, *A Besieged Castle*, 1330–35, illuminated page from *Les Miracles de Notre-Dame* of Gautier de Coincy. Paris, Bibliothèque Nationale.

Pucelle was active as a miniaturist in Paris and northern France in the first thirty years of the 14th century. We have little information about his life and career, but his name appears as many as four times in documents, which is clear evidence of his eminent position. He is first mentioned in the records of the Paris confraternity of the Hôpital de Saint-Jacques-aux-Pèlerins (1319–24) as responsible for designing the great seal of the confraternity. Other important evidence is an inscription at the end of a Bible, now in Paris, signed by Robert Billyng as copyist. The colophon gives the names of Jean (Jehan) Pucelle, Anciau de Cens, and Jaquet Maci as illustrators of the book in 1327. His name also appears in a note to *The Belleville Breviary*, made for Jeanne de Belleville around 1323–26, and in the will of Jeanne d'Évreux (d. 1371), wife of Charles IV the Fair, in which Pucelle is named as illuminator of a manuscript made for the queen in 1325–28. Pucelle is also thought to have been

responsible for the illustrations to *Les Miracles de Notre-Dame* of Gautier de Coincy and some of those in *The Breviary of Blanche of France*. His treatment of space and volume, together with some iconographic features, has led some to suggest that he visited Tuscany, whose art was very widely influential.

The Belleville Breviary *was made for Jeanne de Belleville, wife of Olivier de Clisson, one of the lords who took part in the Norman and Breton rebellion against Philip VI of Valois.*

The theme of the principal scene is continued at the bottom of the page. This is typical of Pucelle and his school.

The Dominican-style breviary was in two volumes. The text included a calendar, most of which is now lost. An article of the creed is paired with each of the months. Another part is devoted to illustrations of the Psalms, as is explained in the introduction, which was probably written by a Dominican theologian.

This breviary is outstanding for the rich ornamentation and the wealth of images from the naturalistic repertoire: animals, plants, flowers, and grotesque figures.

Jean Pucelle, *Saul Tries to Wound David*, ca. 1323–26, illuminated page from *The Belleville Breviary*. Paris, Bibliothèque Nationale.

On stylistic grounds, Jean Pucelle is thought to have been responsible for all the painted scenes. Mahiet, Ancelet, and Jean Chevrier are thought to have been responsible for the secondary decoration.

Jean Pucelle

In this scene Christ is seized by the centurion. On his right are the apostles, with Peter drawing his sword. On Christ's left, armed soldiers are shouting and crowding toward him.

The miniatures consist of a cycle about Mary, another about Christ, and a third about Saint Louis, who was often identified with Christ in the French art of the period.

The use of grisaille illustrates the links among different techniques: it may derive from the technique used in stained glass, or it could be an attempt to imitate sculpture.

▲ Jean Pucelle, *The Capture of Christ*, 1325–28, illuminated page from *The Book of Hours of Jeanne d'Évreux*. New York, Metropolitan Museum.

The influence of Italian art is clear in this book of hours, Pucelle's first wholly autograph work. It was made for the queen, Jeanne d'Évreux, who left it in her will to Charles V.

These are grisaille miniatures: the modeling of the figures is achieved solely with shades of gray. In a few places, the monochrome is interrupted by patches of color for backgrounds and flesh tints.

Pedro Serra was the third of four painter brothers. He adopted the Sienese Gothic style brought to Barcelona by Ferrer Bassa and taken up by Ramon Destorrents.

Pedro Serra

Serra is documented from 1346 to 1405. He and his three brothers—Francesc, Jaume, and Joan—all became painters. He was a pupil of Destorrents, as we know from his apprenticeship contract at the latter's workshop for the years 1353–58. His artistic training seems to have been interrupted in 1362, probably when Destorrents and Pedro's brother Francesc died in a fresh plague epidemic at Barcelona. The artistic activities of the Serra workshop are documented for the whole second half of the 14th century and into the 15th. The workshop adopted the current Sienese style, marking a profound change in Catalan painting. Two works by Pedro Serra are documented: *The Retable of the Virgin and Child with Saints*, a monumental polyptych commissioned in 1393 for the chapel of the Holy Spirit in Manresa Cathedral; and the central panel of *The Retable of Saint Bartholomew and Saint Bernard of Clairvaux*, part of a polyptych intended for the monastery of Sant Domènec at Barcelona, documented at 1395. These works belong to the last stage of his career. Serra dwells on descriptive detail in all his figures and chooses enamel-bright colors for their faces. He is also thought to have made the central panel of *Madonna of the Angels* and the bodies in the predella for the same retable, which came from Tortosa Cathedral. In this painting, the enthroned Madonna is surrounded by angels playing musical instruments. She delicately holds a fine thread tied to the bird that perches on the Child's hand.

Documented at Barcelona and in Catalonia from 1346 to 1405

Where he worked
Barcelona

Principal works
Madonna of the Angels
(attr., Barcelona, Museo Nacional de Arte de Catalunya, ca. 1385);
Retable of the Virgin and Child with Saints
(Manresa, cathedral, chapel of the Holy Spirit, 1394);
Retable of Saint Bartholomew and Saint Bernard of Clairvaux (Vic, Museo Episcopal, 1395);
Virgin, Angels, and Saints
(attr., Syracuse, Museo Nazionale di Palazzo Bellomo, late 14th century)

Links with other artists
Ferrer Bassa, Ramon Destorrents

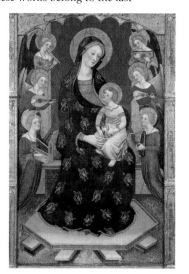

◄ Pedro Serra, *Madonna of the Angels*, ca. 1385. Barcelona, Museo Nacional de Arte de Catalunya.

*Together with Peter Parler, Claus Sluter is one of the most origi-
nal sculptors of the late 14th century. His works are striking for
their strong pathos and forceful expression.*

Claus Sluter

Haarlem ca. 1360–Dijon
1406

Where he worked
Brussels, Dijon, Germolles;
in 1393, he and Jean de
Beaumetz, Philip the Bold's
chief painter, visited
Mehun-sur-Yèvre

Principal works
*Funerary Monument of
Philip the Bold* (Dijon,
Musée des Beaux-Arts,
from 1381); church portal
at the Carthusian
monastery of Champmol
(Dijon, 1390–93); *Well of
Moses* (Dijon, Carthusian
monastery of Champmol,
ca. 1395–1402)

Links with other artists
Jean de Beaumetz

Notes of interest
By March 1792, during the
French Revolution, the
demolition of the
Champmol monastery had
already begun. Although
the effigy of Philip the Bold
was destroyed, the tomb
itself was largely saved.
The portal and the Well of
Moses were left in situ.

▶ Claus Sluter, *Madonna
and Child*, from the
portal of the Carthusian
monastery at Champmol,
ca. 1390–93, Dijon.

Sluter was born at Haarlem in Holland around 1360. His name
appears in the register of Brussels stonecarvers, whom he proba-
bly joined around 1379. It is thought that he trained in Brussels,
for he was in contact with members of the stonecarvers' guild
there on several occasions. In 1385, he entered the service of
Philip the Bold, Duke of Burgundy, as assistant to Jean de
Marville, who was chief sculptor at the Champmol Carthusian
monastery site where the dukes of Burgundy were to be buried.
After the death of Jean, Sluter was appointed his successor in
July 1389. As the duke's principal sculptor, he had a certain
amount of freedom in expressing his artistic ideas, and he super-
vised a group of assistants. He worked on the church portal at
the Champmol monastery and continued
work on the duke's tomb; both projects had
been designed and begun under Jean de
Marville, but Sluter gave them his own
imprint. For the tomb of Philip the Bold
(completed by Sluter's nephew Claus de
Werve), Sluter introduced a series of niches
in which he placed mourning and weeping
figures, each one expressing an individual
reaction to the loss of the duke. In 1393 he
also made a curious group for Philip the Bold
in which the duke and Margaret of Flanders
appear in a pastoral setting. It was intended
for Germolles Castle, but is now lost. In
1395, Sluter began constructing *The Well of
Moses* in the Champmol monastery cloister.
It gave him an opportunity to create a series
of great sculptures, being in charge of both
design and production.

The well was erected at the center of the principal cloister of the Champmol monastery. It provides a dramatic representation of the mystery of the Passion.

The affliction of the weeping angels contrasts with the solemnity of the prophets below. The individuality of the latter is emphasized, and they play their part in the drama of the Passion with intense realism.

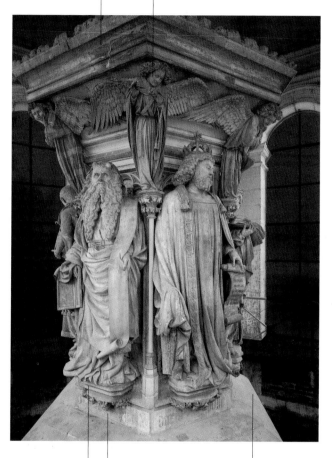

Six prophets—King David, Moses, Jeremiah, Zechariah, Daniel, and Isaiah—are arranged around a support. Weeping angels are above them, and the whole structure supported a Crucifixion.

The iconography of this work is based on the view that the conformity of Old and New Testaments illustrates the inevitability of Christ's suffering.

The expressive force of the prophets is linked to the powerful representation of body volume and to their freedom from architectural constraint. These are the typical qualities of Sluter's sculpture.

Claus Sluter, *The Well of Moses*, Carthusian monastery of Champmol, a. 1395–1402. Dijon.

One of the most important sculptors of the early 14th century,
he was influenced by Giovanni Pisano and Arnolfo di Cambio,
developing his own concept of plasticity.

Tino di Camaino

Siena ca. 1280–Naples
1336

Where he worked
Siena, Pisa, Florence,
Naples

Principal works
Tomb of San Ranieri (Pisa,
Museo dell'Opera della
Primaziale Pisana, 1306);
funerary monuments:
Cardinal Riccardo Petroni
(Siena, cathedral,
1317–18); Bishop Antonio
d'Orso (Florence, cathedral
1321); Mary of Hungary
(Naples, Santa Maria
Donnaregina, 1325)

Links with other artists
Arnolfo di Cambio,
Giovanni Pisano

Notes of interest
In July 1315, Tino left Pisa
to join the army of the
Guelph League. In 1322,
the Elders of Pisa dismissed
him from his post there on
the grounds that "he is a
Guelph and fought against
the Pisans at the battle of
Montecatini."

Born in Siena around 1280, Tino di Camaino was probably
trained under his father, Camaino di Crescentino, one of the
principal master masons at the Siena cathedral building site
when it was directed by Giovanni Pisano. The latter's influence
on Tino was particularly strong at the beginning of his career,
although Tino's sculpture was calmer and worked in broad
blocks. The first work by Tino's own hand is thought to be the
tomb of San Ranieri (1306) in Pisa, which has now been broken
up. Other works followed, such as the sculptures for the funer-
ary monument of Henry VII. In April 1315, Tino, who was
now in charge of the Pisa cathedral site, received payment for
the tomb. In July he left the city because of strife between Pisa
and Siena, but the prestige he had acquired in Pisa led to impor-
tant new commissions in Siena and later in Florence. In Siena
he was responsible for the funerary monument of Cardinal
Riccardo Petroni (1317–18), which was similar in type to

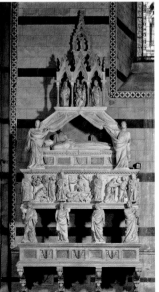

Arnolfo di Cambio's monument for
Cardinal De Braye, but Tino's har-
monious style also strongly echoed
Sienese painting. He was sum-
moned to Naples in late 1323 by
Robert of Anjou. There executing
numerous public and private com-
missions and heading a flourishing
workshop, he blended his knowl-
edge of French and Tuscan art
with that of the Angevin court to
produce a more elegant style of
his own.

▶ Tino di Camaino,
Funerary Monument of
Cardinal Riccardo Petroni,
1317–18. Siena, cathedral.

The sarcophagus rests on three lions supported by two arches that act as a base. The concept of the bishop seated in the isolation of death atop the sarcophagus is quite original.

The low relief on the front of the sarcophagus, in which Bishop d'Orso presents himself before God for judgment, accompanied by the Virgin and angels, interprets the event almost as a courtly ceremony.

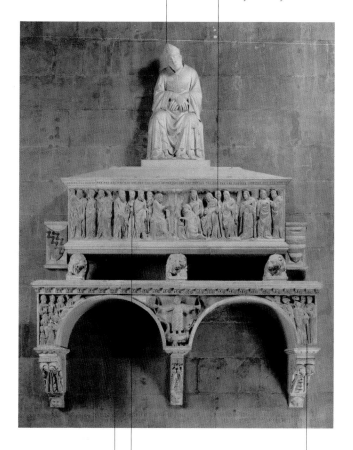

The tomb is placed against the inside of the facade wall of the cathedral, Santa Maria del Fiore. Below it, a long inscription engraved on the wall includes the sculptor's name.

The figures lack the dramatic quality found in Giovanni Pisano's work. Here, light slides over the sculpted surfaces, and draperies have a soft flow.

There is an allegory of Death in the spandrels at the top of the base.

▲ Tino di Camaino, Funerary Monument of Bishop Antonio d'Orso, 1321. Florence, cathedral.

Vitale was the great founder of the Bolognese school of painting. He was able to synthesize in a personal way the innumerable stimuli he received from the complex culture of his native city.

Vitale da Bologna

Born Aymo degli Equi
Bologna 1310(?); docu-
mented from 1330 to 1359

Where he worked
Bologna, Ferrara, Udine,
Pomposa

Principal works
Saint George and the Dragon (Bologna, Pinacoteca Nazionale, ca. 1334); *Madonna dei Denti* (Bologna, Museo Davia-Bargellini, 1345); *Scenes from the Life of Saint Nicholas* (Udine, cathedral, chapel of San Niccolò, ca. 1349); *Scenes from the Life of Saint Eustace* (Pomposa, abbey, 1351); *Scenes from the Life of the Virgin and Saint Mary Magdalen* (Bologna, Santa Maria dei Servi, ca. 1359)

Links with other artists
Tomaso Barisini

Notes of interest
That Vitale had a flourish-ing workshop is confirmed by a document of 1343, which tells of a commission for four wooden statues for Ferrara cathedral, to be painted in white and gold.

Vitale's early career is tied to the San Francesco building site in Bologna, where he worked from 1330 on. His formative period was spent in a city that had many contacts with Gothic culture, thanks to the cosmopolitan climate created not only by the university and scriptoria associated with it but also by the proximity of Rimini, where there was an important school of Giottesque painting. Vitale absorbed these influences but still managed to create a style of his own, as is evident in his *Madonna dei Denti* (1345), with its sharp features, agitated fingers, and an elegance reminiscent of French ivories; and in the frescoes of the same period in the church of Sant'Apollonia at Mezzaratta. His Gothic style and almost abstract naturalism were so successful that he had to assemble a workshop. In 1348 he is documented at Udine, where he decorated the main chapel in the cathedral. Among the few surviving fragments of these frescoes is *Susannah and the Elders*, in which the almost grotesque faces and gestures of the elders contrast with the delightful nude figure of Susannah. Vitale found so much work at Udine that a branch of his workshop may have been set up there. After decorating the apse of Pomposa abbey with frescoes

► Vitale da Bologna, *Susannah and the Elders*, ca. 1348. Udine, cathedral.

(1351), he was again in Bologna, painting *Scenes from the Life of the Virgin and Saint Mary Magdalen* in Santa Maria dei Servi. The rich colors of these frescoes are enhanced with jewel-like materials and unusually beautiful flesh tones.

This is probably an early work. The image is intensified by the use of gold, the enameled blue of the background, and the red lacquer of Saint George's robe.

The action takes place in a basic, barely indicated landscape, which stands out against the blue background. The princess also appears in this unreal space, watching from a distance.

There is an allusion to the Equi family in the acronym of the artist's name on the horse's rump. It also appears in the decorative band of the fresco cycle in Santa Maria dei Servi in Bologna.

Saint George lunges violently forward to pierce the dragon, while the horse twists away because of the knight's movement and because it has stepped on the dragon.

▲ Vitale da Bologna, *Saint George and the Dragon*, ca. 1334. Bologna, Pinacoteca Nazionale.